"If other countries had a theory of design, Italy had a philosophy, maybe even an ideology of design."
Umberto Eco, 1986

"Everything is permissible as long as it is fantastic."
Carlo Mollino, 1951

Published in 2013 by Goodman Fiell
An imprint of the Carlton Publishing Group
20 Mortimer Street
London W1T 3JW

www.carltonbooks.co.uk

A CIP catalogue record for this book is available from the British Library.

ISBN 978-1-84796-047-4

Text and design © 2013 Goodman Fiell

Printed in China

MASTERPIECES OF ITALIAN DESIGN

Foreword by Michele De Lucchi
Charlotte & Peter Fiell
and Catharine Rossi

GOODMAN
FIELL

Contents

Foreword

It is not only the skill and genius of the designers that have made Italian design famous throughout the world.

Its success is also due to the intelligence, tenacity and vision of the Italian entrepreneurs who have made it a reality, who have built it up and sustained it economically. The processes of management, decision-taking, organisation and production carried out in our companies have no parallel in those of our international competitors because they rest on a combination of attitudes that blend individualism with social cohesion, sensitivity with rationality, experimentation with pragmatism, aesthetic sense with transgression, passion with ambition – in a unique and extraordinary coalescence.

But Italy's designers and entrepreneurs could never have achieved their success without the fundamental contribution of the artisans scattered throughout the peninsula and who have miraculously survived the endemic economic crises which have constantly afflicted the country. The talent in the hands of simple artisans, the marble cutters of Carrara, the glassworkers of Murano, the cabinetmakers of Brianza, the metalworkers, the silversmiths, the jewellers and so forth – these are the raw materials of our most famous and best-recognised products.

It is the artisans who make it possible to realise the innumerable prototypes – always of the highest quality – that mark each stage in the development process and perfecting of those ideas that otherwise would not see the light of day but would undoubtedly remain designs. It is the artisans who supervise production and who give every product the value of an object executed with care and competence.

The love of the prototype, dedication to executing it and the value attributed to it – both with regard to understanding the product and its own intrinsic value – are essential to grasping the Italian phenomenon of design and fashion: they are the link that joins the world of art to that of industry. They are something very close to any Italian's heart.

Michele De Lucchi

Below: Zanotta promotional photograph showing plan views of the Sacco bean bag designed by Piero Gatti, Cesare Paolini and Franco Teodoro for Zanotta, 1968–69

Introduction

An industry for design and a love of quality

Italian design is recognized throughout the world for its functional innovation, elegant aesthetics and stylish refinement. From fashion to urban planning, industrial design and interior design, Italian design is distinguished by a purposeful beauty, which is both logically engaging and emotionally compelling. This balance of opposites, the head with the heart, is what makes Italian design so special and has led to the creation of some of the most desirable products ever made.

Today, thanks to the pioneering work of Italian designers over the decades, the phrase "Made in Italy" is now a trusted indicator of design excellence and high-quality manufacture. Indeed, one could say that more than any other country Italy is a "land of design". Since the Second World War, Italy has played a major role in shaping the overall direction of modern design on the international stage.

What makes Italy so unique is that it has an extraordinary "industry for design" – with its designers diligently pursuing the goal of the better-designed product and its impressive manufacturing base being able to translate their ideas into masterful and often groundbreaking design solutions. This interconnected and well-developed community of design professionals and design-led companies, mainly based in and around Milan and Turin, has not only been hugely economically beneficial to the country but has also ensured that design has long been an integral feature of Italian life as well as a defining aspect of its culture.

It is no coincidence that Italy is the country where designers seem to enjoy the highest social standing, with eminent practitioners elevated to guru-like status. These revered maestros of design are in turn more than happy to impart their wisdom to younger generations of designers, often through teaching or employment in their offices. This results in a generational thread that runs through Italian design, much like in centuries gone by when apprentices learnt from master craftsmen. The design-related disciplines of engineering and architecture are in fact so highly respected in Italy that qualified practitioners are given a title – Ing and Arch, respectively – before their surnames. Designers in Italy often study to post-graduate level one of these two subjects before embarking on a design career – this was especially true in the past – and by default this gives their work a greater degree of refinement because it is ultimately underpinned by an in-depth understanding of materials and construction.

Related to this is a longstanding and illustrious tradition of practitioners working as architect-designers, with such practitioners undertaking commissions for the design of industrially manufactured products while at the same time working on the planning of office buildings, urban centres and the like. This desire to encompass the whole gamut of design practice was memorably articulated by the influential architect, writer and educator Ernesto Rogers whose design maxim was *dal cucchiaio alla città* (from the spoon to the city) – and this neatly sums up the ethos of Italian design: no object is too insignificant for careful consideration by a designer, nor is any project too large, for the creation of both are often governed by the same design principles. This memorable slogan was actually coined in an article written by Rogers in 1952, in which he suggested that if one examined a spoon closely enough it would be possible to envisage the type of city that the culture that had designed it would build. As Ettore Sottsass noted: "I make no special difference between architecture and design, they are two different stages of invention."[1] And ultimately, it is the Italian designer's talent for imaginative invention that gives their designs – from the spoon to the city – such a powerful advantage in the global design market.

Apart from design being seen as an overarching profession, in Italy there is also a tendency for design to be consciously intellectualized. As a vocation it is held in very high regard as a fundamental aspect of the wider national *cultura*, which is a source of great patriotic pride. But there is also a widespread passion for design excellence, which seems to transcend class or status. An example of this can be seen in the buying habits of Italians who often prefer to purchase fewer things but better things, being generally happy to pay a premium for something that is really well designed

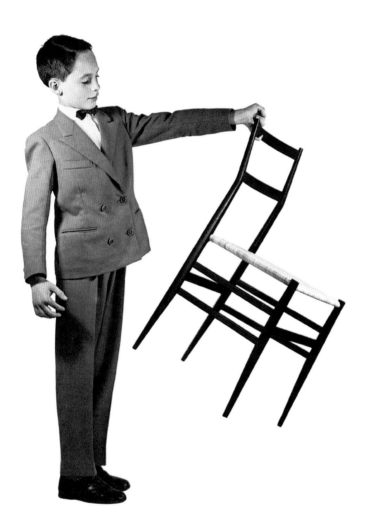

and beautifully made. The reason for this is that a significant proportion of the population understands and appreciates the notion of "quality", and this has had the consequential effect of Italy having a disproportionately high number of luxury goods companies and design-led firms given the size of its population. One finds that products made in Italy are either of the finest quality and executed by well-known manufacturers (who often have global brand name recognition) or small specialist family-run firms, or they are mid-market goods that are relatively showy and not particularly concerned with quality – and this is as true for clothing and make-up as it is for furniture and lighting.

The Milan Furniture Fair (*Salone del Mobile*), held every April, is a telling exposition of Italian manufacturing with hall upon hall dedicated to middle-of-the-road products often destined for export, while other pavilions host an impressive number of truly world-class Italian design-led manufacturers creating cutting-edge designs, such as Kartell, Cassina, B&B Italia, Ycami and Edra. There is, however, one exception to this feature of Italian manufacturing: the national car industry. It seems to be able to provide design excellence at whatever the price point, from the nippy

Above: Model No.699 Superleggera chair designed by Gio Ponti for Cassina, 1957 – Cassina publicity photograph demonstrating its lightness

little Fiat Cinquecento (1957) (see page 102) to the exquisite Ferrari 458 Italia (2009) (see page 234). There is also one more thing to remember. Italian design is not, nor has it ever been, intended solely for the home market, in fact far from it. Since the Second World War design-led exports have been a highly significant generator of national wealth as well as a provider of global cultural status. Even today, in America, Asia and elsewhere in Europe the term "Italian design" is generally accepted as meaning high-quality and stylish execution.

La Bella Figura and The Italian Line

Certainly in Italy there is a collective appreciation of stylish and beautiful things, as the Italian columnist Beppe Severgnini has noted: "We are prepared to give up a lot for the sake of beauty, even when it doesn't come in a miniskirt."[2] This national obsession with aesthetics, which at times sweeps all other considerations aside, is reflected in the rather curious and very Italian notion of *la bella figura*, which has no direct equivalent meaning in English but directly translates as "the beautiful figure". Essentially it is, as the cultural commentator and design critic Stephen Bayley

notes, "a belief that appearances, comportment and graciousness are overwhelmingly significant in a well-managed life".[3] And this conviction is as relevant to a person's appearance as it is to the things they choose to surround themselves with on a daily basis – objects of design in Italy frequently also being objects of desire thanks to their appealing outward form.

And this brings us onto another aspect of design in Italy that is so uniquely Italian, the famous Italian Line (*La Linea Italiana*) or the way in which many Italian products are distinguished by elegant and expressively gestural flowing forms. This is an approach to design that often leads to visually seductive, bold graphic profiles which compel the eye to rove round a product's contours, whether it is the undulating outline of a Ferrari 250 TR racing car (1957) (see page 108) or the shapely figure of Marco Zanuso's Lady chair for Arflex (1951) (see page 76). Many acknowledged icons of Italian design can be easily identified solely by their silhouettes: for example, the Luminator floor light by Pietro Chiesa (c.1933) (see page 44), the Moka Express coffee maker by Alfonso Bialetti (1933) (see page 42) or the Carlton bookcase by Ettore Sottsass (1981) (see page 204). These are classic designs that cast long metaphysical and influential shadows in the annals of design history and have become timeless symbols of Italian design excellence

Approaches to design and the role of manufacturers

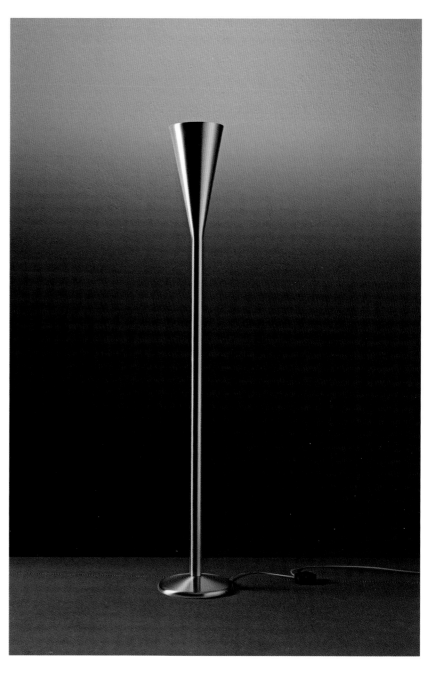

Above: Model No. 0556 Luminator floor light designed by Pietro Chiesa for Fontana Arte, c.1933

Like their counterparts in Scandinavia, designers in Italy have long sought the realization of ideal forms that are evolutions of earlier typologies. Products brought about in this manner are not subject to stylistic whims, having been formally and functionally honed over many generations. Because of this they often possess an inherent rightness and can be described as "design without adjectives", as Gio Ponti famously stated. A perfect example of this evolutionary approach to design is Ponti's Model No. 699 Superleggera chair (1957) (see page 96), which was a consciously modern re-interpretation of the lightweight and elegant Chiavari chair traditionally made in Italy's coastal Liguria region.

This does not mean that on occasions Italian design cannot also be utterly revolutionary, because it can be and frequently is – one only has to look to the extraordinary futuristic environments designed by Joe Colombo, or the plethora of cutting-edge lighting solutions created by Achille

Castiglioni (see pages 124 and 128), or the groundbreaking office equipment developed by Mario Bellini (see pages 190 and 206) for Olivetti. Experimentation to find a better solution is one of the key distinguishing features of Italian design and the reason it has consistently remained at the cutting edge. In Italy, whether a designer chooses to employ an evolutionary or revolutionary approach to problem solving, the resulting outcome is almost always marked by a refreshing originality, which can be technical, intellectual or aesthetic. Put simply, Italian designers love a challenge and generally have the imagination to find, almost instinctively, the best solution within the given constraints.

While Italy has long been an epicentre for design practice, it has also, just as importantly, been a focal point for design-led manufacturing. Milan in particular is renowned as one of the great industrial design hubs of the world thanks in part to the long-held excellence of design teaching at the Politecnico di Milano. No other city can boast of such an impressive cluster of world-class design-led companies, and it is one of Italy's great strengths that there exists a tight collaboration between designers and manufacturers. Italian companies, on the whole, are far more likely to be supportive of designers who want to experiment than those in other countries. They fully understand that in order to create groundbreaking products the creativity of design visionaries must be nurtured and that these talented individuals need to be allowed to explore the outermost boundaries of form and function. It could be said that innovation is just an inherent part of Italian design and manufacturing culture.

Enlightened Italian manufacturers recognize that designers cannot work alone and that the process by which a concept is turned into a successful product by necessity requires both technical support and an appropriate level of investment, particularly in terms of research and development. Through this appreciation that the design process requires financial commitment and almost always relies upon efficient teamwork, Italian manufacturers generally provide designers with a high degree of technical backup in the form of well-qualified production engineers and material scientists. Ultimately, it is these dedicated behind-the-scenes individuals who bring Italian design to life – without their considerable input many design concepts would remain just ideas on paper and would not have become the products that we have all come to love and admire so much. Virtually every masterpiece shown over the coming pages has been the fruit of a very close working relationship between a designer, a team of production specialists and a culturally savvy manufacturer.

Italy's past and its influence on modern Italian design

To understand the unique characteristics of a nation's design output, one really needs to understand the country's heritage and the impact this has had on its economic and industrial development. With regard to Italy this is especially tricky as strictly speaking it has only been a country since 1861. Some historians try to get around this by stating that prior to its formation as a nation state the peninsula had a "geographic expression".[4] Interesting as this is, it cannot be entirely true as prior to unification Italy was effectively a patchwork of city-states and other small independent entities. Before 1861, there were sixteen distinct provinces that included the Papal States as well as small kingdoms, duchies and principalities, republics and united provinces with often very different histories, customs and traditions. In fact, the only unifying thread was that all these different regional powers had at some stage far back in their histories been part of the Roman Empire. Yet so had other countries and states beyond the boundaries of this boot-shaped peninsula that is surrounded by the Mediterranean, Tyrrhenian, Adriatic and Ionian Seas.

Among the territories that were to eventually unite and form Italy, there were distinct local craft traditions, such as chair making, metalworking, pottery and basketwork. The peninsula's main regional cities, such as Florence, Milan, Venice and Naples each had definable styles of craftsmanship, which had as much to do with regional trade links as with the patronage of the ruling families in the various provinces. There was, however, a tradition of leading artists moving from one city to another according to commissions, and this was to a lesser extent also true of decorative artists, for example the goldsmith Benvenuto Cellini worked in Rome, Florence and Mantua. It is

not until the late nineteenth century, following Giuseppe Garibaldi's successful invasion of Sicily and the resulting proclamation of Victor Emmanuel II as king of a united Italy in 1861, that one can refer to "Italian design" in its truest sense.

In this newly unified land, as in many other European countries at the time, there was a search for a strong and coherent national identity that would cohesively bind the population to the country's new state institutions. At the same time, there must have been a general feeling that having made the momentous decision to unite, this new and youthful nation was taking a decisive leap forward into a new modern age. Given this desire for national identity, twinned with a forward-looking spirit for Italian freedom and unity, it should come as no surprise that after a National Romanticist dalliance with historical revivalism – a feature common to most European countries during this period – the first truly Italian style of modern design was Arte Nuova (New Art), also known as Stile Florale or Stile Liberty, named after the London department store's promotion of the Art Nouveau style and its exporting success in continental Europe. This distinctively Italian interpretation of the Art Nouveau style was blatantly avant-garde, unlike the preceding Neo-Revivalist style that had enjoyed popularity in Italy throughout the nineteenth century.

Arte Nuova at the Turin exhibition

Emerging slightly later than other New Art movements in Europe, Arte Nuova blossomed in Italy around the turn of the twentieth century and marked a major historical turning point for Italian design, with Italy emerging as a leading contributor to the development of contemporary design. This was especially true after its hosting of the Esposizione Internationale d'Arte Decorativa Moderna in Turin in 1902. Writing of the event in the daily newspaper, *Il Tempo*, the reporter G. Machi enthusiastically described it as "the first exposition in Italy free of academic and conventional shackles – is a fact, a living entity…that deserves admiration. It is the first time that we in Italy have had the courage to break with tradition…it is beautiful and glorious when this happens in Italy".[5] What the Arte Nuova style marked unequivocally was the first tentative steps towards reconciling art with industry in Italy, and the 1902 Turin exhibition can be seen as an important means of boosting this impetus and effectively raising the profile of contemporary Italian design and architecture both at home and abroad.

The main exhibition building was the flamboyantly arched Vestibolo d'Onore (Hall of Honour), which was designed by the talented Raimondo D'Aronco and reflected the influence of the Vienna Secessionists. D'Aronco was also responsible for the design of the Italian Pavilion and the Pavilion of Interiors that housed installations by leading Art Nouveau designers from other European countries, including Charles Rennie Mackintosh, Victor Horta, Henry van de Velde, Peter Behrens and Josef Maria Olbrich. Among the Italian architects and designers who also created room installations for this landmark exhibition were Carlo Zen, Agostino Lauro, Vittorio Ducrot, Eugenio Quarti, Alberto Issel and Giacomo Cometti. The work of these designers shared a common aesthetic: bold looping forms that melted into one another, a virtuoso level of cabinetmaking, the use of floral motifs that had a vigorous organicism and an exquisite attention to detailing, whether in the gilded mounts or the careful inlaying of precious materials, such as mother-of-pearl.

Without question, the most sublime example of Italian Art Nouveau shown at the Turin exhibition was Carlo Bugatti's "games and conversation room" installation, which quickly became nicknamed the *camera a chiocciola* (snail room) thanks to the shell-like forms employed for the large banquette and chairs. Apart from introducing motifs found in the natural world, Bugatti also played with Moorish references – giving the whole room a sense of eastern exoticism, rather like some fanciful illustration from a children's storybook. This type of eccentric interior design would later find expression in the oeuvres of Carlo Mollino and Joe Colombo – both of whose work displayed a strong sense of otherworldly fantasy and overt theatricality.

La Domenica del Corriere

Anno IV. — N. 19. SI PUBBLICA A MILANO OGNI DOMENICA Uffici del giornale: Via Pietro Verri, 14 MILANO

Dono agli Abbonati del " Corriere della Sera "

11 Maggio 1902. Centesimi 10 il Numero.

APERTURA DELLA Iª ESPOSIZIONE INTERNAZIONALE D'ARTE DECORATIVA MODERNA A TORINO: DAVANTI LA ROTONDA D'ONORE.
(Disegno di A. Beltrame, dal vero).

Above: Cover of *La Domenica del Corriere* newspaper showing the Hall of Honour designed by Raimondo D'Aronco at Esposizione Internationale d'Arte Decorativa Moderna in Turin, 1902

Futurism, Novecento and Rationalism

Seven years after the ground-breaking Turin exhibition, the poet and editor Filippo Tommaso Marinetti published his *Manifesto del Futurismo* (Futurist Manifesto) in the Bologna-based *Giornale dell'Emilia* on 5 February, 1909 followed days later by its publication in French in that most august of Parisian newspapers, *Le Figaro*. This celebration of industrial progress and vehement rejection of the past was also an affirmation that "the world's magnificence has been enriched by a new beauty: the beauty of speed". This "incendiary manifesto" – as Marinetti put it – sought to free Italy from "its smelly gangrene of professors, archaeologists, guides and antiquarians" and suggested that "for too long has Italy been a dealer in second-hand clothes".

Cloaked in this overtly provocative language that derided pastiches of the past there was a call to arms for an authentic modern expression of modern industrialized life that, unlike Arte Nuova (which remained a popular style in Italy up until the First World War), celebrated the technological marvels of contemporary life and industrial progress, especially factories, bridges, steamers, locomotives, planes and, of course, the beloved automobile. Marinetti's rallying cry was not only embraced by musicians, poets, writers and filmmakers but also by designers who saw Futurism as a means of disassociating with the past and embracing modernity. Importantly, it was the first cultural movement to distance itself from nature and instead glorify the energetic flux of the metropolis. Artists and designers associated with this faction used fragmented Cubist-like forms such as those displayed on the cover of Fortunato Depero's book (1927) (see page 36) as a means of evoking a sense of speed and acceleration.

Depero himself went one step further and established in 1919 a craft workshop known as the Casa d'Arte Futurista in Rovereto, which operated throughout the 1920s and produced fine art, tapestries, wooden toys, carpets, windows and posters. The visionary architect Antonio Sant'Elia also joined the movement and between 1912 and 1914 executed a series of drawings for a futurist *Città Nuova* (New City) that featured dynamic and astonishingly forward-looking buildings with plain unadorned proto-Brutalistic surfaces. These proposals were conceived to be symbolic of the contemporary age and were a visual expression of the principles laid down by Sant'Elia in his 1914 *Manisfesto*

dell'Architettura Futurista (Manifesto of Futurist Architecture). In the manifesto, Sant'Elia called for the abolishment of the decorative and proclaimed that in the future architecture would be about "impermanence and transience", saying, "Every generation must build its own city". Sadly, Sant'Elia died in 1916 while fighting in the First World War, at the tender age of 28, and as a result the majority of his buildings remained as unbuilt concepts. Nevertheless, the manifesto outlining his futuristic vision was highly influential on later designers and architects, especially in Holland where members of the De Stijl group received it in 1917. Attempting to subvert bourgeois culture, Futurism, which was aligned to Fascism in Italy, expressed an aggressive machine-age aesthetic and sought to create order through radicalism. As such it must be seen as the first radical design movement, not only in Italy but anywhere in the world.

While the proponents of Futurism were enthusiastically exulting the industrialization of the modern world, the Olivetti company was actually putting theory into practice, for example with its M1 typewriter (1910) (see page 28), which was exhibited at the Esposizione Internazionale delle Industrie e del Lavoro, an important industrial trade fair held in Turin in 1911. With its undecorated simple black form, this starkly functional design was a demonstration "not only that Italy was beginning to compete in the area of the decorative arts but also that a new Italian industrial aesthetic, which acknowledged the new artistic consciousness associated with the idea of the 'machine age' was beginning to emerge"[6]. Similarly, the teardrop-shaped Aerodinamica racing car of 1914 designed by Giuseppe Merosi (see page 30) was a manifestation of a new Italian functionalist approach to design, which had shrugged off the historical decorative tradition in favour of a new industrialized aesthetic where form more or less followed function.

In 1923, another art and design movement also aligned to the Fascists and known as Novecento, meaning "twentieth century", was officially launched at an exhibition in Milan. Diametrically opposed in its goals to the Futurists, this movement sought to revitalize Classicism but within a modern idiom. It aimed to counter both the "fake antique" and the "ugly modern" in architecture and design, and essentially it was a classicizing interpretation of the Art Deco style, being both inspired by the work of contemporary French decorators as well as the Wiener Werkstätte.

Although the Novecento style made few inroads into industrial mass-production, the Moka Express espresso-maker with its distinctive form, designed by Alfonso Bialetti in 1933 (see page 42) is a

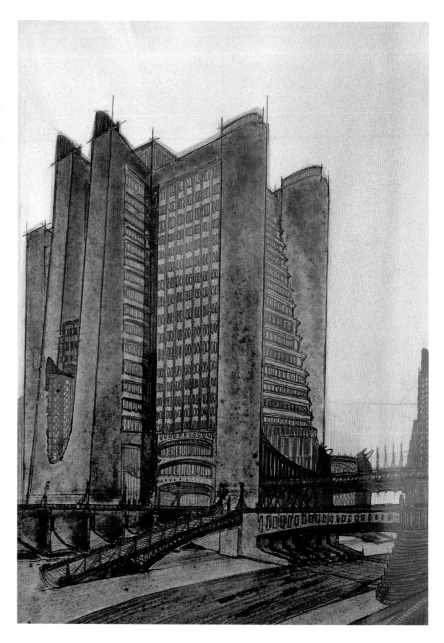

Above: Watercolour study of "The New City" by Antonio Sant'Elia, 1914

notable exception. It is, however, the ceramics designed by Gio Ponti for Richard Ginori – such as the Alato vase (see page 34) that perhaps best characterize the refined classical modernity of Novecento, which like the Fascist Party with which it had strong links, looked back nostalgically to the glories of Italy's imperial past and attempted to re-create them in the modern world. The founding of *Domus* magazine in 1928 by the publisher Gianni Mazzocchi and the architect Gio Ponti was of great influence to the development of Italian design and was used as a means to publicize the work of designers aligned to the Novecento movement. Although initially produced as a lifestyle, architecture and decorating magazine, under Ponti's editorship it soon turned into the most authoritative voice on design and architecture in Italy. It was so successful and strident in championing the cause of Italian design both at home and abroad that it eventually became known as the "Mediterranean megaphone". It also functioned as Ponti's "living diary" by not only documenting his work and that of other designers he admired and also acting as a forum in which to debate and raise awareness of the design issues that concerned him.

Another design and architecture movement that was pioneered in Italy during the 1920s and 1930s was Rationalism, which sought to reconcile the Functionalism of the European avant-garde with Italy's classical tradition. Like the Novecento movement, Rationalism also had its own mouthpiece in the form of *Casa Bella* magazine (later to become *Casabella*) that was also founded in 1928 and which from 1933 was under the editorship of the architect, Giuseppe Pagano. Rationalism essentially occupied the middle ground between the industrially inspired designs of the Futurists and the overtly Neo-Classicist work of the Novecento movement.

One of the purest and most notable manifestations of this new style, which was characterized by a severe geometric formal vocabulary and the use of state-of-the-art materials, was Giuseppe Terragni's Casa del Fascio (Fascist headquarters building) in Como. This totally unified scheme was furnished with suitably progressive Modernist designs, such as Terragni's Follia chair (see page 46) from 1934. Rationalism was initially embraced by the Fascists who regarded themselves as champions of a new world order, which Rationalist designs symbolically represented; however, eventually they opted instead for the Novecento style, with its more overtly Classical and imperialistic connotations.

During the 1930s, through what was effectively a battle of applied art styles, Italian industry developed rapidly and as a consequence a number of virtuoso designs intended for industrialized production appeared that revealed the beginning of an identifiable Italian approach to design. Among these were the elegant Luminator floor light (c.1933) by Pietro Chiesa for Fontana Arte (see page 44), the characterful Fiat 500 Topolino (1936) by Dante Giacosa (see page 48) and the plastic-housed 574 radio (1938–39) by Livio Castiglioni, Pier Giacomo Castiglioni and Luigi Caccia Dominioni for Phonola (see page 58). What these designs shared was a sense of logic and purpose clothed in elegance, and it is this ability to incorporate technology into a beautifully formed product that has been one of the key hallmarks of Italian design ever since.

It is easy to forget that during this period, Italy was under Fascist dictatorship, with Benito Mussolini having ascended to power in 1922. There was a growing sense of nationalism inside Italy's borders – this patriotic fervour found expression in many products designs, with Italian designers' interpretation of modernity being inspired by Classical antecedents in the proportions and forms they employed, which by default gave their designs a distinguishing formal elegance.

Reconstruction and the economic miracle

In Italy, as in other European countries, the Second World War wholly impeded the development of any non-military design while all resources and efforts were focused on wartime production. At the same time, numerous Italian factories were destroyed by Allied bombing campaigns, with the industrial heartlands of Milan and Turin being the target of repeated bombardment in 1943. April 1945 saw the end of Mussolini's vision of recreating a Roman Empire – he was captured

by Italian partisans and unceremoniously executed as the Allied forces closed in on Milan, which was the first of the Axis capitals to fall. After five long years of war, from 1940 to 1945, Italy was a battered shadow of its former self, having lost almost half-a-million civilians and soldiers and having had much of its vital infrastructure ruined. For example, the 1943 bombing of Milan left 230,000 people homeless,[7] all of who needed urgent rehousing at the war's end.

It was not just the war years that had taken their toll, but the preceding years of dire economic malaise brought about by Fascist misrule during the 1920s and 1930s. The leadership had disregarded the economic necessity of international trade and had instead followed a policy of self-sufficiency, which "led to the development of costly and unprofitable enterprises and to the suppression of undertakings which did not fit into a preconceived framework of power and privilege"[8], according to the eminent scholar of political theory Mario Einaudi.

Against this background of political, economic and administrative turmoil, in 1941 five leading Italian economists published a prophetic proposal for post-war economic reform, which centred on the need for an export-led recovery. In 1945, Italy emerged from the Second World War both physically and morally tattered. The situation on the ground was very bleak indeed, with over 3 million houses and their contents destroyed, and essential commodities and raw materials in very short supply or simply non-existent. Poverty-stricken and war-torn, Italy was still a predominantly rural society that was very regional in its outlook, however, a number of enlightened manufacturers such as Fiat, Olivetti and Pirelli, according to the historian Paul Ginsborg, "knew that their survival in a competitive market depended on an extensive programme of reconstruction and rationalization"[9] – similar to that already outlined in the economists' earlier recommendations.

Over the next five years Italy emerged miraculously like a phoenix from the flames of war and soared into a new-found prosperity, thanks to a number of key policy initiatives taken by the anti-Fascist coalition government formed in 1946 and headed by Prime Minister Alcide De Gasperi. The most significant of these initiatives was opposition to state control over the affairs of private businesses and a laissez-faire approach when it came to these companies trading overseas, yet at the same time the post-war policy makers sought, through protectionist measures, to financially safeguard the home market's interests. The state also bolstered these initiatives with more direct help, via the provision of cheap credit as well as inexpensive energy and steel. In addition to this the government became more directly involved in the economic growth of the country through its state-run holding company, the Istituto per la Ricostruzione Industriale (also known as the IRI), an entity that had been set up earlier in 1933 and was responsible for the regulation of Italy's publicly-owned industries, from airlines and telephone networks to car-manufacturers and machine tool companies. It was, however, the government's implementation of a low wages policy that was perhaps the most decisive factor in enabling Italian industry to manufacture competitively priced goods that could be exported for much-needed foreign income.

American aid in the form of the Marshall Plan, officially known as the European Recovery Program, was also critical to the success of Italy's reconstruction, with around US$1.2 billion being injected into the Italian economy between 1948 and 1951 in the form of grants and loans. During this period, Italy also received another $2.2 billion in the form of food and fuel from America. The legendary Italian industrialist and chairman of Fiat Gianni Agnelli noted of the Marshall Plan: "In the immediate post-war years, the whole of Europe was in a recession. So first of all, it helped us step out of a recession; it gave a certain amount of speed to the economy. But that was the first step"[10] This financial shot in the arm courtesy of the Marshall Plan together with a growing Italian middle-class eager to buy consumer products after the deprivations of the war years proved to be the perfect tonic for economic recovery. And it just so happened that Italy had a surfeit of highly trained architects, engineers and designers who were perfectly adept at turning their hands to the creation of progressively-designed goods for the newly affluent home-owners of Italy and also crucially for the booming homemaking generation in America. Set against a

background of often quite haphazard civic rebuilding programmes being frantically embarked upon in the late 1940s, industrial design was the one area in which Italian architects could hone their creative powers.

During the immediate post-war period there was often an emphasis on styling rather than technological innovation, with designers imaginatively utilizing available materials and low-tech production methods to create stylish products that would ultimately revitalize Italian industry. Through this reliance on styling was born the Italian Line, which was inspired in part by American streamlining that had similarly been used during the 1930s depression to enhance products' consumer appeal. The Italian Line was used to help cloak function in an alluring skin, thereby often compensating for any technical deficiencies a product might have with visual charm. This then gave the design a competitive advantage over other similar products in the marketplace. Italian designers' predominant focus on "product aesthetics" enabled Italian manufacturers to create goods that the rest of the world really wanted to buy. It was thus was a key driver of *il miracolo economico* (the economic miracle), the country's dramatic export-led recovery that transformed Italy from a struggling rural economy into a major industrialized power.

The golden age of Italian design

Luckily for Italian designers during this early post-war period, they could rely on the skilled expertise of family-run craft workshops, for example the Turin joinery shop of Apelli & Varesio, which executed many of Carlo Mollino's flamboyant "Turinesque Baroque" furniture pieces (see pages 60, 64 and 68). During these years of reconstruction small-scale production offered by these small specialist fabricators helped to minimize risk to manufacturers and enabled them to produce more unusual and aesthetically progressive designs. The inherent flexibility of small-scale production was one of Italy's greatest assets, for it allowed manufacturers of ceramics, glassware, cutlery, lighting, furniture and the like, to quickly adapt product lines in response to the latest trends.

Throughout this era, there was a continuing stylistic struggle between the Neo-Rationalist and the Anti-Rationalist camps, with Franco Albini championing the utilitarian cause of the former through his editorship of *Casabella*, and Gio Ponti as editor of *Domus* promoting the more bourgeois approach of the latter which sought to imbue design with a greater sense of artistry, influenced by tendencies within contemporary fine art. This continuing battle of the styles also had a political dimension, with Rationalism still being associated in many minds with the Fascist period, while also somewhat ironically now being advocated by the left-wing Popular Front. The theme of the VIII Milan Triennale in 1947 was the home, and the event specifically highlighted the need for post-war housing solutions, such as multifunctional furnishings that enabled small apartments to be used as studios or offices during working hours as well as living spaces. Many of the exhibits on show displayed a distinctly Neo-Rationalist bias, stressing the need for low-cost solutions that were suitable for mass-production – essentially democratic designs for the masses. Later in 1947 the left-wing Popular Front was removed from the coalition government and the more centrist Christian Democrats gained sole political control.

This political shift heralded a new mood, which was reflected in Italian design and accorded with Ponti's call for quality rather than quantity. One designer who agreed with Ponti's stance was his good friend Carlo Mollino who is famously remembered for his quip "Everything is permissible as long as it is fantastic." However, as the renowned Mollino historians Fulvio and Napoleone Ferrari have noted, a more exacting and extended translation of this well-known quote (which originally appeared in an interview with Mollino in the April 1950 issue of *Domus*) is: "Everything is allowed as long as the fantasy is preserved, that is a frail beauty, beyond any intellectualized programme." This is perhaps even more revealing; as the Ferraris explain, what Mollino meant was, "that to create an authentic artwork you don't need to follow any prescriptive credo or set aesthetic, but instead can use any means or media as long as your work is spurred on by imagination"[11].

Many other designers began to follow the more pragmatic and less doctrinal approach offered by Gio Ponti's "gentle manifesto". This less utilitarian approach to design also made sound commercial sense, as middle-class consumers – both at home and abroad – preferred its more sculptural contemporary look. The new focus on the "artistic" qualities of design thus enabled Italian design to become widely associated with a very particular visual identity which was both stylish and sophisticated. During the early 1950s, a host of Italian products exemplified this contemporary fashionable look: Marcello Nizzoli's Lettera 22 typewriter (1950) (see page 74), Marco Zanuso's Lady chair for Arflex (1951) (see page 76), Corradino d'Ascanio's Vespa 150 motor scooter (1955) (see page 92), Ezio Pirali's VE505 table fan (1953) (see page 84), Osvaldo Borsani's P40 lounge chair (1954) (see page 86), and Angelo Lelli's suspended ceiling light (1954) (see page 90) – all of which heralded a distinctive new aesthetic direction in Italian design. As design historian Penny Sparke has noted of such product designs, "Their sensuous curves expressed a voluptuousness and opulence which did not discredit their essential utility. The body-shell aesthetic they advocated was not merely an attempt to make industrial artefacts sculptural: it reflected another important factor which had wider significance within the culture and economy of the period – Italy's dependence on the USA."[12]

This reliance on American funding had prompted the removal of left-leaning parties from the coalition government. Increasingly Italian firms were benefitting from both American money andcrucial US manufacturing expertise, such as the implementation of efficient assembly-line mass-production methods based on Fordist principles. The American film industry during the Fifties also did much to publicize post-war Italian design, which was to become synonymous with sophistication and style in the minds of the American moviegoer. Hollywood's obsession with Italy during the 1950s saw the release of *Roman Holiday* (1953), *Three Coins in the Fountain* (1954) and a host of other movies all filmed in Rome's famous Cinecittà film studio. Italy's famous *dolce vita* lifestyle soon rippled far beyond the country's shores, with espresso coffee bars springing up in fashionable parts of London and New York as well as elsewhere in Europe and America, introducing a younger generation to their first taste of Italian *cultura* – the hissing espresso machine transforming coffee making into a captivating sensorial performance.

The launch of the Compasso d'Oro awards by the La Rinascente department store in 1954, at the instigation of Gio Ponti, was also another huge impetus to the development of Italian design. On the one hand it officially and publically rewarded manufacturers and designers for their innovative designs and on the other it effectively promoted every year the very best Italian products through a related exhibition, which received widespread publicity in all the major design journals of the day. By the mid-1950s, just ten years after the cessation of war, Italy was a society transformed. Instead of looking back to a painful past, its government, manufacturers and designers – like those in the two other Axis powers, Germany and Japan – had chosen to look forward optimistically and embrace a future based on a free-market capitalist doctrine. Having looked into the abyss, Italy had been galvanized into action and with Marshall Plan dollars, together with the skill of its workforce, had managed to build a confident society and a booming economy, with manufacturing leading the way.

Italian design goes Pop

As the boom years continued into the late 1950s, a new car was launched that expressed the youthful optimism of the period: the Fiat 500 Nuova (1957) (see page 102) or as it became better known, the Cinquecento. Winning a coveted Compasso d'Oro award in 1959, this endearingly compact city car by Dante Giacosa reflected a proto-Pop aesthetic and in many ways heralded a new chapter in Italian design that would be increasingly expressed through characterful and bold forms that challenged perceived notions of how things should be or what they should look like. Another late 1950s design that was similarly daring was Achille and Pier Giacomo Castiglioni's

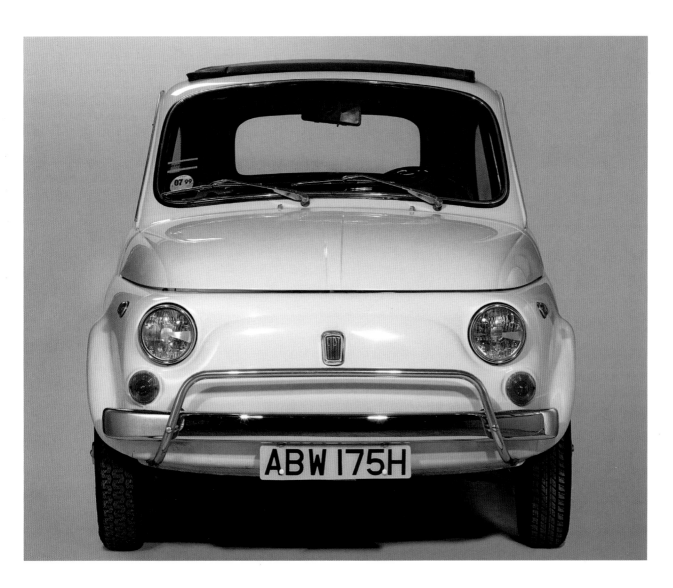

Above: Fiat 500 Nuova car designed by Dante Giacosa for FIAT, 1957

Mezzadro (Sharecropper) stool (1957), which like a Marcel Duchamp "ready-made" artwork utilized a "found" tractor seat in its construction. Over the following decade, the Castiglioni brothers would continue to seek playful yet also rational design solutions, such as their famous Arco floor light (1962) (see page 128), which reflected the increasingly experimental and innovative nature of Italian design during the 1960s.

In the early 1960s, the French art critic and cultural philosopher Pierre Restany introduced Pop Art to Italy through his articles in *Domus*[13]. It had first emerged with the formation of the Independent Group in London and the "combine" artworks of Robert Rauschenberg in America during the late 1950s. Immediately, Pop as a cultural phenomenon found rich and fertile design soil in Italy, in which to not only take root and grow but also to mutate spectacularly. During the 1960s and early 1970s, there was a climate of social and political unrest in Western Europe and America, with a new youthful spirit that questioned the status quo of the establishment and sought to reform all aspects of life. It was a period of booming consumerism with ever-increasing numbers of buyers eager to acquire the "next latest thing". It was also a time when the post-war baby boom instigated a crucial shift of emphasis within the mass-market towards a more youth-based demographic which resulted in a much greater pluralism of taste than earlier generations. Despite rampant consumerism, there was – paradoxically – an anti-materialist tendency, which was in tune with the "anything goes" ethos

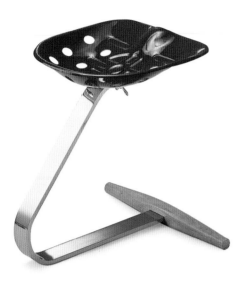

of the age and the subsequent rejection of pre-conceived notions about what constituted "Good Design". Instead, this new and younger generation tended to prefer low-cost transient yet innovative design solutions that satisfied their voracious appetite for the grooviest, hippest and coolest new products – whether it was a Sacco bean bag (1968–69) (see page 170) or a bright red Valentine typewriter (1969) (see page 180).

Italian manufacturers realized the only way to stay competitive with design developments abroad was to invest heavily in research and development and to give free creative rein to designers and allow them to creatively experiment in order to come up with the next must-have new product. The post-war generation of Italian architect-designers – from Ettore Sottsass and Joe Colombo to Vico Magistretti and Mario Bellini – were given all the necessary tools with which to realize their design visions by manufacturers, including access to specialized craftsmen and skilled production technicians. Essentially functioning as "concept factories", firms such as Artemide, Kartell, Poltronova and Zanotta embraced popular culture and manufactured groundbreaking designs that often exploited the formal and functional potential of newly available plastics – for example the Model No. 4999 child's chair (1960) designed by Marco Zanuso and Richard Sapper for Kartell was the first chair ever to be entirely made of injection-moulded plastic (see page 114). It was, however, the designs of Joe Colombo that perhaps best expressed the spirit of Pop in Italy with their overt Space Age connotations, whether it was his Visiona 1 habitat conceived as though a space station environment for Bayer AG in Cologne (1969) or his individual designs for mass-production such as the Tubo chair (1969) (see page 172) or the Boby trolley (1970) (see page 182). Through his work, Colombo was inventing the future and pulling it into the present, but simultaneously his work had a functional logic that exploited the idea of modular systems – often incorporating cell-like units that were intended to save space and labour.

Ettore Sottsass similarly embraced the challenges of Pop but in a very different way to Colombo. He was a playful subversive who had originally cut his industrial design teeth working for Olivetti, and by the early 1960s was exploring the Anti-Design tendencies of Pop through the creation of ceramics that were influenced by Indian mysticism and the design of furniture for Poltronova that incorporated plastic laminates made by Abet Laminati. Significantly, these first explorations into counter-design can be seen to be the genus from which Italian Post-Modernism would evolve. Gaetano Pesce was similarly influenced by Pop, especially the oversized and out-of-context artworks of Claes Oldenburg. He also explored the expressive and symbolic potential of new materials, most notably squishy polyurethane foam, which he used to create his landmark Up Series (1969) range of furniture, which turned the act of buying furniture into a full-blown "design happening" (see page 176). It was, however, the Blow chair designed by Gionatan De Pas, Donato D'Urbino and Paolo Lomazzi in 1967 that was perhaps the most iconic Italian Pop design of them all with its playful light-hearted expendability dismissing the traditional associations of furniture with costliness and permanence (see page 156).

Radical Design and Anti-Design

The 1960s also saw the founding of several influential Radical Design groups, most notably Archizoom by Andrea Branzi, Paolo Deganello, Gilberto Corretti and Massimo Morozzi in 1966, a collective that gave rise to a number of seminal architectural projections, including No-Stop City, which

Top: No-Stop City architectural projections for an endless future metropolis designed by Archizoom, 1969–70

Above: Apartment installation designed by Joe Colombo and shown at an interior design exhibition held in Milan, 1970 – featuring his Cabriolet bed, Rotoliving unit and Multi-Chairs

sought to demonstrate that if Rationalism was taken to its logical conclusion it became absurd. Superstudio's Monumento Continuo (Continious Monument) of 1969 was a similarly radical architectural projection. As Branzi noted, "Criticism of the Modern Movement was also and above all expressed by taking Rationalism to an extreme, with the intention of exposing the underlying contradictions of the movement, along with the fragile nature of its apparent unity of research"[14].

Archizoom also famously mocked the pretensions of "good taste" and by inference "Good Design" through its referencing of kitsch, with its faux-leopard skin Safari seating unit (1968) for Poltronova, which was an early and subversive antecedent of Post-Modernism (see page 166). An automobile design that reflected a similar over-the-top aesthetic was the Lamborghini Countach, unveiled in 1971 (see page 288). With its overtly masculine styling, its eye-catching wedge-like form and its scissor-like uplifting doors, this supercar was anything but understated. Indeed, it was nothing less than Italian design at its most confident.

In 1972, the avant-garde reputation of Italian design reached its cultural zenith with the staging of a major exhibition at New York's Museum of Modern Art entitled Italy: The New Domestic Landscape – Achievements and Problems of Italian Design, which was curated by the architect and design theorist Emilio Ambasz. Showcasing the whole gamut of contemporary Italian design intended for the home environment, the exhibition included not only products meant for large-scale production such as Vico Magistretti's Selene chair for Artemide (see page 174) but also futuristic installations such as Joe Colombo's Total Furnishing Unit, which speculated on future modes of living. One especially memorable design was Mario Bellini's bright green mobile conversation pit and sleeping area, the Kar-a-Sutra, which was a collaborative project between Citroën and Pirelli and reflected the playful and informal zeitgeist of the early 1970s. More than anything else this landmark exhibition brought to light the two opposing currents that were running through Italian design at this stage: engineering-orientated design with its goal of large-scale mass-production versus semantic counter-design which gleefully announced the demise of Modern design. This latter category was itself divided into playful Anti-Design that had a Pop sensibility, and its more theoretical, politicized and experimental cousin, Radical Design. In 1973, a year after the MoMA exhibition, Olivetti launched Mario Bellini's Divisumma electronic printing calculator (see page 190), which reflected the forward-looking tendency of Italian design within other realms of product design outside the domestic sphere. Yet even this thoughtfully conceived, innovative portable calculator in bright yellow plastic would come to seem rather outré in light of the oil crisis that occurred the same year, which gave rise to the realization that the boom had turned to bust and that a new kind of design sensibility was needed to address the changing demands of these new straitened times.

Neo-Rationalism and Global Tools

While Italian design had creatively flourished during the psychedelic Age of Aquarius, spanning the late 1960s to the early 1970s, and Italian designers and design groups had explored artistic avenues with abandon and investigated the formal potential of new materials and technologies with joyful relish, the oil crisis of 1973 and subsequent widespread economic recession brought the heady world of "concept factories" down with a rather unceremonious bump. The pursuit of "design for design's sake" was abruptly curtailed, as manufacturers by necessity had to rein in research-and-development budgets and ultimately take a more financially conservative line towards the business of design. As domestic and export markets contracted, so manufacturers in Italy and elsewhere looked for "safe products" that they could sell to the mainstream – for instance, in furniture design bright plastics with their high tooling costs were out and in their place wood, steel and glass became the materials of choice.

It was during the 1970s that there was also a major re-evaluation of Modernism with mainstream taste turning to more austere rational solutions that were the stylistic antithesis of the Pop aesthetic. During this period, earlier Modern Movement designs became truly popular for the first time and the Italian furniture manufacturing company Cassina – which had already acquired the European production rights to Le Corbusier's furniture and certain Bauhaus designs in the 1960s – was now very successfully retailing such "modern furniture classics" as part of its I Maestri collection.[15] Although at the time it may not have seemed to have had much bearing on Italian design, it was a significant step for a well-known Italian manufacturer to be producing designs that had been created by non-Italian designers. It was also an indication of how the design world was becoming more internationalized in its outlook and underscored a desire among manufacturers to find ways of reducing research and development costs.

The pervasive conservatism that existed in contemporary mainstream design during the mid-to-late 1970s reflected a widespread return to the precepts of Modernism – a sort of uninspiring Neo-Rationalism. Yet fermenting under the surface was the Radical Design movement, which having already emerged during the late 1960s was now finding a lot more to agitate against, with what it detested most being the utter banality of so much mass-produced design. The architect, designer and artist, Riccardo Dalisi had already undertaken experiments with *tecnologia povera* (poor technology) by organizing workshops for underprivileged children in the Traiano district of Naples in 1973, in an attempt to bring personal and spontaneous creativity back to design practice.

This proactive design research inspired the founding of a new school of counter-architecture and design in the editorial offices of *Casabella* magazine in January 1973. Known as Global Tools, this new venture's founding members included Archizoom Associati, Remo Buti, Riccardo Dalisi, Ugo La Pietra, Gruppo 9999, Gaetano Pesce, Gianni Pettena, Ettore Sottsass, Superstudio, Gruppo UFO and Zziggurat. In the magazine's March 1973 issue the venture defined itself as "a system of workshops for the propagation of the use of natural materials, and the relevant behaviours" and explained its objective as being "to simulate the free development of individual creativity."[16] With its do-it-yourself ethos and left-leaning political agenda, Global Tools sought to creatively connect ordinary people with the design process. For its brief two years of operation, Global Tools was the central forum for the Radical Design debate, with the project's disbandment in 1975 signifying the end of the first phase of the Radical Design movement in Italy.

Studio Alchimia and Memphis

Despite the eventual break up of Global Tools, new mutating shoots of Radical Design had appeared the previous year when the designer Alessandro Mendini set two identical simply constructed "ideal" chairs alight outside the offices of *Casabella* where he was editor-in-chief. Both chairs bore the name Lassù (Up There) and the act of burning them was intended to blur the

boundaries between art and design. This act of incendiary design provocation was followed up by another symbolic chair burning later that same year in which another Lassù chair was taken to a quarry and placed on a flight of steps before being engulfed in flames and photographed. This now legendary act of destruction was intended to announce the possibility that, like a phoenix, when one type of design is destroyed a new variety might emerge from its ashes.

Two years later, in 1976, the architect Alessandro Guerriero founded Studio Alchimia, which would become the main champion of this new and provocative form of intellectually challenging counter-design, which is best described as second phase Radical Design. Although initially intended to function as a gallery space in which to exhibit work that was not creatively encumbered by the constraints of industrial mass production, Studio Alchimia soon became an influential design studio that produced avant-garde work by Ettore Sottsass, Alessandro Mendini, Andrea Branzi, Paola Navone and Michele De Lucchi, among others. The studio's name, which alluded to the pseudoscientific predecessor of chemistry, was a confrontational jibe at the scientific rationale underlying Modernism. It also referenced alchemy's association with magical transmutation – with the transformation of existing designs becoming a defining feature of the work produced by the studio. The best-known examples of this approach were Alessandro Mendini's redesigns of "iconic" or "found" furniture pieces such as his Proust Armchair (1978), which as an act of "banal design" comprised the decoration of an existing "antique" chair with pointillist multi-coloured dabs of paint (see page 198). Studio Alchimia's ironically named Bau.Haus 1 and Bau.Haus 2 collections, of 1978 and 1979 respectively, consciously referenced popular culture in its ridiculing of the banal cliché of Modernist designs – for instance, Marcel Breuer's Wassily chair was embellished by Mendini with colourful biomorphic camouflage-like forms. Andrea Branzi explained Studio Alchimia's central and rather pessimistic premise by stating: "Operations of redesign consisted of touching up found objects or famous products of design to illustrate the impossibility of designing something new in respect to what has already been designed."[17] Self-consciously elitist and politically intellectualized, Studio Alchimia's jokey yet subversive activities were absolutely central to the second wave of Radical Design in Italy and importantly laid the philosophical groundwork for the founding of the Memphis design group in 1981.

It is difficult to comprehend the startling impact Memphis must have had when it first splashed onto the design world's stage with its provocative debut at the Milan Furniture Fair in 1981. It was a riotous design circus with the enigmatic Ettore Sottsass taking the role of ringmaster

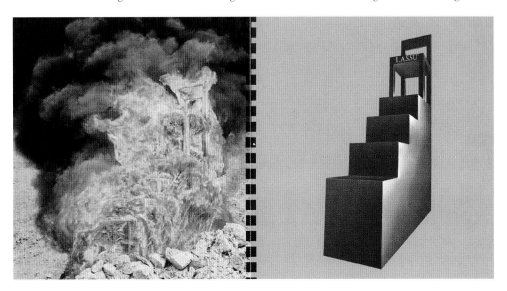

Right: Lassù chair designed and symbolically burnt by Alessandro Mendini, 1974

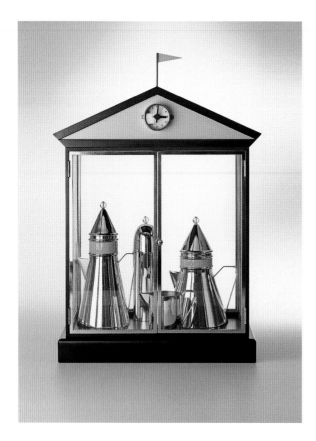

Left: Tea & Coffee Piazza service
designed by Aldo Rossi for Alessi as
part of its Tea & Coffee Piazza project,
1982

for its youthful band of merry design renegades – which included not only Italian designers, such as Michele De Lucchi and Marco Zanini, but also foreign practitioners: notably George Sowden, Nathalie Du Pasquier, Martine Bedin and Masanori Emeda (later to be joined by Hans Hollein, Shiro Kuramata, Peter Shire and Michael Graves). Extremely media-savvy, Memphis did what no Anti-Design group had really managed to do before: popularize Post-Modernist theory by repackaging it into, as the design journalist Alice Rawsthorn puts it, "a fun, seductive form that millions understood".[18]

Although Sottsass had been associated with Studio Alchimia, he had found its focus on "banal design" and "redesign" too creatively restrictive, and his founding of Memphis was an attempt to find a new creative approach to design that was less intellectualized and rhetorically laden. Essentially a design collaborative, its name had been inspired by the lyrics of a Bob Dylan song, "Stuck Inside of Mobile with the Memphis Blues Again", which had been playing at their group's first gathering in 1980, getting stuck on the last three words repeatedly. The name also had a suitably ironic double entendre, being both the home of the ancient Egyptian capital of culture and the Tennessee birthplace of Elvis Presley. Indeed, double-coded meaning was as much a feature of Memphis designs as was the use of eye-catching colour combinations, bold totemic forms, and plastic laminates with New Wave style geometric and biomorphic patterning. There was absolutely nothing subtle about Memphis designs, and they heralded a new language of Post-Modern Italian design that was exuberantly playful and that captured the emerging optimism of the early 1980s as the world's economy started to heave itself out of recession. Memphis designs caught the attention of the design press around the world and in so doing helped disseminate Post-Modernism globally. Through the diverse nationality of its members Memphis also heralded a new age of internationalism in design, especially in Italy.

The internationalization of Italian design, then and now

Another Italian initiative that attracted the design media's attention was Alessi's Tea & Coffee Piazza project, which ran from 1979 to 1983 and, like Memphis, involved not only Italian architect-designers, such as Aldo Rossi and Ettore Sottsass, but also non-Italian designers such as Michael Graves and Robert Venturi. But it was Rossi's Post-Modern architectonic design for this creatively unencumbered project, complete with its classical pediment and jaunty little flag, that was the most widely publicized of all the silver tea and coffee sets executed for the programme. By including a mix of Italian and non-Italian designers, not only did Alessi find it easier to publicize this project overseas but it also helped to give the work, and thereby Alessi, a greater international cachet. In fact, it marked a real turning point for the Crusinallo-based company, and bolstered by its success many other design-led Italian companies also began commissioning non-Italian designers to create new products for them. It was, however, a La Spezia-born designer, Stefano Giovannoni, who would contribute the most designs to Alessi's product line over the following years. Playfully Post-Modern, Giovannoni's work with its cartoonized forms,

from his Girotondo range of 1989 (designed with Guido Venturini) to his Family Follows Fiction series of colourful plastic designs (1993) had a universally understood "Neo-Pop" commercial appeal that transcended cultural boundaries and was yet another manifestation of the growing internationalization of Italian design.

This new global emphasis within the Italian design industry was ultimately a reflection of a wider cultural shift, with the economic boom of the 1980s having heralded ever-accelerating globalization throughout the 1990s and 2000s. The late 1980s also saw the rise of the "design superstar" and although some of these were Italian by birth, many were not. In order to compete in the now globalized design market, Italian manufacturers rather than relying solely on home-grown talent as they had done so successfully in the past, were now increasingly commissioning design superstars from all over the world. The reason for this was two-fold; firstly these designers had brand name recognition and working with them brought prestige to the patron companies, and secondly these design-maestros had highly distinctive design signatures and as such were commercially safe pairs of hands to work with. This turn of events, however, meant that despite the increased interest in design during the 1990s and 2000s, and the consequential rapid growth of design-led Italian manufacturers, very few Italian designers actually made it onto this rarefied world stage of design superstars, some key exceptions being Michele De Lucchi, Alberto Meda and Antonio Citterio. Interestingly, the latter two have both worked for the German manufacturer Vitra – which demonstrates the truly international nature of the design world today. And yet, both these designers create work that retains a definable Italian sensibility about it, being both beautifully engineered and having a refined elegance that encapsulates the very essence of *La Linea Italiana*.

Today, Italian design continues to be associated with design excellence, yet this reputation is born out of decades of talented designers being supported by manufacturers to create the most avant-garde work they can. The last few years of economic crisis – which have been especially hard felt in Italy – have been devastating to many within the Italian design industry on a personal and creative level, because ultimately at its heart Italy is an industrious nation. It is little known outside of Italy, but Article 1 of the Constitution of the Italian Republic drawn up in 1947 states, "Italy is a democratic Republic founded on labour" and one of the main reasons Italian design has flourished throughout the decades is because ultimately as a nation it has an "industry for design". This essential element of Italian *cultura* needs to be carefully tended, nurtured and encouraged, especially in the coming years as competitive pressure from emerging economies continues to exert itself. For ultimately, design is Italy, and Italy is design. It is inconceivable to think of one without the other, because design is so intricately woven into the fabric of everyday Italian life.

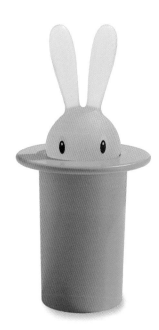

Below: Magic Bunny toothpick holder designed by Stefano Giovannoni for Alessi, 1998

Overleaf: Pagani Huayra, officially debuted in 2011 – the latest mid-engined hypercar from Pagani, which succeeded the company's earlier Zonda

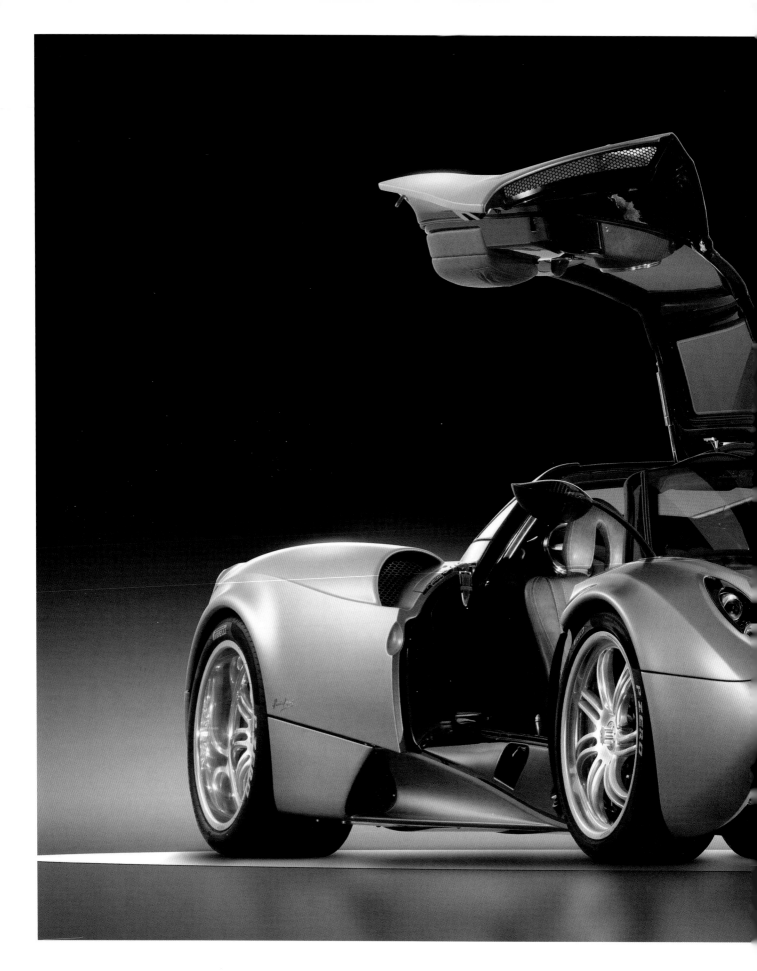

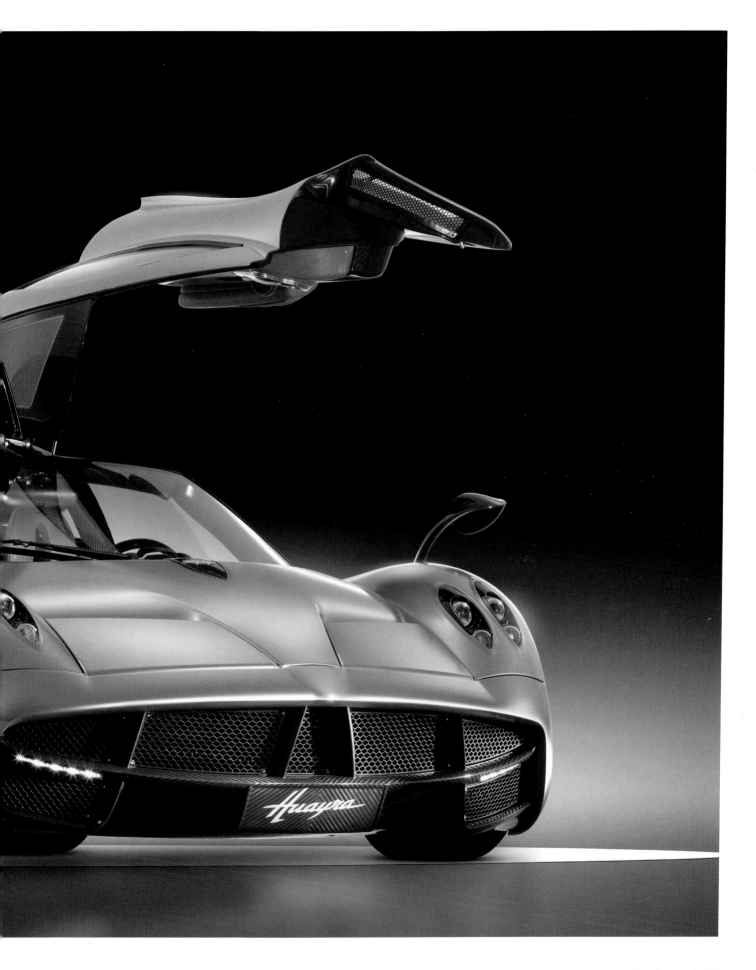

Cobra chair, 1902
Vellum-covered wood, paint, gilding and
stamped copper
Carlo Bugatti Workshop, Milan

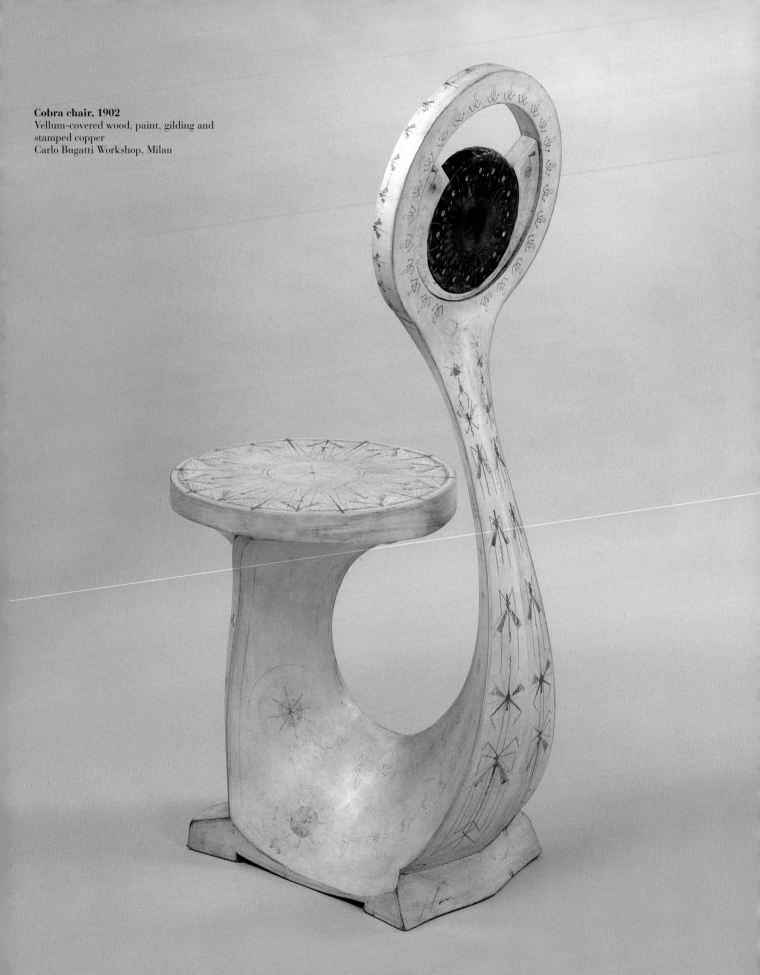

Cobra chair, 1902
Carlo Bugatti (1856–1940)

Held in Turin in 1902, the Esposizione Internazionale d'Arte Decorative Moderna was the first large-scale Italian exhibition of the industrial and decorative arts. Importantly, it marked a significant modern turning point within Italian design thanks to its criteria for selection, which were: "Only original products that show a decisive tendency toward aesthetic renewal of form will be admitted. Neither mere imitations of past styles nor industrial products not inspired by an artistic sense will be accepted."

Among the most notable installations housed in Raimondo D'Aronco's fanciful Art Nouveau pavilions were Charles Rennie Mackintosh's Rose Boudoir and a truly remarkable "games and conversation room" designed by Carlo Bugatti, which incorporated Moresque-inspired furnishings that were within the full-blown Art Nouveau style. Informed by his studies into circular forms and curved shapes, the room consisted of a sweeping upholstered banquette as well as a table and three extraordinary chairs, the shape of which was inspired by a snail shell. These chairs with their curious organic form were unlike anything that had been seen before and resulted in the installation soon becoming nicknamed the *"camera a chiocciola"* (snail room).

These designs were referred to as either the Cobra or Snail chairs, and their wooden carcasses were fully covered in vellum and embellished with stylized motifs depicting insects highlighted in gold and red, while a gleaming stamped disc of copper adorned their back sections. Their continuous spiralling organic forms were remarkably progressive and can be considered to represent the pinnacle of Bugatti's oeuvre.

Of course, the sheer originality of Bugatti's Snail Room installation "provoked, within the jury as well as the public, the liveliest discussions... and the most heated debates", but eventually resulted in him being awarded the event's highest prize, the Diploma of Honour, for having become "the first person in Italy to create, and not just dream of a modern style of furniture". Indeed, the Snail Room marked a watershed moment having revealed emphatically a new and bold Art Nouveau tendency within Italian design, which in Italy became known as the Stile Liberty.

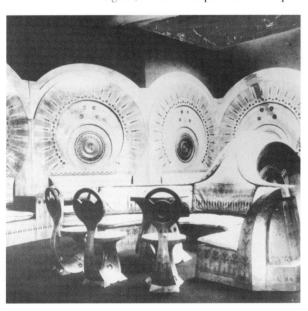

Above: Games and conversation room designed by Carlo Bugatti for the 1902 Esposizione Internazionale d'Arte Decorative Moderna – nicknamed the "Snail Room"

M1 typewriter, 1910
Camillo Olivetti (1868–1943)

Designed by the inventor and entrepreneur Camillo Olivetti in 1910, the M1 was the first typewriter to be industrially produced in Italy and was also one of the country's first mass-consumer products. Prior to this, Camillo Olivetti had studied engineering at the Politecnico di Torino (Turin Polytechnic). He then worked in a manufacturing factory in London to gain hands-on experience before beginning work as an electrical engineering assistant at the University of Stanford, where he also studied physics and engineering. It is believed that it was during his two-year stint in America that he first encountered "modern" typewriters such as those produced by Underwood.

In 1908, after returning to Italy, Olivetti established his own typewriter manufacturing company in Ivrea known as, Ing. C. Olivetti e C. Three years later on the 29th of March 1911, the company launched

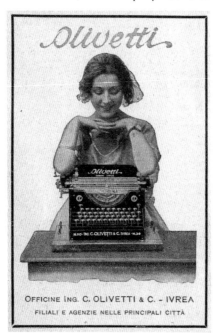

Above: Early Olivetti advertisement for the M1 typewriter, c.1910

the M1 typewriter alongside another model in the Palazzo del Giornale (Pavilion of the Newspaper) at the Esposizione Internazionale di Torino (Turin International Exhibition). With its four rows of keys and simple carriage shift, the M1 typewriter at first glance seemed to be based closely on a model designed by Franz Wagner and produced by Underwood. This new Italian machine, however, boasted a number of advanced technical functions that truly set it apart. The Turin Expo's official catalogue described it as "a typewriter of the first class…[with] original design, legible characters, standard keyboard, two-coloured ribbon, decimal tabulator, back-space, multiple margin adjustment, modern workmanship, absolute precision."

Featuring a robust construction, thoughtful keyboard layout and ball-bearing mounted carriage and escapement the M1 set a new level of technical superiority and aesthetic sophistication in typewriter design. As Camillo Olivetti was to later note, "a typewriter should not be a geegaw for the drawing room, ornate or in questionable taste. It should have an appearance that is serious and elegant at the same time".

Within one month of the M1's launch, Olivetti won a contract to supply one hundred machines to the Italian Navy and by 1913 it had produced over 1,000 units. The successful mass-production of the design was attributable to the implementation of various automated machines within the Olivetti factory, which were actually also shown at the 1911 Turin Expo. As is noted of Camillo Olivetti in the official company history *Olivetti 1908–1958*, "As an industrial technician…[he] was perhaps prouder of demonstrating the ingenuity and modernity of his methods than of showing the public his finished product." It was Olivetti's belief in modern design and innovation, so eloquently demonstrated through the realization of the M1 typewriter, that would subsequently guide the whole ethos of his Irvea-based company and ensure that over the coming decades the name Olivetti would become synonymous with Italian design excellence.

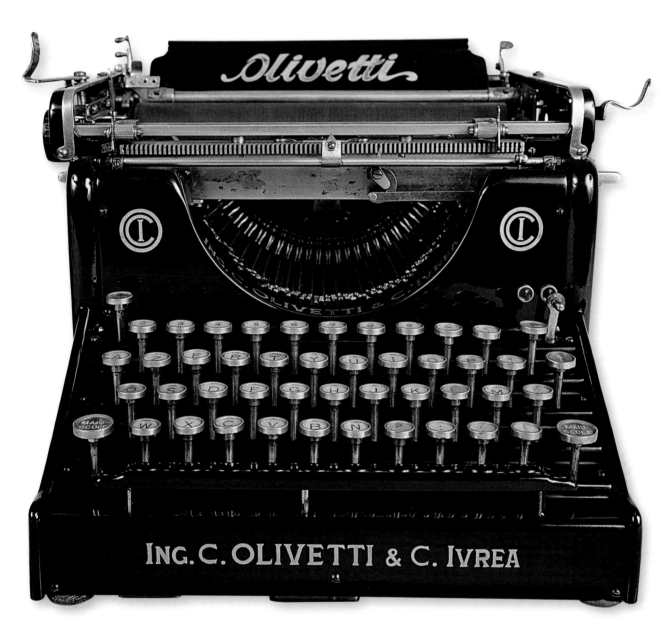

M1 typewriter, 1910
Enamelled metal, wood, brass, other materials
Ing. C. Olivetti e C., Ivrea

A.L.F.A. 40/60 HP Aerodinamica racing car, 1914

Giuseppe Merosi (1872–1956)

The origins of Alfa Romeo can be traced back to the Anonima Lombarda Fabbrica Automobili (A.L.F.A.), a Milanese car manufacturing company founded in 1910. The same year, the talented automotive engineer and designer Giuseppe Merosi joined the fledgling company and the following year the firm began racing its cars competitively. Because of this, the business was more interested in how to make cars go faster than many of its competitor manufacturers, and it was consequently one of the first auto makers to understand the speed advantages derived from aerodynamic forms that reduced drag.

In 1914, Merosi was commissioned by Count Marco Ricotti to design a radical new concept car called the Aerodinamica. This remarkable prototypical vehicle was also known as the Siluro Ricotti and had a tear-shaped body built by the master coachbuilder Ercole Castagna on an existing 1913 A.L.F.A. 40/60 chassis. Looking like a silver bullet, its damascened aluminium bodywork was far more structurally unified that those of previously made automobiles and it was the very first car to boast a curved glass windscreen. The Aerodinamica's tapering teardrop-shaped body was inspired by a dirigible and thanks to its slippery aerodynamic efficiency gave the car a reported top speed of 150 kph (93 mph) – an impressive 14kph increase on existing A.L.F.A. models. Its engine was accessed through the square doors in its bodywork located just behind the front wheels, while the scooped section at the front tapered back to a brass Mercedes-style radiator.

Reputedly intended as both a road and racing model, the Aerodinamica vehicle was an extremely early example of aerodynamic principles being applied to automotive design. Despite its teardrop-shaped body being aerodynamically correct, its large size, which meant it could comfortably accommodate at least three passengers in its back seat, together with its high centre of gravity, meant it was not as fast as it could have been. The first model designed as a prototype for Count Ricotti was an open-topped model, however, later production variations made between 1914 and 1922 were fully enclosed and had circular porthole-type windows. Although today the Aerodinamica appears like a rather curious Steampunk vehicle, in its day it must have seemed like a striking streamlined vision of the future, and indeed in some ways it was, being one of the very first cars to be designed from an aerodynamic perspective. To this extent the Aerodinamica can be seen to have heralded the elegant sleek lines that have become such a defining characteristic of Italian automotive design.

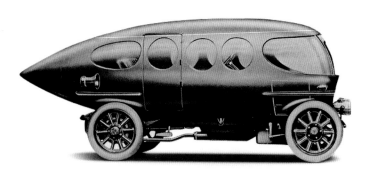

Above: Early image of the A.L.F.A. 40/60 HP Aerodinamica racing car showing its tear-drop form, c.1914

A.L.F.A. 40/60 HP Aerodinamica racing car, 1914
Damascened aluminium, other materials
Ercole Castagna/Carrozzeria Castagna & C., Milan

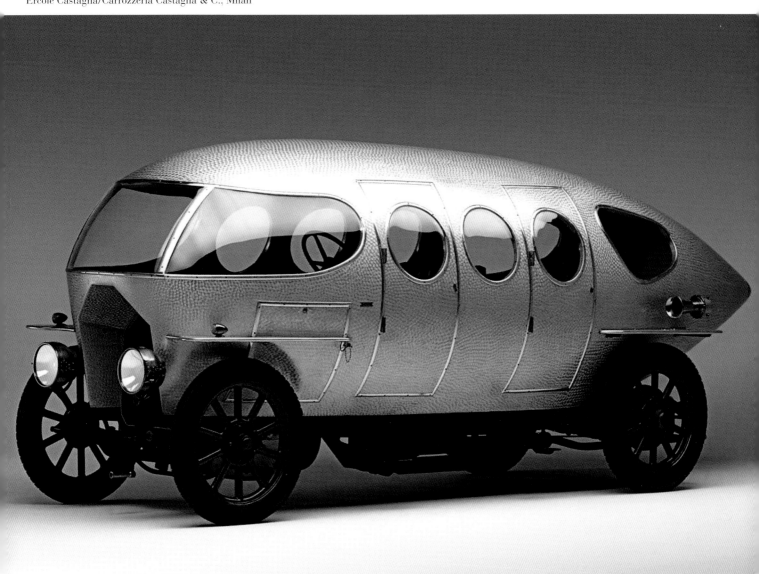

Model No. 267 rocking chair, c.1915
Lacquered beech, cane
Società Anonima Antonio Volpe, Udine

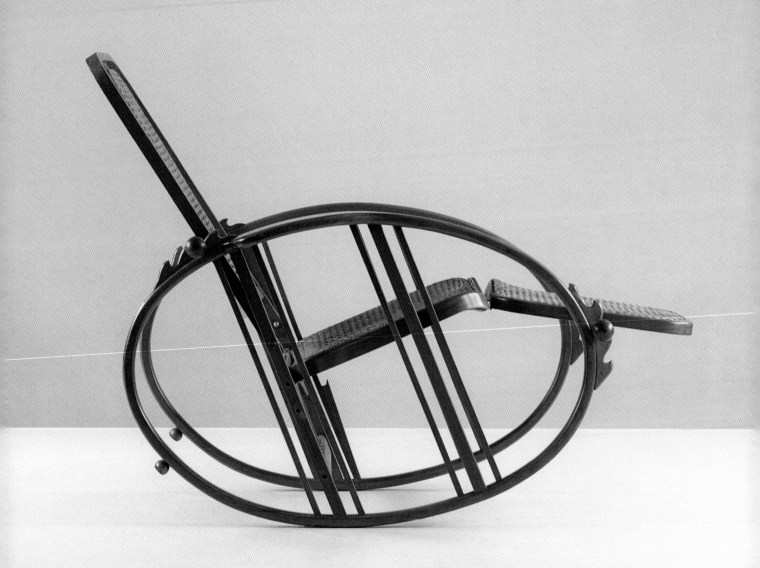

The Model no. 267 rocking chair is also known as the Egg, due to the generously sized oval-shaped rockers that sit on either side of its moulded beechwood seat and caned rectangular back. Both the rockers and the rest of the frame are made from steam-bent beechwood, and the chair speaks of the popularity of bentwood furniture more generally at this time, in Italy and elsewhere.

In the early 1900s, the production of bentwood furniture was dominated by Thonet, the Austrian manufacturer that had introduced the steam-bending process in the middle of the previous century. Following the expiration of the firm's patent for the process in 1869, a number of competitors emerged to claim their share of the expanding market. They included the businessman Antonio Volpe, who in 1882 set up the Società Anonima Antonio Volpe in Udine, in northeast Italy. The city and its surroundings are one of the country's main furniture-

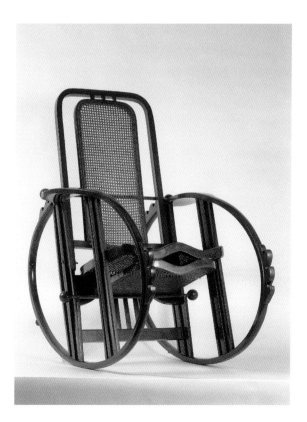

producing districts, alongside Brianza to the north of Milan and Murgia in the south, and a number of firms specializing in bentwood furniture were established in the area in this period. Volpe positioned himself in direct competition with Thonet, producing a variety of chairs and other bentwood furnishings that were aimed solely at the domestic market. In the early 1900s the firm won a number of accolades for its designs, until the factory was destroyed during the First World War. Although subsequently rebuilt, Società Anonima Antonio Volpe ultimately lost its battle in the bentwood market and closed in 1940.

Although no longer in production, the design of Model no. 267 remains an exemplar of early twentieth century Italian furniture design. The forward slanting elements contained in each rocker enforce the dynamism of the design, and the combination of curved and linear forms makes for a highly ordered form in line with the fledgling Art Nouveau style of the time. Despite the high calibre of its design, the figure responsible for the rocking chair is unknown. It was previously attributed to Josef Hoffmann, the Austrian architect who was highly influential on the decorative arts at the turn of the twentieth century through his association with the Viennese Secession and Wiener Werkstätte. Certainly there are clear echoes of Hoffmann's work, in particular his Sitzmachine from 1905, which had similarly curving bentwood armrests and strongly geometric detailing. In the 1980s, however, a catalogue for the firm from the period was unearthed which listed neither Hoffmann nor any designer as responsible for the chair, and its authorship remains a mystery.

Left: Model No.267 rocking chair shown with footrest folded away under the seat

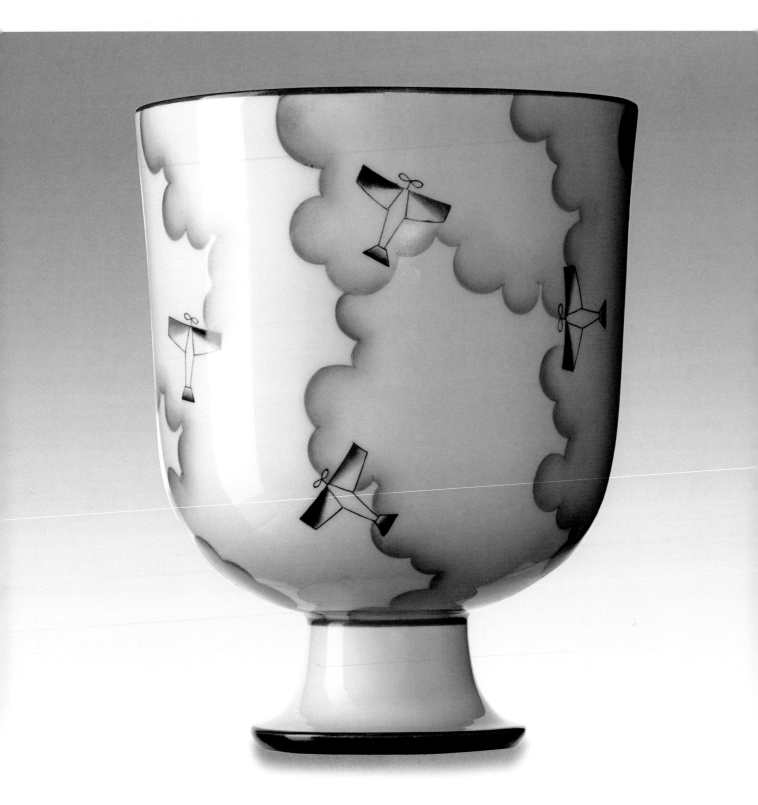

Alato vase, 1920s
Glazed porcelain
Società Ceramica Richard-Ginori, Doccia

Alato vase, 1920s
Gio Ponti (1891–1979)

Born in Milan in 1891, Gio Ponti is today recognized as one of Italy's most important twentieth-century architects. Like many of his contemporaries he was a polymath; following his graduation in architecture from the Politecnico di Milano in 1921 he embarked on a rich and varied career that spanned a number of design disciplines including furniture, fabrics, lighting and ceramics. Ponti was not only important as a designer, but also as a cultural patron. In 1928 he became founding editor of *Domus*, the magazine he oversaw until his death in 1979 (with the exception of the years 1940–47 when he left to set up *Stile* magazine). The architect was an enthusiastic promoter of Italy's artistic heritage and he used both magazines as platforms to promote the best of Italian architecture and design, including his collaborations with manufacturers such as Venini and Richard-Ginori, for whom Ponti designed the Alato vase.

Richard-Ginori's origins date back to 1735, when the firm began producing historical reproductions in majolica and lusterware in Doccia near Florence. In the mid-nineteenth century the firm started to manufacture more contemporary styles, following the appointment of Marquis Lorenzo Ginori Lisci in 1848. In 1896 the company became Società Ceramica Richard-Ginori, following its purchase by Giulio Richard, who owned several factories in cities including Turin and Milan. Ponti started visiting the Milan location in 1921 and two years later was appointed artistic director, a role he would retain until 1930. Ponti oversaw the firm's entire catalogue, working on designs at the company's Milan factory that were then developed into prototypes at its Doccia factory. These designs were intended to be produced on a large scale and across a range of formats with Ponti creating a repertoire of largely Renaissance- and Classical-inspired decorative motifs that could be transferred onto a variety of porcelain and ironstone forms including vases, plates and other dinnerware.

The Alato vase is one of the most forward-looking of the architect's designs for the firm. In keeping with the nationalist Neo-Classical style that Ponti favoured in the 1920s and 1930s, there are references to Italy's past in the Alato vase, chiefly in its classical, urn-like shape. The decoration is in the same Art Deco vein of the whole series, but while the majority of these were updatings of Renaissance and Classical motifs, the Alato vase was more contemporary in its aesthetic. Alato, which translates as "winged" in English, is decorated with a number of aeroplanes soaring through the sky in the red, white and green of the Italian flag.

In 1925 Ponti curated a display of his designs for Richard-Ginori at the Paris Expo. Awarded the *Grand Prix*, this was one of a number of accolades that the collaboration was awarded in the 1920s. Ponti continued to design for the firm into the 1930s and late 1940s, creating designs including the Hands series from 1935, but by this point the architect was already preoccupied with other activities. Following a hiatus in its manufacture, in 1983 Richard-Ginori brought the Alato back into production.

Il dono di una coppa o di un portacenere RICHARD GINORI serie «sport» è testimonianza del buon gusto del donatore, pegno di amicizia, richiamo ed invito alle gioie salutari degli sports preferiti

SOCIETÀ CERAMICA
RICHARD-GINORI
Sede Centrale - MILANO - Via Bigli, 1

MILANO - Corso del Littorio, 1
MILANO - Via Dante, 13
BERGAMO - Via Tasso, 50
GENOVA - Via XX Settembre, 3 nero
FIRENZE - Via XX Rondinelli, 7
PISA - Via Vit. Emanuele, 22
NAPOLI - Via S. Brigida, 30-33

SASSARI - Piazza Azuni
TORINO - Via XX Settembre, 17
TRIESTE - Via Carducci, 20
BOLOGNA - Via Rizzoli, 10
LIVORNO - Via Vitt. Emanuele, 27
ROMA - Via del Traloro, 147-51
CAGLIARI - Via Campidano, 9

Above: Richard-Ginori advertisement for the Sport range of ceramics designed by Gio Ponti, 1934

Depero Futurista book, 1927
Printed paper, metal bolts
Edizioni Italiana Dinamo-Azari, Milan

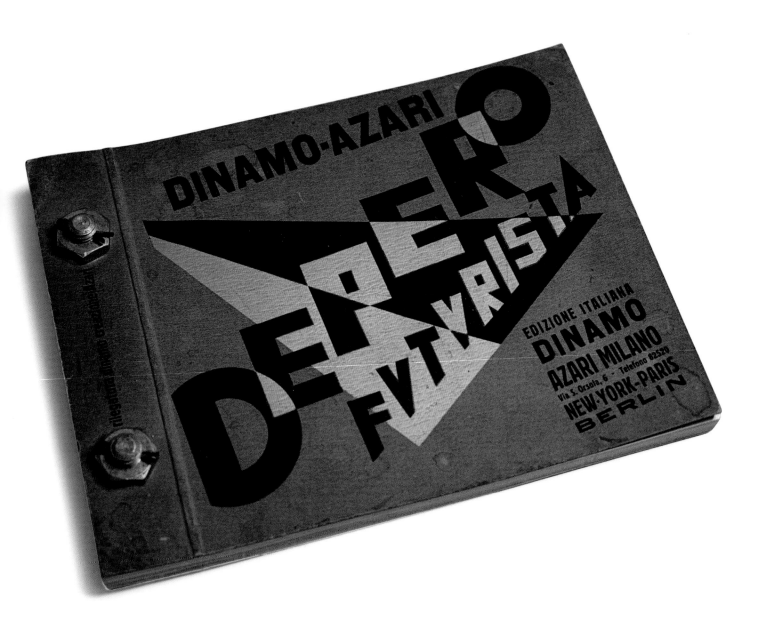

Depero Futurista book, 1927

Fortunato Depero (1892–1960)

In 1909, the poet Filippo Tommaso Marinetti announced the birth of the Italian Futurist movement with *Founding and Manifesto of Futurism*, published on the front page of the French newspaper *Le Figaro*. This was a deliberately provocative act, characteristic of a movement that rejected the splendours of Italy's past in favour of all that was new. Burdened by the weight of Italy's traditions, they looked to create a modern, future-orientated Italy that embraced the exciting advances in modern industry and technology, and championed the styles, speeds and shapes of cars, machinery and modern urban life. Their avant-garde enthusiasm for modernity infused works in a variety of disciplines, from bronze sculptures to furnishings, ceramics to photography, created by artists such as Umberto Boccioni and Gino Severini. Much of the movement's most powerful work was in the field of graphics, and Fortunato Depero's *Depero Futurista* book from 1927 is a prime example of this.

Depero was born in the northern Italian town of Fondo in 1892. As with many of his contemporaries, he practised across a number of disciplines, and worked as an Italian painter, sculptor and graphic designer. Following an apprenticeship to a marble maker and, familiar with Marinetti's manifesto, in 1914 Depero moved to Rome where he met the futurist painter Giacomo Balla, and a year later they wrote together a second Futurist manifesto, the *Futurist Reconstruction of the Universe*. At the same time they produced designs for costumes that were greatly admired by the Ballet Russes's founder Sergei Diaghilev and in 1927 designed a pavilion for the 1927 Monza Biennale, the precursor to the Milan Triennale exhibitions. Depero's heavy involvement with this artistic avant-garde did not preclude his work in more commercial realms. During a stint in New York in the late 1920s he created covers for magazines such as *Vanity Fair* and *Vogue*, and in Italy, was responsible for advertising campaigns for companies such as Italian drinks brands Campari and San Pellegrino. These two realms can be seen to have influenced each other in the *Depero Futurista* book.

Published by the Milan-based Edizioni Italiana Dinamo-Azari in a limited edition of 1,000 copies, *Depero Futurista* embodies many key traits of Italian Futurism. It is also considered one of the first "object books", and represents a landmark in the history of printing. In line with the group's subversive ethos, Depero broke all typographic conventions, creating pages in which the text appears in different colours, sizes and fonts, laid out in variety of directions, creating compositions that blur the boundaries between word and image. These are printed on a variety of different papers, interlaced with graphics from his work for Campari and other companies. The most striking aspect of the book is its cover: a small number of the copies have sheet metal covers, and all are bound with industrial metal bolts, in the ultimate expression of the Futurist's love of the modern machine.

Left: Visiting card designed by Fortunato Depero for the Depero Typographic Works, 1927 – showing a similarly dynamic composition of lettering

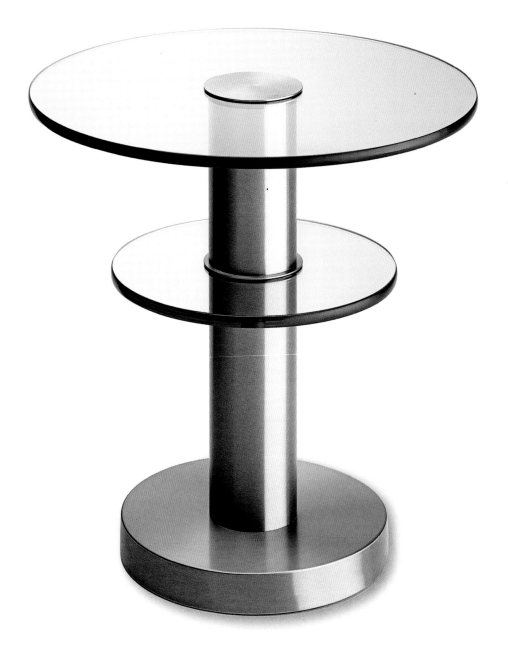

Table, 1932
Nickel-plated brass, glass
Fontana Arte, Corsico

One of the towering figures of Italian design, Gio Ponti was not only a brilliant architect and designer but also a highly influential critic and writer, whose editorship of the Milanese architecture and design journal *Domus* remains legendary. In 1931 Ponti was appointed the art director of the plate glass manufacturing firm, Luigi Fontana & C., where the following year he and Pietro Chiesa founded a new artistic division of the company known as Fontana Arte – an entity that went on to become one of the leading and most influential furniture and lighting companies of the period.

Like his colleague Chiesa, Ponti created a large number of elegantly modern designs for Fontana Arte, including this small modernistic table with its polished nickel-plated pedestal shaft piercing two concentric disks made of thick safety glass. According to Fontana Arte, the design was intended to pay homage to the industrial construction glass that Luigi Fontana was still manufacturing at the time. Through its innovative use of industrial glass and its strident formal geometry, this state-of-the-art table possessed a strong Machine Age aesthetic, which reflected the modernistic tendencies within the Italian Rationalist movement. By staggering the diameters of the two rounds of "Securit" glass, Ponti not only reduced the overall visual mass of the design but also imbued it with both a strong sense of dynamism and Classicism – attributes that typify the work of the Italian Rationalist Movement, and set it apart from the more utilitarian Modernist designs that were emerging from other European countries, most notably Germany and Holland. This simple yet elegant design was also highly practical with its two versatile surfaces and its easy-to-keep-clean modern lines.

Rightly regarded as a veritable icon of thirties Italian design, the Tavolino 1932 was certainly startlingly progressive for its day and it is unsurprising that it remains in production today – its stripped-down essentialist and architectonic columnar form can be seen to transcend the whims of fashion. It is a truly timeless design by one of Italy's most gifted design masters.

Left: Fontana Advertisement for Corteccia table designed by Pietro Chiesa, 1937

Model BF sewing machine, c.1932
Metal casing, other materials
Vittorio Necchi, Pavia

Model BF sewing machine, c.1932
Emilio Cerri (d.1947)

The origins of the Necchi sewing machine company can be traced back to the late nineteenth century, when Ambrogio Necchi took over the running of a metal casting factory in Pavia, which he had inherited from his grandfather and father. By the 1880s the company was employing around 170 workers who built cast-iron machinery parts. It was Ambrogio's son, Vittorio, who was to transform the company into one of the world's leading manufacturers of sewing machines. Having returned from the First World War, the management of the family business fell onto Vittorio's reluctant shoulders; he had no inclination for mechanics and preferred classical studies and photography instead. It was his wife's insistence about wanting to purchase a sewing machine that eventually led him to the idea of making a model for domestic use in his family's cast-iron foundry. The first Necchi

sewing machine, the Model BD, was a relatively simple machine with basic features that was inspired by models already being produced by other manufacturers.

After having engineers work on developing numerous advanced features for its sewing machines, Necchi eventually launched the landmark Model BF machine in the early 1930s. This new model marked a new level of functionality by being the first machine for household sewing that boasted a zigzag sewing feature, and with its sleek black metal casing it also had a strong modern aesthetic. This elegant and refined machine was designed by the company's technical director, Emilio Cerri, who had previously worked for FIAT. At Necchi, he had been responsible for implementing a complete reorganization programme to improve not only the design of the sewing machines but also their manufacture. The BF stood for *Bobbina Famiglia* (the family sewing machine) and it was this model that was to bring Necchi widespread recognition and ultimately lead the company to increasing success during the post-war period. Necchi later launched the Model BU, which was a slightly modified and improved version of this landmark sewing machine, yet its design layout remained essentially the same.

With its stripped-down aesthetic, the Model BF revealed the influence of Modern Movement functionalism within Italy during the 1930s; even though it was intended as a workhorse for seamstresses it retained a certain Italian stylishness with its elegantly curved lines and perfectly placed logo in sans-serif gold capital lettering.

Left: Actress Cécile Aubry in the 1953 film *Piovuto dal Cielo* (*Rained from Heaven*) – shown with a Necchi Model BF sewing machine

Moka Express espresso maker, 1933

Alfonso Bialetti (1888–1970)

Without Alfonso Bialetti the Italian kitchen would be missing one of its staple ingredients: the espresso coffee maker. An ever-present fixture on stovetops in Italy and elsewhere, the coffee maker is a product that seems to have been around forever and is made by any number of firms, and yet it is less than a hundred years old, and its design is unchanged from Bialetti's 1930s invention.

In 1918 Alfonso Bialetti set up a workshop in Crusinallo, a northwestern Italian town with a pedigree in domestic metalware production: the town is also home to Alessi, whose current owner, Alberto Alessi, is Bialetti's grandson. At first Bialetti focused on the production of metal components, but then shifted the firm's attention to manufacturing its own designs. At the time, coffee production was dominated by complex, large-scale machines destined for public bars and restaurants that could only be operated by trained baristas. Instead, Bialetti proposed a design that was small and simple enough for domestic use and yet was still able to produce coffee of restaurant quality.

There are a number of methods for making coffee: these include the Moka and the Neapolitan, both of which are used on the hob. In the case of the latter, only the container is turned over after boiling to allow water to percolate through the coffee, relying on gravity rather than the pressure used by the Espresso method. Bialetti's design was inspired by watching top-loading washing machines, and it uses the pressure method: to produce coffee you simply unscrew the two halves, fill the bottom and central chambers with water and coffee respectively, tighten and place on the hob. Boiling water is forced through the coffee grounds to produce the dark elixir. Bialetti spent eight years developing his idea, and in 1930 he produced his first version: a convex design with a wooden handle and knob. In 1933 the wooden handles were replaced with ones made from Bakelite, by which time the form had become the faceted, eight-sided shape that is recognisable today.

The Bialetti Moka Express is an identifiably thirties object. Its faceted design was inspired by the Art Deco movement of that decade, and is another example of Italian manufacturers' understanding of the potential to use design to distinguish their products. The use of aluminium was similarly of the period; this was a relatively new material for domestic goods in the 1930s, but its use was heavily promoted by the fascist regime as part of its bid to autarchy, as aluminium was one of the few materials that could be produced domestically in Italy at the time. The casting process was an imported technique, however – the result of Bialetti's earlier experience in the French aluminium industry. Despite the use of these advanced technologies, at first the coffee maker could only be made in small-scale production runs, making this a luxurious object for the few. In the post-war period the coffee maker was put into mass production, transforming it into an inexpensive, accessible object.

The rising popularity of the coffee maker in the 1950s informed the other key element of its design. In response to the product's widespread imitation, in 1953 the cartoonist Paul Campani designed the firm's logo, a caricature of Bialetti himself. Since then, the logo has been included on all Bialetti products, from the electric and multi-coloured versions of the Moka Express, to the broadening range of domestic goods made by the Bialetti brand.

solo la famosa caffettiera

MOKA EXPRESS
ha il super-filtro

in casa, in ogni luogo, un espresso come al bar

MOKA EXPRESS PRODOTTO BIALETTI

Left: Bialetti advertisement for Moka Express espresso maker, 1957

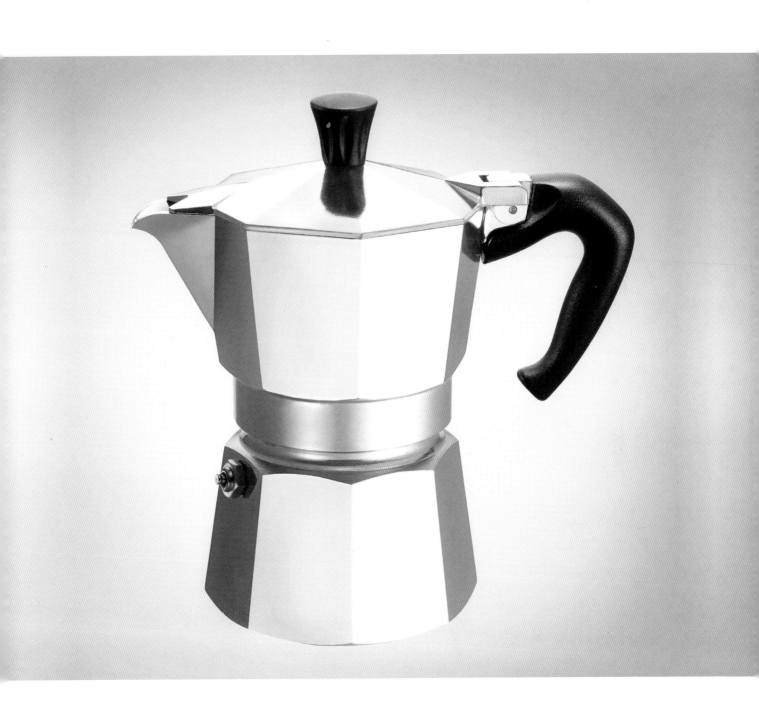

Moka Express espresso maker, 1933
Aluminium, Bakelite
Bialetti Industrie, Crusinallo

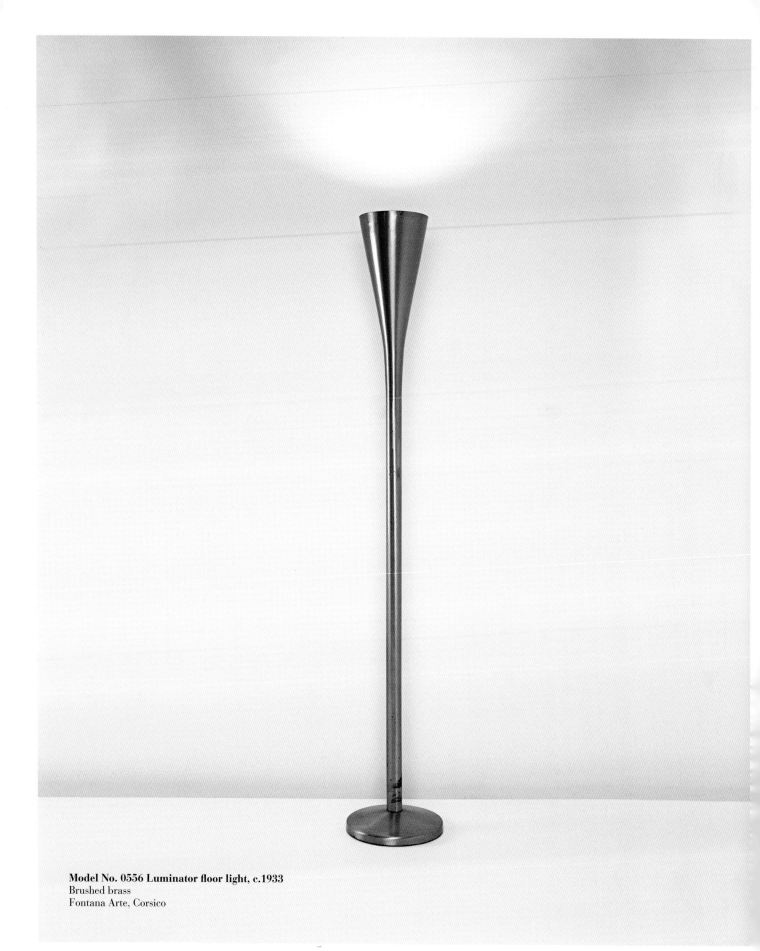

Model No. 0556 Luminator floor light, c.1933
Brushed brass
Fontana Arte, Corsico

Model No. 0556 Luminator floor light, c.1933
Pietro Chiesa (1892–1948)

Pietro Chiesa was one of the greatest proponents of Italian Rationalism during the 1920s and 1930s, with his architecture, furniture and lighting being widely publicized throughout this period especially in *Domus* magazine. In 1932, he also co-founded with Gio Ponti the well-known Corsico-based lighting and furniture company, Fontana Arte, as the artistic manufacturing division of the Luigi Fontana glassworks.

As co-artistic director, one of the first designs that Chiesa created for this new venture was his Luminator floor light, which although conceptually simple – essentially a flaring column of tubular brass – had a sleek and almost monumental presence. Stripped of any superfluous ornament, this modern-day electrified *torchière* had a sleek classical elegance with its subtle fluting form, which was executed in either brushed brass or enamelled brass.

The Luminator looked especially impressive in an interior when used as a pair, while its large scale, measuring 187cm high, also ensured that it had a strong presence within any room setting. Significantly, the Luminator was the first uplighter designed for domestic use, and exploited the kind of dramatic indirect illumination that had previously only been used by professional photographers in their studios. Its name also reflected the desire among Italian Rationalists to link their designs to associations with industrial progress, with the word "luminator" sounding as though it was a machine for illumination, rather than just a floor light.

It is a tribute to this design's enduring iconic status that it remains in production with its original manufacturer some eighty years after its introduction, and there is little doubt that the Luminator can be seen as the defining masterwork of Pietro Chiesa's illustrious career.

Left: Fontana Advertisement for Luminator floor light designed by Pietro Chiesa, c.1933

Follia chair, 1934

Giuseppe Terragni (1904–1943)

During the 1930s, Giuseppe Terragni was the pre-eminent Italian Rationalist, whose Casa del Fascio (1932–36) – the Fascist headquarters building – in Como has since become widely regarded as this progressive movement's architectural masterpiece. For this landmark edifice, which was fundamentally a Classical palazzo within the Modern idiom, he created some suitably modern furniture, including a number of functionalist-inspired chairs. Of these, it is the Follia chair that is perhaps the most striking both in terms of its innovative construction and its resulting pared-down, essentialist aesthetic.

With its simple black-lacquered-wood back section, plain square seat and four simple legs, it is a design stripped of any superfluous ornament or decoration. Without any form of padding it did not make too many concessions to comfort either. However, its use of two sprung bands of chrome-plated steel used to connect the seat to the back lifted the design out of the ordinary everyday and into the realms of the extraordinary. This seemingly simple construction gave the chair not only a strong graphic profile and visual lightness, but it also allowed a certain amount of springy resilience that provided a modicum of comfort. But the main role of this chair was as a prop on a stage set – a manifestation and projection of the new Italian authoritarianism that was heralded by Benito Mussolini's rise to power in 1925. However, this stridently modern look that had been initially embraced by the Fascist regime soon fell out of favour, and was replaced by the more historicizing Novecento style with its overtly imperial connotations. Although relatively short-lived, the Italian Rationalist movement was a bold national expression of the emerging International Style, and as such the Follia chair encapsulated its aesthetic purity brilliantly.

Left: View of Follia chair from above

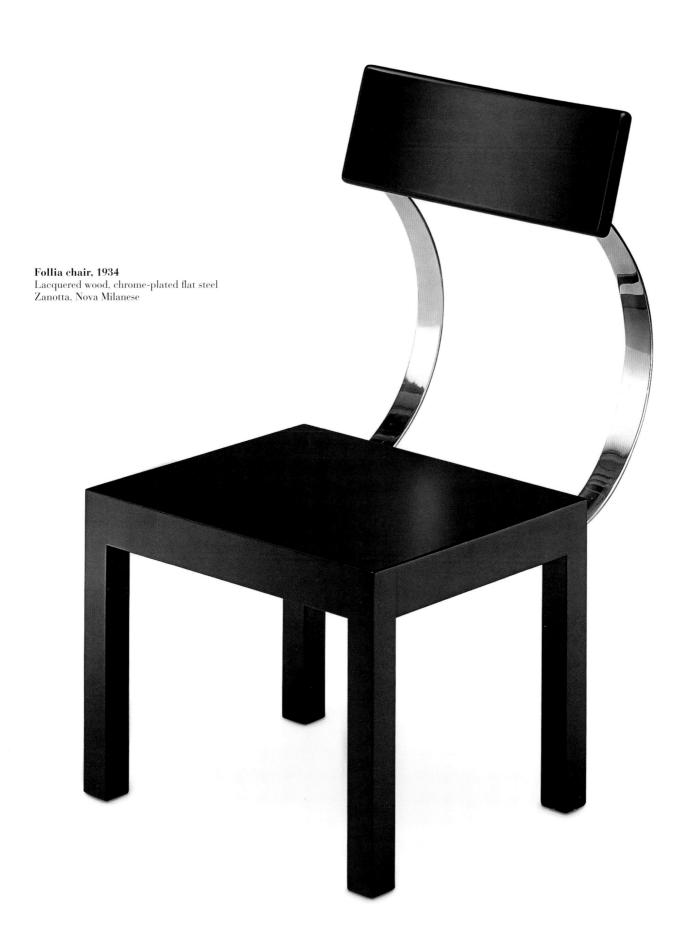

Follia chair, 1934
Lacquered wood, chrome-plated flat steel
Zanotta, Nova Milanese

Fiat 500A Topolino, 1936

Dante Giacosa (1905–1996)

The diminutive Fiat 500A might have been small, but it certainly had a big personality that endeared it to the Italian public and earned it the nickname "Topolino" meaning Little Mouse (which incidentally was also the Italian name for Disney's popular cartoon character, Mickey Mouse).

The Fiat 500A was the brainchild of the Italian car designer Dante Giacosa who had as a young man enjoyed classical studies, which he later acknowledged gave him "a sense of proportion and balance without which I could not do my job". He also studied mechanical engineering at the Politecnico di Torino (Polytechnic of Turin) before joining the FIAT car manufacturing company after graduating in 1927 and having responded to one of the firm's advertisements in a newspaper. He initially worked as a draftsman but soon his undeniable car-designing talents were being recognized, and around 1932 he was asked to develop a new small yet stylish car.

The resulting Fiat 500A was launched in 1936 and with its compact layout and streamlined form it marked a huge advance in the design of small cars for the everyman. The vehicle's rounded curvaceous form broke the convention of the box shape, while its lightweight metal body meant it was highly suited to large-scale mass production. It was equipped with a four-cylinder, side-valve, water-cooled engine, which Giacosa placed right at the front of the chassis ahead of the front axle, with the radiator located behind it so as to enable an aerodynamically sloping nose profile. This innovative configuration provided exceptional forward visibility and better legroom for the driver and front passenger as a result of the lowered seat height.

By lowering the seat height, Giacosa was consequently also able to lower the roofline and give the car a lower centre of gravity, which enabled better handling. Initially, the car was given a quarter-elliptic leaf-spring rear suspension; however, this was later upgraded to a stronger semi-elliptic system to help it cope with customers overloading the Little Mouse. Its use of an independent front suspension was also highly influential on the design of later high-performance compact cars.

The Topolino was at the time the world's smallest mass-produced car, and a staggering 519,000 units were built between 1936 and 1955. And it wasn't just popular in the home market – it went on to become Italy's biggest-selling export vehicle to the United States from 1938 to 1939. Giacosa also designed a number of variations of this classic little car, including the slightly modified 500B (1948), the marginally longer 500C (1949), the 500C Belvedere wooden-framed station wagon (1950) and a couple of micro truck models (1948–50). During the late 1950s Giacosa was tasked with re-designing the 500A. This resulted in the outstanding Nuova 500, which although quite different in its styling, still owed a great conceptual debt to the Topolino.

Like the Volkswagen Beetle in Germany or the Austin Seven in England, the Fiat 500A helped to democratize car ownership – and being the first successful Italian car designed and built for the masses it had an enormous impact of the lives of hundreds of thousands of ordinary people and their families throughout Italy.

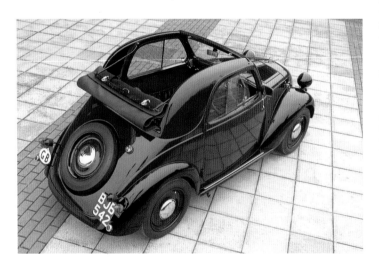

Above: View of the Fiat 500A Topolino showing the sunroof in open position

Overleaf: Fiat 500A Topolino cars rolling off FIAT plant's production line, 1947

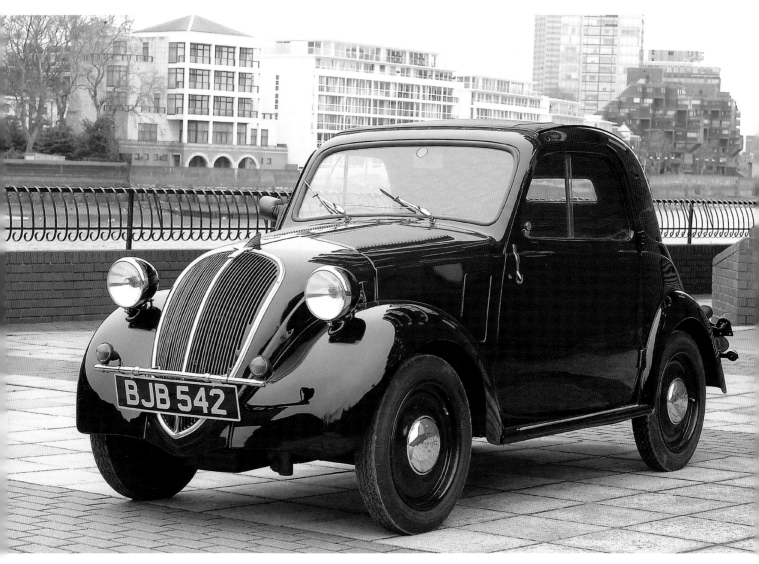

Fiat 500A Topolino, 1936
Pressed metal, other materials
FIAT (Fabbrica Italiana Automobili Torino), Turin

Alfa Romeo 8C 2900B Le Mans Speciale racing car, 1938

Alfa Corse & Carrozzeria Touring (founded 1926)

An Italian automotive designer of Hungarian descent, Vittorio Jano, replaced Giuseppe Merosi as Alfa Romeo's chief engineer in 1923. On this appointment Jano immediately instigated a new design programme that would lead to the development of Alfa Romeo's famous P2 racing cars which, with their straight eight-cylinder engines, went on to win the first ever Grand Prix World Championship held in 1925. To ensure Alfa's racing prowess Jano continued developing high-performance engines including the 6C launched in 1928 and then the 8C introduced in 1931. The latter was used to power various Alfa Romeo racing, road and sports models during the 1930s, including the sublime Alfa Romeo 8C 2900B of 1938, considered to be one of the most beautiful cars ever produced by the company.

The 8C engine had originally been intended for only competition use, most notably the legendary Mille Miglia race. However, by the autumn of 1931 Alfa Romeo had begun selling both short- and long-chassis variants incorporating the 8C, and various Italian coachbuilders had begun designing sleek bodies to clothe this powerful new engine. The most notable of these was the 2900B Le Mans Speciale, a streamlined racing coupé that was developed by Alfa Corse (Alfa Romeo's factory racing team) and the famed coachbuilder Carrozzeria Touring for entry into the legendary 24-hour Le Mans race of 1938. Around this time most Le Mans racers were open-topped cars, however, to improve the Alfa Romeo's aerodynamic efficiency Alfa Corse and Carrozzeria Touring opted instead for an enclosed driver's cockpit to keep speed-sapping drag to a minimum. This exquisitely beautiful car with its wind-sweeping lines, driven by the French racing drivers Raymond Sommer and Clemente Biondetti, duly entered into the annals of racing history by taking an astonishing eleven-lap lead over its nearest rival during the 1938 Le Mans race – at over one hour and some 160 kilometres ahead this lead was the largest ever recorded in the history of Le Mans. Sadly, however, this extraordinary feat was not translated into ultimate victory due to tyre problems and the car eventually had to be retired because of a dropped engine valve.

After this crushing disappointment, Alfa Corse never raced the Le Mans Speciale again. However, the car's historic performance – topping at one stage a then-astounding 209 kph (130 mph) – conclusively proved to the world that streamlined car bodies based on aerodynamic research could give a racing team a clear and decisive advantage. After the war, the 8C 2900B Le Mans Speciale fell into private ownership and was entered into various minor races. Eventually it was returned to its country of birth and is now one of the most prized exhibits at the Alfa Romeo Museum in Arese.

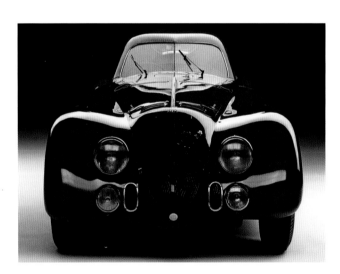

Above: Frontal view of the Alfa Romeo 8C 2900B Le Mans Speciale racing car showing streamlined form

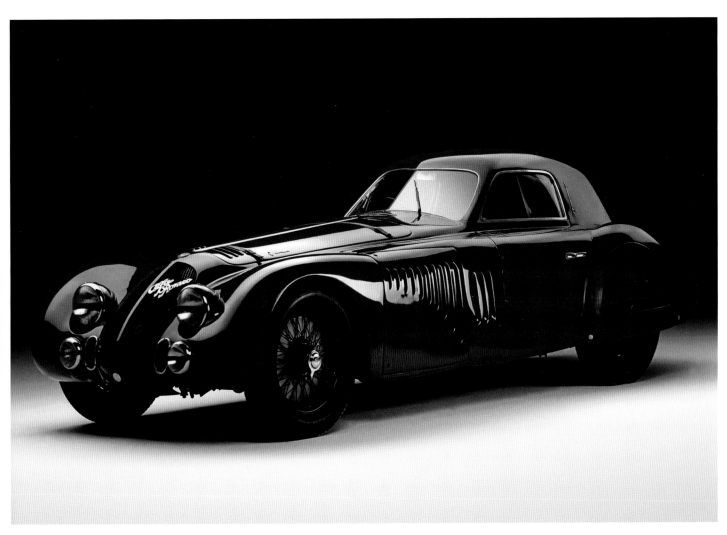

Alfa Romeo 8C 2900B Le Mans Speciale racing car, 1938
Various materials
Alfa Romeo, Turin

**Moto Guzzi GTC/L motorcycle, 1938
(built to Condor specifications)**
Aluminium, magnesium alloy, other materials
Moto Guzzi, Mandello del Lario

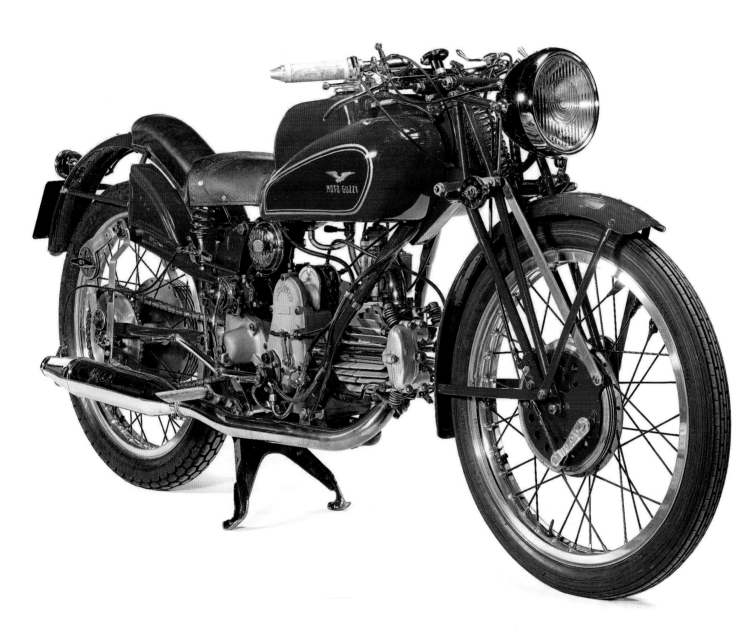

Moto Guzzi GTC/L motorcycle, 1938 (built to Condor specifications)

Carlo Guzzi (1889–1964)

Among biking aficionados, the name Moto Guzzi is revered not only for the innovative motorcycles that the company has produced over many decades but also for the historic central role it has played in establishing Italy as a centre of motorcycle-manufacturing excellence.

The earliest origins of this celebrated motorbike marque can be traced back to 1919, when the aircraft mechanic Carlo Guzzi – while stationed with the Miraglia Squadron based just outside Venice – created his first prototype motorcycle. This early bike was an unconventional model in that its single-cylinder engine was installed in a horizontal position. Subsequently, this type of "flat single" became a hallmark of later Moto Guzzi models.

The Moto Guzzi firm was officially established in 1921 by Guzzi together with Giovanni Ravelli (an already famous pilot and motorcycle racer),

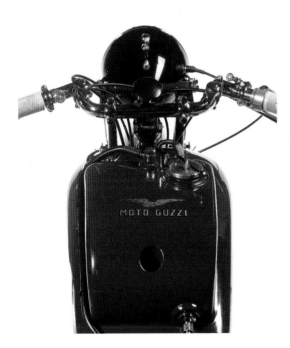

Above: View of the Moto Guzzi GTC/L motorcycle's oil tank emblazoned with the company's distinctive logo

Giorgio Parodi (another pilot who was also the son of a wealthy Genovese ship-owner) and Giorgio's brother, Angelo. Right from the start, racing was used as a way of promoting Guzzi and Parodi's fledgling marque and Ravelli was responsible for solidifying the firm's reputation through his racing prowess. Despite the firm's success on the racetrack, it was not until the late 1930s that modified versions of their successful works racers were finally offered for sale to the public.

In 1937, the company launched its first customer race bike, the GTC – which was a modified version of the GTV roadster. But although this bike was reliable it was hampered by its street-bike origins. The GTC was then swiftly superseded the following year by an altogether superior model known as GTC/L – with the L standing for *leggera* (lightweight). Also known as the Nuova C, this new customer bike used parts similar to those used in the works team's supercharged 250 Grand Prix racing bike and also incorporated magnesium alloy for its hubs and brakes. The Moto Guzzi model shown here is a pre-war GTC/L built to Condor race bike specifications that was specially made in October 1938 for the Italian highway patrol police. It is an extremely rare pre-production version of the legendary Condor, which was Moto Guzzi's first successful purpose-built production racer that was introduced in 1939.

Boasting a cylinder barrel and head made of aluminium and crankcases made of magnesium alloy, the Condor was even lighter in weight than its GTC/L predecessor – weighing in at an incredible 140kg (308lb). This reduction of weight meant even better high-speed performance, as the Condor's subsequent plethora of racing successes attested. Although only 69 Condors were built prior to its discontinuation in 1940, this remarkable bike established Moto Guzzi as one of the greatest motorcycle marques of all time and was the blueprint for the company's legendary post-war Dondolino model.

Caccia cutlery, 1938
Luigi Caccia Dominioni (1913–)

The Caccia cutlery is named after its creator, the Milanese architect Luigi Caccia Dominioni. Born in 1913, Caccia Dominioni trained at the Politecnico di Milano, and started his professional life in Venice where he set up a design studio with fellow Milanese architects Livio and Pier Giacomo Castiglioni following his graduation in 1936. As typical of the post-war generation of Italian architects, Caccia Dominioni worked across a number of design disciplines, and all his work is characterised by the same functionalist elegance of the slender, pared-down design of the Caccia cutlery set from 1938.

The cutlery is an essay in functionalist aesthetics. As with the other pieces in the set, the different function of the two main parts of the knife, the handle and blade, is articulated by the different thickness of each, while the fork rejects the excess of a four-pronged design in favour of just three. The formal purity and Neo-Classical quality of the cutlery is characteristic of the Novecento movement that was popular among Milanese architects such as Gio Ponti, Emilio Lancia and Pietro Chiesa in the 1930s.

In 1940 the then-unnamed cutlery set was presented at the VII Milan Triennale in an exhibition of metal- and glassware curated by Ignazio Gardella. Gardella was one of several architects with whom, following his move back to Milan in 1947, Caccia Dominioni would co-found Azucena, a contemporary design store and studio that demonstrated the same balance of craftsmanship and industrial prowess as the cutlery's design. Commenting on its appearance at the Triennale in *Domus* magazine, Ponti praised Caccia's design for being "the most beautiful cutlery in existence", a seal of approval confirmed by its later inclusion in MoMA's design collection.

The Triennale exhibition also included LCD02, a cutlery set that Caccia Dominioni had co-designed with Livio and Pier Giacomo Castiglioni. As with LCD02 and the other designs for cutlery and tableware selected for the exhibition, the Caccia cutlery set was included for its exploration of the potential of new materials such as steel and the possibilities of associated production techniques, namely moulding and die casting. However, reflecting the small-scale, artisanal nature of the Italian design industry during this period, the cutlery was only available in silver at the time. In 1990 the design was put into production by Officina Alessi as the Caccia cutlery set, or model 90022. Manufactured in either stainless steel or silver-plated nickel, this reissued set was completed with the addition of several pieces designed by Caccia Dominioni and the Castiglioni brothers and based on Dominioni's original 1930s drawings.

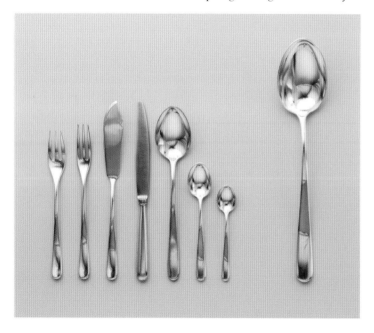

Above: Early examples of the silver Caccia flatware including serving spoon and fish knife produced by Ditta Spoggi, 1938

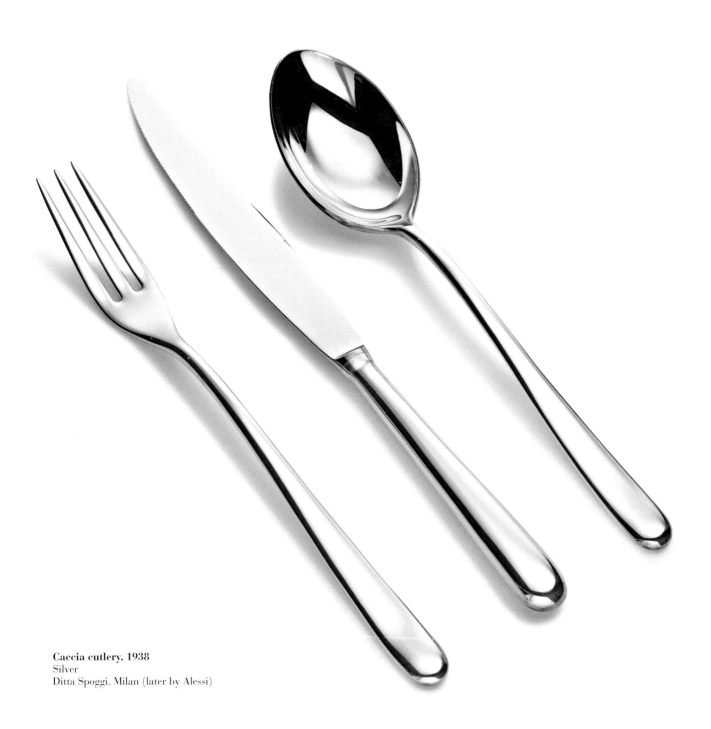

Caccia cutlery, 1938
Silver
Ditta Spoggi. Milan (later by Alessi)

Model No. 547 radio, 1938–39

Livio Castiglioni (1911–1979), Pier Giacomo Castiglioni (1913–1968) & Luigi Caccia Dominioni (1913–)

Introduced in 1940, the Model No. 547 radio designed by Livio Castiglioni, Pier Giacomo Castiglioni and Luigi Caccia Dominioni for Phonola was an extremely progressive design for its day being one of the first "true" Italian radios that was not designed to resemble a piece of furniture. Perhaps even more significantly, it was also the first Italian product to be successfully mass-produced in plastic.

Previously, Luigi Caccia Dominioni and Pier Giacomo Castiglioni had both studied architecture at the Politecnico di Milano, graduating in 1937. They then joined forces with the latter's elder brother, Livio Castiglioni, and established a Milan-based studio, which would become noted for its pioneering design work over the coming years. One of their most significant commissions was the design of a radio exhibition for the VII Milan Triennale – and it was while working on this project that they decided to develop their own highly innovative five-valve radio design. In fact the exhibition had been prompted

by a lively debate within the Italian design community about the phenomenon of "radio furniture", with Gio Ponti among others arguing that it was inappropriate to hide new radio technology inside wood-veneered, antique-style cabinets. Although there had been several earlier attempts by Italian designers to reform the layout and styling of radios, none had been truly successful: until the debut of the radical 547, with its straightforward push-buttons, easy-to-read square dial and unified housing made of either gleaming brown, black, green or white Bakelite which incorporated a raised speaker head.

At around the same time, the talented design trio also created a similarly forward-looking, though not quite so stylish, three-valve radio known as the Model No. 303, also manufactured by Phonola. As Ponti noted in the November 1940 edition of *Domus* magazine: "The architects were responsible not only for the form of their cases but also the rational arrangement of the radio components determined by these cases. This was the only way to achieve the consistency and coherency between container and content that is the basis for a rationally conceived object with a pleasant appearance." Functionally innovative, the Model No. 547 radio was also designed so that it could either be used as a tabletop set or wall-mounted. A veritable landmark within radio design, this seminal machine-age product powerfully demonstrated the viability of plastics as materials with which to successfully mass-manufacture products and also emphatically demonstrated the Milanese design community's extraordinary ability to create innovative game-changing products that were truly modern in conception, manufacture and aesthetics.

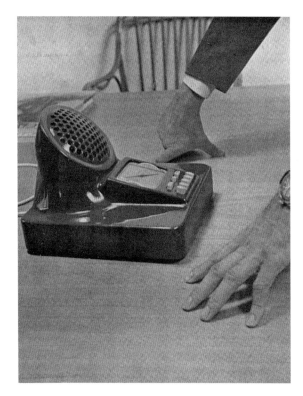

Left: Photograph published in the November 1940 issue of *Domus* magazine, showing the Model No. 547 radio in use

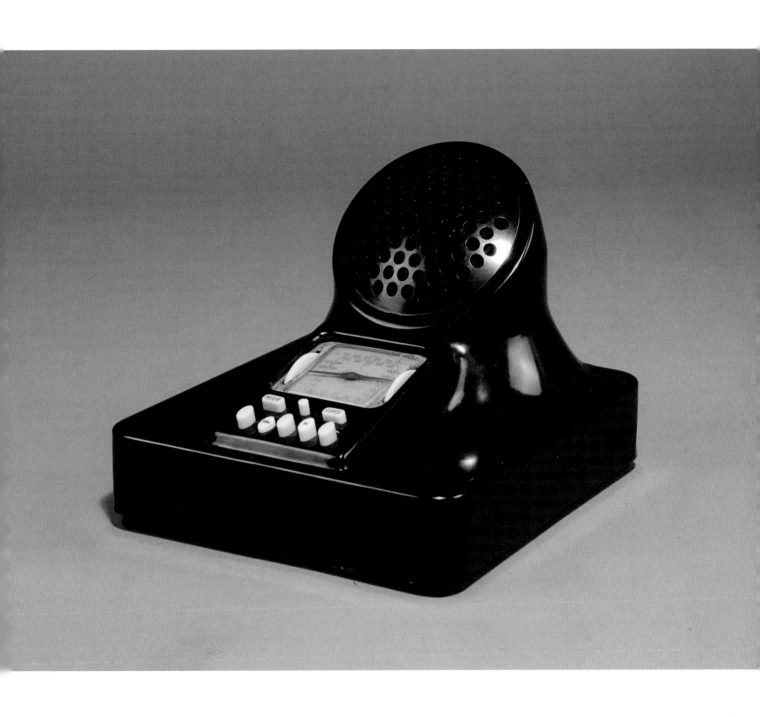

Model No. 547 radio, 1938–39
Bakelite (phenol formaldehyde)
Phonola, Milan

Lounge chair for Casa M-1, Turin, 1946

Carlo Mollino (1905–1973)

Carlo Mollino was an extraordinarily gifted architect and furniture designer whose work during the late 1940s epitomized the post-war stylistic bravado of Italian design. Unlike many of his contemporaries in Italy, Mollino did not subscribe to any Rationalist canon of design, but instead preferred a more personalized approach that was typified by the use of sweeping expressive forms that the American designer and critic George Nelson dubbed in 1948 "Turinese Baroque".

Mollino's uniquely flamboyant approach reflected his overwhelming passion for life – with racing cars, skiing and erotic photography being among his most notable hobbies. The son of a prominent civil engineer, Mollino had initially studied art history prior to enrolling at the School of Architecture at the University of Turin, and it was this understanding of historical styles that

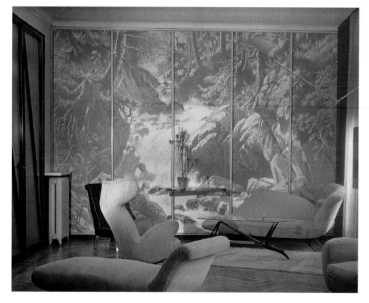

Above: The living room in the Casa M-1 apartment, Turin designed by Carlo Mollino in 1946 for Ada and Cesare Minola

allowed him to confidently explore his own and highly original vocabulary of form. From the mid-1940s to the mid-1950s, Mollino worked on an impressive number of architecture and interiors commissions that ranged from private residences and hotels to alpine ski resorts and commercial complexes. Among these was his Casa M-1 project, which involved the design of interiors for an apartment on the Via Perrone in Turin. This was not only one of his earliest domestic commissions but also one of his most stylistically resolved, which encompassed special site-specific furnishings designed for the flat's interiors, including this elegant armchair for the living room. Essentially a modern re-working of the traditional wing chair, this lounge chair was highly biomorphic in form with its bold organic curves hugging the sitter in padded comfort.

Commissioned by Ada and Cesare Minola, the design and implementation of the interiors for the Casa M-1 apartment commenced in the summer of 1944 but was not actually completed until the summer of 1946. Despite the fact that the majority of the work was carried out at the height of the Second World War, the skilled craftsmen working on this project were able to create a visual tour-de-force of special effects using only the modest materials available to them – a tribute to their skills and to Mollino's inventive imagination.

This striking lounge chair was not only the most interesting furniture piece designed for this extraordinary interior project but was also one of the most original seating designs created by Mollino during his prolific and idiosyncratic career – it is quite simply the quintessential Mollino chair.

Lounge chair for Casa M-1, Turin, 1946
Ebonized carved wood, velvet-covered upholstery
Giovanni Cellerino, Turin

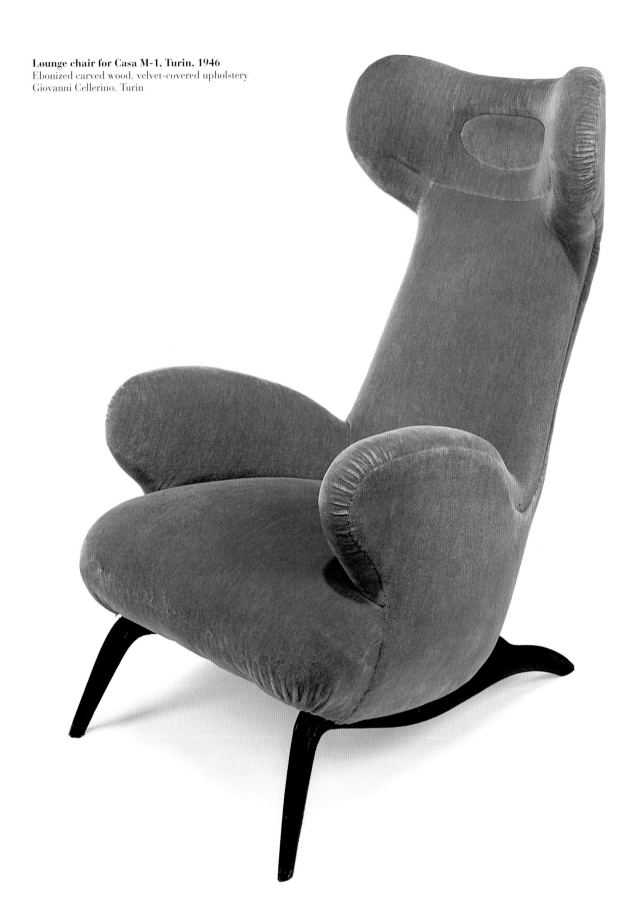

Model No. DP 47 La Cornuta espresso machine, 1947
Gio Ponti (1891–1979), Antonio Fornaroli (active 1930s–50s) & Alberto Rosselli (1921–1976)

Launched in 1948, La Cornuta coffee machine belongs to a celebrated family of objects that appeared on the Italian design scene in the 1940s. This was a diverse tribe, whose other members included Piaggio & Co's 1946 Vespa and the Lexikon 80 typewriter, designed by Marcello Nizzoli for Olivetti in 1948. Despite their different functions, these objects shared a similar style: a curving profile and distinct sculptural quality that became known as *La Linea Italiana* (The Italian Line).

La Linea Italiana reveals the ambitions and influences of Italian design in the immediate post-war period. On the one hand, it has echoes of the organic sculpture of Henry Moore, expressing the cross-fertilization that takes place between artistic disciplines in Italy. On the other, it recalls the American Streamlining style of the earlier twentieth century – a reminder of the cultural and economic proximity between America and Italy in this period, including dependence for post-war regeneration. It was in this context that La Cornuta was produced, symbolizing Italy's social, cultural and economic reconstruction in the aftermath of the Second World War; it was one of the objects that would inform the growing stature of Italian design in the decades that followed.

The coffee machine was designed by the formidable trio of Gio Ponti, Antonio

Fornaroli and Alberto Rosselli: three Milanese architects who promoted industrial design. Ponti and Rosselli had been working together since 1933, when they set up a studio with Eugenio Soncini in Milan. The studio closed in 1945, and in 1952 Ponti and Rosselli joined forces with Fornaroli to set up Studio Ponti-Fornaroli-Rosselli, or Studio P.F.R. Together with engineer Pier Luigi Nervi, the studio was responsible not just for symbols of design, but for the most powerful architectural symbol of Italy's post-war renewal: the soaring Pirelli skyscraper, completed in Milan in 1958.

The Cornuta espresso machine was produced by La Pavoni, which has been manufacturing espresso machines since it was established in Milan in 1905 by Desiderio Pavoni. The first machine that Pavoni put into production was Ideale, based on a design patented four years earlier by the engineer Luigi Berezza. Despite the indelible association between Italy and espresso, the drink is not an Italian invention, and it was La Pavoni who introduced and popularized the culture of espresso drinking in the country. As with Bialetti's 1933 Moka Express, La Cornuta relies on the espresso method for the production of its coffee; albeit this time on a commercial scale, with the possibility of making multiple cups of coffee at the same time, as is necessary in bars and restaurants. The design speaks of this public display with the production of coffee being essentially "an event", with steam playing a key part in the performance and ritual of coffee making. La Cornuta was significant not just on aesthetic grounds but also on a technical level: this was the first machine to have a horizontal boiler, the cylindrical element that forms the main component of the machine. Rising from this main cylindrical section are a series of curving spouts, the form of which gave the coffee machine its nickname, La Cornuta (translating as "the horned"). Considered a cornerstone of Italian industrial design, the Model No. DP 47 was a beast of a machine that used a spring-loaded piston to exert a pressure of ten atmospheres, forcing the boiling water and steam through the ground coffee compartment to produce an altogether superior-tasting result.

Left: Patents for the Model No. DP 47 La Cornuta espresso machine, 1947 – showing the variant with two "horns"

Model No. DP 47 La Cornuta espresso machine, 1947
Chrome-plated metal
La Pavoni, Milan

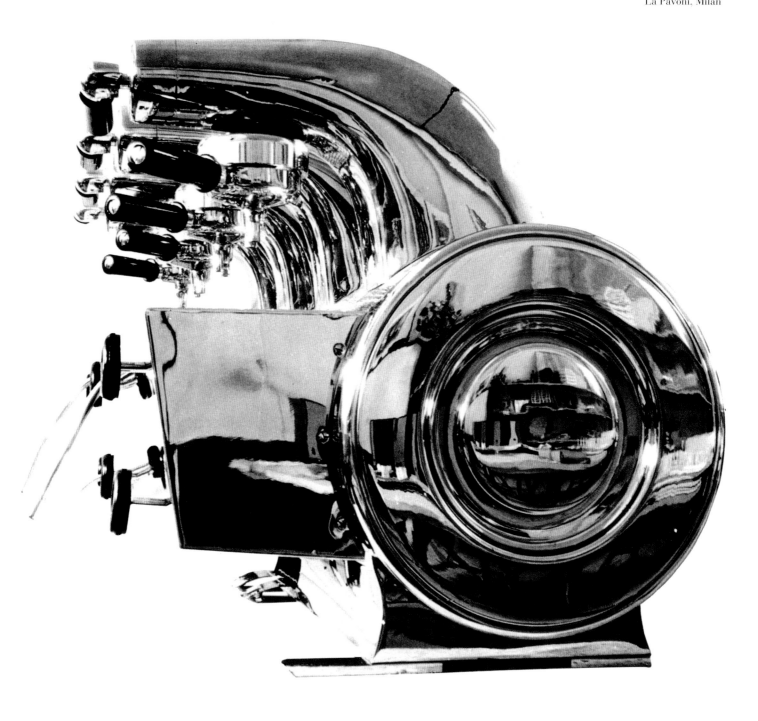

Writing desk for the Casa Orengo, Turin, 1949

Carlo Mollino (1905–1973)

The Casa Orengo in Turin was Carlo Mollino's last major domestic interior commission and, according to records, was designed between October 1949 and February 1950. Significantly, it marked a clear shift away from his earlier interior schemes, which were often relatively decorative in style and inspired by 1930s Surrealism, towards something all altogether more airy, modern looking and ultimately organic.

For the rooms of this luxurious apartment created for an Italian nobleman, the splendidly named Marquis Vladi Orengo, various site-specific furnishings were specially designed by Mollino, including a version of his well-known serpentine Arabesque table made of a wave-like piece of moulded plywood. A photographic mural of gushing water falling in eddies over rocks was used by Mollino in the apartment to create an additional sense of organic vibrancy and Surrealistic quirkiness – effectively bringing the outside world indoors, a feature that would become increasingly popular in interior design during the 1950s and 1960s. He also used skillfully printed textile panels and screen-like devices to delineate the apartment's open-plan spaces into different functionally designated areas. Often Mollino also broke up the geometry of his interiors by positioning furniture in unexpected places or designing pieces with dynamic asymmetrical forms. One of the most celebrated examples of this type of furniture is the writing desk created specially for the Casa Orengo apartment, shown here.

This extraordinary desk typifies Mollino's use of dramatic organic forms, that he called "streamlined surreal". It features a writing surface made of thin Securit safety glass that almost appears to hover above the sculpted solid maple leg elements, while the handy glass-topped cantilevered black Marbrite shelf unit protrudes to the left as if magically defying gravity. Similarly, the stack of five drawers to the right gives the design a strong architectonic presence and effectively anchors the design both physically and visually. The eye-catching pierced form of the writing desk's frame appears to have been inspired by the earlier furniture designs of Antoni y Cornet Gaudí and suggests a similar sense of oozing material plasticity. By contrasting the warm-coloured maple with the shiny black planes of the plastic laminate this design was also imbued with an interesting tactility, while the lines of the desk possessed a strong gestural quality that is utterly visually captivating.

This is a piece of furniture that expressively displays Mollino's remarkable talent for sculpting form into function and demonstrates his unique ability to infuse a sense of thrilling theatricality into his designs. As the renowned Mollino authority Fulvio Ferrari has noted of this uniquely gifted design maestro: "He continued the tradition of those eclectic Italian Renaissance artists whose work expressed the harmonious coming-together of science and art, logic and poetry, beauty and practicality."

Above: Writing desk for the Società Reale Mutua di Assicurazioni, 1948 – also designed by Mollino and similarly inspired by aeronautical engineering

Overleaf: The living room in the Casa M-1 apartment, Turin designed by Carlo Mollino in 1946 for Ada and Cesare Minola

Writing desk for the Casa Orengo, Turin, 1949
Tempered security plate glass, brass, Marbrite laminate,
maple. Apelli & Varesio, Turin

Arabesque table, 1949
Carlo Mollino (1905–1973)

Possibly the most poetic use of plywood ever, Carlo Mollino's Arabesque table is not only a beautiful demonstration of Italian ingenuity but also of its designer's maxim that "everything is permissible as long as it is fantastic": a maxim that seems to have been applied to Italian design ever since.

Although Italian designers during the post-war period did not have access to the advanced mass-production processes derived from wartime researches that their counterparts in America enjoyed, they more than made up for it with their creative imaginations. They were also able to draw on the expertise of highly skilled craftsmen working in small family-run specialist workshops to produce innovative designs that were more often than not destined for the export market.

Mollino's extraordinarily beautiful Arabesque table was produced in the workshops of Apelli & Varesio, a company based in Turin that specialized in the extreme moulding of plywood and was the producer of many of Mollino's other furniture designs. The Arabesque table was a dramatic manifestation of Italian design bravado with its glass top and lower tier, which are securely attached with brass fittings to its frame, appearing to be suspended in air. While American designers, most notably Charles Eames and Eero Saarinen, were researching the functional possibilities of plywood in their furniture designs during this period, Mollino was instead exploring this man-made material's expressive potential to the full. The Arabesque table with its gestural elegance exemplified the astonishing originality of his design output and was produced in a number of variants, including a smaller side table model.

Mollino obtained the structure of the table by bending a sheet of plywood into an S-shape, then cutting holes into it both to lighten the piece (visually and physically) and to provide more integrity to the structure – just as an engineer would design a structure, but with the use of organic shaped holes. The two tempered glass surfaces then tie the structure together in order to prevent its deformation. Gio Ponti defined this table as "all structure", each part being necessary and functional. The solution is very rational yet it is not Rationalist in style.

More than any other design by Mollino, the Arabesque table epitomized his flamboyant "Turinese Baroque" approach to design: as he memorably stated, "The best explanation of one's work is contained in its silent exposition."

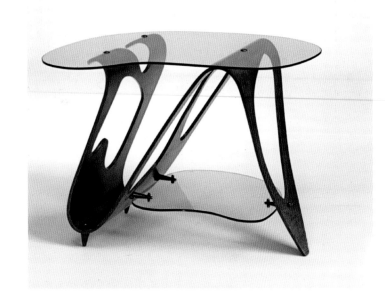

Left: Rare smaller variation of the Arabesque table designed by Carlo Mollino, c.1949

Arabesque table, 1949
Moulded plywood, tempered security glass, brass
Apelli & Varesio, Turin

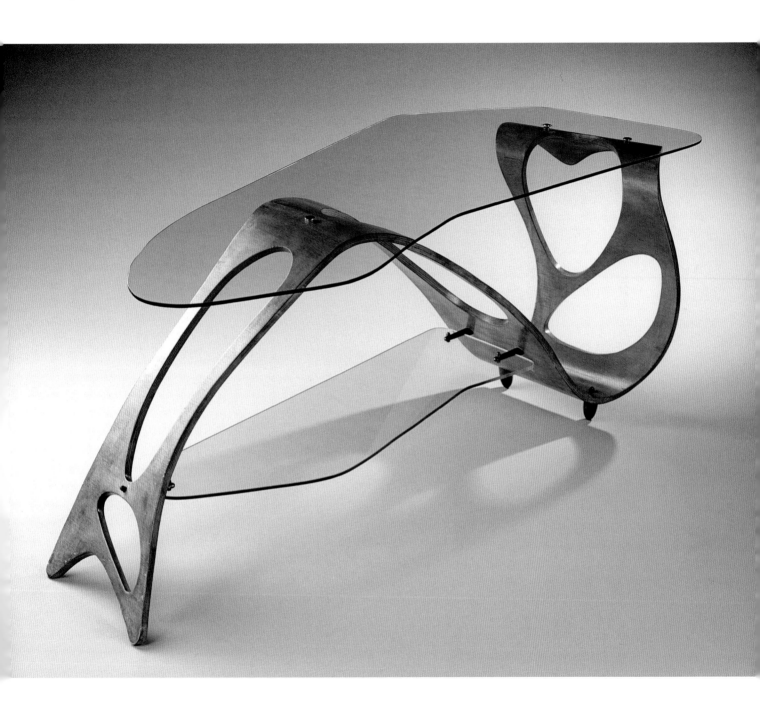

Architettura cabinet, 1949

Piero Fornasetti (1913–1988) & Gio Ponti (1891–1979)

The design of the Architettura bureau cabinet exemplifies the close relationship between the arts in Italy and is a product of the frequent crossovers between them. The wooden bureau was made by the Milanese furniture producers I Fratelli Radici following a design by the architect Gio Ponti, while the artist and designer Piero Fornasetti was responsible for its highly decorated surface. Despite their different professions, Fornasetti and Ponti had much in common: both were born and lived in Milan, both worked across a number of disciplines and with a broad range of materials and both advocated the importance of ornament at a time when it was challenged by modernist orthodoxy.

Like Ponti, Fornasetti was a prolific figure, and his renown largely rests on the inexhaustible inventiveness of his highly decorative works. His designs for ceramics, furniture, textiles and other products were inspired by an array of motifs, and he found the language of architecture particularly potent. He applied architectural motifs to a range of objects: from glassware engraved with building plans to plates decorated with the domes of Italian churches, and furniture screen-printed with imaginary architectural scenes.

The decoration of the Architettura cabinet is inspired by eighteenth- and nineteenth-century architectural prints, and it expresses Fornasetti's interest in both historical ornament and contemporary styles. The juxtaposition of buildings drawn in a variety of scales and perspectives demonstrates the influence of metaphysical painting on Fornasetti's output, in particular the surreal, Neo-Classical scenes created by Giorgio de Chirico and his younger brother Alberto Savinio in the 1930s. This decoration is not just found on the outside of the bureau cabinet; opening the doors of the *trumeau*, as this style of furniture is also known, reveals its inside is also entirely covered in decoration. Despite this exuberant embrace of ornament, the Architettura retains an ordered, restrained feel, thanks to the subdued colour palette and carefully considered composition.

Fornasetti was a highly skilled practitioner, yet he was not a professionally trained designer. He had taken up drawing at the famed Brera Academy in Milan in 1930, but his resistance to its traditional methods of teaching drawing saw his expulsion two years later. This lack of conventional training informed his unusual approach to both the designs and the techniques he developed, which he kept a closely guarded secret. For the Architettura cabinet, he created a series of lithographs that he printed onto sheets that were then transferred onto fibre-board (Masonite) panels affixed to the bureau's solid wooden carcass and finally coated with a protective clear varnish.

The Architettura cabinet was designed at the peak of Fornasetti and Ponti's collaboration. Their partnership had started in the early 1940s, when Ponti encountered Fornasetti's designs at the VII Milan Triennale in 1940, where he had been exhibiting since the 1930s. Ponti subsequently commissioned Fornasetti to produce the illustrations for the annual Lunari calendar, and he continued to design these into the 1960s. Fornasetti's exile to Switzerland between 1943 and 1946 put a temporary halt to their blooming partnership until it was resumed in the late 1940s. They worked together on a number of designs for furniture and interiors in the late 1940s and early 1950s, including the interiors of the Lucarno apartment in Milan and the Casino in San Remo, a room set for the IX Milan Triennale in 1951 and furniture, including several bureau cabinets.

In the 1960s Fornasetti and Ponti's professional and personal relationship faded, and Fornasetti's reputation went into decline in the decade that followed. Rediscovered in the early 1980s, his legacy has been ensured by his son, Barnaba Fornasetti, who oversees the ongoing production of his father's designs from the family's Milanese home, the interiors of which are a testament to Piero Fornasetti's immense creativity.

Architettura cabinet, 1949
Piero Fornasetti (1913–1988) & Gio Ponti (1891–1979)
Hand-painted and lithographic transfer-printed fibre-
board, solid wood
I Fratelli Radici, Milan

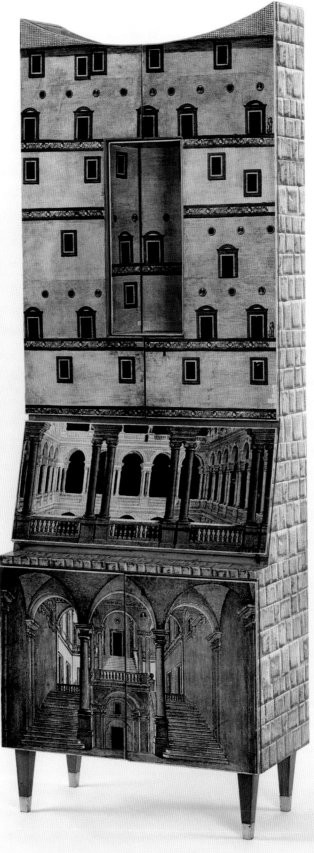

Tema & Variazioni plates, 1950–59

Piero Fornasetti (1913–1988)

The name Tema & Variazioni (Themes and Variations) could be used to describe Piero Fornasetti's entire approach to design. In a career that spanned five decades, from the 1930s to the 1980s, his work was defined by near-infinite interpretations and alterations of a diverse set of visual forms, from architectural motifs to harlequins, butterflies, playing cards, hands and faces. It was the last of these that became the basis for Tema & Variazioni, a series of dinner plates that Fornasetti started in 1950; he went on to produce over five hundred different versions in the decades that followed.

Every single plate in the eclectic Tema & Variazioni series features the same face, a woman whose features are obscured, deformed and defaced in a variety of ways that include any number of artistic and ornamental styles. In each one it is her large eyes that are most notable, staring blankly from beneath the porcelain's translucent glaze. For many years the identity of the woman remained unknown, a mystery that Fornasetti took delight in perpetuating. Suggestions ranged from Leonardo Da Vinci's similarly enigmatic Mona Lisa to Fornasetti's mistress Luisa Baccara. Today, the Fornasetti company confirm that it was the face of Lina Cavalieri, a nineteenth-century Italian opera singer, whose face Fornasetti happened on in a magazine from the period.

For Fornasetti, it was not the identity of the face that was important but its appearance. Her strongly Mediterranean features chimed well with the Neo-Classical and Nationalist concerns of the Novecento movement of the 1920s that the artist and designer used as part of his eclectic repertoire of cultural and historical references. The plates demonstrate the surrealist vein that permeates much of Fornasetti's work, in particular an effective use of trompe l'oeil that is also seen in his Architettura cabinet of 1949. The face in Tema & Variazioni resembles the wooden engravings that would have been used in newspapers of the previous century, yet this was an illusion: Fornasetti drew the face with Indian ink, using a cross-hatching technique to create the drawing that was then printed onto the plates' porcelain surface.

Fornasetti did not just apply the face to the Tema & Variazioni dinner plates but to a variety of objects including cigarette boxes and textiles. As with many of Fornasetti's creations, the artist and designer did not design the actual plates he decorated for Tema & Variazioni. These were blanks made by companies including the ceramics manufacturer Eschenbach in the German town of Selb. Today the Tema & Variazioni plates are made in-house by the Fornasetti Atelier in Milan, and new versions continue to be added under the eye of Piero's son Barnaba Fornasetti, inspired by the Fornasetti archive, alongside designs authored in collaboration with the British architect Nigel Coates.

Above: Piero Fornasetti standing in front of a selection of his Tema & Variazioni plates.

Tema & Variazioni plates, 1950–59
Piero Fornasetti (1913–1988)
Hard-paste porcelain with printed decoration
Fornasetti, Milan

Lettera 22 typewriter, 1950

Marcello Nizzoli (1887–1969)

One of the leading industrial designers in Italy during the postwar period, Marcello Nizzoli was also a highly talented graphic designer; it was his innate sense of composition that made his designs for products so remarkable and forward-looking. Before the Second World War, Nizzoli had worked as both a commercial artist and an interior architect, notably designing bold Art Deco posters for Campari, interiors shown at the VI Milan Triennale in 1930 and the spatially striking Sala delle Medaglie d'Oro (Hall of Gold Medals) at the Eposizione dell'Aeronautica Italiana (Exhibition of Aeronautics), staged at the Palazzo dell'Arte in Milan in 1934. For the latter project, Nizzoli was highly influenced by his friend, the Rationalist architect, graphic designer and critic, Edoardo Persico, who he had met in 1931. The same year the two designers had also created an advertisement for Olivetti, which marked the beginning of a creatively fruitful relationship between Nizzoli and the Ivrea-based office equipment manufacturer.

After Persico's death in 1936, Nizzoli was hired by Olivetti as a commercial artist to create numerous visually dynamic advertisements for the company; he was also given the task of coordinating the look of the products they were manufacturing. Crucial to its success, Olivetti understood the importance of implementing a "total design" policy, from the design of its state-of-the-art factory and workers' housing to its products and publicity materials. In 1940, Nizzoli began designing actual products for the company, most notably the Lexikon 80 (1946) that revolutionized the formal language of the humble manual typewriter with its sleekly-styled enamelled aluminium housing.

It was, however, Nizzoli's later Lettera 22 typewriter of 1950 that fully revealed his genius as an industrial designer. Small and compact, the portable Lettera 22 was also extremely stylish and easy to use thanks to the supreme clarity of its layout. It was available in a range of attractive colours – dusky blue, vibrant turquoise, bright red, olive green, creamy beige and steely grey – thereby transforming the trusty typewriter into a fashionable object of desire. Even its zip-round vinyl carrying case was suitably modish with its bold stripes. Importantly for the success of the Lettera 22, the typewriter was supported with an excellent publicity campaign of eye-catching and innovative advertisements designed not only by Nizzoli himself but by other graphic designers too, most notably Edigio Bonfante, Walter Ballmer and Giovanni Pintori. The Lettera 22 epitomized the extraordinary ability of Italian designers during the post-war period to create attractively styled, appealing modern-looking products for the export market, and as such these designs were central to the economic miracle that transformed Italy from a mainly rural economy into a major industrial powerhouse during the post-war period.

Left: Olivetti advertisement designed by Giovanni Pintori promoting the Lettera 22 typewriter, c.1950

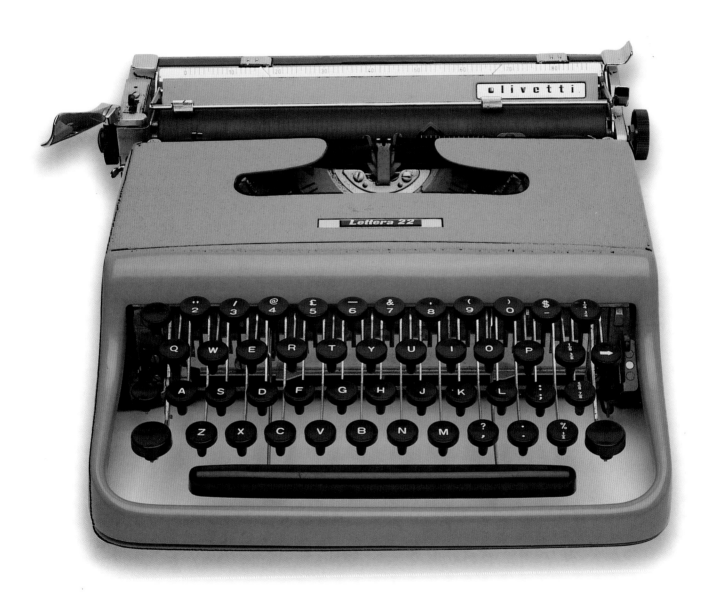

Lettera 22 typewriter, 1950
Enamelled metal, other materials
Olivetti SpA, Ivrea, Italy

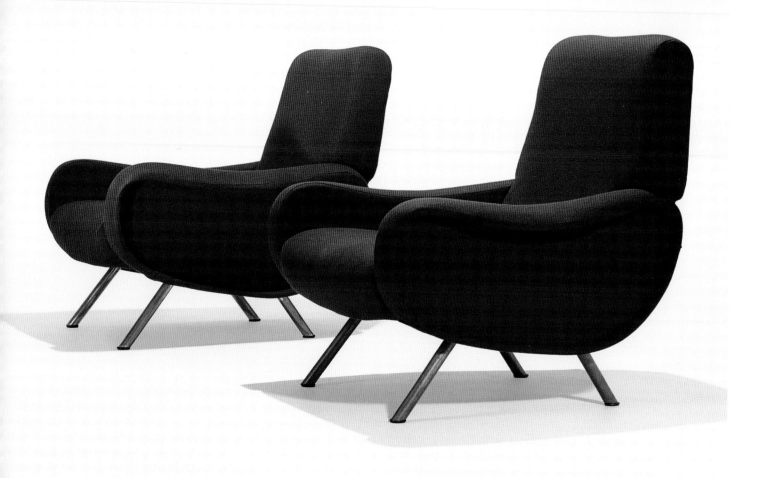

Lady armchair, 1951
Wood, webbing, textile-covered foam rubber upholstery,
brass or enamelled tubular metal
Arflex, Milan

Right: Arflex advertisement, 1950s –
featuring the Lady armchair alongside the
Triennale sofa and Senior armchair, both of
which were also designed by Marco Zanuso

Lady armchair, 1951
Marco Zanuso (1916–2001)

During the late 1940s, a newly developed man-made material heralded a fresh sculptural confidence in Italian post-war seating design. This wondrous material, known in Italy as *gommapiuma*, was a squishy foam-rubber material that had been previously developed in the late 1930s by the renowned tyre manufacturing company Pirelli.

In fact, just prior to the outbreak of the Second World War, Pirelli had commissioned Erberto Carboni to design a lounge chair that used this new material, but soon after the company was forced to focus on wartime production, including the manufacture of gas masks for the Italian army and underwater breathing equipment for the navy. At the same time the Allies heavily damaged Pirelli's factories in Milan with their repeated bombardment of the city. After the war, the company was able to turn its attention again to commercializing its materials innovations and in 1948 commissioned the young architect Marco Zanuso to investigate the potential of its foam rubber as an upholstery material.

Moulded into thick lattice-like cellular sheets, Pirelli's *gommapiuma* offered comfortable seat upholstery without the need for traditional seat springs. By doing away with bulky springing and horsehair padding, foam rubber quite simply opened up a whole new world of aesthetic possibilities to Italian furniture designers and allowed them to create sleeker and more stylish chair designs. As Zanuso was to later note, "One could revolutionize not only the system of upholstery but also structural manufacturing and formal potential. When our prototypes acquired visually exciting and new contours, a company was founded to put models like the Lady into production with industrial standards that were previously unimaginable."

This new sister company established by Pirelli in March 1950 was named Arflex, and it worked closely with Zanuso to develop a range of chairs that made use of the company's state-of-the-art manufacturing technology and typified a new aesthetic direction in post-war Italian design. Among these designs, it was the Lady armchair that became the best known and which was awarded a gold medal at the IX Milan Triennale of 1951.

Elegant and stylish, the Lady armchair with its feminine rounded curves was a masterpiece of sculptural form. It featured a simple internal wooden frame and resilient elasticated seat webbing, which was then fully upholstered in different thicknesses of foam to provide the maximum comfort. Through this use of foam upholstery Zanuso was able to create a chair that was far more ergonomically refined than earlier traditionally constructed seating designs, with its contours comfortably echoing the shape of the human body. Arflex also produced variations of the award-winning design, including the smaller Baby armchair, the higher-backed Senior armchair and also a sofa. But it was the Lady armchair with its perfect proportions that was the enduring star of the range: a beautiful and innovative seating design that came to define the sophisticated post-war Italian look.

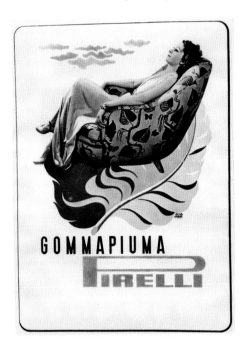

Left: Pirelli advertisement for *gommapiuma* showing chair with latex-foam upholstery designed by Erberto Carboni, 1939

Pezzato vase (Model No. 4319), c.1951–52
Fused coloured glass squares
Venini & C., Murano (Venice)

Pezzato vase (Model No. 4319), c.1951–52
Fulvio Bianconi (1915–1996)

Bright colours, bold forms and impressive displays of technique are some of the qualities that make Italy's glassware so desirable. The Pezzato (dappled) series, first designed by Fulvio Bianconi in 1950 for Venini is firmly within this tradition: the pieces' multi-coloured irregular squares are a riotous patchwork of colour, strikingly visual designs that demonstrate Bianconi's expertise in the fields of graphics and illustration.

In the 1950s Venini was one of a number of firms, alongside Seguso and Barovier & Toso, creating a modern, design-led language for Venetian glass, with the island of Murano having a reputation as a centre of highly skilled blown glass production dating back to the thirteenth century. The firm was set up in 1921 as Cappellin-Venini & C. by Giacomo Cappellin, a Venetian antiques dealer, and Paolo Venini, a Milanese lawyer from a glassblowing family. The firm began exhibiting in the 1920s with

Above: Pezzato vase designed by Fulvio Bianconi for Venini, c.1950

a range inspired by glassware depicted in Renaissance paintings, demonstrating an interest in balancing modern and historical forms that would continue into the post-war period. By 1930 Venini had taken over the company and began collaborations with architects and designers from outside of the Murano tradition, including Gio Ponti, Carlo Scarpa and the Swedish ceramist Tyra Lundgren.

In 1948 Venini appointed Fulvio Bianconi as the firm's artistic director. Born in Padua in 1915, Bianconi had studied design and drawing in Venice before moving to Milan where he worked for Motta, one of a number of publishers and firms that he would work with in his career as a graphic designer and illustrator. It is his work with glass that Bianconi is primarily known for, however: in 1946 Bianconi made repeated visits to Murano in order to learn more about its glassmaking techniques, and it was on one of these trips that he met Paolo Venini. The Pezzato series were not the first works that Bianconi made for Venini: these were preceded by the Commedia dell'Arte figurines, presented at the 1948 Venice Biennale and most notably the Fazzoletto (handkerchief) vase of 1948–49, which is included in MoMA's permanent design collection.

Bianconi began designing the Pezzato series in 1950, and examples were displayed at both the 1951 Milan Triennale and Venice Biennale a year later. The pieces are is made of translucent multi-coloured irregular *tesserae* (flat square shapes), which are laid onto a metal plate then heated and fused together into a cylindrical shape which is then blown into the desired form. The Pezzato range was available in nine patchwork colourways: Arlechhino (Harlequin), Americano (American), Asia, Venezia (Venice), Parigi (Paris), Stoccoloma (Stockholm), Bagdad, Oslo or Istambul (Istanbul). Shown here is the bottle-shaped Model No. 4319 vase in the Venezia colourway, identifiable by its aquamarine, grape and mole grey colour scheme.

Pinocchio diving mask, 1952
Tempered glass, rubber, metal
Cressi, Genoa

Pinocchio diving mask, 1952

Luigi Ferraro (1914–2006)

As anyone who is into scuba diving knows, the name Cressi (formerly Cressi-sub) has long been associated with the manufacture of superlative watersports equipment, but less well known is the fact that the company has been at the forefront of developing pioneering inventions within this field since the late 1930s. The origins of this Genoa-based company go back to 1938, when brothers Edidio and Nanni Cressi began manufacturing masks and spear guns by hand for the emerging spear-fishing and diving community that was then frequenting the northern coast of the Mediterranean. In 1943, the brothers handcrafted a new and innovative mask, known as the Sirena, which was subsequently put into production and became a mainstay of Cressi for some three decades. This early production mask had a large oval lens that covered the nose and was held in place by a black rubber mount that fitted tightly over the contours of the diver's face using an adjustable strap. This model, like all other masks of the time, did have a major drawback in that the diver was unable to pinch his or her nose in order to equalize the pressure in their ears.

By 1946 – the year that Cressi was officially incorporated – the firm had in its catalogue both masks and a comprehensive range of spear guns of varying lengths and strengths to suit a variety of divers from sporting amateur to commercial professional. Around 1948, the sports equipment inventor, Luigi Ferraro who was by now working as a designer for the company invented and patented a new kind of swimfin that was later launched as the Rodine fin in 1953 (*rodine* meaning swallow in Italian). This new and innovative design was the first full foot-pocket fin, and was far more comfortable to wear and use than earlier models, which Ferraro had gained first hand knowledge of during the war while on underwater missions. It was, however, Ferraro's design of the Pinocchio mask in 1952 that would prove his greatest contribution to the world of diving and also Cressi's most enduring product, with it still being featured in the company's catalogue some sixty years after it was first introduced.

Marking a major innovation, the Pinocchio was the very first diving mask to have a dedicated nose pocket, which as every diver knows makes pressure equalization much easier. Essentially the mask echoed the contours of the face using a rubber that was so soft and supple that it was easy for the diver to "pinch-and-blow" thereby quickly and efficiently easing the discomfort building up in the ears because of the water's atmospheric pressure acting upon them. The name of this mask with its anatomically-shaped nose made of rubber was taken from Carlo Collodi's much-loved story of the wooden puppet who dreamt of becoming a real boy and this proved to be a stroke of marketing genius, giving the mask with its prominent nasal feature a friendly character-by-name association. Eventually, Ferraro left Cressi in 1962 to found his own sports equipment company, Technisub, however, the Cressi family continued to pioneer various design revolutions within its chosen field of expertise and to this day the company remains proudly at the cutting edge of diving equipment innovation and technology.

Above: *Mondo Sommerso* magazine cover with a woman wearing a variant of the Pinocchio diving mask, 1961

Oriente vase, 1952
Blown and fused glass
Aureliano Toso, Murano (Venice)

Oriente vase, 1952
Dino Martens (1894–1970)

Corrado "Dino" Martens was first and foremost a painter. He studied at Venice's Accademia di Belle Arti and during his career exhibited in various cities both in Italy and internationally. As with a number of fine artists he turned his talents to Venetian glass, and in the 1920s and early 1930s Martens worked as a painter and designer of glass vessels and mosaics for a number of Muranese firms, including the engraved glass specialist SALIR and Salviati & C., and his designs for these companies were exhibited in both Milan and Venice. After his enlistment in military service in Eritrea in 1935 and subsequent travels to Asmara, Martens returned to Italy in the late 1930s. In 1944 he was appointed head designer at Aureliano Toso, a position he held until 1959. Together with the firm's master glassblower Aldo Bon, Martens assisted in developing an international profile for the company in the 1950s, producing glassware such as the Oriente vase from 1952.

The firm's origins date back to 1938 with the establishment of the Aureliano Toso glassworks by the son of a local glassmaker. At first it specialized in historical interpretations of traditional techniques including *zanfirico*, which dates back to the sixteenth century, in which canes of coloured rods of glass are twisted into a delicate pattern. Martens would use these techniques as the basis for his designs for glassware for the company, as seen in the Zanfirico series from 1948 and the Oriente vase from 1952.

The Oriente vase is a dazzling, colourful vessel made of blown and fused glass. It was available in a variety of irregular-shaped forms, all of which are recognizable for their riotous patchwork of opaque and semi-opaque glass pieces stretching and snaking around the vessel's surface in hues ranging from blue to yellow, red, white and gold that blur into each other. The individual pieces that make up the surface are created using updated ancient Venetian techniques in a combination of tradition and innovation. This was characteristic of the most progressive Murano glassware in the 1950s and cemented its international reputation. The techniques that make up the Oriente vase include aventurine glass, recognizable for its opaque and semi-opaque glittering surface and bubbled *reticello* glass fragments, which Martens would lay out in compositions to be fused together by the glasswork's skilled *maestri*.

Left: Oriente vase designed by Dino Martens for Aureliano Toso, 1954

Model No. VE505 table fan, 1953

Ezio Pirali (1921–)

First held in 1954, the Compasso d'Oro awards were established to promote the cause of Good Design in Italy through a related annual exhibition held at the La Rinascente department store in Milan. With their strident promotion of well-designed Italian goods, the awards also became a crucial spur for the much-needed export market and as such can be seen to have played a crucial role in the post-war flowering of Italian design.

The Compasso d'Oro (Golden Compass) award was actually the brainchild of Aldo Borletti, the vice-president of La Rinascente, and among the jurors for the first competition were the renowned architect-designers Gio Ponti, Alberto Rosselli and Marco Zanuso. As was stated in *Domus* magazine, of which Ponti was editor-in-chief, the award was given to products that were seen to be making "a decisive contribution to the problem of industrial aesthetics in Italy".

Among the first products to win the award was a small electrical fan intended for home use that had been designed by Ezio Pirali a year earlier in 1953. The diminutive Model No. VE505 represented a truly innovative breakthrough in the design of such appliances, with its revolutionary cage constructed of two intersecting circles of chromed steel wire and its safety blades made of rubber. Lightweight and easy to carry, the Model No. VE505 could be positioned either horizontally on a table or in an inclined upright position thanks to its six small stabilizing bumpers.

An electromechanical engineer by training, Pirali was the CEO of the company that manufactured this remarkable fan and was responsible for the design and development of many other household electronic goods produced by Fabbriche Elettriche Riunite, which later became known as Zerowatt. Through his designs Pirali forged a strong and identifiable house style for the company, which was typified by sleek, essentialist forms and high-quality precision engineering.

Without doubt, the Model No. VE505 reflected the extraordinary inventiveness found in post-war Italian design – an attribute that was born out of dire financial necessity and that was a significant factor in the ensuing Italian economic miracle.

Left: Alternative view of the Model No. VE505 table fan

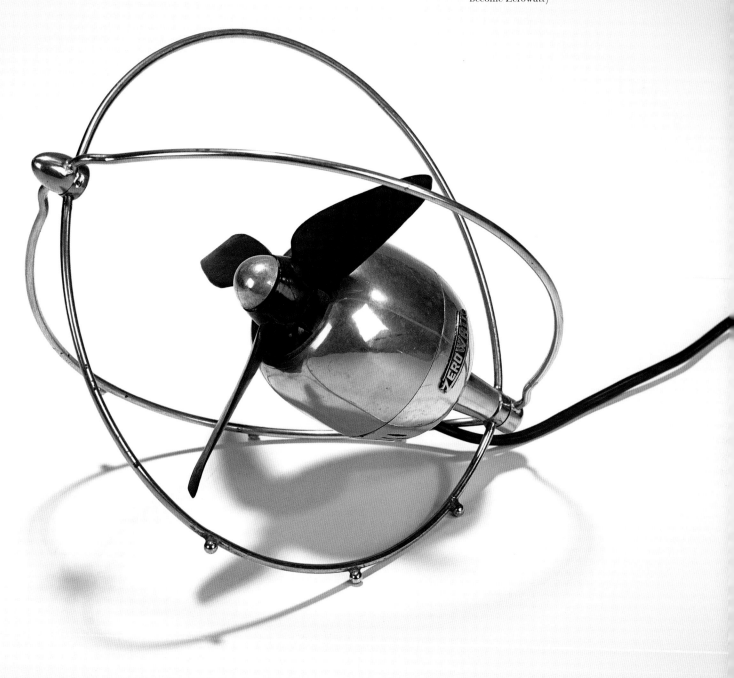

Model No. VE505 table fan, 1953
Aluminium, chromed steel, rubber
FER (Fabbriche Elettriche Riunite), Milan (later to
become Zerowatt)

P40 lounge chair, 1954
Enamelled steel, textile-covered latex foam upholstery
Tecno, Milan

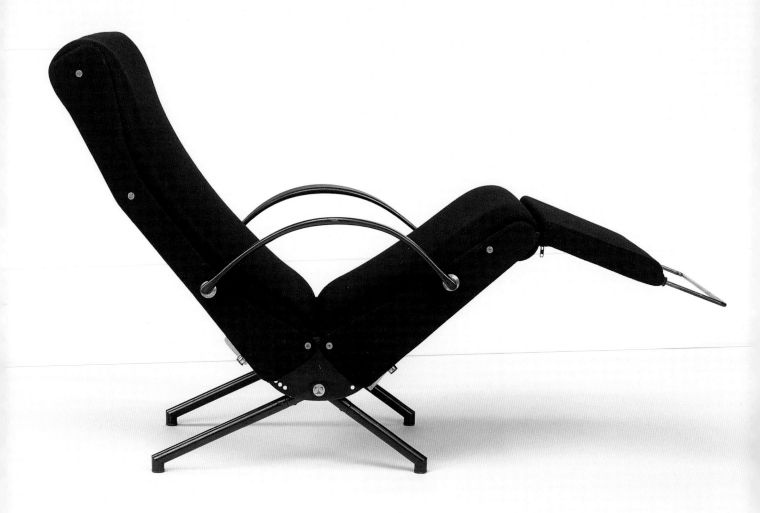

P40 lounge chair, 1954

Osvaldo Borsani (1911–1985)

Osvaldo and Fulgenzio Borsani's Milanese furniture company, Tecno, evolved from their father's workshop Atelier Varedo (later known as Arredamento Borsani). Officially established in 1953, Tecno became one of the most innovative furniture manufacturing companies in Italy with the vast majority of its modern-style seating, case furniture and shelving being designed by co-founder Osvaldo Borsani. The innovative nature of Borsani's work was the direct result of his deeply held commitment to technological research and development.

Among Borsani's many original furniture designs, the P40 lounge chair stands out above all others, not only for its stylish good looks but also for its use of newly developed materials and its extraordinary functional adaptability. Utilizing foam rubber upholstering material developed by Pirelli and elasticized webbing supported on an articulated frame made of pressed steel,

this handsome design had a remarkable degree of functional flexibility, being able to be smoothly adjusted into an astonishing 486 different positions. Its footrest was completely retractable, while its armrests, made of flexible strips of rubber, could be pushed downwards to provide an armless configuration. It was awarded the Honour Diploma at the X Milan Triennale in 1954 and was later described in the catalogue of the landmark Modern Chairs exhibition held at the Whitechapel Art Gallery in 1971 as "a machine for sitting, of the greatest sophistication".

Designed the same year, the matching D70 sofa used a similar construction to Borsani's stylish lounge chair and could be folded down through 180 degrees so that it could be pressed into service as a sofa bed when needed. The supreme functionality of both the P40 and D70 can be directly attributed to both Borsani's rational approach to design and to the need for multi-functional furnishings that were suitable for the much smaller living spaces provided by the new apartment blocks built during the post-war years. It was these designs' elegantly stylish aesthetics as much as their purposeful utility that undoubtedly contributed to their commercial success and also to the remarkable longevity of their appeal.

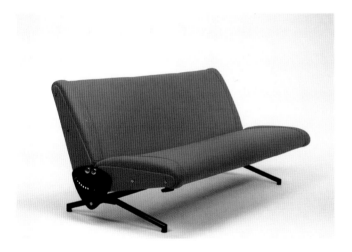

Left: D70 sofa designed by Osvaldo Borsani for Tecno, 1954

Sommerso vase, 1954

Flavio Poli (1900–1984)

The 1950s represented a revival in Italian glassware. Led by the glassworks of Barovier & Toso, Seguso Vetri d'Arte and Venini, the period was characterized by a willingness to experiment, bold colours and an embrace of modern, design-led forms. With its simple blown silhouette and lack of decoration, save the layers of internal *sommerso* (submerged) coloured glass, Flavio Poli's vase is exemplary of this rebirth in Italy's glass tradition, affirmed by its receipt of the inaugural Compasso d'Oro design award in 1954.

Poli was neither a Murano maestro nor a Milanese architect. He had trained as a ceramicist and only started experimenting in glassware in the late 1920s, when he worked at the short-lived IVAM (Industrie Vetri Artistici Muranese) glassworks on Murano. Following its closure two years later, Poli gained further experience on the

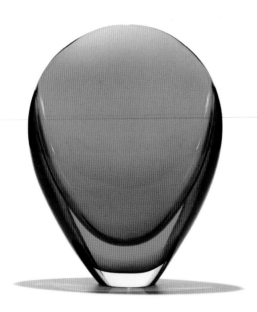

Above: Valva vase designed by Flavio Poli for Seguso Vetri d'Arte, c.1951

island. In 1934, he was appointed as artistic director of Seguso Vetri d'Arte and made a partner in the company three years later. The firm had not been in existence long; it was set up in 1931 under the name Artistica Vetreria e Soffieria Barovier Seguso e Ferro by a group of Muranese *maestri* who had previously worked at the island's Vetreria Artistica Barovier & C. Right from the start the company's history was one of restructures, changes in fortune and ownership: Poli's employment in 1937 coincided with the departure of one of the founding owners, Luigi Olimpio Ferro, which change led to the firm's renaming as Seguso Vetri d'Arte. At first Poli's designs for the firm were distinguished by animal and female figurines, but over time he shifted towards more abstract and sculptural forms, such as the Sommerso vases. While Poli can be credited with the idea for this glassware, like many of his designs, these were made by the firm's foremost glassblowing maestro, and founding owner, Archimede Seguso.

The Sommerso vase is one of Poli's best-known designs for the company, exhibited alongside his other works at both the Milan Triennali and Venice Biennali in the 1950s. It demonstrates the affinity between Scandinavian and Italian glassware in the 1950s and their mutual influence; the Nordic-inspired strong form and unadorned surface is accompanied by a Mediterranean injection of colour. The vessel rejects the decorative frippery of more tourist-orientated Murano glass in favour of a functionalist language and reflects Poli's sculptural ambitions for the island's wares.

Poli worked for Seguso Vetri d'Arte until 1963 when he sold his shares back to the firm and moved to the Società Veneziana di Conterie e Cristallerie. Seguso Vetri d'Arte continued to develop designs for *sommerso* vases, most notably in collaboration with the architect Mario Pinzoni, and the technique was imitated widely on the island. It is Poli's original design for the Sommerso, however, that is recognized as the most significant, and has led to its inclusion in several museum collections, such as that of MoMA in New York.

Sommerso vase, 1954
Coloured glass, cased in clear glass
Seguso Vetri d'Arte, Venice (Murano)

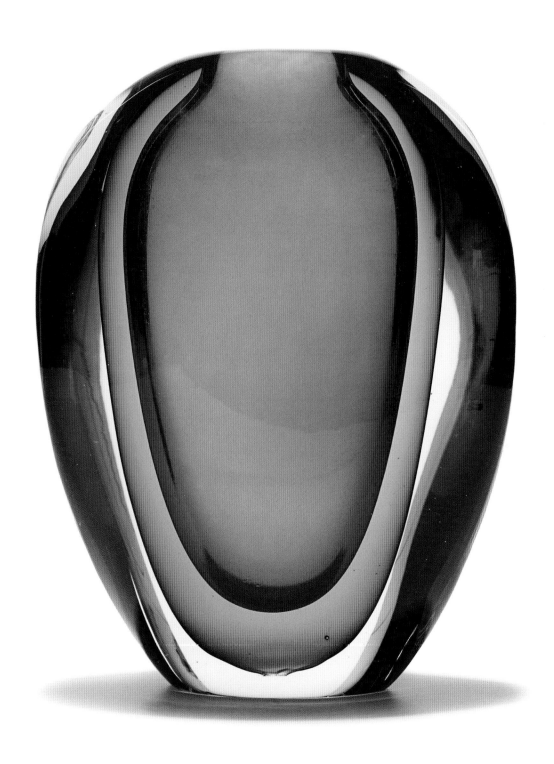

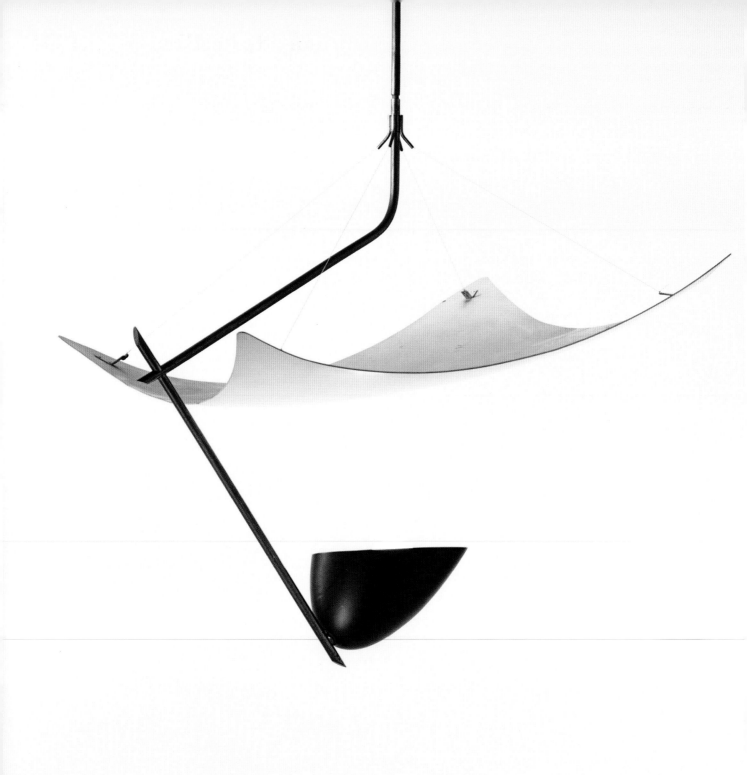

Suspended ceiling light, 1954
Enamelled metal, brass, nylon
Arredoluce, Monza

Suspended ceiling light, 1954

Angelo Lelli (active 1950s–70s)

Arredoluce was one of the most progressive lighting manufacturers in Italy, or anywhere else, during the 1950s and 1960s. The design of many of its beautiful and inventive products have since been attributed to the company's founder, Angelo Lelli, including this remarkable ceiling light with its kite-like reflector suspended on thin, virtually invisible nylon threads. The striking curved scooped element gives the design an almost mobile-like quality and suggests the influence of contemporary sculpture, particularly the mobiles created by Alexander Calder during the 1950s. Sometimes referred to as the kite light, this ceiling fixture was one of several produced by Arredoluce that had a strong dynamic quality derived from the use of contrasting-coloured elements, in this case black and white.

The Monza-based company employed craftsmen with a high level of skill and competence – a consistent feature of many design-led Italian companies – and it was this well-grounded workshop knowledge of different materials and manufacturing techniques that allowed designers working for Arredoluce to create truly avant-garde lighting designs that were highly progressive in both form and function.

Apart from Angelo Lelli, a number of other leading designers also worked for the company around this time, including the Castiglioni brothers, Gio Ponti and Ettore Sottsass. It was, however, Lelli's suspended ceiling light of 1954 that was perhaps the most radical and attractive of all the many lights produced by Arredoluce, and it is this light that best reflects the supreme elegance and new sculptural confidence emerging in Italian design during the post-war period.

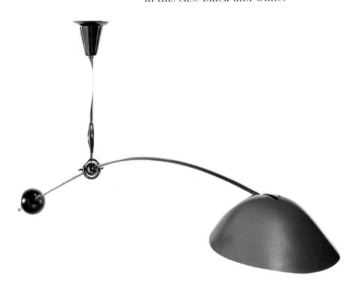

Left: Counterbalanced ceiling light designed by Angelo Lelli for Arredoluce, 1964

Vespa GS150 motor scooter, 1955
Sheet steel, aluminium, other materials
Piaggio, Sestri Ponente

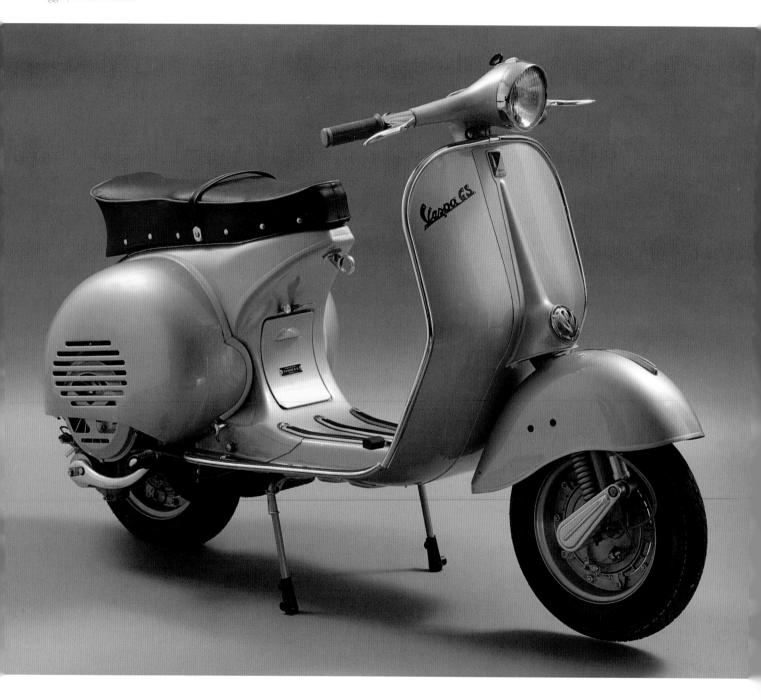

Vespa GS150 motor scooter, 1955
Corradino D'Ascanio (1891–1981)

No design is more evocative of post-war spirit in Italy than the spritely and indomitable Vespa scooter, which became inextricably linked in the cinema-going public's mind with Gregory Peck and Audrey Hepburn's amorous liaison in the comedy drama *Roman Holiday* (1953) – an all-time classic film that featured a memorable scooter-ride sequence. Indeed, the Vespa played such a starring role in this romantic cinematic adventure that it was even included in the film's publicity posters. The model that was featured in the film, which was introduced in 1951 and is now generally considered the "classic" Vespa, was the Model 125.

Prior to this, Enrico Piaggio – whose family's aircraft-manufacturing company had perfected the art of mass-production during the war years with its assembly of aircraft and aircraft engines as well as trucks, trams, buses, funicular railways and aluminium locking systems – had sought to diversify his factory's peacetime product line with the manufacture of an easy-to-run and inexpensive scooter, inspired by similar models used by the US military during the Second World War. This was a smart business move as there was a real need for affordable modes of private transportation in Italy during the immediate post-war years. To this end, the factory built its first prototype in 1943, designed by the engineer Renzo Spolti and known as the MP5 Paperino. But this rather inelegant and cumbersome model was not to Enrico Piaggio's liking and he subsequently tasked the gifted Italian aeronautical engineer General Corradino D'Ascanio with creating a totally new vehicle that was simple to operate and maintain as well as being cheap to run. Unlike the layout of traditional motorcycles with a front-mounted engine, D'Ascanio instead placed the engine of his new creation – the MP6 prototype of 1945 – on the rear wheel, which was a highly innovative concept. This prototype was subsequently christened the Vespa thanks to Enrico Piaggio's remark that "it looks like a wasp" when it was first presented to him. This model was further refined into the Vespa 98, Piaggio's first production scooter, which was launched in 1946 and cost 55,000 lire. The design of this early model included the characteristic uni-frame step-through steel body that rises at the front to provide the rider with some protection from the elements but was also intended by its designer to offer a modicum of modesty for women wearing dresses. In addition to these features, the Vespa 98 also had a zippy two-stroke engine that produced a maximum top speed of 60 kph (37 mph).

Launched five years later, the Vespa 125 had an enhanced suspension system that boasted coil-springing on both wheels (unlike the Vespa 98, which only had this on its front wheel) and hydraulic shock absorbers. Its engine capacity was also uprated to 124cc, which enabled an extra 10km per hour top speed. A variation of the classic model known as the Vespa 125 U (with the U standing for "utility") was introduced in 1953 and two years later the more powerful Vespa GS150 was introduced – another legendary Vespa design that is widely acknowledged to be the most beautiful scooter ever produced. The Vespa 125 (and its later incarnation as the Vespa GS150, shown here, with its high-mounted headlight) not only embodied the carefree, optimistic and youthful spirit of the period but was also the first two-wheeled vehicle to possess a fashionable cachet that appealed to both men and women, making it a true Italian design legend that skillfully combined fun practicality with cutting-edge style.

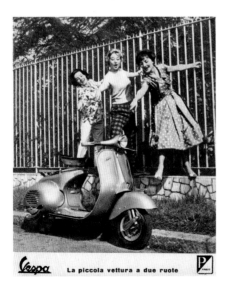

Above: Piaggio advertisement promoting the Vespa 150 motor scooter, 1950s

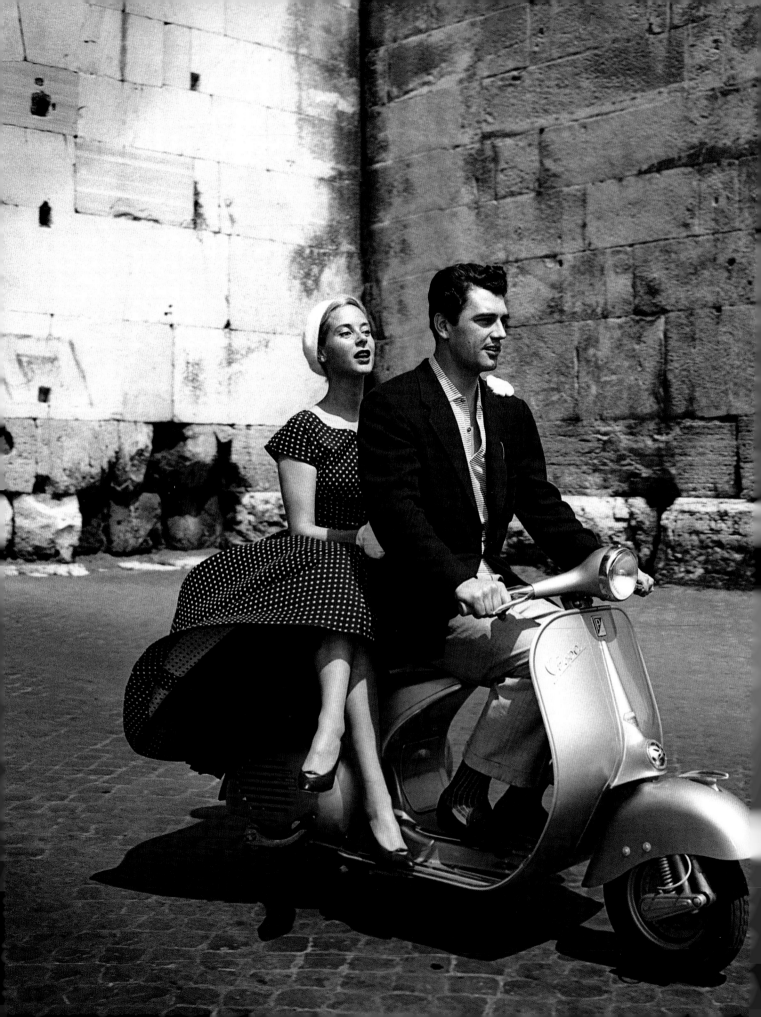

Left: British actor, Edmund Purdom and French actress, Geneviève Page on a Vespa 150 scooting around Rome, 1957

LB7 bookcase, 1956
Franco Albini (1905–1977)

The Rationalist architect-designer Franco Albini was one of the greatest prophets of modern Italian design. After completing his studies in architecture at the Politecnico di Milano in 1929, he served an apprenticeship in the Milanese architectural partnership of Gio Ponti and Emilio Lancia. During this formative period in his career, Albini also had direct contact with various talented cabinet-makers and craftsmen, from whom he sought to learn as much as possible about each craft and especially the creative potential that they would allow. As a consequence, his designs, especially those for furniture, always reflected a deep understanding of process and materials.

Around this time he travelled to Barcelona where he visited the German Pavilion designed by Ludwig Mies van der Rohe for the 1929 Barcelona International Exposition and also visited Paris where he made a pilgrimage to Le Corbusier's studio. It was through these first-hand encounters that he discovered the Modern Movement and was inspired by its rational doctrine and industrialized approach to design. He subsequently became a leading protagonist of the Rationalist movement as well as a widely respected commentator on the Italy's contemporary cultural scene.

In 1931, Albini set up his own practice in Milan where he initially took on the challenge of workers' housing – a worthy field of architecture that he continued to work in during the post-war reconstruction period. During the 1940s and 1950s, Albini worked simultaneously in the fields of furniture design, product design, architecture, urban planning, exhibition design and interior design; excelling within all areas of endeavor.

On many of his furniture projects he collaborated with the talented architect-designer Franca Helg; however, in the design of his LB7 modular bookcase from 1956 he worked alone. Comprising a system of ladder-like vertical elements, the LB7 bookcase was startlingly progressive for its day and reflected Albini's systematic and rational approach to design. The elements were cleverly fixed into position using adjustable fittings that held the units in place through the pressure exerted between the floor and the ceiling, thereby eliminating the need for wall-damaging nails or screws. The elements could also be connected together to produce a bookcase of any width and had a series of holes in their vertical struts that allowed their shelves to be placed at different heights. This innovative shelving system came with matching cabinet options in two sizes and was initially made available in walnut, teak or rosewood, or alternatively with an ebonized finish. Because the units were held in place between the floor and ceiling through pressure and therefore did not need to be fixed onto a wall like traditional bookshelves, it meant that the LB7 could also be used as a room-divider – a type of furniture that would become such a defining feature of fashionable Mid-Century Modern interiors. And, of course, Albini's LB7 was the most elegant and ingenious room-divider of them all. Recently reissued as part of Cassina's I Maestri range and renamed the Infinito, this classic Rationalist design has an enduring aesthetic and functional appeal that proves that the tenets of Good Design are ultimately timeless.

Above: Alternative view of the LB7 modular bookcase – this example is the reissued Cassina version

LB7 bookcase, 1956
Stained mahogany, enamelled aluminium, brass
Carlo Poggi, Pavia

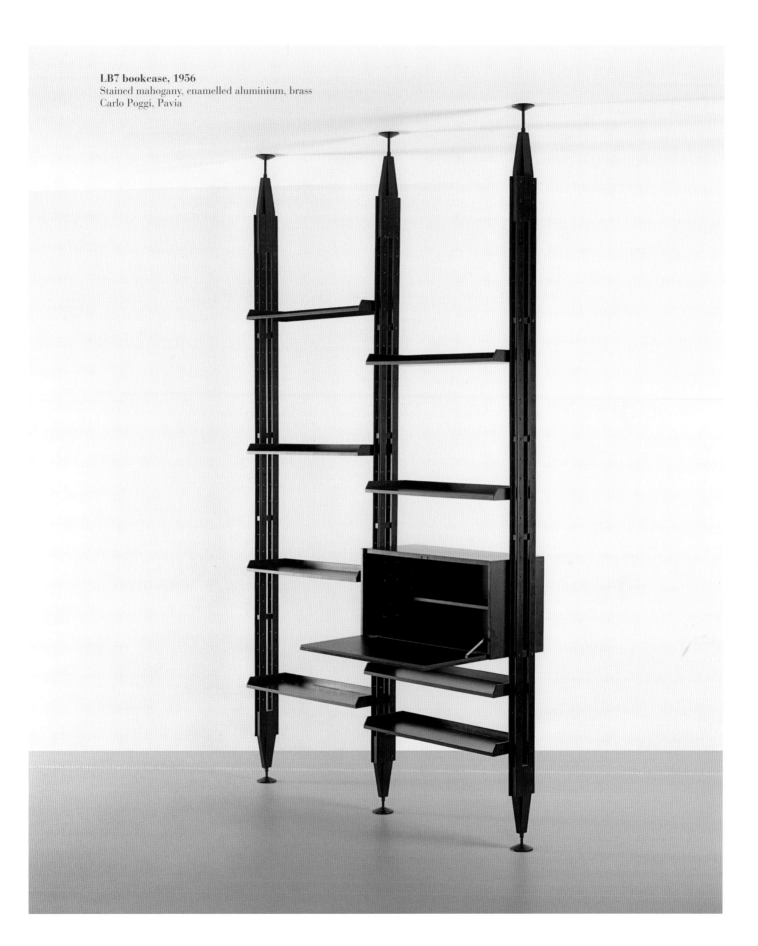

Como tea and coffee service, 1956

Lino Sabattini (1925–)

The Como tea and coffee service is an exercise in elegance. Designed in 1956 by the silversmith and designer Lino Sabattini, each part of the service expresses the sculptural, streamlined aesthetic that was a hallmark of the celebrated *linea Italiana* (Italian line) in the 1950s. Made of stamped sheet metal for the Parisian silverware producer Christofle, any extruding elements such as spouts and cane-wrapped handles have been integrated into the form of each vessel, while the flat hinged lids of both the tea and coffee pots are as inconspicuous as possible.

Sabattini had no formal design training. He served an apprenticeship at a metalware workshop on Lake Como, where he had formative experiences with ceramicist Rolando Hettner. In 1955 he opened his own workshop in Milan, where he manufactured objects based on others' designs. Sabattini started to gain prominence thanks to the Milanese architect Gio Ponti, who published the designer's work in *Domus*, the magazine Ponti edited, and arranged for it to be exhibited in Paris, the home of Christofle.

Christofle's roots go back to the late eighteenth century, when André Christofle founded a metal workshop in Paris. It was only in 1830 that the firm was fully established, when Charles Christofle took over the jewellery business of his brother-in-law, Hugues Calmette, to whom he had been apprenticed. Christofle established a reputation as a purveyor of luxury jewellery, and in 1842 purchased the patent for an industrial electroplating process for precious metal: a process that had been developed by the Englishman George Richards Elkington two years earlier. Industrial electroplating reduced the time and danger traditionally involved in the process and enabled Christofle to increase the scale of its production while at the same time maintaining its quality.

In 1845 Christofle registered a hallmark as a master silversmith and began producing domestic silverware alongside more extravagant commissions for clients including Napoleon III, the Orient Express, the Ritz hotel and, in the twentieth century, the *Normandie* cruise liner. As with many companies at the time, Christofle suffered from both bomb damage and a sharp decline in demand during Second World War, but the company kept going by collaborating with artists such as Man Ray and Jean Cocteau on porcelain and painted plates.

This desire to engage with contemporary styles and designers has been a hallmark of Christofle's output. In the 1950s the company responded to the popularity of Italian and Scandinavian design through collaborations with the Finnish designer Tapio Wirkkala, who designed a cutlery range for the firm, and with Gio Ponti, who had already in 1928 designed the Fleche candelabra. In 1956 Sabattini was appointed head of Christofle's Milan studio, a position he held until 1963. In that period he designed the majority of the firm's Nouvelle Formes range to which the Como service belongs, although it only remained in production from 1960 to 1970. Following his departure from Christofle, in 1964 Sabattini set up Argenteria Sabattini in Bregnano near Como, and won a number of prestigious Compasso d'Oro awards for his designs.

Left: Christofle advertisement showing various silverware pieces including the Como service, 1959

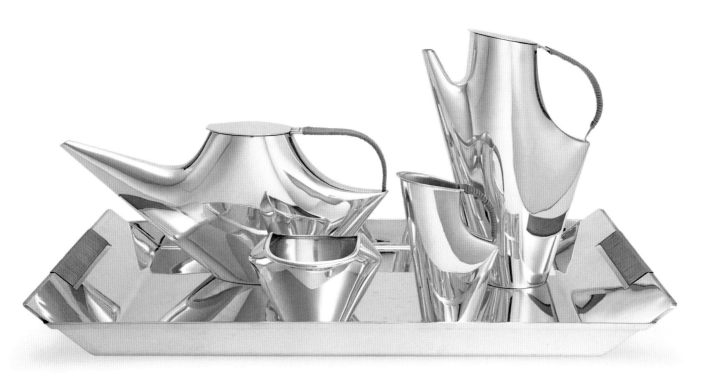

Como tea and coffee service, 1956
Stamped, silver-plated metal
Christofle et Cie, Paris

Model No. 699 Superleggera chair, 1957
Gio Ponti (1891-1979)

Combining strength with remarkable lightness, the Superleggera chair is considered by many to be Gio Ponti's supreme masterwork. Inspired by traditional Italian fisherman's chairs made in Chiavari on the northwestern coast of Italy since the early nineteenth century and also by the Scandinavian chairs that were themselves based on earlier successful vernacular precedents, the Superleggera was an evolutionary yet also revolutionary design. Described by Ponti as a "chair-chair...an ordinary chair and not one with an adjective", the Superleggera was not intended to be an exercise in avant-garde aesthetics but a genuine realization of an ideal form or *Sedia Tipo* (typical chair).

Although the first chair by Ponti with bent back and pointed legs appeared in 1949, it took another five years to develop the Leggera chair (Model No. 676) and then another year or so of further development and progressive lightening to reach the final refined form of the Model No. 699 Superleggera. Launched in 1957, this extraordinarily elegant

Above: Cassina publicity photograph showing two-tone version of the Superleggera chair and demonstrating its incredible lightness, c.1957

chair weighed in at an incredible 1.7 kg and could be easily lifted with just one finger. Its manufacturer, Cassina, demonstrated the strength and resilience of the chair by hurling examples into the air "to dizzy heights" and letting them fall onto the ground where they would bounce but not break.

Highly functional and also stylish, the Superleggera became a celebrated exemplar of Italian post war design excellence and continues to be a lasting testament to Ponti's "gentle manifesto" of design, which sought to build upon rather than reject the triumphs of the past. Not surprisingly given its vernacular ancestry, the Superleggera was initially marketed by Cassina as suitable for naval use as well as ideal for hotel furnishings and was described in the company's catalogue as an "Entirely ash-wood chair of first quality. Accurately dried with special tenon joints and electrically bent rear legs." It was available in a number of finishes – bleached or natural ash or ebonized black. Its direct antecedent, the earlier Model No. 676 Leggera, looks in comparison heavy and more traditional, whereas the Superleggera has an altogether crisper and more modern appearance. By using a thinner seat profile and very tight caning, as well as two simple un-upholstered back splats, Ponti lightened the chair physically and visually.

After having spent literally years perfecting the ultimate super lightweight chair, Ponti went on to create "the last possible lightening" of the Superleggera around 1957. Produced in two-tone black and white for special occasions such as the XI Milan Triennale and the Eurodomus exhibition, this version used visually trickery to create the illusion of half a chair. Known as the Harlequin chair, this version of the Superleggera predicted the quirky eccentricity of Italian Radical Design in the late 1960s.

The fact that the Superleggera has remained in uninterrupted production for over 50 years is testament to its timeless classicism and its functional and aesthetic durability. It is a true masterpiece of essentialist design and perfectly reflects Ponti's belief that "The past does not exist... in culture everything is contemporary... only the present exists. In it we recreate the past and imagine the future."

Model No. 699 Superleggera chair, 1957
Natural or ebonized ash, woven rush
Cassina, Meda

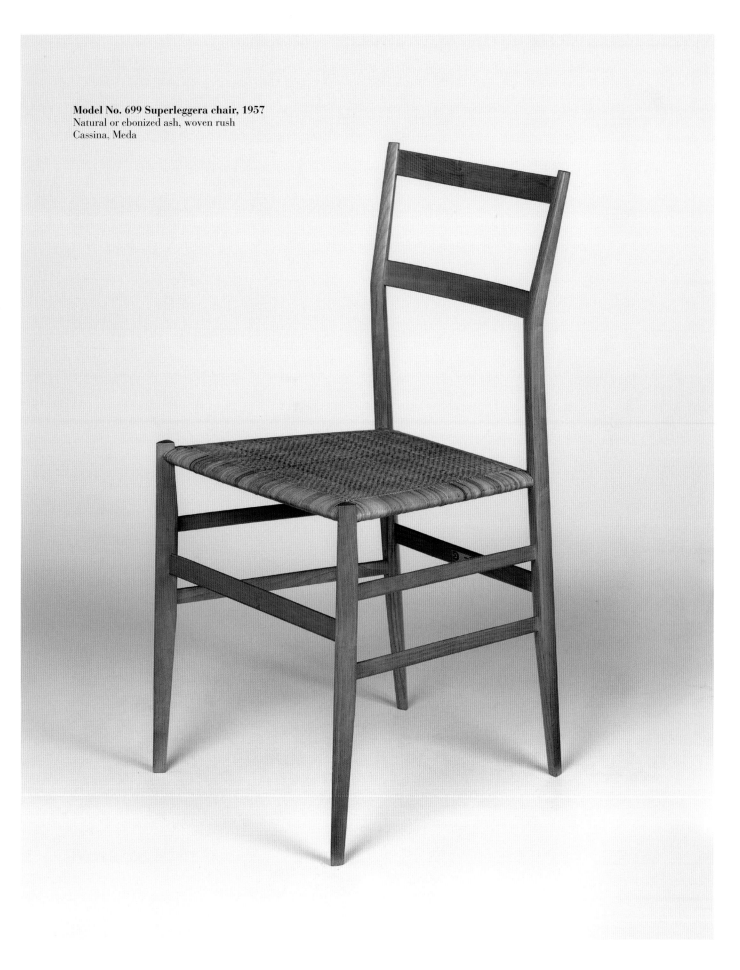

Fiat 500 Nuova, 1957

Dante Giacosa (1905–1996)

Dante Giacosa was a car-designing genius who not only created the revolutionary Fiat 500 Topolino of 1936 – the first car in Italy democratically designed for the everyman – but also its equally popular successor the Fiat 500 Nuova, or, as it is better known, the Cinquecento. This characterful little automobile completely re-defined the term "small car" and was one of the first models to be designed specifically as a city run-around. Before the outbreak of the Second World War, several design projects had been in research and development at FIAT, most notably a project for a very compact car. After the war, while Dante Giacosa was working on the design of the Fiat 600 (the Seicento), he returned to the idea of a micro-car and set about designing a vehicle that would benefit from all the research and development already undertaken for the 600. The resulting Fiat 500 Nuova can therefore be seen as a direct successor of the Fiat 600 (the Seicento) that had been launched in 1955 and was the first rear-engined car to be manufactured by FIAT.

The Cinquecento introduced two years later was quite a bit smaller; being over 24 cm shorter in length, 6 cm narrower and over 8 cm lower. One of the ways that this substantial reduction was achieved was by using a space-saving air-cooled rather than water-cooled two-cylinder engine. Giacosa's styling of the new car's body was also far more rounded, almost like a jelly-mould, which gave the vehicle a friendlier demeanour. This, twinned with its bug-eyed headlights and "smiling" fender, gave the Fiat 500 Nuova, which preceded the British-designed Mini by some two years, a prodigious personality that belied its diminutive size, creating a little car with a big heart. With its rear-engined layout, the Cinquecento could – despite measuring just over 297 cm (6 ft) by 321.5 cm (9 ft) – accommodate a driver and passenger plus 70 kg of luggage on its rear bench.

Unveiled in July 1957 to the press in Turin, the Cinquecento shortly afterwards made its public debut in a memorable procession through the streets of the city, which attracted a lot of excitement. Despite its impactful launch, the car suffered from a few initial teething troubles, specifically problems with vibration and lacklustre performance, and as such was not an instant financial success for Fiat. However, these drawbacks were overcome a few months later when the company launched at the Turin Salon a new improved version known as the Normale. This was a slightly more expensive variant of the original model, which was subsequently renamed the Economica and remained available for purchase. In 1958, a zippy sports version of the Fiat 500 Nuova made its debut with a 21 horsepower engine and a rigid one-piece roof – the following year this model was offered with a canvas fold-back roof option (a feature that was also on the earlier standard models).

The true successor of Dante Giacosa's much-loved 500 Topolino, the Fiat 500 Nuova was an outstanding vehicle design and was awarded a Compasso d'Oro in 1959. It was also a highly affordable car with a retail price at its introduction of just 465,000 lire. As a result Fiat went on to sell an impressive nearly 3.9 million units over its 18-year production between 1957 and 1975. In tribute to the Fiat 500 Nuova's enduring legacy, Fiat eventually launched in 2007 a re-edition tribute to this nimble little city car, which like the 1950s original has enjoyed staggering popularity over recent years.

Right: Advertisement promoting the Fiat 500 Nuova, c.1957

Opposite: Cutaway diagram showing compact rear-engine internal layout of the Fiat 500 Nuova

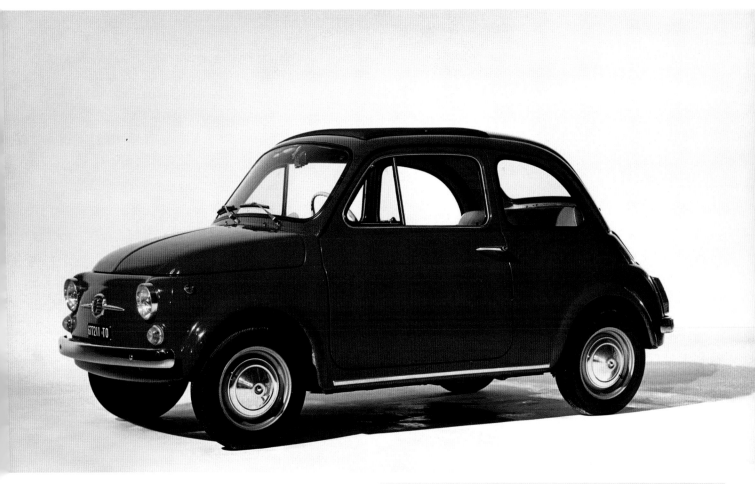

Fiat 500 Nuova, 1957
Various materials
FIAT (Fabbrica Italiana Automobili Torino), Turin

Mirella sewing machine 1957
Enamelled aluminium, other materials
Necchi, Pavia

Mirella sewing machine, 1957
Marcello Nizzoli (1887–1969)

Marcello Nizzoli was both a talented architect and graphic designer and a highly gifted industrial designer who was able to translate the Italian Rationalists' desire for logical forms into seductive three-dimensional objects that were both stylish and functionally resolved. Although he is best remembered for his extensive work for Olivetti, especially his series of adding machines and his iconic Lettera 22 typewriter, he also designed for other Italian companies, including Necchi – the well-known sewing machine manufacturer based in Pavia.

In 1954 Nizzoli designed the two-tone BU Supernova sewing machine for Necchi that boasted a sculpted housing that was far more modern looking and ergonomic than the company's earlier machines. However, more progressive still was Nizzoli's follow up design, the Mirella of 1957, which had an even more unified and sculptural housing made of white and black enamelled aluminium. Aesthetically light years ahead of any other sewing machine then being made, the Mirella had an unequivocally contemporary look that reflected Nizzoli's genius for artful yet functional compositions and exquisitely balanced proportions as well as his refined eye for graphic detailing. Ergonomic and totally "fat-free", this machine not only looked great because of its clean form-follows-function lines, but its highly rational layout was also highly intuitive to use. As one of the first successful consumer products with a white housing, it predicted (like the contemporaneous work of Dieter Rams at Braun) a new formal language of design for small appliances. Four years after the launch of the Mirella, Nizzoli created another sewing machine for Necchi – the Supernova Julia (1961), however, this update of the earlier Supernova did not have the eye-catching gestural elegance or visual unity of the Mirella, which even today is probably the most beautiful-looking machine of its kind even though it has been out of production for decades.

A testament to the ability of Italian designers and manufacturers to create paradigm-shifting products, the Mirella is now in the permanent collection of the Museum of Modern Art in New York and certainly exemplifies the New Italian Look that took the design world by storm during the 1950s.

"La mia macchina per cucire è una NECCHI!"

Left: Necchi advertisement showing Supernova Julia sewing machine designed by Marcello Nizzoli, c.1961

Persol Model No. 649 sunglasses, 1957

Giuseppe Ratti (c.1885–1965)

Attempts to protect eyes against the glare of the sun have a long history. Prehistoric Inuits used ivory goggles to avoid blindness from sun reflected on snow or icy surfaces, while the Roman emperor Nero apparently used to use polished emeralds to shade his eyes when watching gladiator fights. In the eighteenth and nineteenth centuries the first tinted lenses became available, although these were only prescribed to those with vision impairments. The history of sunglasses as a fashion accessory is a twentieth-century phenomenon. They were worn first by film stars in the 1930s, becoming more widely available on the mass market from the 1950s onwards. The Italian brand Persol has played a leading role at the high end of this market, most notably with Model No. 649. Introduced in 1957, today the 649 is the most well-known design in the company's catalogue, recognizable for its flecked tortoiseshell, black or white acetate frame, "Victor Flex" nose bridge and trademark silver arrow on each arm.

Persol was founded in Turin in 1917 by Giuseppe Ratti, a photographer and optician. Named after the Italian phrase *per il sole* (for the sun), at first the company specialized in creating advanced designs to meet the exacting demands of pilots and sports drivers. The origins of the 649 are similarly functional; they were originally designed for Turinese tram drivers who needed sunglasses that were big enough to protect their eyes from dust and air pollution. Like all Persol glasses, these were mounted with the famous yellow-brown lenses, which were developed in the 1920s. Produced in neutral crystal made from the purest silica, the unique characteristics of each high-quality lens is owed to a special *en masse* manufacturing process that determines its colouring and guarantees extremely high protection from the sun's harmful rays.

In the 1960s Model No. 649 was introduced with a dose of glamour, appearing in several films that secured their fame and desirability. They were first worn by the Italian actor Marcello Mastroianni in the 1961 comedy *Divorzio all'italiana* (Divorce Italian Style), and in the late 1960s the American actor Steve McQueen wore Persol sunglasses both on and off screen. In 1968's *The Thomas Crown Affair* he sported model 714, introduced in the 1960s and identical to model 649 except that these could be folded in half. He also chose to wear the 649s on a more everyday basis. Since then, many other film stars have worn Persol sunglasses, from Daniel Craig to Nicholas Cage and Tom Cruise, as part of the long-established relationship between film and fashion.

As with many examples of Italian design, Persol sunglasses are a product of fine craftsmanship. It takes five days for the firm's craftsmen to produce each pair at the factory in Lauriano, west of Turin. This is double the amount of time needed to manufacture other sunglasses, due to a complex design that cannot be automated. Key to the comfort and durability of the Persol glasses is the steel-embedded triple-notch nose bridge and meflecto-springed stem system, which the brand first patented in the 1930s. Nylon or metal inserts are built into each acetate stem, endowing the glasses with a flexibility that both reduces pressure on the wearer's head and also enables them to fit different face shapes. Similarly distinctive is *La Freccia Supreme* (the Supreme Arrow), the arrow-shaped insignia that Ratti introduced in the 1930s in a bid to make his products more recognizable in the marketplace.

In 1995 Persol was taken over by the Italian Luxottica Group, which produces eyewear for a number of brands, including Ray Ban and Oakley. Today, Persol sunglasses, along with the brand's range of regular glasses in both male and female styles, continue to be handmade in Italy.

Persol Model No. 649 sunglasses, 1957
Cellulose acetate, metal, crystal lenses
Persol, Turin

Ferrari 250 TR racing car, 1957

Sergio Scaglietti (1920–2011)

Produced from 1957 to 1958 the Ferrari 250 TR is one of the rarest racing cars of all time and one of the most sublimely beautiful. Despite this, when the 250 TR was first launched, it was scathingly referred to as a *barchetta* (little boat) by certain members of the automotive press. Other journalists were more upbeat about its dynamic shape but, even so, they expressed reservations about its seemingly outdated engine technology.

Although Ferrari constructed only 22 examples, the model (and its slightly modified later variations) went on to thoroughly trounce any early media criticism by winning ten of the nineteen international championship races it was entered in between the years 1957 and 1961. By winning the World Championship for Ferrari in 1958 with the British driver Mike Hawthorn at the wheel, the 250 TR subsequently became acknowledged as a motor racing legend.

Above: Frontal view of the Ferrari 250 TR racing car showing sleek aerodynamic nose

The reason for its remarkable competitiveness on the racetrack was due to both its powerful Colombo 12-cylinder engine mounted at a 60° angle and outfitted with six Weber carburetors and to its aerodynamic body that not only reduced drag but also directed air to vents that cooled the brakes. With its 300 horsepower engine, which featured distinctive scarlet valve covers (hence the nomenclature Testa Rossa meaning "red head") the 800 kg vehicle was capable of an impressive 168 mph top speed.

Maranello-based coachbuilding and automotive styling company Carrozzeria Scaglietti was responsible for the design of the 250 TR's achingly beautiful sculptural form with its undulating pontoon fenders that are visually separated from its nacelle body. This alluring sculptural design gave the 250 TR a highly distinctive appearance and epitomized the famed elegance of the *linea Italiana* (Italian line). However, at the time it was considered controversial and so Ferrari subsequently commissioned Pininfarina and Carrozzeria Touring to produce a more conventional body form for its later models. It is the original Scaglietti-designed 250 TRs that have earned legendary status among discerning collectors, and the honour of being among the most desirable Ferraris ever built. The exquisite example shown here, chassis no. 0714TR, is one of the most expensive cars ever sold at auction, having realized over £9,000,000 in 2009 ($12,000,000). Quite simply, it is one of the ultimate Ferraris of all time.

Ferrari 250 TR racing car, 1957
Various materials
Ferrari, Maranello

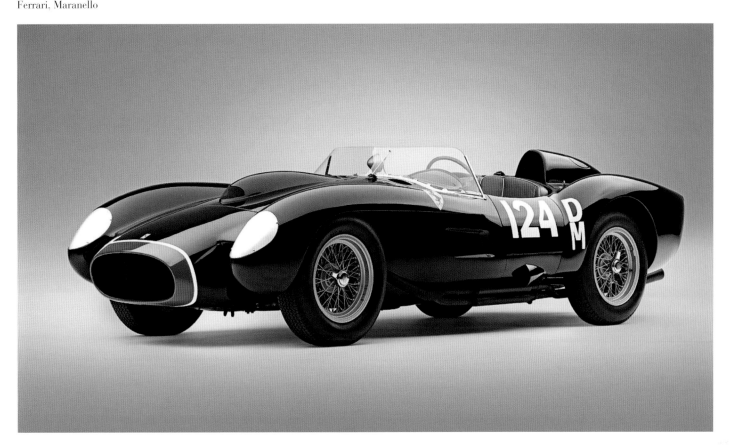

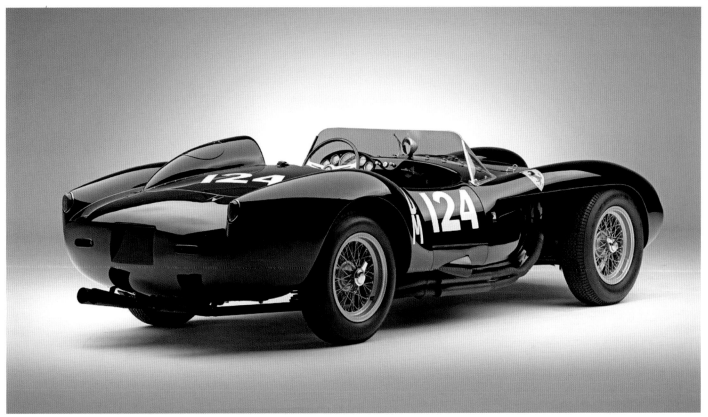

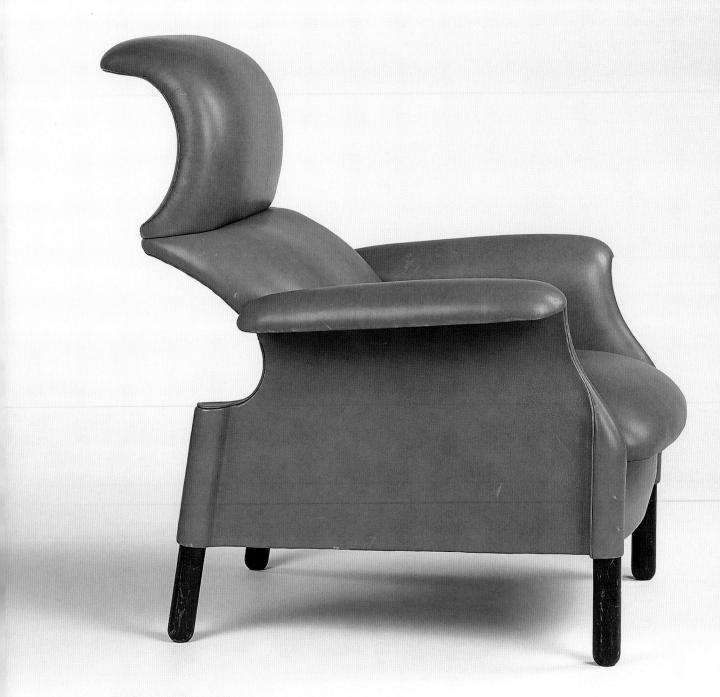

San Luca armchair, 1959
Leather-covered polyurethane-foam-
upholstered frame, rosewood legs
Gavina, Bologna

San Luca armchair, 1959

Achille Castiglioni (1918–2002) & Pier Giacomo Castiglioni (1913–1968)

Following their training in architecture at the Politecnico di Milano, Achille and Pier Giacomo Castiglioni started collaborating together in the late 1930s in the Milanese studio that Pier co-ran together with eldest brother Livio and the architect Luigi Caccia Dominioni. The studio closed in 1940 during the Second World War, and reopened in 1945 with just Achille and Pier Giacomo Castiglioni at the helm. Their 1959 design for the San Luca chair is typical of their output, demonstrating their interest in the fledgling field of industrial design and their celebration of the formal and functional possibilities of new materials and techniques.

The San Luca was produced by Gavina, the Bolognese furniture manufacturer set up by Dino Gavina in 1949 that is recognized for its experimental and progressive approach to design. The chair's unusual form was the result of extensive research into the ergonomics of sitting and was developed through a number of models and prototypes in order to create a chair conceived to be more comfortable than conventional, rigid armchair designs. It consists of three parts (seat, back and headrest) that together create the chair's articulated curving profile. The designers rejected traditional upholstery in favour of cotton or leather-upholstered sections of foam polyurethane padding on a metal frame that enabled the light elegance and irregular form. The chair was initially conceived to be mass-produced in moulded parts, however this proved too costly. So advanced was the design that it was only realizable thanks to Italy's ongoing artisanal tradition: the separate padded components that enabled the chair's curving form had to be individually made and finished before being assembled by hand.

The San Luca chair was exhibited at the XII Milan Triennale in 1960, in a luxurious room set designed by Caccia Dominioni. Its design in 1959 came at the height of Italy's post-war economic boom, and its production a year later coincided with the release of *La Dolce Vita*, Federico Fellini's sweeping portrayal of Italy's "sweet life". The chair's voluptuous curves can be seen to echo those of the film's Swedish star Anita Ekberg, a characteristically Italian celebration of the female form also seen in Marco Zanuso's Lady armchair for Arflex from 1951. The San Luca chair is also associated with Neoliberty, the "new" version of Art Nouveau, known in Italy as the Liberty movement, which first emerged in the mid 1950s in the cities of Milan and Turin. Its proponents included the architectural studio BBPR who rejected a purely modernist style in favour of a renewed embrace of historical styles. Examples of Neoliberty include BBPR's medieval-inspired Torre Velasca skyscraper in Milan and Gae Aulenti's Sgarsul chair, designed for Poltronova in 1961. The latter shares a similar curving profile to the Castiglionis' design, whose bulbous, dynamic profile echoes both eighteenth-century styles and early twentieth-century Futurism.

In 1967 Knoll International bought the product rights to Gavina's designs, and the American firm manufactured the San Luca chair up to 1969 when production was suspended. In 1990 the Italian manufacturer Bernini reissued the chair and introduced Achille Castiglioni's design for an accompanying ottoman, known as the Luca, a year later. Since 2004 the San Luca chair has been manufactured by Poltrona Frau, a firm recognized for the quality of its leather-upholstered furniture.

Secticon Model C1 table clock, Secticon Model T1 mantle/table clock, and Secticon bedside clock, c.1960-62

Angelo Mangiarotti (1921–2012) & Bruno Morassutti (1920–2008)

As with most products involving high levels of engineering skill, the design of clocks in the twentieth century was subject to significant changes in style and prominence, as new technologies and modes of living transformed the functions and forms of the domestic environment. In the early twentieth century, clocks had receded into the background as radios and then televisions grew in popularity. During the 1950s and 1960s, however, a number of highly talented architects and designers turned their attention to the design of clocks within a more modern idiom. They embraced advances in both mechanisms and the new materials available, especially the formal possibilities offered by plastics, as seen in Angelo Mangiarotti and Bruno Morassutti's range of Secticon clocks, designed between c.1960 and 1962.

Mangiarotti and Morassutti had previously set up a Milanese design studio together in 1955. Mangiarotti had previously graduated as an architect at the Politecnico di Milano in 1948, and between 1953 and 1954 he worked as a guest lecturer at the Institute of Technology in Illinois, Chicago, where he had formative encounters with the German modernist Ludwig Mies van der Rohe and the America architect Frank Lloyd Wright, who promoted organic architecture. In contrast, Padua-born Morassutti had studied architecture at the Istituto Universitario di Venezia (Venice University), but like Mangiarotti, he had also travelled to America during the immediate post-war period, working in Wright's studio between 1949 and 1950 before returning to Italy in 1951.

The Rationalist and organic influences of these architects' American experiences is evident in the design of their Secticon clocks, one of a series of designs they produced in their five-year partnership. The sculptural design of their gleaming plastic housings is integral to the clocks' overall sleek appearance – there are no external buttons, dials or any other elements that might disrupt their striking silhouettes. The designers produced three versions of the Secticon clock in plastic, all designed for the Swiss manufacturer Le Porte-Échappement Universel SA in La Chaux-de-Fonds, once the centre of the nation's watch-making industry.

The mid-sized table clock with its tilted face was inspired by earlier maritime clocks and was intended to allow the user to read the time easily whether they were in a seated or a standing position. The largest clock had a distinctive swelling circular head, while the smallest clock in the range had, in contrast, a compact pebble-like form. All three designs were notable for their sculptural and visually unified plastic housings that perfectly hid their inner working mechanism, which was an innovative electro-mechanical battery-operated transistor system. This new type of movement had been recently developed by the clocks' manufacturer and incorporated a constant-force escapement, which meant that the clocks boasted a precision impressive for the period.

In 2005 the German clock manufacturer Klein & More created a new edition of the mid-sized Secticon clock, and it remains in production today as a veritable icon of Italian design. As Mangiarotti explained, the aim of his Secticon clock designs were, "to create forms expressing a new standard of precision".

Above: Advertisement for the Secticon clock published in *Domus*, August 1960

**Secticon Model C1 table clock, Secticon Model T1 mantle/
table clock, and Secticon bedside clock, c.1960-62**
Melamine, brass, transistorized electric clock motor
Secticon Portescap (Le Porte-Échappement Universel) La
Chaux-de-Fonds, Switzerland

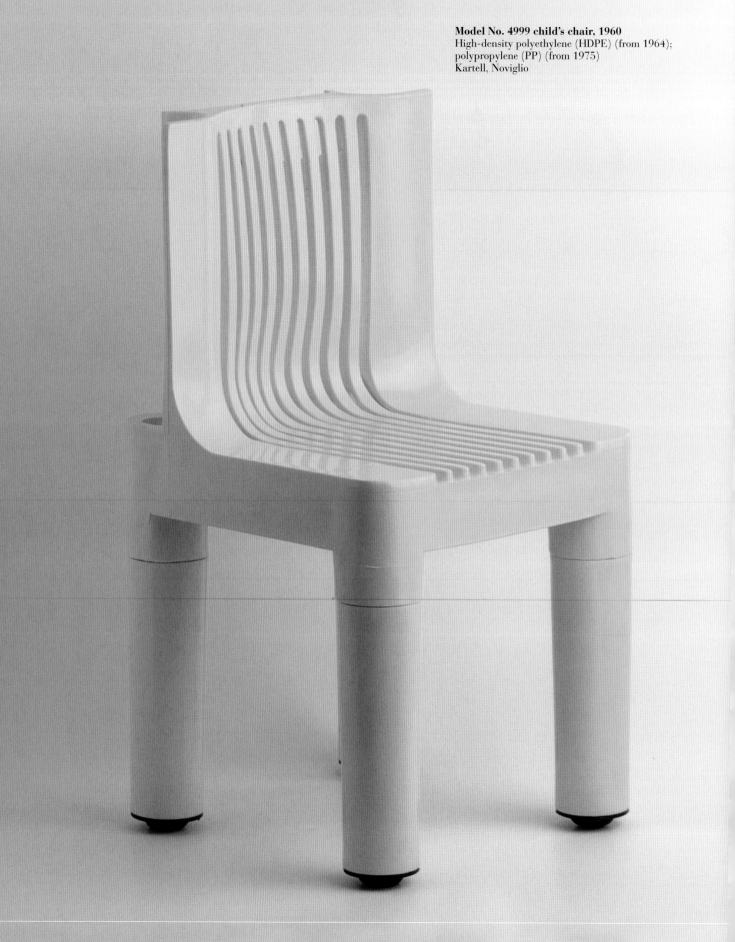

Model No. 4999 child's chair, 1960
High-density polyethylene (HDPE) (from 1964);
polypropylene (PP) (from 1975)
Kartell, Noviglio

Model No. 4999 child's chair, 1960
Marco Zanuso (1916–2001) & Richard Sapper (1932–)

As the first chair in the world to be made entirely of injection-moulded plastic, the Model No. 4999 child's chair set a crucially important precedent both in the design of chairs and also in the use of thermoplastics for the production of larger-scale consumer items. Because of this, it received a prestigious Compasso d'Oro award in 1964 – an accolade only bestowed on designed products that are deemed to be truly groundbreaking.

This diminutive chair designed by Marco Zanuso and Richard Sapper in 1960 was initially moulded in high-density polyethylene – a resilient polymer with an excellent strength-to-weight ratio and exceptional chemical resistance properties. However, because it was still difficult to injection-mould large items in plastic during the 1960s, the chair's ribbed seating section was fabricated separately from its four cylindrical legs. These were designed to slot into the underside of the seat. Although not made in a single form, its designers conceived the assembled chair almost as a lightweight building block, so that a number of them could be stacked one on top of the other. These elements could then be used by children to construct play forts, dens and the like, thereby adding a degree of interactive fun into the design.

Produced in gleaming red, bright yellow, royal blue or white plastic, the Model No. 4999 chair was certainly a radical departure from the way children's seating had previously been conceived, with existing models typically being little more than miniaturized versions of adult-sized chairs. In contrast, Zanuso and Sapper's innovative little chair was designed from a child-centric point of view that promoted imaginative experimentation, and as such it reflected the growing belief among child experts during this period in the educational benefits of non-prescriptive creative play.

Weighing in at just 2.24 kg, the Model No. 4999 chair could also be scrubbed clean and its inherent water resistance made it ideal for outdoor use. As a Kartell advertisement emblazoned with child's writing stated, "we can leave it in the garden…wash it when it's dirty" and went on to declare that it was "a beautiful chair that is good for us".

The Model No. 4999's pioneering use of thermoplastics, which shifted from polyethylene to even more resilient polypropylene, demonstrated Zanuso's lifelong creativity with newly developed materials and his ability to form them into super-stylish products that were both functionally innovative and aesthetically ground-breaking. Although it was a compact design, the Model No. 4999 made a huge impact on the way seating designs were subsequently developed, and can be seen to have heralded the advent of the ubiquitous monobloc plastic chair.

Left: Kartell promotional photograph showing the Model No.4999 child's chair stacked like a building toy. c.1960

Spazio office system, c.1961
Enamelled steel, vinyl, plastic
Olivetti, Ivrea

The Milanese architecture and design practice BBPR was founded in 1932 by Gianluigi Banfi, Lodovico Barbiano di Belgiojoso, Enrico Peressutti and Ernesto Rogers and was to become one of the greatest proponents of Italian Rationalism over the succeeding decades. Although best remembered for its public buildings, town planning and exhibition design work, the group also created a number of innovative furniture designs. Among these, the Spazio office system for Olivetti was by far the most groundbreaking, designed from the outset as a flexible and comprehensive system of various interchangeable units for modern office spaces.

As *Domus* magazine noted in its May 1960 issue, this new line of office furniture was developed out of elements that were "like Meccano pieces, out of which complex combinations could be assembled". Initially, the range comprised a desk, a table and a telephone table, but soon shelving units and desk returns were also added to the range. The standardized elements were made of pressed sheets of steel and had hinged connections for easy assembly and reconfiguration, which meant, importantly, that they were also easy to warehouse and transport in a "flat pack" unassembled state. The legs of the desk had distinctive disc-like feet that could be level adjusted to ensure a flat working surface, a specially designed task light could be clipped onto the desks, and there were different colour options for the desktops, thereby delivering a degree of personal customization.

As one of the first completely integrated office furniture systems, the Spazio range was hugely influential on the development of later office equipment. And with its no-nonsense, staunchly industrial appearance it had, as the Italian design commentator Stefano Casciani has noted, a "neo-machinery" aesthetic, which was clearly intended to look the business.

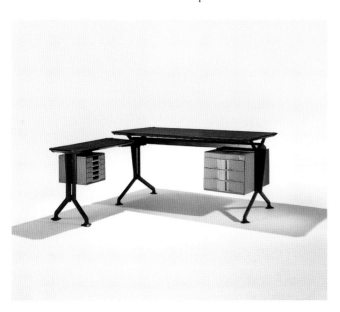

Left: Spazio desk with attached return element, c.1961

Riva Aquarama motorboat, 1962
Varnished mahogany, other materials
Riva, Sarnico

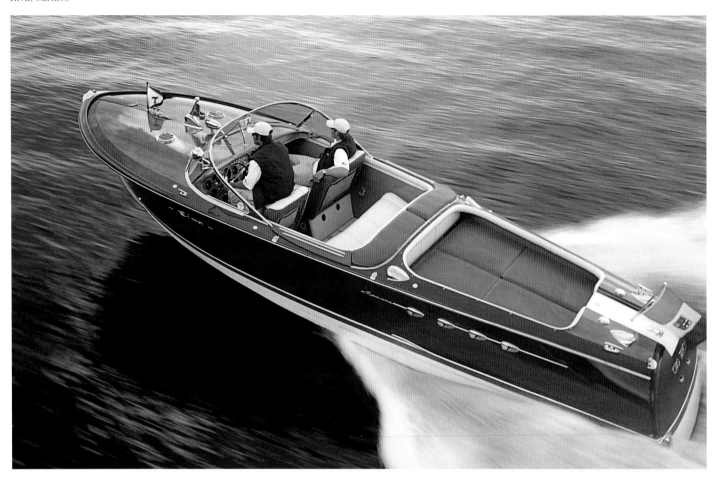

Above and Right: Interior detail and view
of twin engines

Overleaf: Riva Aquarama being driven at
full throttle

Riva Aquarama motorboat, 1962
Carlo Riva (1922–) & Giorgio Barilani (1933–)

There are certain designs that evocatively conjure up the golden period of Italy's post-war renaissance – the famed and fabled *dolce vita* years – the Vespa scooter, the diminutive yet perky Cinquecento and, of course, the sublimely beautiful Riva Aquarama motorboat. The Riva story, however, begins much earlier: in 1842, a tempestuous storm wreaked utter havoc on the fishing community on Lake d'Iseo by destroying their boats. Luckily for all involved, there was a young but skilled carpenter by the name of Pietro Riva who had recently arrived from the Lake Como area who set about repairing the storm-damaged boats against all the odds.

Hailed as a saviour by the local townsfolk, Riva settled in Sarnico on the shores of Lake Iseo and established a boatyard there, where he began building yachts the like of which had never been seen before. The boat-building firm continued to prosper when the company's reins were handed over to Pietro's son Ernesto who, according to company history, "introduced technical innovations which raised the quality of what was still artisan production". Ernesto Riva also had the bright idea of fitting his yachts with internal combustion engines. It was under his guidance that the company began building large boats for transporting people and goods across the Italian lakes. After the First World War the company continued to grow, as did its reputation, now being under the guardianship of the founder's grandson Serafino, who steered the firm's production away from transportation boats towards motorboats, specifically speedboats, that went on to win a number of national and international competitions during the 1920s and 1930s.

After the Second World War, Carlo Riva – now the fourth boat-building generation of his family – took over the running of the firm, and Riva was to experience a boost of well-deserved recognition for its superlative speedboats that were constructed from the best available materials – including beautifully grained mahogany – and painstakingly executed down to the smallest of details by talented and dedicated craftsmen, whose artisanal skills had been honed over generations. While other boat builders turned to fibreglass and plastics, Riva stayed true to traditional materials and craftsmanship yet continued to pioneer beautiful and purposeful forms for its watercraft.

During the late 1950s and early 1960s, as Italy became a sun-kissed playground for the rich and famous, the Riva brand became utterly synonymous with elegance and status, while its boats became evermore refined to the point of perfection thanks to the skills of the boat designer Giorgio Barilani who had joined the company in 1956. This gifted architect-designer was responsible together with Carlo Riva for the creation of company's most sublime design, the Aquarama, which was introduced in 1962 and was a refinement of Riva's earlier Tritone model. As Barliani notes, a number of variants were designed, yet ultimately it was Carlo Riva who made the decision as to which one was eventually put into production.

Known as "the Ferrari of the boat world", the twin-engined Aquarama was originally intended as an elegant yet powerful lake runabout but ended up as a nautical legend. This was due in no small part to its enduring association with Hollywood glamour, as movie stars were snapped by the first generation of paparazzi photographers while enjoying the delights of the Italian lakes from its sunbathing decks. This speedboat's evocative name came from its wide windscreen that allowed panoramic views from its helm and also acknowledged its Hollywood celebrity associations by making oblique reference to the newly introduced wider movie format, Cinerama.

Barilani remained at the company for the rest of his career, notably taking responsibility for the design of the evolutionary Aquarama Special in 1972. But it is the original Aquarama with its gleaming wooden hull varnished to perfection that remains the design everyone thinks of when the name Riva is mentioned. This is no surprise for it was quite simply the most beautiful watercraft of its kind – the ultimate pleasure boat for those who could either afford it themselves or knew someone who could.

Ferrari 250 GTO, 1962

Sergio Scaglietti (1920–2011), Giotto Bizzarrini (1926–) & Mauro Forghieri (1935–)

No other car brand has quite the same cachet as Ferrari, nor the same level of passionate fan worship. To understand the Ferrari phenomenon, one has to look to the origins of the company, which are firmly based in the world of motor racing. Enzo Ferrari, who had already gained a glittering reputation as a gifted racing driver, founded the Scuderia Ferrari (Ferrari stable) in 1929 to design, build and race superlative high-performance cars. This venture acted predominantly as Alfa Romeo's racing team until 1937 and then Enzo briefly headed Corse Alfa before leaving in 1939 to set up his own company, Auto Avio Costruzioni (later to become Ferrari) in Modena. During the war the factory was moved to Maranello and as soon as the war ended Enzo began designing the first car to actually bear the Ferrari name, which was unveiled two years later as the 125 Sport. Powered by a high-performance 1.5 litre V12 engine and having a sculpted aerodynamic body, this road-and-racing sports car set the design agenda for all subsequent Ferraris – power and beauty. Four years later, Ferrari won its first Formula 1 World Championship Grand Prix and then in the subsequent two seasons took the Formula 1 world title with the legendary Alberto Ascari driving for its team. By winning competitions at the highest level, these early Ferrari racing cars gave the Italian population something to actively celebrate during the financially difficult years of post-war reconstruction – and in so doing the marque forged a unique emotional link with the Italian public.

Apart from its prowess on the racetrack, Ferrari became famed for its production of sublimely elegant "Gran Turismo" cars. Like their Formula 1 brethren, these cars inspired a passionate following among Ferrari fans: although most could never have afforded one, they could certainly appreciate the combination of raw throaty power with sensual aesthetics. These luxury high-performance automobiles, usually two-door coupés, were designed for long-distance travel and were also created to compete in GT racing.

Of these touring models, there is one that motoring aficionados widely acknowledge as being one of the greatest Ferraris of all time: the Ferrari 250 GTO from 1962. Ferrari's chief engineer Giotto Bizzarrini initially worked on the car's early development with the coachbuilder and designer Sergio Scaglietti, but another engineer, Mauro Forghieri, was then brought in by Enzo Ferrari to replace Bizzarrini. It was Forghieri and Scaglietti working together who ultimately used data gathered from wind tunnel and road track testing to refine the Ferrari 250 GTO's sublimely beautiful and aerodynamically efficient body shape. Ferrari raced this low-slung car in Group 3 Grand Touring Car competitions, even though it had only produced 39 examples when the FIA's regulations stipulated that to take part in these races at least 100 examples of a car had to be built – Ferrari dodged this annoying little detail by numbering the cars' chassis out of sequence making it appear that more cars had been made than actually had been. Ferrari went on to win impressively the FIA's International Championship for GT Manufacturers (over 2000cc class) with the Ferrari 250 GTO over the next three consecutive years: 1962, 1963 and 1964. With its lightweight tubular frame, A-arm front suspension, live-axle rear end, disc brakes and distinctive Borrani wire wheels, the front-engined Ferrari 250 GTO racing car was essentially equipped with all the typical early 1960s Ferrari kit. But it did have two major differences: a Porsche-designed five-speed gear box and a metal gate that defined the shift pattern, which made gear-changing easier and quicker than on earlier Ferrari models.

Believed by many to be the Ferrari that best embodies the attributes of the marque, the Ferrari 250 GTO is one of the most highly prized models in the rarified world of Ferrari collectors. An example that was originally made for Sterling Moss became the world's most expensive car in 2012 – selling privately for $35 million. A hefty price tag but then as any *tifosi* would argue, it is a legendary car from the world's most legendary marque – and how could you possibly put a price on that.

Ferrari 250 GTO, 1962
Various materials
Ferrari, Maranello

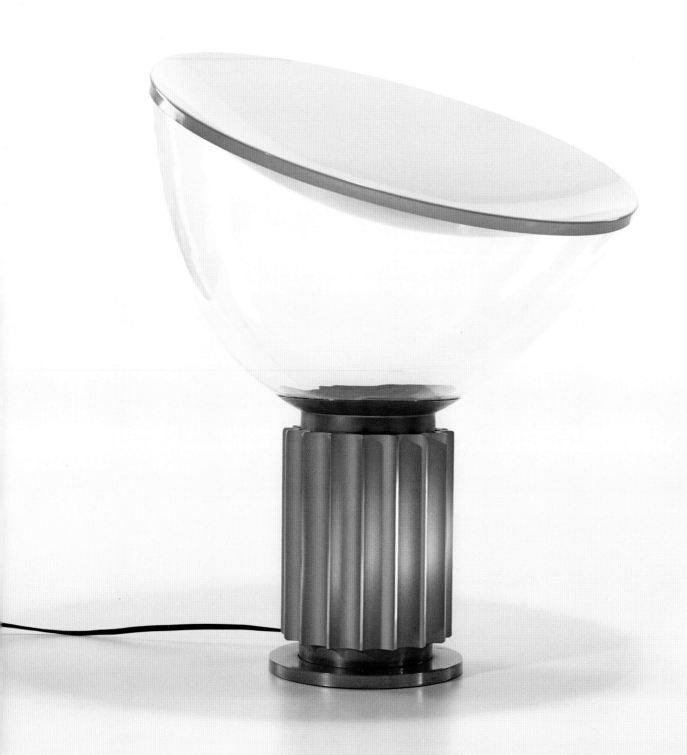

Taccia table/floor light, 1962
Steel, enamelled aluminium, glass
Flos, Bovezzo

Taccia table/floor light, 1962
Achille Castiglioni (1918–2002) & Pier Giacomo Castiglioni (1913–1968)

The Politecnico di Milano, founded in 1863 as the Istituto Tecnico Superiore, was to become during the twentieth century one of the most influential architecture and design teaching institutions in the world. The establishment of this august school of higher education had been originally influenced by the ideas of the Italian philosopher Carlo Cattaneo who argued for an interdisciplinary approach to learning and the primacy of practical solutions in his review *Il Politecnico*, first published in Milan in 1839. During the inter-war years and beyond, guided by this hands-on multi-disciplinary teaching method, the Politecnico became a hot house of design talent, boasting an impressive roll call of world-class alumni. It was this generation of designers and architects who would go on to fundamentally shape Italian design in the immediate post-war years and beyond, not only through the design of progressive products but also through their own design teaching at their alma mater.

Among this impressive crop of

highly talented Politecnico-trained creatives were the Castiglioni brothers, Achille and Pier Giacomo, who stand out for their remarkable ability to design products that had an underlying functional logic as well as an undeniable classical modernity. It was these key attributes that would over the years ensure that virtually all the products the brothers designed together went on to become icons and would ultimately define the look of Milanese design in the latter half of the twentieth century.

One of the Castiglioni brothers' most famous designs is the ingenious Taccia table light, which was launched in the early 1960s and has since become widely acknowledged as a much-loved classic of Italian design. Its construction incorporates three main elements – a fluted aluminum column that houses a hidden incandescent light bulb and provides ventilation openings to ensure that the light does not overheat, a rotating clear glass parabolic bowl that holds the reflector in place and can be used to alter the direction of the emitted light and a curved spun aluminum reflector that effectively bounces the emitted light into the room. Because of its impressive size, the design can be used either as a table light or a floor light, and therefore functions both as a light source and as a light sculpture. With its precisely engineered aluminium supporting column and perfectly formed glass bowl, the Taccia must have seemed a highly futuristic design solution when it was first introduced, and was certainly in tune with the space-age visions of the period.

Providing a soft diffused light that can be easily directed by turning the light bowl through 360 degrees, the Taccia is a simple yet highly original lighting solution that illustrates the Castiglionis' desire to "achieve adequate results with minimum means". By combining an overtly industrial aesthetic with a classical column-like form, the Taccia not only reflects the striking architectonic character of Milanese design but also presaged the ironic Neo-Classicist vocabulary of Post-Modernism that found such fertile ground in Italy during the early 1980s.

Above: Design drawing by Achille Castigiloni for the Taccia table/floor light, c.1962

Zig-Zag textile, 1962
Machine-knitted woollen yarn
Missoni, Milan

Zig-Zag textile, 1962

Ottavio Missoni (1921–2013) & Rosita Missoni (1932–)

Since its establishment in 1953, the Milanese fashion house Missoni has gained an international reputation for its kaleidoscopic range of bright colours, bold patterns and distinctive textures. Originally used only in their designs for knitwear, today the company's distinctive stripes and zigzags are applied to an ever-expanding range of clothing and accessories, from dresses and handbags to swimwear, home furnishings and fragrance packaging. Missoni is not just a design brand but a lifestyle choice.

The firm was set up by Rosita and Ottavio "Tai" Missoni as a workshop and factory for knitted ready-to-wear clothing in Gallarate, north of Milan. Born in Dubrovnik, Ottavio already had experience in the industry from a knitwear company that he had established in Trieste with athlete Giorgio Oberwerger where together they produced the tracksuits worn by the Italian team at the 1948 Olympics. Rosita too had experience in the field, as her family owned a factory manufacturing shawls, bedspreads and other embroidered fabrics near Gallarate. They got married in 1953, and established their company, which was at first a continuation of the Trieste business, in the same year. .

In these early years the duo worked with the Biki boutique in Milan and collaborated with its manager, Louis Hildago, on collections for Rinascente, the Italian department store. In 1958 they unveiled their first collection, a series of stripy shirt dresses called Milano-Sympathy. Present at the launch was the influential Italian fashion journalist Anna Piaggi, who would play a significant role in promoting their work to the fashion world. The early 1960s was marked by increasing success for the firm. They moved into larger premises in Gallarate in response to their expanding business, where they started experimenting with the patterns and textiles for which they would become best known.

The Zig-Zag design dates back to 1962. By then the designers were creating more complex variations on their original designs, but they were all still based on the stripped pattern. It was at this point that Rosita Missoni began using the machinery that would prove to mark a turning point for the company: the Raschel warp knitting machines that had produced the intricately embroidered fabrics at her family's factory and that could produce the zigzag pattern. The Missonis repurposed this machinery to produce knitted coats and jackets in the distinctive zigzag pattern, alongside ongoing experiments in striped, wavy and other styles in fabrics including rayon-viscose and silk.

In the 1960s and 1970s the Missonis gained ever-increasing prominence. They were part of a coterie of Milan-based designers, alongside the likes of Giorgio Armani and Krizia, who challenged Florence's historic crown as Italy's fashion capital. While the preference for minimalism in the 1990s saw a decline in Missoni's popularity, today the family-run brand is in healthy condition and has expanded into the hotel industry as well as overseeing a growing line of products that are instantly recognizable for their inimitable designs.

Above: A model wearing a colorful outfit designed by Missoni while posing on pillows covered in Missoni fabric, 1975

Arco floor light, 1962

Achille Castiglioni (1918–2002) & Pier Giacomo Castiglioni (1913–1968)

The arch has been a defining feature of Classical architecture since ancient times. Not surprisingly, Achille Castiglioni and Pier Giacomo Castiglioni referenced this archetypal and quintessentially Italian architectural form when trying to essentially restructure the traditional ceiling light into something more functionally flexibile.

Playfully subverting convention, their Arco (arch) floor light from the early 1960s transformed the ceiling light into an autonomous freestanding floor unit that could be moved as required. Street lighting, which by necessity often arches over the roads or pavements it is intended to illuminate, originally inspired this seemingly simple yet thoroughly ingenious solution. It is one of the Castiglioni brothers' best-known lighting designs and has spawned many knock-offs. The Arco was originally intended for dining areas, which is why the light source is positioned nearly 2.5 m (8 ft) away from its base, allowing sufficient room for a table and chairs to be arranged underneath its arching stem and centered below its polished aluminium shade.

Unlike most traditional fixed-placed ceiling lights, the Arco offers a degree of flexibility in that it has three separate height adjustments. Not all dining areas are sited in the centre of a room, but that is the place ceiling fixtures are traditionally located. The Arco, however, overcomes this common problem in that it is movable and can be used to illuminate a table wherever it happens to be positioned in a room. Two people can move it by inserting a broomstick through the hole provided in its base and then lifting and carrying it from either side into the required position. The weighty stabilizing mass of the 65 kg (143 lb) base is hewn from Carrara marble – a beautiful and distinctive white stone that has been quarried in the Italian alpine town of Carrara since Roman times and has been a favourite material of celebrated sculptors throughout history, from Michelangelo to Antonio Canova. The use of this finely grained marble gives the Arco both a sculptural and an architectural presence, and because it is a very dense and heavy material the Castiglioni brothers were able to securely anchor their arching design to the ground with the minimum of physical and visual mass. When it was first launched the Arco caused quite a stir, because nothing like it had ever been seen before. Its progressive credentials were further verified by its inclusion in the landmark 1972 The New Domestic Landscape exhibition held at the MoMA, New York.

More than 50 years after its introduction, the Arco remains more popular than ever since it is so well suited to open-plan, loft-style interiors. It is an enduring and undeniable design classic that eloquently characterizes the Castiglioni brothers' extraordinary ability to think outside the conventional design box and create products that were conceptually innovative yet at the same time grounded in practical reality.

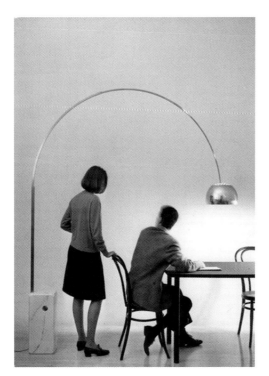

Above: Flos publicity photograph promoting the Arco floor light, 1960s

Arco floor light, 1962
Carrara marble, satin-finished stainless steel, polished aluminium
Flos, Bovezzo

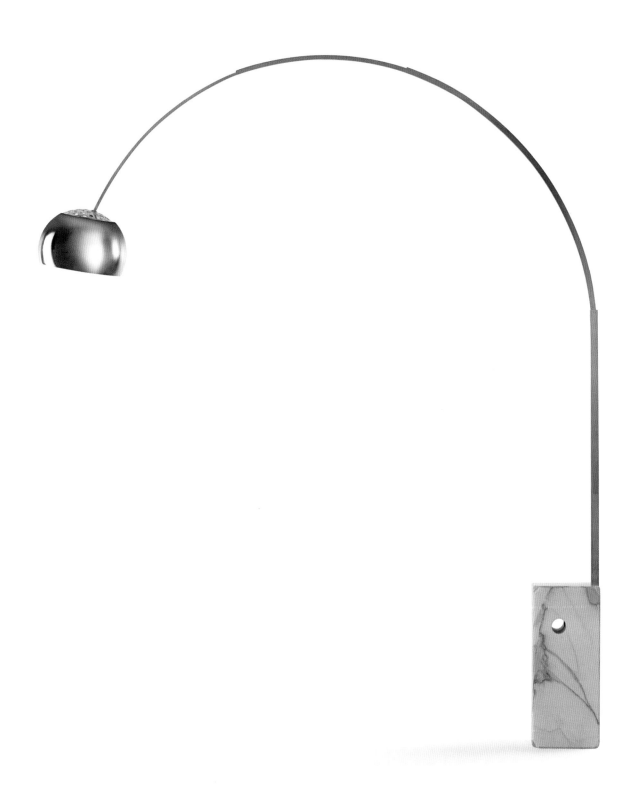

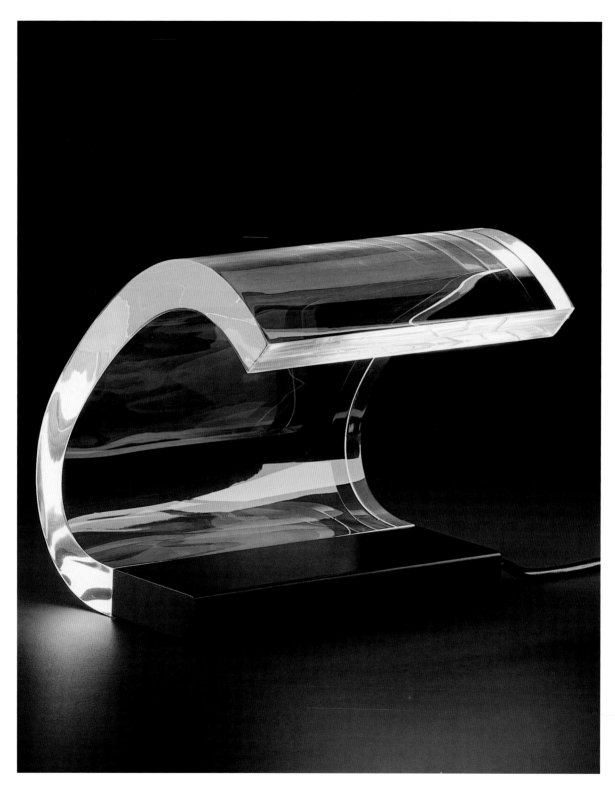

Acrilica table light, 1962–63
Polymethyl methacrylate (PMMA),
enamelled metal
Oluce, San Guiliano Milanese

Acrilica table light, 1962–63

Joe Colombo (1930–1971)

During the 1960s a plethora of newly available plastics expanded the formal and functional possibilities of design. During this period Italy already had a well-developed plastics manufacturing industry, renowned for its pioneering research and development. It is therefore not surprising that it was Italian designers above all others who explored the creative potential of these exciting new polymers. Indeed, together with Britain, Germany and America, Italy had been at the forefront of plastics manufacturing technology since the early 1950s with the Nobel-prize winning chemist Giulio Natta first polymerizing polypropylene in 1953 in collaboration with the Italian company Montecatini. With regards to lighting design, it was acrylic – or to give it is correct technical name, polymethyl methacrylate (PMMA) – that became

Above: Lobby area of the Pontinental Hotel in Asinara, Sardinia, designed by Joe Colombo, 1962–64 and published in *Domus* December 1964.

Pop designers' plastic material of choice.

This transparent glass-like thermoplastic was first used by Joe Colombo to make prismatic ceiling fixtures for the lobby area of the Pontinental Hotel in Asinara, Sardinia (1962–64). These early acrylic lights hung down like futuristic stalactites from the hotel's wooden panelling and diffracted the light in a very interesting manner, with the edges of the polymer blocks glowing more brightly than the rest – an optical phenomenon known as "live edge". The acrylic also helped to softly diffuse the emitted light and as such produced a pleasant indirect glow. This early interior design project was later awarded an IN-Arch prize in 1964 and can also be seen to be the genus from which Colombo would develop one of his best-loved designs: the Acrilica table light.

With his brother Gianni, Colombo evolved his hotel light fixtures into the design of the Acrilica table light, which was manufactured by Oluce. Awarded a gold medal at the XIII Milan Triennale in 1964, this elegant design can be seen as the culmination of Colombo's studies into the thermoplastic and optical properties of PMMA. Easily moulded using heat and pressure, the acrylic was formed into a C-shaped curve that eloquently revealed the material's extraordinary ability to carry light even round bends. A naturally transparent and colourless polymer with a high transmission level for visible light, polymethyl methacrylate is rather confusingly sold under numerous trade names, including Plexiglas, Lucite, Acrylex and Perspex. Although this impressive synthetic polymer had previously been used to make jewellery in the 1930s and medical equipment in the 1940s, it wasn't until the 1960s that its true expressive potential was fully exploited by Italian designers. Joe Colombo's landmark design skillfully utilized the material's almost magical optical properties to convey the optimistic and futuristic zeitgeist of the period to a stunningly dramatic effect.

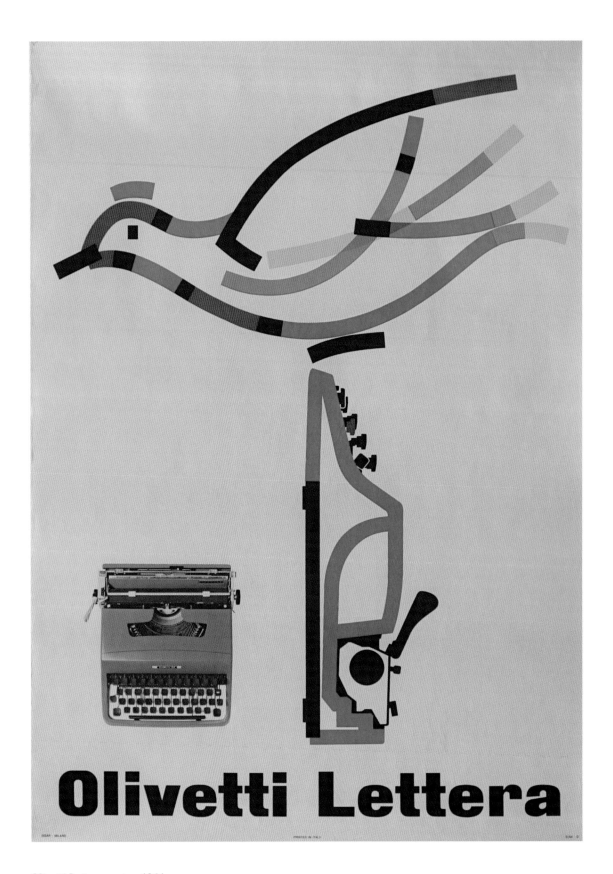

Olivetti Lettera poster, 1964
Offset printed paper
Olivetti, Ivrea

Olivetti Lettera poster, 1964
Giovanni Pintori (1912–1999)

Giovanni Pintori is one of the most celebrated Italian graphic designers of all time . His legendary career at Olivetti produced numerous distinctive and captivating posters and advertising campaigns that reflected the forward-looking optimism that Italy experienced during the 1950s and 1960s.

At the age of eighteen he had won a scholarship to study commercial graphic design at the ISIA (Istituto superiore di industrie artistiche) in Monza – one of the leading Italian art institutions of its day. It was there that he trained under the two great maestros of Italian graphic design, Marcello Nizzoli and Edoardo Persico. Nizzoli went on to become the chief designer at Olivetti and Perisco was eventually appointed the editor-in-chief and designer of the leading architecture journal, *Casabella*.

After graduating from ISIA in 1936, Pintori was invited to join the team at Olivetti's technical publicity department, where he undertook the design of posters, advertisements and publicity banners. Four years later he was tasked with running this important division, a managerial role that he remained artistically committed to for the next 27 years. During this creatively prolific tenure, he designed literally hundreds of posters and advertisements that fused typography, photography and illustration into eye-catching and thought-provoking works. Although Marcello Nizzoli had already laid down the groundwork for Olivetti's corporate identity, Pintori built upon this to ensure that Olivetti's corporate projections were kept up-to-date with current trends.

Pintori's impressive body of work was universally understood thanks mainly to its bold simplicity. This meant that his graphic communications, such as the poster advertising the Lettera typewriter from 1964 (shown here), worked extremely well in conveying Olivetti's cutting-edge design credentials across many language barriers. In fact, Pintori's work can be seen to have been a key element of the company's "total design" policy, which led to great export success during its golden years. Like Herbert Matter's graphic design work for Knoll International, Pintori's work for Olivetti had endearing humorous charm that hooked the viewer with its ever-so-stylish delivery.

Above: Olivetti advertisement for Lettera 22 typewriter by Giovanni Pintori, c.1964

Algol television, 1964

Marco Zanuso (1916–2001) & Richard Sapper (1932–)

Marco Zanuso and Richard Sapper's 1964 design for the Algol television set is intertwined with the changing status of television in post-war Italy. Up until the 1960s in Italy, as elsewhere, televisions tended to be boxed up in wooden cabinets, objects that spoke more of conventional furnishings and conventional craftsmanship than emergent technologies and the new aesthetic possibilities these brought. The Algol rejected this conservative approach in favour of a bold, colourful design that looked to the future of television rather than to its past.

Algol was the second television that Sapper and Zanuso designed for Brionvega. The first was the Doney, designed two years earlier in 1962 and significant for being the first portable transistor television. The Doney's compact design was possible thanks to a shift from wired to printed circuits and increasingly smaller components: a development that meant that designers could change not just the size, but also the shape, of television sets. This was what was distinctive about the later Algol set, whose design did not just overturn the idea of what a television was meant to look like, but where it was intended to live. Batteries meant that it did not need to be plugged into a mains socket, while the pullout handle and UHF circular and extractable VHF rod antennae assisted portability and storage. The tilted 11-inch screen meant that the set could be placed at any angle and on any surface, even on the floor. Zanuso compared this distinctive feature of the Algol's design to a puppy gazing up at its owner, a quality that can be interpreted as an expression not just of the informal modes of living championed in the 1960s but also of the changing relationship between man and technology at the time.

Zanuso and Sapper designed both Algol and Doney, along with 1965's TS 502 radio set and the Black television from 1969 for the TV and radio manufacturer Brionvega. Like many Italian manufacturers, Brionvega started life as a family firm, set up by the Venetian-born Giuseppe Brion and his wife Rita on moving to Milan at the end of the Second World War. Following experiences at the manufacturers Phonola and Radiomarelli, in 1945 Brion set up the firm BPM with the engineer Leone Pajetta. Initially devoted to producing electrical and electronic components, in the early 1950s they began producing their own radio sets and changed the company name to Vega: the brightest star in the Lyra constellation and a metaphor for the company's stellar ambitions in terms of both the quality of its output and the share of the market these would command.

In 1952 the firm ventured into the realm of television production and was responsible for the production of the first all-Italian manufactured television set. The firm continued to change its name throughout this period, first to Brion Vega and then merging the two to create the name as it is known today. From the start, Brionvega understood the potential of design to distinguish its wares from the rest of the marketplace, working first with Roldolfo Bonetto and then architects such as Zanuso, Sapper and the Castiglioni brothers. Following the death of Giuseppe Brion in 1968, his son Ennio Brion continued these collaborations, adding Ettore Sottsass and Mario Bellini to the cast of creative collaborators in the 1980s and 1990s.

Algol was produced throughout the 1960s, the decade seen to represent the high watermark of Brionvega's creativity and innovative approach; although even in this period the level of critical acclaim the firm received was not matched by sufficiently substantial sales. In 1992 the firm was taken over by Gruppo Seleco, which was then itself taken over by Industrie Formenti in 1997. In 2001 Brionvega restarted production of some of its most celebrated historic models, including an update of both the Algol television and TS 502 radio, which was reissued as the Model No. TS 522, and, with a radio alarm clock, as the Model No. TS 522 CR.

Algol television, 1964
ABS plastic, metal
Brionvega, Milan

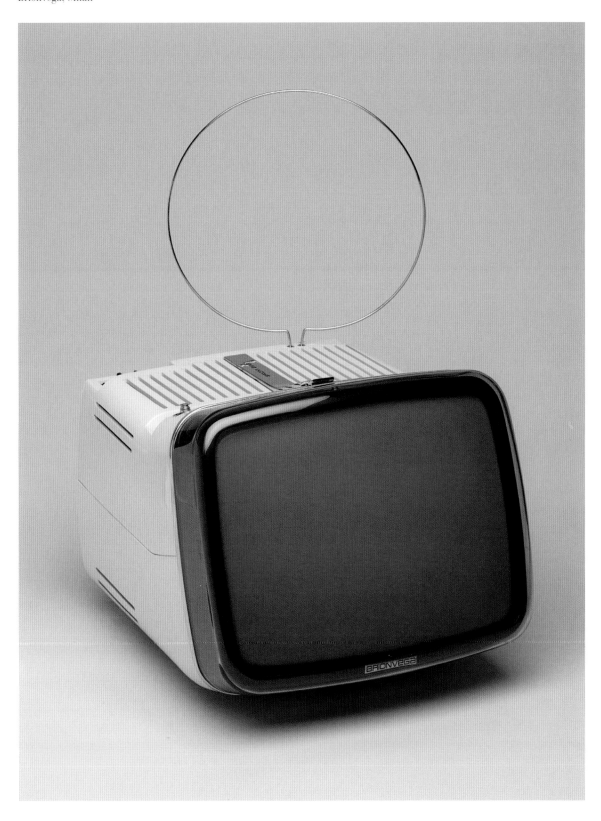

Smoke glasses, 1964

Joe Colombo (1930–1971)

Joe Colombo is a designer celebrated for his futuristic vision, an enthusiasm for the possibilities of tomorrow expressed in his bold, curving forms and exploration of the emergent realm of plastics. Colombo did not confine his experimentation to new materials and technologies, but also to redesigning existing forms, as seen in the unusual shape of his Smoke glasses from 1964.

Produced by Arnolfo di Cambio, Smoke is a range of differently-sized crystal glassware, identifiable for its cylindrical goblet and flat, thick circular base joined by a short, asymmetrical stem of varying length. While the range expresses a sculptural quality found in much of Colombo's art and design practice, it is actually a highly functional response to a problem that the heavy-smoking designer was keenly aware of – how to hold a drinking glass and a cigarette in one hand at the same time. The unusual asymmetric stem of the crystal glass, which is the focal point of the design, was conceived ergonomically to allow the user to hold a glass comfortably and securely with just the hook of their thumb, leaving their index and middle fingers free to hold a cigarette.

Above: Assimetrico glass designed by Joe Colombo for Tiroler Glashütte/Claus Joseph Riedel K.G., 1964

Arnolfo di Cambio, a glassworks located in Colle Val d'Elsa, a Tuscan town historically renowned for its manufacture of crystalware, put the Smoke glassware range into production in 1964. Founded the previous year, Arnolfo di Cambio was a newcomer to the town's manufacturing landscape and was endowed with youthful energy that informed its openness to the contemporary design scene, seeking out collaborations with other celebrated architects such as Sergio Asti, Cini Boeri and Ettore Sottsass. The results of these collaborations, along with Smoke, continue to appear in Arnolfo di Cambio's catalogue alongside more recent collaborations with the likes of Konstantin Grcic and Alberto Nason. Despite its receptiveness to innovative modern design, the company remains committed to handcrafted, artisanal high-quality production with skilled glassblowers and hand-cutters producing each piece individually, so that it is rare for any one piece to be exactly the same as another.

While Smoke was the only design he produced for Arnolfo di Cambio, this was not the only glassware that Colombo created. In the same year he designed another version of the asymmetric glassware for the Austrian manufacturer Tiroler Glashütte, Claus Joseph Riedel K.G. Included in MoMA's permanent collection, the aptly named Assimetrico (asymmetric) drinking glass shares the same off-centre design, albeit this time with an organically shaped stem that flares out to form the base. Unlike the Smoke, however, this design was never intended to serve the dual-function of allowing the user to both smoke and drink at the same time, but rather it enabled the user to hold a glass comfortably and securely thanks to its ergonomic form.

Beyond these drinking glasses, Colombo designed other products with his own habits and love of socializing in mind; including 1969's Optimal, a highly innovative pipe designed to stand independently on both its horizontal and vertical axes. While Colombo's design career ended with his premature death in 1971, his objects continue to have a value beyond their bespoke purpose and amidst changing social customs, making Smoke a highly useful and desirable design for both smokers and non-smokers alike.

Smoke glasses, 1964
Lead crystal
Arnolfo di Cambio, Colle Val d'Elsa

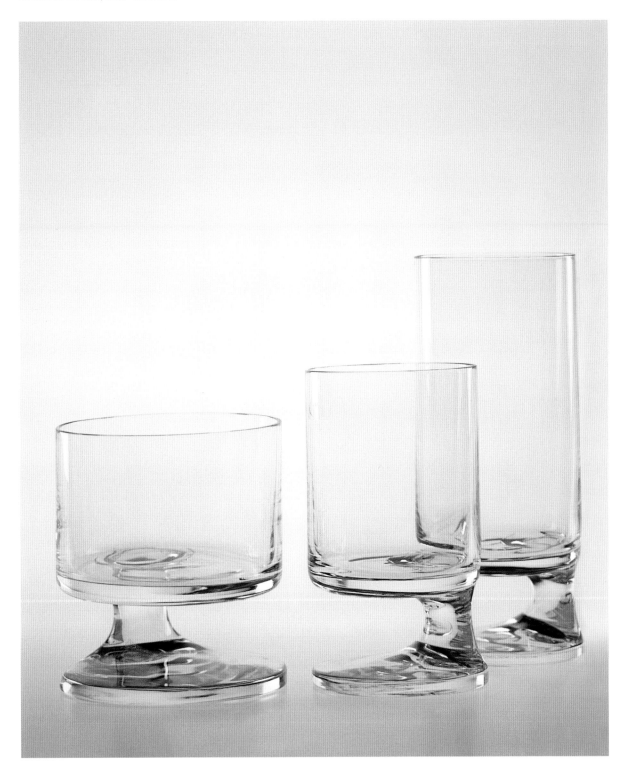

SF.260 light attack/trainer aircraft, first flight 1964

Stelio Frati (1919–2010)

The sheer high-speed manoeuvrability of the SF.260 airplane is quite simply astounding, especially when seen in a flying demonstration as it swoops and dives at seemingly impossible earth-gratingly low levels. The mechanical engineer and aircraft designer Stelio Frati originally designed this light aircraft for the aircraft-manufacturer Aviamilano. It was actually put into production by another Italian company, SIAI-Marchetti, which acquired the production rights to its design shortly after the first flight of its prototype (the SF.250) on the 15th of July 1964.

The SF.260 was specifically designed to be an agile sports plane to be used for aerobatics, however, it soon found an additional role as a military trainer. It is an acknowledgment of this aeroplane's nimble handling and flying-style adaptability that even today, some fifty years after its introduction, it remains in production and is used extensively as both a trainer for young pilots and as a light-attack aircraft by twenty-seven different air forces around the world, including the Italian Air Force. It has also been used in recent years as a fighter trainer for NATO forces. Additionally the SF.260

boasts an impressive operational history considering its diminutive size, having seen active service in numerous troubled hotspots where conflicts have erupted over the last few decades, from Chad, Libya and Sri Lanka to Nicaragua, Zimbabwe and the Philippines.

So what is it about Stelio Frati's design that has made the SF.260 such a high-flying phenomenon? Well, first of all it just looks "right", which is often a sure sign that the designer has managed to get the aerodynamics of an aircraft spot-on. As Nigel Moll noted in the October 1984 issue of Flying magazine: "To Stelio Frati, needless aerodynamic drag is the greatest evil. Nearly all of his designs are variations on a theme, and each is instantly recognizable as 'a Frati'. They are fast for their horsepower and they look it. Frati has been widely hailed as a genius, the Dior of airplane designers."

As a young boy, Frati learnt the fundamentals of aerodynamics by building models, which were so technically sophisticated that he became the Italian national champion for powered free-flight models in 1940. He subsequently trained as a mechanical engineer at the Politecnico di Milano and, while there, assisted in the design of a radial-engine flying bomb. Once the war had ended, the Politecnico opened a new aeronautical department and Frati taught aircraft design there for the next ten years, which gave him the time to expand his already considerable knowledge.

During the 1950s Frati went on to design a number of distinctive production aircraft, but it was the SF.260 that was to really solidify his reputation as a veritable maestro of aircraft design. The SF.260 was Frati's first all-metal aeroplane and was originally piston-engine driven, however, a later turboprop version – the SF.260TP – was introduced in 1980. With its beautiful streamlined form, the SF.260 boasted fabulous handling and impressive aerobatic capabilities, but it could also be fitted with weapon pods for tactical strikes and radar for surveillance and rescue missions giving it a true functional versatility. But above all the SF.260 became one of the world's most revered training aircraft, and the reason for this is probably because it is just so much fun to fly thanks to its sporting DNA.

Above: Vector drawing of the SF.260 aircraft

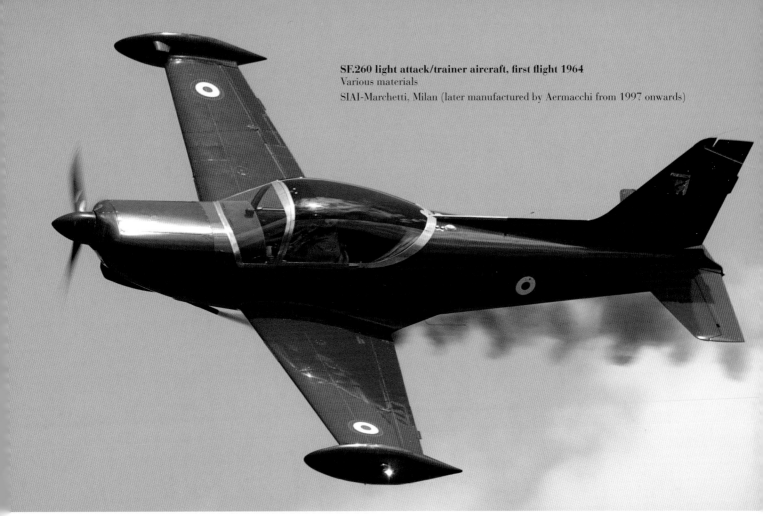

SF.260 light attack/trainer aircraft, first flight 1964
Various materials
SIAI-Marchetti, Milan (later manufactured by Aermacchi from 1997 onwards)

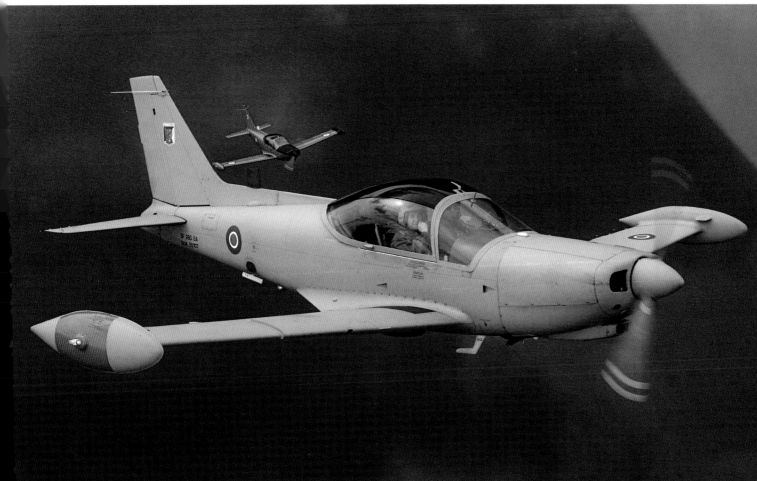

Model No. TS 502 radio, 1965
ABS plastic, aluminium
Brionvega, Milan

Model No. TS 502 radio, 1965

Marco Zanuso (1916–2001) & Richard Sapper (German, 1932–)

In 1965, one year after they designed the portable Algol television, Zanuso and Sapper designed their first radio – the portable TS 502. As with their other designs for Brionvega, the TS 502 broke the mould of radio design with its bright colours and a highly experimental, sculptural cuboid form. Available in a number of colours including red, white, yellow and black, their design defied the conventional aesthetic for radios in Italy up to that point, and exemplified Italian designers' attempts to celebrate plastic, elevating it from a material of cheap imitation to one worthy of use by innovative designers. Like other Italian manufacturers, Brionvega was not afraid to explore the aesthetic and cultural possibilities offered by new materials and technologies, and in the case of the TS 502 fully exploited both the potential of newly available ABS plastic and the increasing miniaturization of transistorized equipment.

The most distinctive element of the TS 502 is that it is a radio of two halves. This was the first folding radio, consisting of two identical vacuum-moulded ABS cubes hinged together. When open, the black surfaces of the interior contained the dials and displays for operating the radio. Closing the two halves dramatically changed the object's appearance, transforming it from a radio set into a sculptural object that gave no hint of its technological function. Each element conspired to lend the product this mysterious appearance, from the fold-down antennae to the rectangular metal handle that fitted flush with the top of the surface.

The designers' interest in the cuboid radio form did not end with the TS 502; in 1965 they designed the RR 127, also for Brionvega, which comprised largely the same components, albeit this time in a vertical rather than horizontal arrangement.

Sapper and Zanuso received widespread recognition for their innovative designs for the TS 502 and the earlier Algol: both are housed in MoMA's permanent design collection, both were nominated for a Compasso d'Oro and each was awarded gold at the second biennial exhibition of industrial design at Ljubljana in 1965. Recognizing the importance of keeping up-to-date with changing technologies, in 1966 Brionvega improved the technical performance of each, and new models were put into production in the 1960s and 1970s; in 1977 the radio was reissued as the TS 505. More recently, following the acquisition of Brionvega's radio and sound division by the specialist Italian audio producer, SIM2 Multimedia, the radio was reissued as the Model No TS 522, and also with a radio alarm clock as the Model No. TS 522 CR.

Above: Brionvega advertisement for the Model No. TS 502 radio, 1968

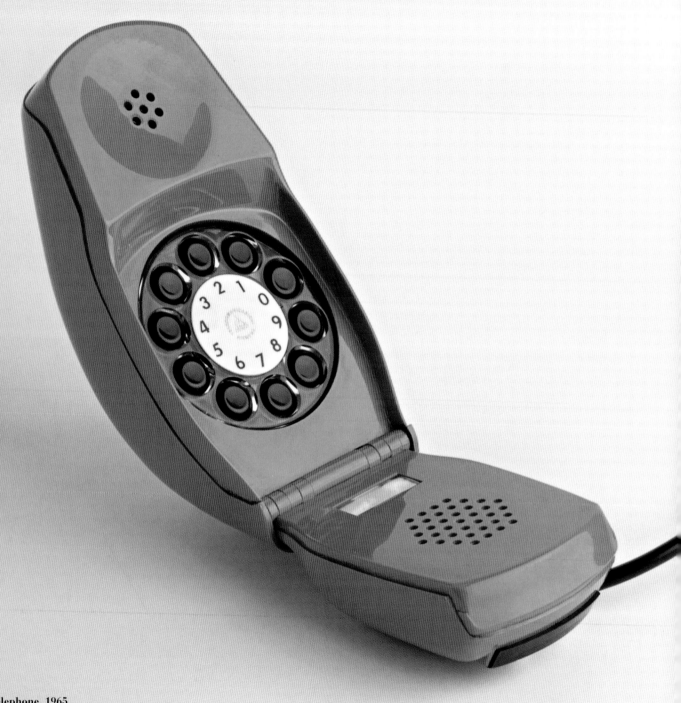

Grillo telephone, 1965
Acrylonitrile-butadiene-styrene (ABS), other materials
Società Italiana Telecomunicazioni Siemens, Milan

Grillo telephone, 1965

Marco Zanuso (1916–2001) & Richard Sapper (1932–)

Marco Zanuso and Richard Sapper began working together in 1958 and over the next nineteen years created numerous groundbreaking products together. These designs always reflected Zanuso's extraordinary ability to develop new forms and applications from newly developed materials, and Sapper's innate understanding of how to create purposeful solutions through highly resolved engineering. The Grillo was one of their most notable products – a revolutionary telephone design that folded in on itself to create a compact sculptural form.

The name of this telephone design means "cricket" in Italian, and refers to its unusual springing action when picked up and its curious chirping ringtone. In addition, the Grillo had a rotary dial integrated into its main body – an innovative feature that was to prove highly influential for the design of subsequent telephones. The origins of this landmark product can be traced to an earlier design for a folding telephone patented by Marco Zanuso in 1963, the rights to which were held by the Società Italiana Telecomunicazioni Siemens. This earlier design, which never made it into production, was less ergonomically refined than the later Grillo and had a harder-edged aesthetic. Essentially, Siemen's wanted a lighter and more compact model than its existing range of telephones, which could also be moved around rather than having to be fixed to a wall or remaining in a static position on a table. The Grillo was Zanuso and Sapper's response to this brief and, with its compact design encased in a clam-like body made of shiny ABS plastic, it fulfilled the company's need eloquently and also extremely stylishly.

Made feasible by the availability of newly developed thermoplastics and the increasing miniaturization of technology, the Grillo was a highly integrated design that could be held in the hand as a single unit. When at rest, the closed Grillo had the appearance of a smooth pebble, with its fluid lines inviting interaction, but, when opened for use, its earpiece and mouthpiece were perfectly placed ergonomically. Furthermore, this seminal design not only exploited the strength and tactile smoothness of ABS but also the fact that this innovative new thermoplastic could be dyed easily to produce a number of attractive hues: white, red, orange, khaki green and mid-blue. This naturally made the telephone still more appealing, especially to younger and more fashion-conscious consumers.

A testament to Zanuso and Sapper's imaginative and human-centric approach to problem solving, the Grillo telephone subsequently received a Compasso d'Oro award in 1967 – the Italian design community's greatest accolade.

Above: Alternative view of Grillo telephone showing it closed and with its specially designed plug

Model No. RR 126 radio-phonograph, 1965

Achille Castiglioni (1918–2002) & Pier Giacomo Castiglioni (1913–1968)

Designed in 1965, the Model No. RR 126 radio-phonograph is one of the last designs produced in the 25 year partnership between Achille and Pier Giacomo Castiglioni, who died just three years later. Produced by the Milanese radio and television manufacturer Brionvega, it demonstrates an enthusiasm for new technology combined with a flexibility and user-orientation that was evident throughout all of the Castiglionis' celebrated designs.

The distinctive appearance of the RR 126 is in part due to its lack of a fixed form. The freestanding system consists of three separate parts, each with coloured laminated wooden surfaces and brown rims, which can be arranged in a number of different configurations. The radio was designed for semi-professional use, which informed both this innovative modular design as well as the system's stereophonic high-fidelity sound quality.

At the centre of the sound system is the oblong body section that contains an AM/FM radio receiver, hi-fi amplifier and a record player with a detachable Perspex lid that sits on top. Located on the front of the system are the displays, control dials and buttons, whose large size enables easy tuning and adjustment of both tone and volume. Their positioning resembles a human face, lending the RR 126 an anthropomorphic and playful quality that exemplifies the designers' understanding of the need to inject warmth and familiarity into these advanced technologies.

On either side of the central section are two loudspeaker cubes that can be configured depending on how the sound system is being used: stacked on top of the main part of the radio, disabling the record player but optimising up-close sound; flanked on either side of the central section or detached completely and placed elsewhere in the room to maximise stereophonic sound, a feature possible thanks to the extension leads that attach the speakers to the rest of the sound system.

These elements sit on top of the sound system's stand, a single column in an inverted T shape. Made of cast aluminium, its base includes four castors that make it easy to move, further enhancing the radio's user-friendly design. Despite the RR 126's industrial appearance, the wooden speakers and aluminium stand are not mass-produced but are handmade by Italy's reservoir of artisans. As with several other designs from the 1960s, the value of the design continues to be recognized – in 2008, Brionvega and SIM2 Multimedia reissued the radio-phonograph as the RR 226, updated in line with technological advancement, including the addition of a CD and MP3 player.

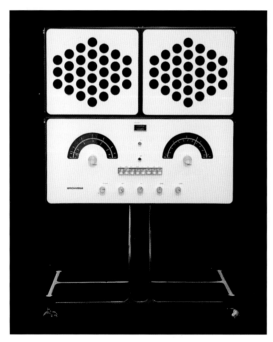

Above: Alternative view of the Model No.RR 126 radio-phonograph with its speakers folded up

Model No. RR 126 radio-phonograph, 1965
Plastic laminate, masonite, aluminium
Brionvega, Milan

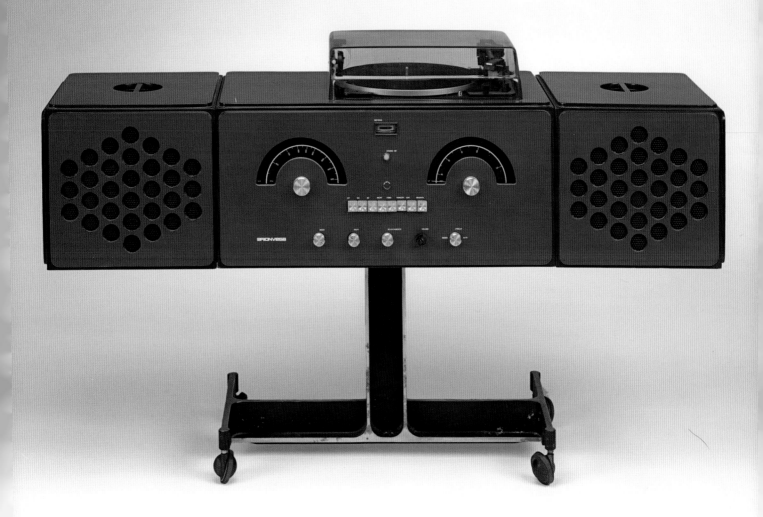

Cifra 3 table clock, 1965
ABS plastic, metal
Solari & C., Udine

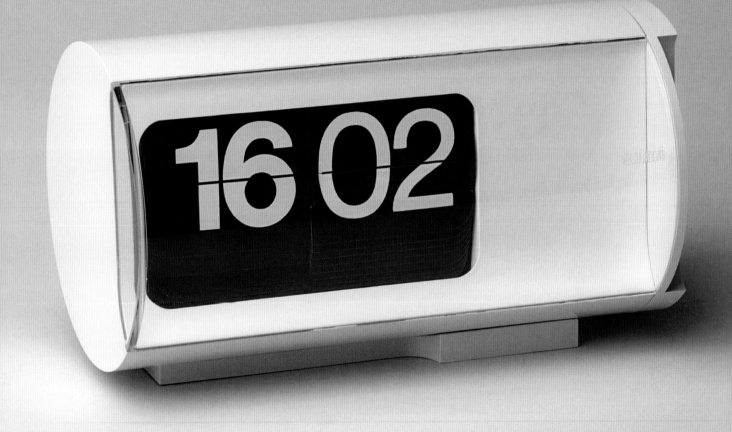

Cifra 3 table clock, 1965
Gino Valle (1923–2003)

The architect Gino Valle started out his career in the architectural office of his father, Provino Valle, located in their native town of Udine. He rose to prominence in the late 1950s following the establishment of his architectural studio in the town in 1955, with his sister the architect Nani Valle. Alongside the studio's design of buildings for both public and private use, Valle also worked as an industrial designer and in the 1950s designed refrigerators, cookers and other domestic appliances for Zanussi, clocks for the Ritz Italora and transport indicator boards for train stations and airports for Solari, the Udinese clock manufacturer. He also used his expert knowledge of electro-mechanical technology to develop a range of cylindrical table clocks, of which the cream Cifra 3 model from 1965 is the best known.

Like his earlier indicator boards, Cifra 3 used a split-flap display that was easy to read. In this case, a battery-powered rotating cylinder that turned the flaps over in order controlled the numbers.

Above: Side view of the Cifra 3 table clock

Initially the flaps were produced in metal and then later in plastic, with black backgrounds onto which the white numbers were printed. To enhance the clock's legibility even further different "weights" of the famous Helvetica font were used in order to easily distinguish between hours and minutes. The clock's graphics were not actually designed by Valle, but by the Unimark International Studio, whose founding members in 1965 included the celebrated designer Massimo Vignelli, best known for his design for the New York City Subway system map and his corporate identity designs for Knoll. The Cifra 3 was, however, a perfect synthesis of geometric purity with graphic clarity. Its stark pared-down cylindrical housing made of shiny ABS plastic and transparent polycarbonate offered the perfect clean "white space" setting for the display of numerals. Valle's highly considered layout of this clock also incorporated a discreet yet easy-to-understand semi-circular control on the design's right-hand side – because the majority of users would be right rather than left-handed – which allowed the hours and minutes to be adjusted independently.

The Cifra range of clocks debuted in 1956 with the Cifra 5, designed by Valle, his sister Nani, the Belgian designer John Myer and the graphic designer Michele Provinciali. Comprising two separate square windows for the hours and minutes, the Cifra 5 was recognized as a landmark design with the awarding of a Compasso d'Oro the same year. Given the success of its predecessor, the Cifra 3, with its more compact and simpler design, had its popularity on the marketplace guaranteed. Although analog clocks have since lost ground to digital technology, the company continues to manufacture various Cifra clock models, including the rectangular Cifra 6010 model.

Eclisse table light, 1965
Vico Magistretti (1920–2006)

The diminutive Eclisse table light is one of Vico Magistretti's best-loved lighting designs, and even though it was designed nearly half a century ago it remains in production with its original manufacturer thanks to its enduring good looks and functional appeal.

Awarded a coveted Compasso d'Oro award in 1967, this lighting design comprises three hemispheres of enamelled aluminium, a construction that is seemingly simple yet also utterly ingenious. The idea for the light's overall design first came to Magistretti while he was travelling on Milan's subway system and thinking about the scene from Victor Hugo's *Les Miserables*, when the police are pursuing the story's protagonist, Jean Valjean, through the dark sewers of Paris. As the story goes, "The sergeant in command of the patrol had raised his lantern, and the squad had begun to gaze into the mist in the direction whence the sound proceeded. This was an indescribable moment for Jean Valjean. Happily, if he saw the lantern well, the lantern saw him but ill. It was light and he was shadow."

For Magistretti this was a "eureka moment" as he realized that this idea could be applied to the design of bedside lighting, where there is a need for easy regulation of brightness. He subsequently sketched a design for a light made of three hemispheres – one acting as a base, another as a shade and the third controlling the amount of light emitted by functioning as an eyelid-like shield.

The resulting product, which was introduced by Artemide in 1967, has a rotating element that provides an almost solar-eclipse effect, as it partially obscures the light source to a varying degree depending on how far it is adjusted manually by the user. Because this device allows the emitted light to be controlled very precisely, it means that any refracted light is kept to a minimum, which is good news for anyone else trying to sleep while a partner is reading in bed. In fact, the light's title means "eclipse" in English. As with other lighting designs by Magistretti, the play of light accentuates the juxtaposition of the simple geometric forms used. Although small in scale, the Eclisse has a strong sculptural and characterful presence that has ensured its status as an enduring icon of 1960s Italian design.

Left: Artemide promotional photograph showing two Eclisse lights when their visor elements are fully closed

Eclisse table light, 1965
Enamelled aluminium
Artemide, Pregnana Milanese

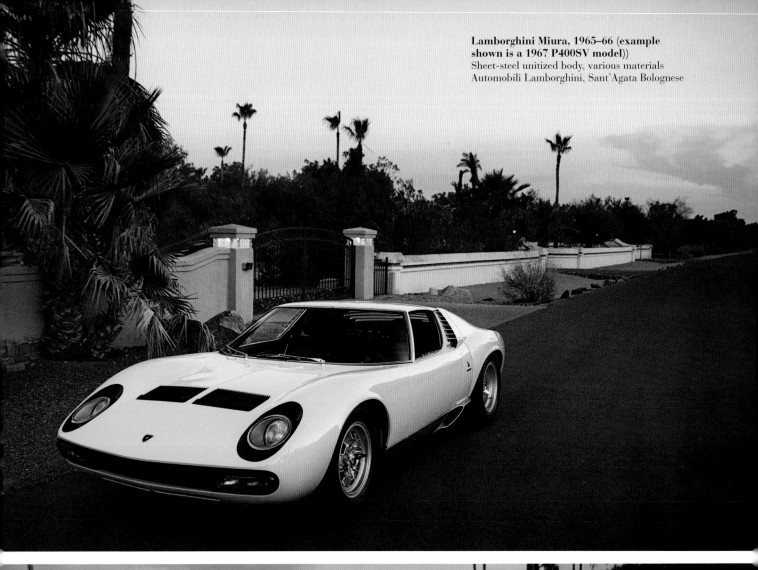

Lamborghini Miura, 1965–66 (example shown is a 1967 P400SV model))
Sheet-steel unitized body, various materials
Automobili Lamborghini, Sant'Agata Bolognese

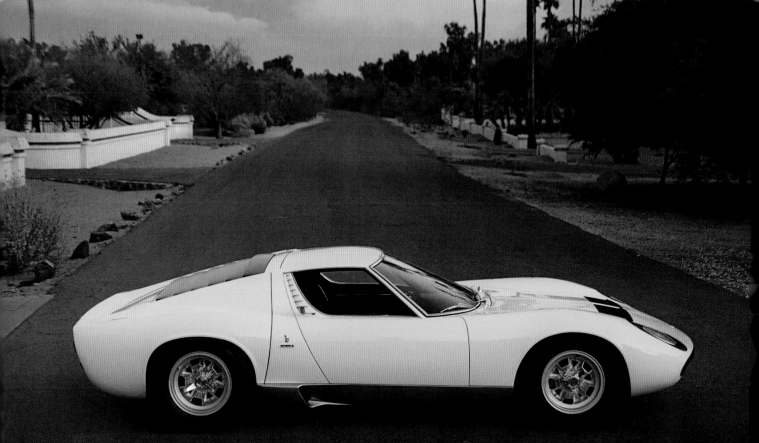

Lamborghini Miura, 1965–66
Giorgetto Giugiaro (1938–) & Marcello Gandini (1938–)

Believed by many car aficionados to be the greatest Lamborghini ever made, the Miura was also the world's first "supercar" – a term reputedly coined by the renowned British motoring journalist L.J.K. Setright to describe this remarkable vehicle, which was then the fastest car on the road. Setright also wrote an expanded article about the Miura that was published in the December 1967 and January 1968 issues of *Car* magazine, which detailed his "1000 miles in the Miura" road trip across Europe and extolled the design's high performance virtues.

The naked chassis of this extraordinary automobile was created by the famous automotive engineer Gianpaolo Dallara and was first unveiled at the Turin Salon in 1965, where it created a sensation thanks to its radically new mechanical layout which featured a quad cam V12 engine mounted centrally and transversely to the rear, thereby breaking all pre-existing rules about how one should build a really fast car. These controversial bare bones were then subsequently clothed in one of the most beautiful car bodies ever styled by Bertone. Who exactly at Bertone was

ultimately responsible for this tour de force in sensuous gleaming metal is still a matter of conjecture. Marcello Gandini is generally credited with the design of the Miura, but as the car critic and design guru Stephen Bayley has pointed out, "Authorship of masterpieces is often disputed. Ask any Titian expert. It is no different with the Lamborghini Miura… Because [Giorgetto] Giugiaro left Bertone for Ghia as the Miura design was being finalized, his successor, Marcello Gandini, could claim it. But history will prove the concept was Giugiaro's – early autograph sketches prove it."

In fact the Miura was the result of both Giugiaro's and Gandini's work and, therefore, they should share the credit for it. It was a design with a truly astonishing voluptuous appearance, and twinned with its high-performance credentials the overall package was utterly deserving of its "super" prefix. It was also a stroke of genius by Lamborghini to offer it in such shocking hues that absolutely enhanced its bold and distinctively un-Ferrari lines. The gleaming acidic lime green or bright orange paint finish shouted loudly that this was a car that thought good taste, aka "good design", was boring, much like the Anti-Design groups whose work was coming to the fore in Italy around the same time, such as Superstudio and Gruppo Strum.

The Lamborghini Miura was a superlative sports car that became a potent symbol of both youth and wealth, and it was utterly uncompromising – for example, it was designed to be very low to the ground, which meant you needed to be pretty agile, indeed young, to even be able to get in and out of it. This was a true supercar that was not only about throbbing power and jaw-dropping speed – with a top speed of 171 mph (276 kph) and an acceleration of 0–60 mph in 6.7 seconds – but was also about creating a personal statement through brash look-at-me design. It was a flagrant and provocative challenge to Ferrari's supremacy and in this case the ambitious Mr. Ferrucio Lamborghini certainly created a brand-building performer that many would argue was not just the first real supercar but possibly the ultimate supercar of all time.

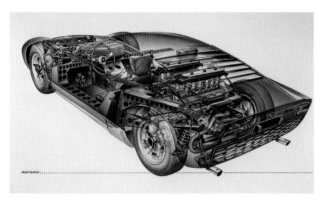

Above: Diagram showing a cut away of the Miura car's internal layout

Overleaf: Lamborghini Miura P400SV, 1967 showing the distinctive opening of the bonnet and rear end

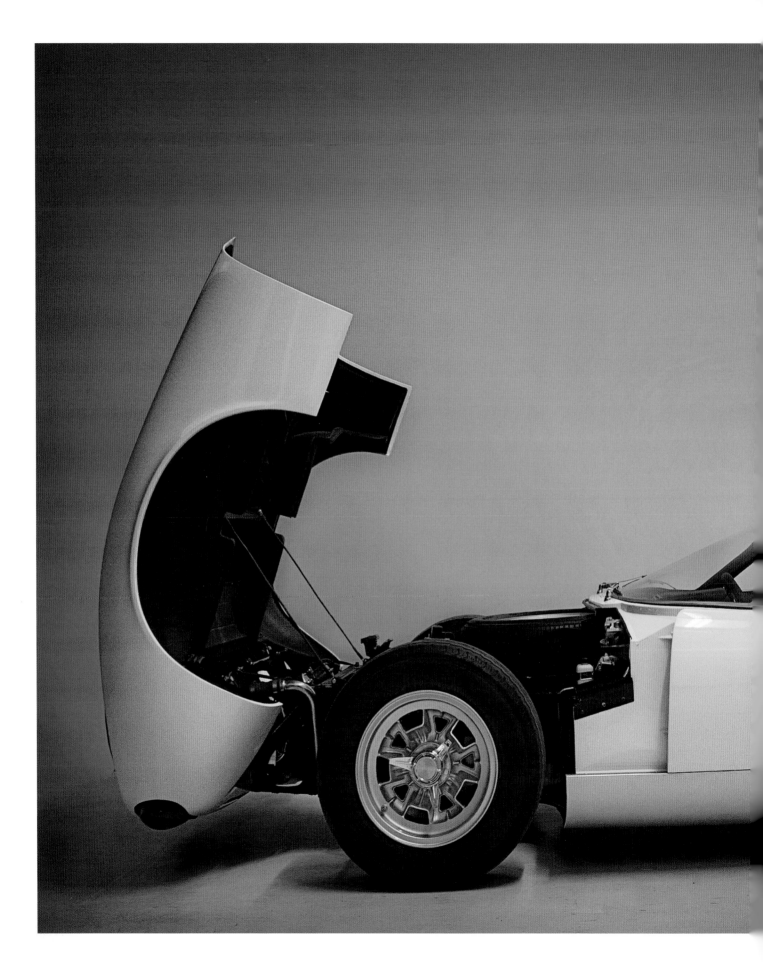

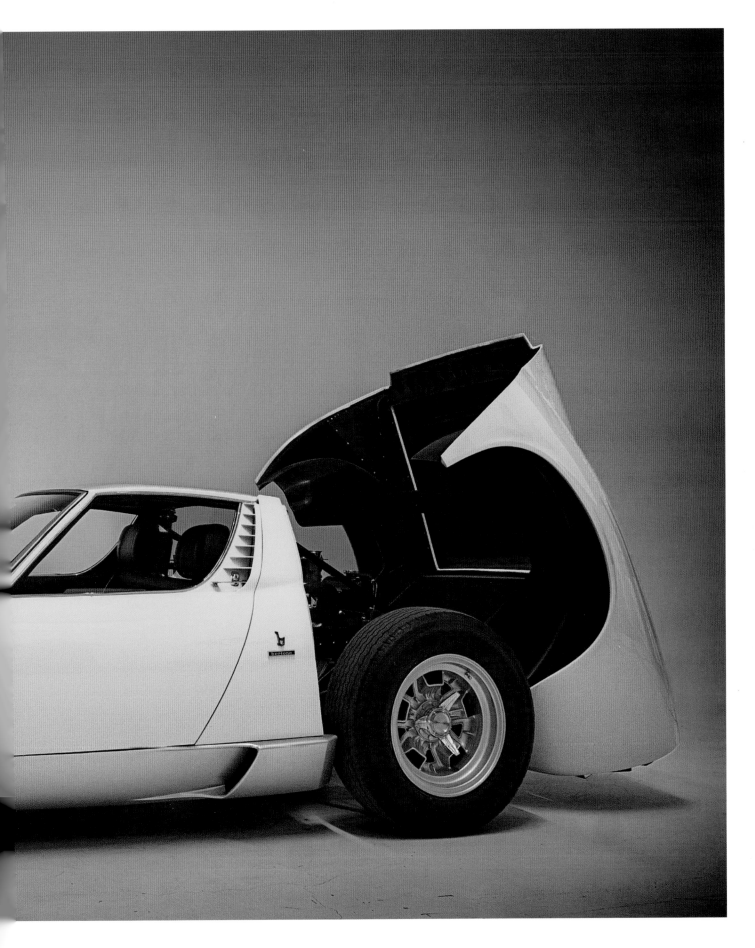

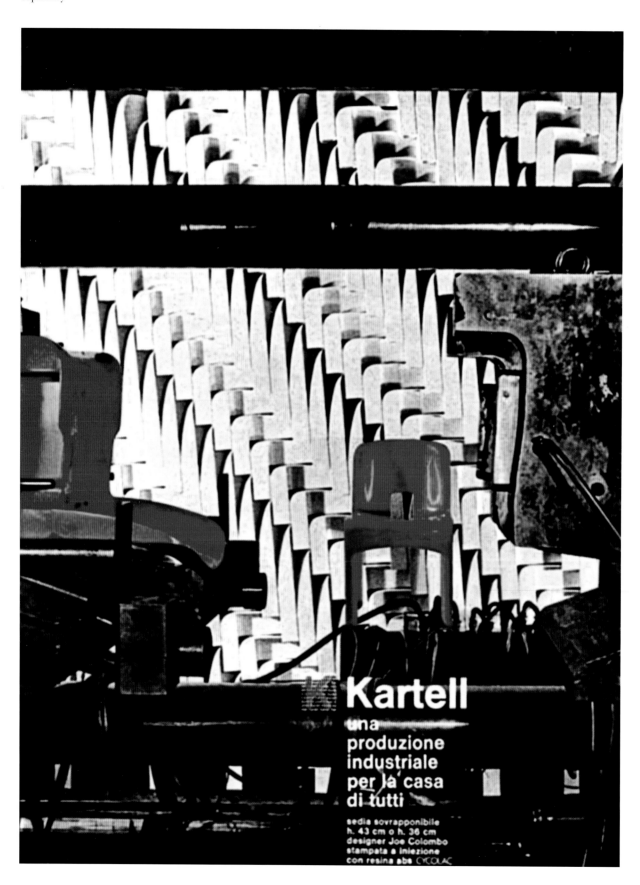

Model No. 4860 Universale chair, 1965–67

Joe Colombo (1930–1971)

Throughout the history of design, the idea of universality has captured the imaginations of designers trying to create the better product. Universality implies a shared need and a democratic solution. Universality in a specific product has also often meant built-in adaptability – can the design be altered to perform different tasks to suit different user requirements in different contexts? Universality has similarly always implied affordability – is this product cheap enough for the everyman to be able to buy it? Indeed, the notion of universality in design, until relatively recently, was seen as a utopian goal.

The most influential Italian designer of his generation, Joe Colombo was captivated by the idea of universality as he wove the future into the present with his Space Age designs. He enthusiastically embraced the concept of large-scale mass production and the possibilities presented by new synthetic materials and advanced manufacturing technologies. Colombo continued to experiment with different polymers and moulding techniques throughout his short yet highly productive career, resulting in the creation of several landmark product designs in plastic, all of which were intended to have a universality

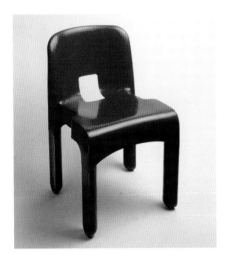

Model No. 4860 Universale chair, 1965–67
Acrylonitrile-butadiene-styrene (ABS) (1967–70); polyamide (PA – nylon) (1971–75); polypropylene (PP) (1975–present)
Kartell, Noviglio

of appeal. The most influential of these was his aptly named Universale chair, developed between 1965 and 1967 for the famous Milanese furniture company Kartell.

A major landmark in the history of seating design, the Universale was the first adult-sized, single-material plastic chair manufactured in an injection-moulded thermoplastic – in this case glossy-surfaced ABS. As with his other designs function and materials ultimately determined the bold and sturdy form of the Universale. Its development pushed both the physical limits of the polymer employed and the outermost boundaries of plastic moulding technology, and as a result it took two years of painstaking research and development to make the transition from die-cast aluminium prototype to final production model.

As its name makes clear, Colombo intended the chair as a universal seating solution – a goal that he largely achieved with a single-form seat and back section that could be used with three different interchangeable sets of legs at different heights, producing thereby a bar stool, a dining chair and a low lounger. This quintessential Pop design also stacked relatively well, and the hole in its back made it easy to remove from the mould and functioned as a handhold, allowing the design to be carried effortlessly.

By being mass-produced from plastic it was also intended to be relatively inexpensive to buy – a key attribute of any universal product. Unfortunately, the first plastic used in its production, ABS, proved less than ideal as it became brittle when left outdoors. Between 1971 and 1975 nylon was adopted instead, but was to prove too expensive and insufficiently resistant to water. Since 1975, however, the design has been made in polypropylene, an altogether more resilient and durable polymer – and it is this inexpensive thermoplastic that eventually enabled the Universale chair to become a workable universal design.

Colombo can be seen as a design visionary, whose iconoclastic modular products, including this boldly formed plastic chair, were charged with his optimistic dreams of a futuristic utopia. Yet these products also relied upon the availability of inexpensive and colourful plastics – for they were ultimately visions of the Sixties plastic age.

Blow chair, 1967
Gionatan De Pas (1932–1991), Donato D'Urbino (1935–) & Paolo Lomazzi (1936–)

The origins of vinyl resins go back to 1838, when a French chemist, Henri Victor Regnault, observed the formation of a white powder when sealed tubes of vinyl chloride were left in the sunlight. It was not until the mid-1960s, though, that flexible and transparent PVC (polyvinyl chloride) became widely available thanks to the accelerated technological advances made in the development of synthetic materials during the Second World War. Both flexible and rigid PVC had been developed in Germany during the 1930s and were subsequently used there during the war years to compensate for shortages of more conventional materials. After the war, the Allies undertook research into Germany's wartime industries and, as a result of these studies, widely publicized the uses of this remarkable synthetic material. It was, however, the glittering age of Italian design that lasted from the mid-1960s

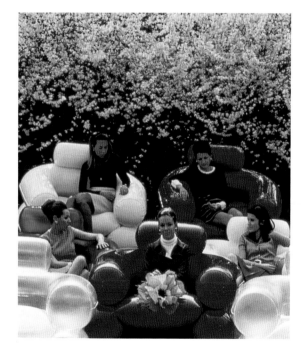

Above: Zanotta promotional photograph of the Blow chair, c. 1967

and the early 1970s, when PVC ultimately reached the zenith of its popularity. In fact, high-frequency, electronically welded PVC offered a whole new world of design possibilities, which can be summed up in one catchy word: inflatables.

Although numerous blow-up chairs and sofas were created during the mid-to-late 1960s – a period of intense creative experimentation in design – it was the Blow chair that became the most celebrated inflatable of the era. Designed for Zanotta by the Milanese design trio, Gionatan De Pas, Donato D'Urbino and Paolo Lomazzi, the Blow chair stood out not only as the first mass-produced inflatable chair from Italy, but also as one of the most commercially successful and widely disseminated seating designs of the period.

As a veritable icon of 1960s Pop culture, the Blow chair's carefree expendability dismissed the traditional associations of furniture with costliness and permanence. This was a design to be bought on a whim, while the act of blowing it up added an element of playful user interaction. Intended to be used indoors or out, the Blow chair was offered in an array of attractive colours as well as in a completely clear version, and was sold in a box so that it could literally be bought off the shelf and taken home – making the act of purchasing furniture a completely spontaneous event. The Blow chair heralded a more youthful and carefree spirit in design. It celebrated ephemeral novelty as well as the aesthetic and functional potential made possible by new polymers – and what could have been more transient than an inexpensive chair made of transparent PVC and filled with air?

Although a quintessential Pop design, the Blow chair can also be seen as the culmination of the Modern Movement's desire for ever increasing reductivism. To this end, the architect, furniture designer and one of the greatest pioneers of the Modern Movement, Marcel Breuer had earlier theorized during the 1920s that the ideal chair of the future would ultimately be a seating design that allowed the user to sit on a "resilient column of air". Paradoxically, it was the anti-Modernist, expendable Pop-inspired Blow chair that came the closest to realizing this utopian Modernist dream.

Blow chair, 1967
Polyvinyl chloride (PVC)
Zanotta, Milan

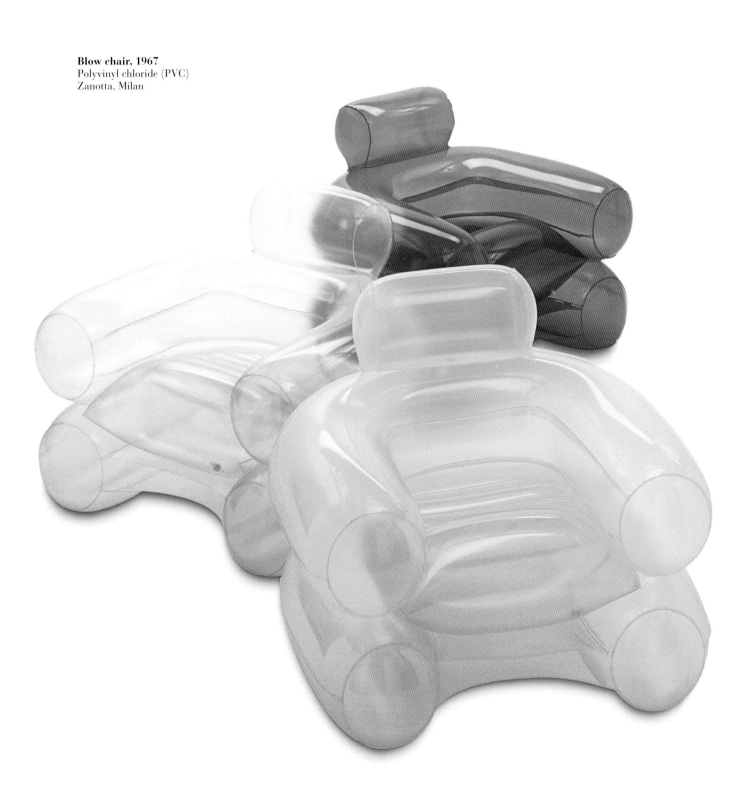

Timor desk calendar, 1967
Acrylonitrile-butadiene-styrene (ABS), lithographed polyvinyl chloride (PVC)
Danese Milano, Milan

Timor desk calendar, 1967

Enzo Mari (1932–)

This stylishly sophisticated office accessory by Enzo Mari was essentially a radically modern re-working of the perpetual desk calendar, a practical and useful item that was popular during the Victorian period. Today, the Timor desk calendar remains one of Mari's most commercially successful designs and is also widely regarded as an icon of 1960s Italian design.

As with other designs by Mari, the Timor has a strong graphic presence and an unassailable design logic, which can be attributed to his sympathetic understanding of the delicate inter-relationship that exists between form, function and materials. It also reflects its manufacturer's long-standing commitment to producing "simple objects of great quality".

Danese, founded in Milan in 1957, has tirelessly dedicated itself to design and manufacturing excellence. As a result, it has succeeded in creating superlative objects irrespective of the materials employed. In this instance, Mari used white or black ABS for the calendar's stand and thin sheet PVC for the 32 fan-like elements adorned with lettering in Italian, English, French or German. The inverted "J" form of the calendar perfectly complements the bold sans-serif typeface used – it is an object where product design and typographic design are harmoniously married.

Although the Timor was designed more than 40 years ago, it still looks as fresh and innovative today as the day it was introduced: showing that, when handled sensitively and intelligently, plastics can imbue a product with both functional and aesthetic longevity. As Enzo Mari has noted, "When I make something for Danese I take the view that it has to outlive the current design trend… the idea being that something that is relevant today will be relevant in three hundred years' time."

Above: Image of the Timor desk calendar showing the 32 calendar elements fanned out

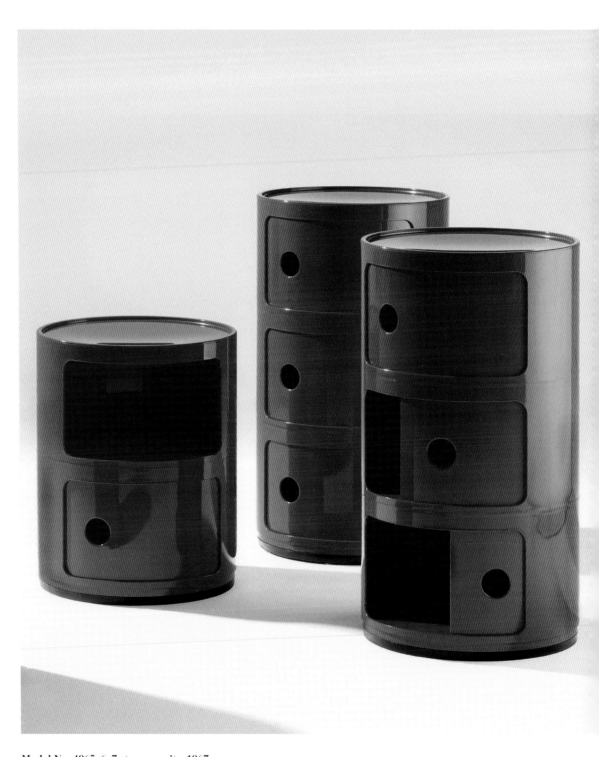

Model No. 4965–6–7 storage units, 1967
Acrylonitrile-butadiene-styrene (ABS)
Kartell, Noviglio

Model No. 4965–6–7 storage units, 1967

Anna Castelli-Ferrieri (1920–2006)

The architect-designer Anna Castelli-Ferrieri was perhaps the greatest female pioneer of modern Italian design during the period spanning the 1950s to the 1980s and was, as the New York Times later wrote, "an emblematic member of a generation of Italian designers that…energetically transformed the world of design with their interest in using new technologies and materials, like plastic… their iconoclastic brio and intuitive elegance became the signature of the Italian modern style". She was also one of the first women to graduate from the highly regarded architecture programme at the Politecnico di Milano in 1943. Her husband, the chemical engineer Giulio Castelli subsequently founded Kartell in 1949 and from then onwards she was highly instrumental in the development of Kartell's impressive range of high-quality plastic household products and furniture designs.

Despite being at the forefront of Italian design and architecture at this time, Castelli-Ferrieri's remarkable contribution as one of the most significant pioneers of plastics in design has often been overlooked. While Kartell was still a fledgling company, Anna collaborated on a number of important architectural and urban planning projects with the architect Ignazio Gardella, including a headquarters building and manufacturing complex for her husband's company in the industrial suburbs of Milan. As the company grew she turned her attention to industrial design, and in 1964 co-designed with Gardella her first product for Kartell: the Model No. 4991 table made of glass-reinforced polyester. This was followed three years later by her revolutionary Model No. 4970 system, which comprised square storage units in two sizes that could be stacked with their openings facing in any of four directions, and that were topped with a tray-like element. These components could also be used in conjunction with optional doors and castors. Launched in 1968 and also known as the Multi Box System, this range became the world's first storage system made entirely of injection-moulded ABS.

Designed at around the same time but appearing a year later, Castelli-Ferrieri's cylindrical Model No. 4965–6–7 stacking storage units had a similar construction, and were also injection moulded in a shiny and hard type of ABS developed by Beylerian. The doors of this range, however, were sliding rather than hinged, which made them even easier to install and use. Originally produced in either white, red, black, yellow or green; these units could be used singly as side tables or bedside cabinets, or alternatively they could be stacked to make useful, tower-like containers for almost any part of the home – even kitchens and bathrooms thanks to their waterproof, wipe-clean, gleaming surfaces. Inexpensive to produce yet extremely durable, the multifunctional Model No. 4965–6–7 units have remained in production for over forty years, which is an undoubted testament to Castelli-Ferrieri's rare ability to fuse rational design logic with an elegant stylistic bravado. The products that resulted ultimately came to define the Neo-Modern look of Italian design during its acknowledged golden period.

Left: Model No. 4970 storage units (Multi-Box System) designed by Anna Castelli-Ferrieri for Kartell, 1967

Gherpe table light, 1967

Superstudio (est. 1966)

The Italian furniture and lighting company Poltronova was founded by Sergio Cammilli in 1956, and during the 1960s and 1970s it went on to become the leading manufacturer of designs by the foremost protagonists of the Radical and Anti-Design movements. One such group was Superstudio, which was founded in Florence by the architecture students Adolfo Natalini and Cristiano Toraldo di Francia in the year of that city's great flood, 1966. Subsequently, Alessandro Magris, Roberto Magris and Piero Frassinelli also joined, and during the next twelve years Superstudio produced work that continually challenged and contested accepted notions of the role of architecture and design in society.

Through its highly innovative and challenging designs, Superstudio questioned the validity of the Modern Movement's advocacy of Rationalism, it overtly criticized consumerism and promoted a "design of evasion", involving objects that were industrially produced, yet poetic and irrational. One such design was their futuristic-looking Gherpe table light, constructed from an arching fan of looped acrylic bands. Though relatively low-tech in its construction, this experimental design took full advantage of the extraordinary optical qualities offered by new synthetic materials, with the acrylic elements in either translucent fluorescent pink, translucent fluorescent yellow or milky white PMMA, which diffused the light in an otherworldly manner. The name of this extraordinary light sculpture makes reference in Italian to a child-scaring monster and the design certainly has an ethereal presence, with the edges of its acrylic bands glowing extra brightly – a phenomenon known as "live edge".

The Gherpe was without question one of the most successful of all the experimental lighting designs to be produced during the golden period of Italian design, which lasted from the mid-1960s to the early 1970s. This remarkable table light also reflected Superstudio's interest in the ideas of mutation and interaction with its repeated plastic loop components being able to be moved over each other to control the intensity of the emitted light. An astonishingly beautiful expression of the utopian ideals projected by Superstudio, the Gherpe was a truly visionary design that poetically captured the idealistic, futuristic and psychedelic zeitgeist of Italian design during the heady Age of Aquarius years.

Above: Launch of a new range of lighting designs on the Poltronova stand at the Design Centre, Florence, 1968 – including the Gherpe light

Gherpe table light, 1967
Polymethyl methacrylate (PMMA), acrylonitrile-butadiene-styrene (ABS), chromed steel
Francesconi, Ronacadelle for Design Centre/Poltronova, Montale

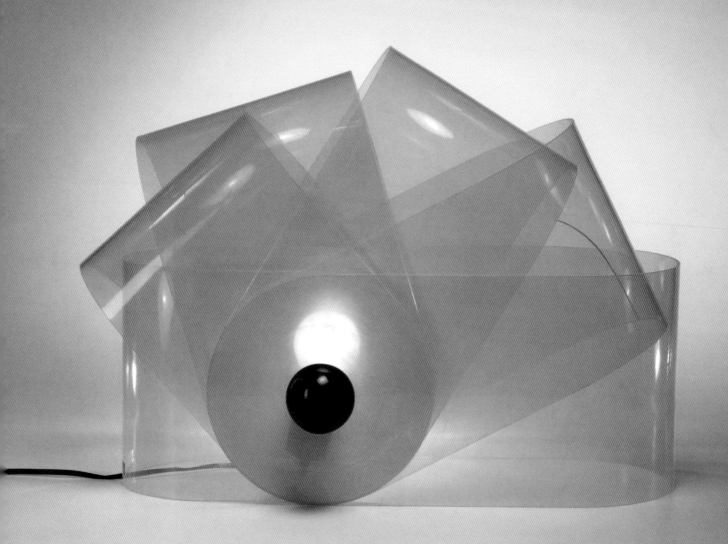

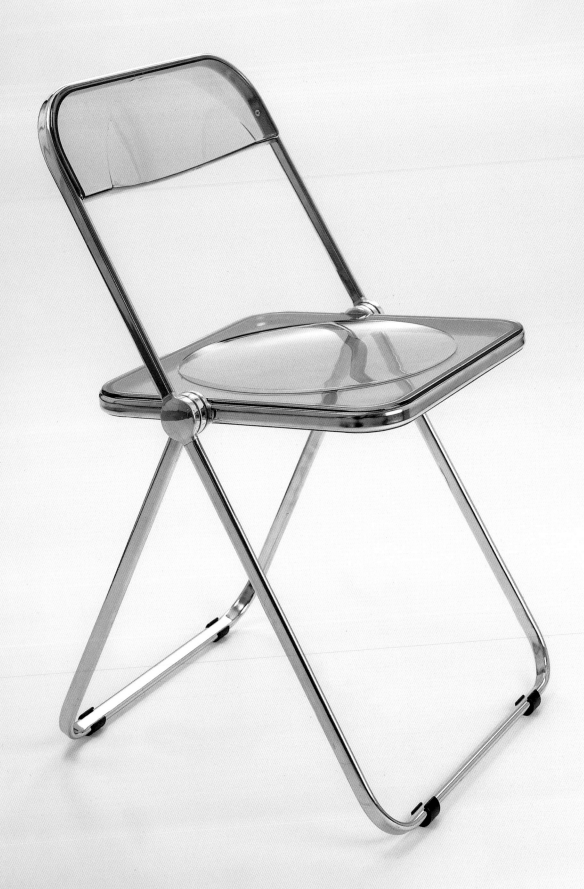

Plia folding chair, 1967
Giancarlo Piretti (1940–)

The earliest origins of the folding chair can be traced back to Scandinavia during the Bronze Age – discovered during an archeological dig in 1899 the so-called "Daensen chair" dates back to the second half of the fourteenth century BC and was essentially a collapsible X-framed stool. Later in the ancient world, the Egyptians, Greeks and Romans all used similar models. Indeed, the folding chair was often the prized possession in a household and a signifier of high status. These early folding seats were usually made of wood, although metal frames were also sometimes employed. It was during the Middle Ages that the folding chair became especially popular, particularly as ecclesiastical furniture. Over the succeeding centuries, folding chairs became increasingly refined, and even in the late nineteenth century August Thonet manufactured a number of lightweight models using a combination of bentwood and plywood.

It was not until the late 1960s that the humble folding chair would be transformed into an object of stylish desire with the launch of the Plia chair. Designed by Giancarlo Piretti in 1967, this Space Age reworking of the traditional folding chair was truly revolutionary. Made of transparent plastic, its see-through back and seat were set into a minimalist steel frame that boasted an innovative three-disc hinge, allowing the chair to be folded in one simple movement. It was Giancarlo Piretti's first design in plastic for Anonima Castelli and used thermo-formed elements initially made of acrylic (PMMA). However, this material was soon changed to Cellidor, a medium-rigidity cellulose triacetate (CT) developed by Bayer, which possessed greater resilience and excellent resistance to weather and heat.

The Plia chair was manufactured in clear, smoky grey or opaque colours, and was extremely popular thanks to its clean, elegant and progressive aesthetic, which predicted the Neo-Modernism of the later 1970s. The Plia was also a highly space-efficient design – when collapsed it was only about 2.5 centimetres (one inch) in depth excluding the central hub. Piretti employed the same type of compact folding mechanism for his later Platone table (1971) and Plona armchair (1970).

Widely acknowledged as a groundbreaking design, the Plia went on to win numerous awards, including Germany's Bundespreis Gute Form (Federal Prize for Good Form) in 1973 and was also included in the "Objects Selected for their Formal and Technical Means" section of the landmark exhibition, Italy: The New Domestic Landscape, held in 1972 at the Museum of Modern Art, New York. The exhibition's curator, Emilio Ambasz, went on to form a design collaboration with Piretti which resulted in a number of seminal chair designs, including the highly influential and ergonomically responsive Vertebra office chair (1977). It was, however, the Plia chair that was Piretti's greatest commercial success, with more than seven million units sold since its launch in 1969, thereby making it one of the most successful chairs of all time.

Above: Anonima Castelli publicity photograph for the Plia chair, 1970

Plia folding chair, 1967
Polymethyl methacrylate (PMMA)/later cellulose triacetate (CT), chrome-plated steel, cast aluminium
Anonima Castelli, Bologna

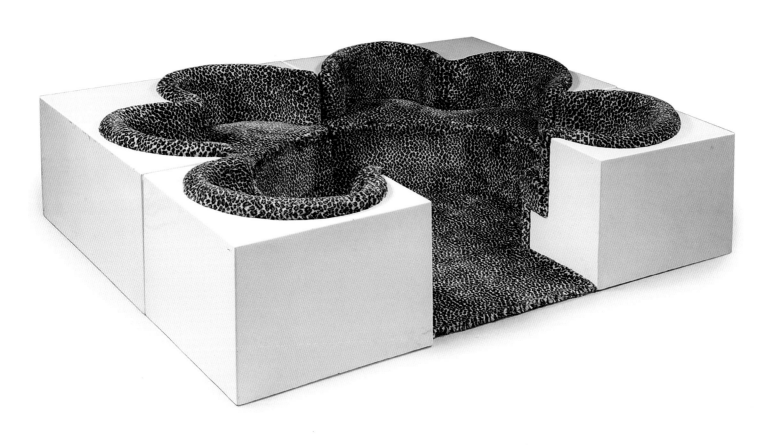

Safari modular seating unit, 1968
Glass fibre-reinforced polyester, fabric-covered foam upholstery
Poltronova, Montale

Safari modular seating unit, 1968

Archizoom Associati (founded 1966)

This sectional "livingscape" seating unit confronts the viewer with its monumental immobility and was an intentionally provocative design statement. Covered in faux leopard skin, the Safari alluded to the kitsch design of the 1950s, and as such intentionally countered the Modern Movement's tenets of "good design" and "good taste".

Archizoom Associati, a radical design group founded by Andrea Branzi, Paolo Deganello, Gilberto Corretti and Massimo Morozzi, designed the Safari in 1968. The group had been founded two years earlier in Florence the same year the Renaissance city had been deluged by flooding. As the Japanese architect Arata Isozaki observed, "I believe the memory and experience of the great flood that visited Florence had a profound effect on members of … Archizoom who graduated from the University that year", and it would appear the destructive submerging of this historic city of culture galvanized the group's members to question the preconceived notions of what a city should be like, and indeed even what a house or furniture should be like.

The name of the group was derived from the British architectural group Archigram and an issue of its journal entitled Zoom. Like its inspiration, the Florence-based group sought to demonstrate that if Rationalism was taken to an extreme it ultimately became illogical and thereby irrational – as the group stated at the time: "The ultimate aim of modern architecture is the elimination of architecture itself." The format of the Safari was inspired more by architecture than by traditional forms of seating, and it was essentially an un-sunken autonomous seating pit. The abstracted and undulating flower-shaped form of its seating arrangement also obliquely referenced the rise of flower-power during this period.

The Safari seating unit was the ultimate expression of, as Austin Powers might have put it, the psychedelic "shagadelic" look and reflected the increasingly casual lifestyles of the younger generation, who did not want the traditional three-piece suite of their parents but rather desired sculptural seating solutions that promoted playful interaction.

Above: Plan view of the Safari sofa showing its undulating petal-like four piece configuration

Vivara textile, c.1968
Printed silk (this example taken from a scarf)
Emilio Pucci, Florence

Vivara textile, c.1968

Emilio Pucci (1914–1992)

In the 1950s and 1960s Emilio Pucci's designs were the uniform of the international Jet Set. His signature psychedelic prints and Capri pants were worn by glamorous names of the era, from Sophia Loren and Marilyn Monroe to Elizabeth Taylor and Jacqueline Kennedy. His designs are as unmistakable as they are elaborate: up to sixteen colours can feature in a single Pucci print. The designs take inspiration from everything from medieval football games to Art Nouveau and African safaris.

Pucci played a central role in the birth of Italian fashion in the post-war period. Although Italy historically had a strong fashion culture, until the 1950s the international marketplace had been dominated by two very different industries: French haute couture versus American sportswear. It was only in the early 1950s that Italy stepped out of the shadows, largely thanks to the fashion shows that Giovanni Battista Giorgioni organized in the palatial setting of Florence's Villa Torrigiani that introduced the media to Italy's fledgling fashion industry. Among the fashion houses showing their wares were Sorelle Fontana, Simonetta and Emilio Pucci, whose luxurious leisurewear filled the gap between the American and French industries and secured Italy's signature style in the area of chic, ready-to-wear fashion.

Born in 1914 to an aristocratic Florentine family, Emilio Pucci – also known as the Marchese di Barsento – lived and worked in the family's Pucci Palace, a Renaissance-era building in the heart of the city. Pucci did not start his career as a fashion designer. An avid sportsman, he raced cars, swam and fenced and was part of Italy's alpine ski team at the 1932 Olympics. He served as a bomber pilot in the Second World War and stayed on in the air force post-war. It was while on leave on a skiing holiday in Switzerland that his future in fashion was born. Pucci had been designing leisurewear for his friends, including a stretch-fabric ski suit for a companion on the skiing trip that was spotted by a photographer named Tom Frissel, who then featured the outfit in the pages of American fashion magazine Harper's Bazaar. Soon American manufacturers were clamouring to put the designs into production, and by the late 1940s Pucci's sportswear outfits were on sale in American department stores such as Lord and Taylor and Neiman Marcus. Pucci soon started production of his own range, and in 1950 opened his first boutique on Capri, the island off Italy's Amalfi Coast that gave his design for stretch fabric trousers their name. In the 1950s and 1960s Pucci expanded his line into a range of products that included silk scarves, blouses and dresses, alongside crew uniforms for the airline Braniff International, porcelain for Rosenthal and even the logo for the Apollo 15 mission patch in 1971.

Among the most famed of all Pucci's patterns, however, is the one shown here. It was designed around 1968 and was to become one of the most recognizable signature Pucci prints, quite literally bearing its creator's autograph. This classic design revealed Pucci's genius for both patternmaking and colour combining and was used not only for scarves and handbags in a variety of distinctive colourways but was also employed for various garments as well. Over the years this masterful print has been revived into the company's various seasonal collections, and even today it possesses an enduring visual vibrancy and rhythm synonymous with the Pucci label.

Although Emilio Pucci died in 1992, the firm has remained a family business. Since the 1990s the brand has been run by Emilio's daughter, Laudomia Pucci, and in 2000 it was taken under the umbrella of the French luxury group LVMH, which oversees the ongoing production of the firm's signature prints and luxury leisurewear.

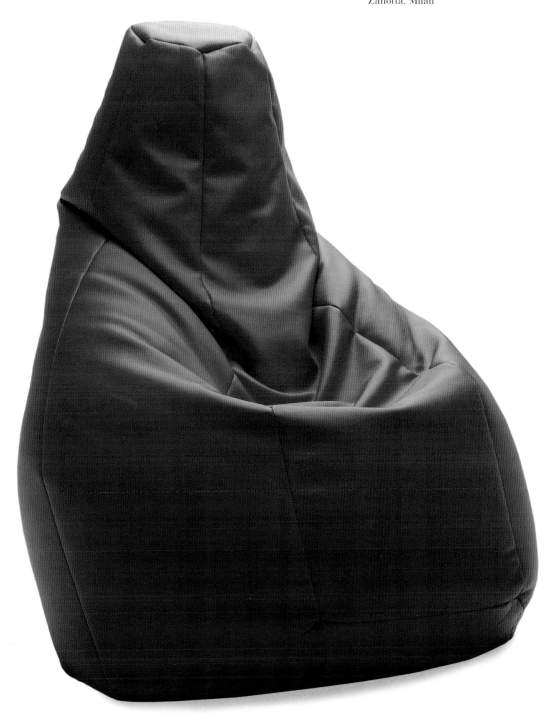

Sacco beanbag, 1968–69

Piero Gatti (1940–), Cesare Paolini (1937–1983) & Franco Teodoro (1939–2005)

The beanbag has since the early 1970s been the youth generation's seat of choice – inexpensive, laid-back and comfortable. Indeed, it is difficult to imagine a time before the beanbag's arrival, it having become such a ubiquitous feature of teenage bedrooms and student flats throughout the world. Yet this seemingly inevitable design was actually the brainchild of three young architects working in Turin during the mid-1960s.

From 1965 until 1983, Piero Gatti, Cesare Paolini and Franco Teodoro worked in various fields of creative activity: architecture, interior design, industrial design, urban planning, corporate identity and graphic design. However, it was the design of their Sacco beanbag in the late 1960s that would bring them the greatest acclaim. As Piero Gatti recalled in a later interview: "Between 1967 and 1968 ergonomics was in fashion…. Many of us were interested in designing objects as flexible as possible, which could adapt to different situations, not just to forms of behaviour but also different physical structures. So we said: think of a chair that will allow these functions. We began to think about a material that would allow this adaptability, both for the body and its positions…. In the end we thought about the old mattresses stuffed with chestnut leaves, widely used by peasants: you take a sack, you fill it with leaves or similar materials, and this moulds itself to fit the body… From this … we got the idea of something, like marbles or balls, that would mould themselves to the body, i.e. behave like a semi-fluid…Then we found a material used in the building trade, foam polystyrene for sound- and heat-proofing. So we cut out an envelope, put these little balls inside and saw it worked."

During the development of the Sacco, a number of prototypes were created using PVC "envelopes" made by a local manufacturer of driving-license covers, which Gatti, Paolini and Teodoro then took photographs of. These early prototypical beanbags were subsequently left lying about their office because the design trio presumed that "no one would ever want to make this thing". They did send images of the prototypes together with photographs of other designs to an American furnishings magazine, which then featured them in an article. This consequently led to a purchase enquiry from Macy's department store, which wanted to place an order for 10,000 units. Astounded by this initial order, Gatti, Paolini and Teodoro immediately contacted Aureliano Zanotta, who they had previously met at the Eurodomus exhibition held in Turin in 1960. Zanotta's eponymous furniture manufacturing company had already gained a reputation for producing pioneering seating designs, most notably with its launch of the Blow chair in 1968. Of course, Aureliano Zanotta was immediately interested in the Sacco and after examining the trio's early attempts began working on the first functional prototypes. Eventually he exhibited three "production" models on his stand at the 1969 Paris Furniture Show, where they were an instant success.

The revolutionary Sacco, with its PVC or leather envelope filled with thousands of tiny polystyrene beads, certainly captured the youthful zeitgeist of the 1960s more than any other seating design of the period. With its low yet extremely comfortable sitting position, it was perfectly aligned to the more relaxed and casual lifestyle of the period. Its commercial success spawned a host of inferior copycat designs, but they were never able to equal the comfort or stylish good looks of Gatti, Paolini and Teodoro's original – the vinyl version of which was an entirely synthetic seating solution.

The Sacco can be seen as an archetypal design of the 1960s plastic age – it simply would have been impossible to develop without access to polystyrene beads, which were the ideal material because of their feather-like lightness and fluid movement. Although often regarded as a quintessential Pop object, the Sacco was viewed by its designers not as an experimental Pop design but instead, as Gatti was to later recall, "a rather precise project… it was a researched and rational object". Yet, it also just happened to be interactive and fun.

Tubo chair, 1969
Lacquered Arcipiuma (glass-reinforced plastic), tubular
steel, rubber, textile-covered polyurethane foam
Flexform, Milan

Tubo chair, 1969
Joe Colombo (1930–1971)

Joe Colombo was a visionary designer who created Space Age furniture, products and environments that quite literally pulled the future into the present. During his brilliant but sadly brief career that spanned just over a decade he pioneered a series of design innovations, from the Universale chair (the first adult-sized chair made entirely of thermoplastic) to the Boby trolley (an all-in-one mobile storage unit). All his designs were intended for what he described as "the environment of the future" yet at the same type possessed an underlying functional logic.

The Tubo chair epitomized Colombo's ability to think outside the conventional design box in order to create something staggeringly original in the creative use of materials, imaginative interpretation of function and novel forward-looking aesthetics. The Tubo (tube) chair was essentially made from four differently sized tubes of glass-reinforced plastic (GRP) that had internally raised edges

and which were upholstered in vinyl or stretch jersey covered polyurethane foam. The four tubular elements could be joined together in a variety of configurations with U-shaped fittings terminating in ball-elements that snapped easily onto the rims of the tubes and held them securely together. While the various combinations provided different seating options, the tubes could also be space-efficiently nested into one another when not in use. Retailed in a drawstring bag, the Tubo was also an early example of furniture that could be bought off-the-shelf and then taken home and assembled with absolute ease.

The Tubo reflected the increasingly nomadic lifestyles of the younger Sixties generation and its desire for furniture that was interactive and transformative, and most of all fun. With this seminal design Colombo also demonstrated that age-old furniture typologies could be swept away and replaced with visions of a Utopian future that were boldly inventive yet struck the right balance between sculptural form and practical function.

Left: Diagram showing the modularity and flexibility of the tube system used to make up the Tubo chair's different seating configurations

Selene chair, 1969
Vico Magistretti (1920–2006)

In 1972, the Museum of Modern Art in New York staged an important exhibition entitled Italy: The New Domestic Landscape and in the show's accompanying catalogue its curator, Emilio Ambasz, identified three main currents within contemporary Italian furniture design, which he described as "conformist, reformist and contesting". The work of Vico Magistretti certainly fell into the first category in that, unlike many of his design compatriots, he maintained the Modernist Rationalist tradition and produced work that accorded with the constraints of not only manufacturing technology but also the needs and concerns of the marketplace. This, however, does not in any way mean that Magistretti's work was not pioneering, for indeed it was – certainly it was often more inventive in terms of its application of materials and technology than the more outré designs of the Radical Design groups such as Superstudio or Archizoom.

Through his design work, Magistretti did not seek to convey intellectualized polemics on the state of design or consumerist consumption, but rather sought eloquent solutions that perfectly balanced form with function. Rather than rejecting the manufacturing status quo, Magistretti embraced it and worked with it to develop new and innovative designs that encompassed the goals of Functionalism and adapted them to the new materials and technologies available.

The design that perhaps best sums up Magistretti's thoughtful approach to problem solving is his graceful Selene chair of 1969. This remarkable single-piece stacking chair was a tour-de-force

of cutting edge design and technological prowess, being made as it was from a single material – compression-moulded Reglar (a glass-reinforced polyester specially produced by Artemide). As Magistretti later explained, "I didn't want a chair to be composed of several different parts, I wanted a single unit; nor did I want to create a chair like Joe Colombo's, that, with its thick, heavy legs looked like an elephant… the key that helped me find the solution for the Selene was the leg's 'S' section."

This ingenious serpentine cross-section for the legs guaranteed enhanced strength and stability, while also ensuring that the minimum amount of plastic was used to the maximum effect. Following on from the development of the Selene side chair, Magistretti then turned his attention to the creation of two related armchairs. For these, he employed a similar configuration for their legs, but this time chose a W-shaped profile that similarly ensured extra strength and stability while also conferring lightness. The resulting designs were the Gaudì chair (1970), and the larger and lower Vicario chair (1971), which like the earlier side chair were also manufactured by Artemide.

The overall design of the Selene (like that of the later Gaudì and Vicario armchairs) was informed by how the malleable unset plastic would "flow" into the mould. Put simply, the technically complex shape of the chair was thoughtfully conceived so as to permit an integrated construction that could be efficiently moulded in polymer resin as a single unit. In Magistretti's words: "the curves, long and connected … the general sinuous aspect … though well-suited functionally for the chair, all stem from a need that addressed a specific constraint of the project" – namely, the choice of materials and manufacturing process. The Selene not only constituted a technical breakthrough in terms of its manufacture but was also a high-quality, affordable and eminently stylish design that notably helped to raise the perceived status of plastic – which had previously been widely regarded by the general public as a poor substitute for natural materials.

Up Series chairs, 1969
Stretch fabric-covered moulded polyurethane foam
C&B Italia, Novedrate (later to become B&B Italia)

Up Series chairs, 1969
Gaetano Pesce (1939–)

During the late 1960s and early 1970s there was a tendency in both fine art and design that was all about improvisation, participation and performance. This new type of situation-based art and design was termed a "happening", an expression coined by the American artist Allan Kaprow in 1957. It was during the late 1960s that Gaetano Pesce, among others, took happenings into the realm of design, most notably with his famous Up Series of seating designed in 1969. Previously, in 1959, Pesce had co-founded Gruppo N, an art collective modelled after the Bauhaus. He had also attended the famous Hochschule für Gestaltung Ulm (The Ulm School of Design) in 1961, and then concluded his architecture and design studies at the University of Venice, graduating in 1964. Despite this formative grounding in Modernist design practice, Pesce became a renegade practitioner who sought to break established design rules in order to create an intellectualized, emotive and ultimately more meaningful interpretation of contemporary design.

His Up Series of "transformation" furniture (as he described it), introduced in 1969, was a radical rethinking of how furniture could be designed, made and sold. Manufactured in squishy jersey-covered polyurethane foam, six of the seven designs that made up the range – Up1 to Up6 – were compressed to one-tenth their original volume and then vacuum-packed into large PVC wrappers. When these sealed envelopes were subsequently opened the designs inflated and literally bounced into life, thus turning the act of purchasing furniture into a rather exciting and fun transformative happening.

The launch, or should we say the first unwrapping, of the Up range was held on the C&B stand at the IX Salone di Mobile di Milano (Milan Furniture Fair) and created quite a media stir. As *Domus* noted: "The biggest surprise of the show was C&B's presentation of the 'Up' series, a revolution in the field of packaging armchairs and sofas ... cut open the sheath and [the design] regains its original shape and volume." Although this might have seemed a bit of a gimmick, it was actually a rational attempt to create furnishings that could be literally bought-off-the-shelf by a younger and more nomadic design-conscious generation. This demographic did not believe in the morality of delayed gratification that had been such a feature of their parents' generation but rather wanted to have fun and innovative products that could be purchased on a whim and then instantly enjoyed.

Like later furniture designs by Pesce, the forms employed for the Up Series were highly symbolic – the Up5 also known as Donna was a consciously female archetypal form, while its accompanying Up6 ottoman was intended to symbolize a ball-and-chain, reflecting as Pesce later noted "the shackles that keep women subjugated". Similarly, the form of the Up3 chair was overtly phallic, while the Up7 took the form of a gigantic foot making it an early example of "design art". This design-sculpture intentionally looked like an over-sized archaeological relic, although paradoxically it was made of a thoroughly modern man-made material – it was intended to celebrate both the old and the new: the Italy of the ancient world and the Italy of the contemporary world, and the greatness of both.

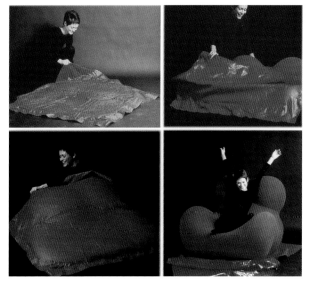

Above: C&B Italia publicity photographs showing the Up5 chair being unpacked and bouncing into life, c.1969

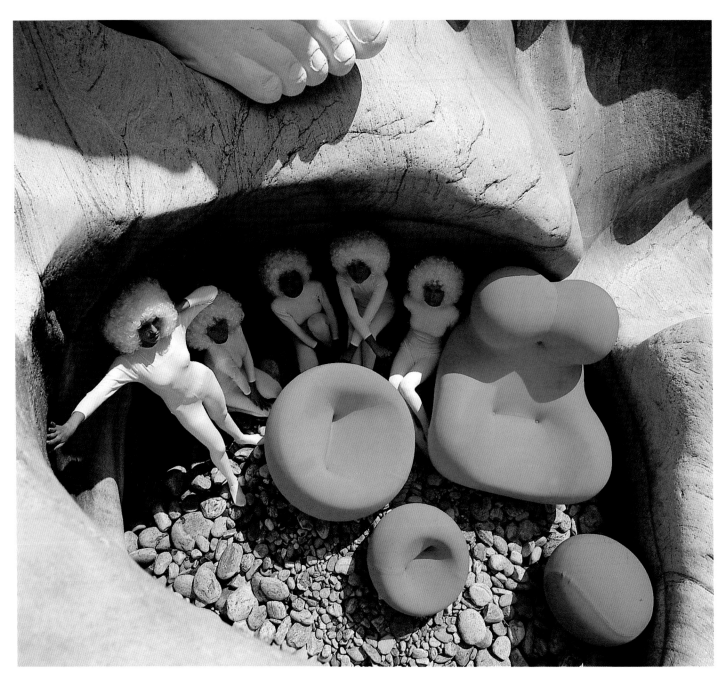

Above: C&B Italia publicity
photograph of the Up Series,
c.1969

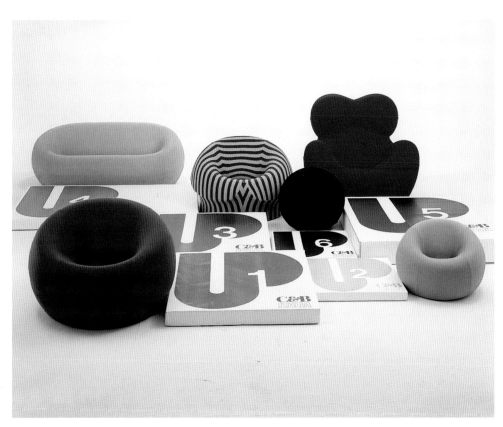

Above: C&B Italia publicity
photograph of the Up Series
(also showing the packaging that
the pieces came in). c.1969

Valentine typewriter, 1969

Ettore Sottsass (1917–2007) & Perry King (1938–)

During the 1950s Olivetti made significant inroads into the design of more stylish and friendly looking typewriters, the portable Lettera 22 by Marcello Nizzoli from 1950 being a notable example with its choice of different colour options. However, because the Lettera's housing was still made of enamelled metal it was heavy to carry around, even if it did come with a stylish two-tone zip-up vinyl carrying case. This problem of weight and portability was spectacularly overcome when in 1969 Olivetti launched a new typewriter called the Valentine, which was designed by Ettore Sottsass and Perry King. This revolutionary new plastic typewriter would subsequently become one of the most influential designs of the 20th century.

As *Domus* magazine said of the Valentine in its June 1969 issue: "The case is a bucket into which you put the typewriter, and the handle is attached to the machine and not to the bucket; you thus carry the machine with the bucket

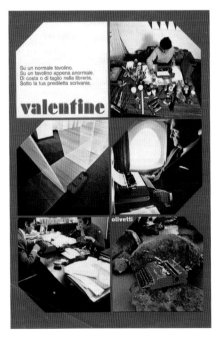

Above: Olivetti advertisement featuring the Valentine typewriter in various contexts, 1969

attached to it. The general idea is that a portable typewriter is no longer a special object, but an everyday tool." Sottsass also expressed this new concept of the ultra-portable typewriter in his choice of colourful polyethylene and ABS – both materials having excellent strength to weight ratios. The machine's chunky yet playful form and its catchy name prominently moulded in a Pop-Deco typeface above the keyboard also added to its fashionable appeal. With its bright red plastic casing and cover and its vibrant orange plastic ribbon spools, the Valentine also possessed a distinctive, toy-like quality that spoke directly to a younger audience, keen to reject the stuffy, grey hierarchies of traditional office life.

The Valentine was a quintessential Pop design that celebrated the plastics age of the 1960s through a bold ergonomic form that showcased the intrinsic, form-giving qualities of the polymers used in its manufacture. As Sottsass noted, the design was "the sort of thing to keep lonely poets company on Sundays in the country", and its playful aesthetic certainly helped to establish a strong emotional connection between object and user, with huge implications for the later design of consumer electronics. Above all, the Valentine proved that if the design of office equipment could be given a treatment that actively endeared it to its users, then this entire product category could be transformed into a context for desirable, fashionable, must-have items – a lesson Jonathan Ive clearly absorbed, as evinced when he came to design the first iMac computer some 30 years later.

The success of the Valentine also revealed that consumers were prepared to pay a premium price for design-led objects that brought a touch of modish glamour into their daily lives. And as they say, the rest is history: through its success other manufacturers of electronic products and office equipment took on board the importance of design as a vital means of gaining a decisive commercial advantage over their competitors.

Valentine typewriter, 1969
Polyethylene (PE), acrylonitrile-butadiene-styrene (ABS), metal
Olivetti, Ivrea

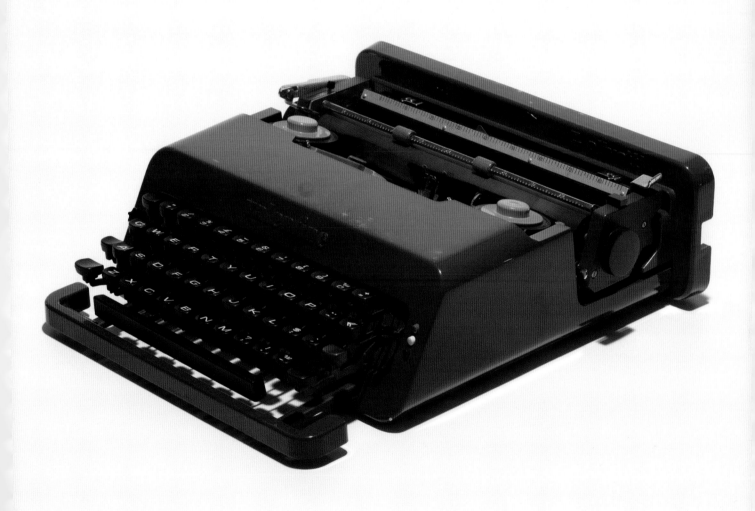

Boby storage trolley, 1970

Joe Colombo (1930-1971)

The Boby trolley is one of those enduring designs that crops up in the most unexpected of places, from dentist's surgeries and hair salons to its more normal domain of architect's offices and graphic design studios. The reason behind its ubiquity is the trolley's useful and versatile design that still looks as fresh as when it was first introduced in 1970.

One of Joe Colombo's best-known designs, the Boby trolley is essentially a mobile storage unit, that was specifically designed for use by architects needing to store drawing materials, drafting equipment and blueprints. Over the years, however, it proved equally useful in both more traditional office environments and also in domestic settings. The Boby trolley epitomized Colombo's love of modular design systems, which also had strong Space Age connotations. Like his other designs produced in plastic, the Boby's form was dictated by functional and manufacturing considerations, while at the same time expressing a bold and futuristic aesthetic that appealed to a youthful audience.

The Boby was designed to be highly functionally flexible in that it could be extended vertically to provide additional storage capacity. Its structural modules and drawers were made of injection-moulded ABS – a shiny and rigid thermoplastic with an excellent strength-to-weight ratio. These elements were then secured in place with concealed galvanized steel tie-rods and screws that allowed the drawers to pivot out easily and effortlessly. On its upper surface, the Boby had a removable oblong cover with a finger-hole, which gave easy access to a hidden storage space running the whole way down one of its sides, which was the space intended for scrolled plans or blueprints. Its black castors were made of hardwearing polypropylene and were positioned for optimum manoeuvrability.

The Boby was (and still is) offered in three heights and a number of drawer configurations and colours. This practical and stylish portable storage system was awarded first prize at SMAU (Salone Macchine e Attrezzature per l'Ufficio/Machinery and Equipment for the Office Fair) in 1971, and has since entered the permanent collections of design museums all over the world as a bold icon of Italian Pop design. Above all, the Boby trolley can be seen to symbolize the utopian aspirations of late 1960s and early 1970s and the popular culture of this remarkable period, which not only celebrated plastics as advanced and empowering materials but also (if somewhat naïvely) held a belief in humanity's salvation through the advancement of science and technology.

Left: B-Line publicity photograph showing Boby trolleys in various configurations and colours

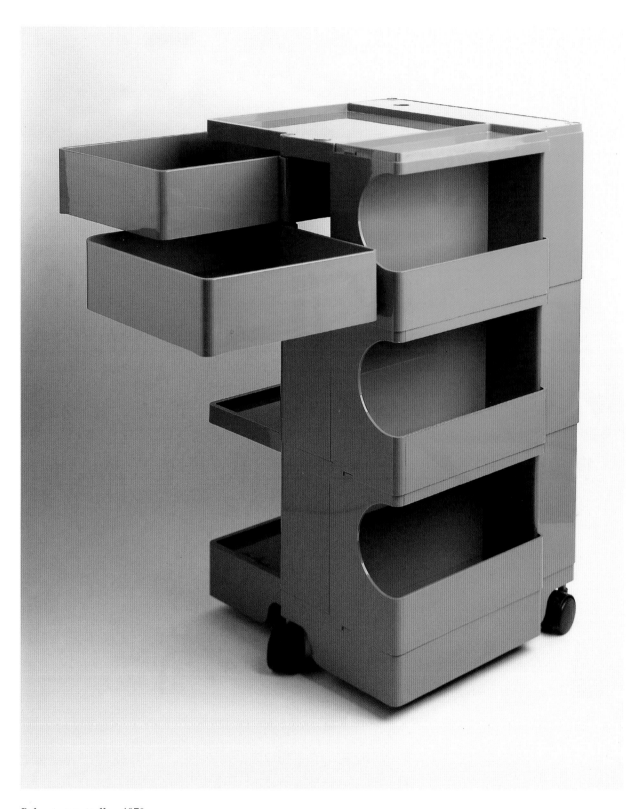

Boby storage trolley, 1970
Acrylonitrile-butadiene-styrene (ABS), galvanized steel, polypropylene (PP)
Bieffeplast, Padua (1970–c.1999) & B–Line, Grisignano di Zocco (1999-present)

Eros table, 1971
Polished marble
Skipper, Milan (reissued by Agapecasa, Mantua)

Eros table, 1971
Angelo Mangiarotti (1921–2012)

Although Angelo Mangiarotti's work is still not particularly well known outside of Italy, he was one of the greatest architect-designers of his generation and his work – whether buildings or products – was distinguished by an elemental monumentality that is becoming increasingly appreciated, especially among design collectors. Mangiarotti took the ideals of the Modern Movement and extended them to create highly original work that was based on Functionalism yet also possessed a rare poetic elegance.

Mangiarotti's Eros series of tables designed in the early 1970s were the result of his pioneering research into the development of constructions that required no traditional joints, screws or nails. He developed a system employing tapering conical legs that were slotted into slab-like tabletops in predetermined positions in such a way that they were held in place by gravity, with the weight of the tabletops bearing down on the legs and ultimately stabilizing them. This seemingly straightforward yet highly innovative "gravity joint" solution also gave this series of tables a remarkable sculptural monumentality as well as an almost playful simplicity – rather like large sculptural toys.

The elegant Eros group comprised round, rectangular, oval, triangular and C-shaped topped tables and was manufactured in either white Carrara marble, grey Carnico marble or black Marquina marble. It also came in a range of heights and sizes, from small side tables to large console and dining tables. Although heavy to transport, the Eros tables had an incredible physical durability thanks to Mangiarotti's choice of material. This, twinned with their almost totemic forms, has given this range of tables a remarkable longevity of appeal. Quite simply some of the most beautiful tables ever produced, the Eros range also can be seen to have revitalized Italy's well-known tradition of marble furniture, which can be traced back to ancient times. As a designer who constantly drew on ethical principles and who had a deep awareness of moral values, Angelo Mangiarotti once remarked "happiness comes from correctness". This sensibility was omnipresent in his work, and the Eros tables undoubtedly provide an undeniable sense of pleasure through their exquisitely and perfectly balanced logical forms.

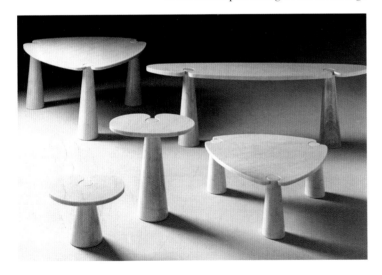

Left: Skipper publicity photograph showing part of the Eros range of tables, c.1971

A109 helicopter, first flight 1971

Bruno Lovera (Active 1960s–70s) & Paolo Bellavita (Active 1960s–70s)

A helicopter might seem a rather odd choice to deem a design masterpiece, but that is exactly what the A109 is – a superbly versatile design solution that is used across the world for both military and commercial purposes. The origins of the manufacturer of this lightweight eight-seater helicopter go back to 1923, when Count Giovanni Agusta – who had previously designed and built a bi-plane known as the Ag1 in 1907 – founded it in the Lombardy region of northern Italy. The company had originally been established to carry out the repair and maintenance of military aircraft, but during the Second World War it started to also manufacture aircraft. After the war, the Treaty of Paris banned the production of military aircraft in Italy and so the company diversified its activities and began building boats, buses and motorcycles – soon becoming famed for the production of its acclaimed championship-winning motorbikes. It was not until 1952 that the company, now under the directorship of Count Giovanni Agusta's descendents, began to manufacture helicopters – initially producing the Bell 47G under license, and then later designs by Sikorsky, Boeing and McDonnell Douglas. Eventually, Agusta made the move into developing and manufacturing rotor-bladed designs of its own – with the large triple-engined Agusta A101 (first flight 1964) designed by Filippo Zappata and the light single-seater Agusta A106 (first flight 1965) being significant early achievements.

It was, however, the A109 series of helicopters that would prove to be Agusta's greatest commercial success within the field of aviation design. Designed by the engineer Bruno Lovera with the assistance of the aerodynamicist Paolo Bellavita, the A109's development began in the mid-1960s when it was initially conceived as a single-engine commercial helicopter. It soon became apparent that it could do with some extra power and so was re-designed in 1969 to accommodate two Allison 250-C14 turbo shaft engines. Finally, on the 4th of August 1971, the first of four prototypes undertook its maiden flight and initially the helicopter was marketed as the A109 Hirundo (meaning "Swallow" in Latin), but this name was soon dropped. After four more years of painstaking refinement and development, the first production model of the helicopter debuted in 1975 and its manufacture subsequently began the following year.

Orders for this distinctive-looking aircraft soon flowed in, and shortly it was not just being used in light transport roles but was also proving its worth as an air ambulance and in search-and-rescue missions. Around this time, Agusta also began developing rugged military versions of the design, one being intended for light attack or close ground supporting roles (equipped with rocket and machine-gun pods and anti-tank missiles for use on the battlefield), while another was specifically adapted for naval operations. Of all the variants of this classic helicopter design it is the eight-seat civil version, now known as the AW109 Power, that has become regarded as the most successful helicopter in its class.

A veritable workhorse of the skies, the lightweight twin-engined A109 has over the last four decades proved time and again its phenomenal functional adaptability: from being used as a luxurious aircraft used to ferry VIPs to being employed for police surveillance work, to working as an ever-reliable air ambulance undertaking medical evacuations. It is even used by the British Special Air Service (SAS) for covert military operations making it an undisputable Italian masterpiece, boasting truly impressive control of the skies above our heads.

A109 helicopter, first flight 1971 (examples shown AW109 Power)
Various materials
Costruzione Aeronautiche Giovanni Agusta, Casina Costa, Samarate (later AgustaWestland)

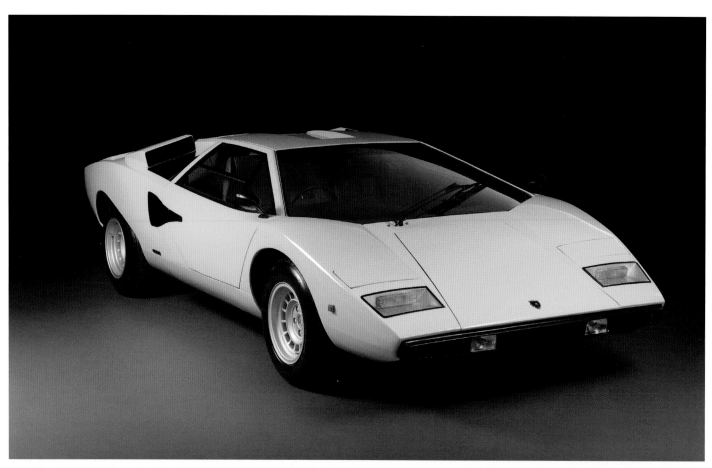

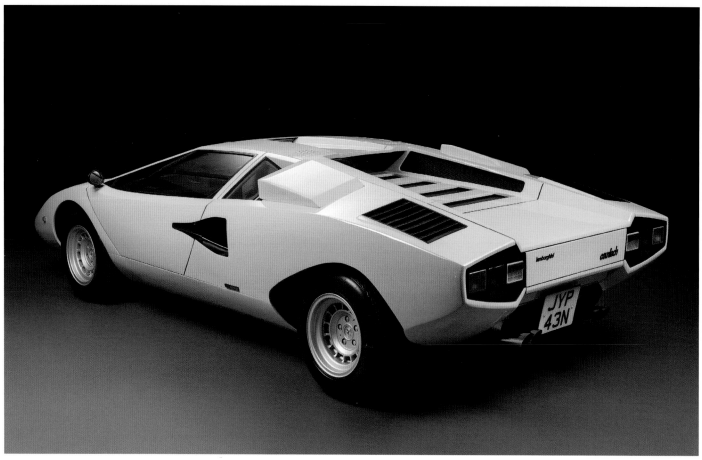

Lamborghini Countach LP 400, unveiled 1971

Marcello Gandini (1938–)

O f all the supercars ever made, the Lamborghini Countach has to be the most instantly recognizable with its bold angular lines shouting a certain over-the-top 1970s machismo – an overtly masculine bravado that quite literally throbs through this swaggering high-performance car. Like the rearing stallion of the Ferrari logo, the raging bull emblem of Lamborghini absolutely embodies the spirit of both the company and the cars that it produces, and most especially the Countach.

Styled by the legendary automotive designer Marcello Gandini at Bertone, the Countach was intended as a replacement for the sublimely beautiful Miura. Work commenced on it in 1970 with the first prototype being unveiled the following year at the Geneva Motor Show. Having a new and longer chassis together with a powerful V-12 engine placed longitudinally (rather than transversely) and further away from the driver's seat, this new supercar – initially known as the LP 500 – provided a significant reduction in interior noise levels. This was a problem that had previously spoilt the driving experience of the Miura, meaning that this earlier elegant and powerful vehicle had not completely satisfied the marque's founder, Ferruccio Lamborghini, whose philosophy was always to create extreme super sports cars without any compromise.

Eventually a modified variant of the car known as the LP400 was put into production with various modifications under the Countach name in 1974, the same year Ferruccio Lamborghini sold his remaining stake in the company to his friend René Leimer. Powered by a 4.0-litre V12 engine, the Countach certainly lived up to its name: an Italian expression that has a similar meaning to the English "Phwooar" or the American "Wow!" or "Holy shit!" – in other words, an extreme

**Lamborghini Countach LP 400,
unveiled 1971**
Aluminium body, other materials
Automobili Lamborghini, Sant'Agata
Bolognese

but also spontaneous expletive of appreciation. In fact the Countach was the only Lamborghini car that did not take its title from a famous Spanish fighting bull – a well-known Lamborghini tradition. The name of the car was instead reputedly coined when the Italian automotive designer Giuseppe "'Nuccio" Bertone made the exclamation when he first saw the car's prototype in his studio – although other sources cite that it was Ferruccio Lamborghini who made the memorable utterance. And no wonder, for it was a car like no one had ever seen before, especially with its futuristic and unique scissor-like door opening mechanism, which would eventually become a defining Lamborghini trademark.

With its sleek yet angular profile, the Countach was utterly distinctive and became a true object of desire among a certain demographic – with posters of this remarkable "dream car" adorning the walls of countless teenage boys' bedrooms throughout the 1970s. It was not just its extreme wedge-like looks, derived from trapezoidal panels executed in aluminium, that made the Countach so special; but also its high-performance that according to the Italian Ministry of Transportation gave it a top speed of 181.6 mph (282.3 kph), which was clocked at the Nardo test track, although a higher speed of 190 mph (306 kph) was controversially claimed by *Fast Lane* magazine.

Although the car's form suggested aerodynamic efficiency, looks can be thoroughly deceiving. The Countach's actual aero credentials when tested under wind-tunnel conditions were pretty terrible. This deficiency, however, was more than made up for with various innovations including a "cabin-forward" layout that allowed room for a larger engine, an aircraft-grade aluminium skin wrapped over a lightweight space-frame and a gearbox that was mounted in front of the engine for better weight distribution.

In production from 1974 to 1990, the Countach underwent four evolutions and during this 16-year period a total of 2,042 cars were produced – although only 157 cars of the original LP 400 version were made. A true supercar legend, the Countach was a flagrant demonstration of Italian automotive passion and design flair, resulting in the most radically styled car of the 1970s – possibly of all time.

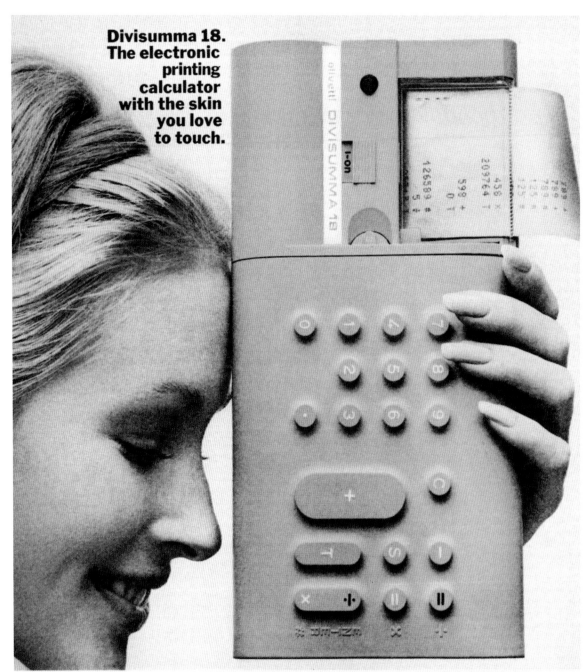

**Divisumma 18.
The electronic
printing
calculator
with the skin
you love
to touch.**

Get mathematically involved with Olivetti.

Divisumma 18 is not only the world's finest portable electronic printing calculator, it's also the first one that's squeezable! Its keyboard's actually made of rubber with "keys" molded right into it. With a few light pats you can solve the most complicated problems of addition, subtraction, multiplication or division. Almost instantaneously! It has a 12 digit capacity, four fixed decimal places, a constant multiplier and divisor. A permanent rechargeable battery. There's also a slightly larger home/office version, the Divisumma 28 (shown at right). See these and the rest of Olivetti's line of great adding, multiplying and calculating machines at your Olivetti dealer. And when you go in, please <u>do</u> squeeze the Divisumma.

olivetti

OLIVETTI CORPORATION OF AMERICA, 500 PARK AVE., NEW YORK CITY 10022

Divisumma 18 electronic printing calculator, 1971–73

Mario Bellini (1935–)

One of the great pioneering proponents of industrial design in Italy, Mario Bellini has throughout his long and highly illustrious career always created products that push the outer boundaries of form and function. His innovative designs have constantly predicted the future but have not been consciously futuristic looking like, for example, the contemporaneous work of Joe Colombo or Verner Panton. Instead, Bellini's designs have always had an underlying functional logic and a refined aesthetic that has been directly informed by his rational yet thoughtful human-centric approach to problem solving.

During his career spanning over five productive decades, Bellini has worked for numerous companies known for the quality of their designs, from Brionvega and Cassina to B&B Italia and Vitra. But it is Bellini's office equipment designs for Olivetti that perhaps best exemplify his extraordinary ability to "skin" technology and create products that are ground-breaking and at the same time possess a

Opposite: Olivetti advertisement showing the Divisumma 18 electronic printing calculator, c.1973 – this image additonally features the Divisumma 28 calculator also designed by Marco Zanuso for Olivetti in 1972

Divisumma 18 electronic printing calculator, 1971–73
Acrylonitrile-butadiene-styrene (ABS), synthetic rubber, melamine formaldehyde resin (MF)
Olivetti, Jvrea

sense of inevitability – a "yes, of course, it makes utter sense to do it this way" sort of feeling.

Between 1963 and 1991, Bellini worked as the chief design consultant for Olivetti – a company that was already internationally recognized for its innovative design-led office machines. In this capacity, Bellini was responsible for developing numerous revolutionary products, including the Divisumma 18 printing calculator. This design was either battery or mains-operated and was highly influential for two principal reasons: the wonderfully tactile, synthetic-rubber elastomer that coated its keyboard, and the bright and playful yellow colouring that differentiated it from the drab, muted appearance of earlier office equipment. By using a combination of three different plastics – shiny ABS, soft rubbery elastomer and hard durable melamine – Bellini was also able to make his calculator considerably lighter, smaller and infinitely more portable than earlier models. The elastomer-covered, nipple-like buttons that were one of the design's most novel features were subsequently widely copied throughout the consumer electronics industry. Seizing on the tactile and expressive potentialities of the newly available synthetic materials, Bellini used them to relate the rapidly evolving technologies of the electronics industry to the playful visual aesthetic of 1960s Pop culture.

In the December 1973 issue of *Domus* magazine, Bellini described the Divisumma 18 as: "A strange object which can be stood upright like a small, reassuring totem; a curious object with the capacity, perhaps, to create what might even be a flow of mutual understanding, seeing that by now everyone is capable of calculating." By demonstrating that electronic products could be sensual, fun and empowering, Bellini blazed a fresh and more youth-oriented trail in the world of industrial design, one that would increasingly use synthetic polymers to forge emotional bonds between object and user. Many subsequent electronic products were similarly distinguished by the utilization of sculptural forms, physical tactility and bold youthful colours. The Divisumma 18 was one of the first and most influential examples of this new kind of product that strove to give technology a more friendly face.

Basilico teapot for the Indian Memory series, 1972
Partially glazed earthenware
Alessio Sarri Ceramiche, Sesto Fiorentino

Right: Cinnamon teapot designed by Ettore Sottsass for
the Indian Memory series, 1972

Basilico teapot for the Indian Memory series, 1972

Ettore Sottsass (1917–2007)

Ettore Sottsass was a prolific and provocative designer, a polymath who sought inspiration from all corners of the world and endeavoured to find out about cultures beyond his own. In the late 1950s and early 1960s he travelled extensively, first to the USA and then East to Burma, India, Nepal and Sri Lanka. These world travels would leave an indelible mark on his design practice for the next five decades, as he sought to use his design skills to create a more meaningful relationship with the objects that surround us. One of the results of this search was the Basilico teapot from the Indian Memory series of 1972, which used the spiritualism of Eastern iconography to express values beyond those of Western consumerism.

Sottsass's attempt to find an alternative design language was first expressed in two collections that he made following a serious kidney infection in 1962: the sombre Ceramiche delle Tenebre (ceramics of darkness) from 1963 and the brightly coloured Ceramiche della Shiva (the ceramics of Shiva) from 1964, whose brighter colours celebrated Sottsass's recovery from the near-fatal illness. Made by Bitossi, a manufacturer

in Montelupo Fiorentino in the heart of Tuscany's ceramic industry, both sets are cultural hybrids whose elementary forms, bold colours and symbolic decoration reveal the architect's admiration for both Eastern symbolism and American pop culture.

Sottsass's experiments with ceramics continued into the 1960s and 1970s, and in 1972 these resulted in the Indian Memory series: a collection of teapots identifiable for their playful geometric forms and lack of surface decoration. There are four teapots in the series; alongside the semi-circular curves of the bright green Basilico are the asymmetric black and grey Cardamon, the sand-coloured rectangular body of the Cinnamon and the squat, oval forms of the grey Pepper teapot. Designed in the early 1970s, the objects remained wooden prototypes until 1987, when they were produced in painted and glazed earthenware by Alessio Sarri, a ceramicist based in the Tuscan town of Sesto Fiorentino. This was the first time that Sarri and Sottsass had worked together, but this was not Sarri's first encounter with the Italian design scene, and their relationship was born out of the ceramicist's earlier collaboration with Matteo Thun, who was one of Sottsass's collaborators in the celebrated Memphis design collective.

Sarri had been responsible for producing Thun's Rara Avis set of cruets and teapots for the second collection of Memphis in 1982. On seeing the results at the launch of the second collection, Sottsass took note of their skilful production and subsequently approached Sarri to realize his Indian Memory series five years later for the German manufacturer Anthologie Quartett. As with Thun's design for the Rara Avis series, these were technically demanding objects, and achieving the desired depth and brightness of colour across the whole of the object's surface proved particularly challenging. This standardized uniformity of surface colour was important to Sottsass. Like the Rara Avis collection, Sottsass had originally conceived the Indian Memory series to be produced in plastics, but the economics of Italy's manufacturing set-up made ceramics a more feasible material.

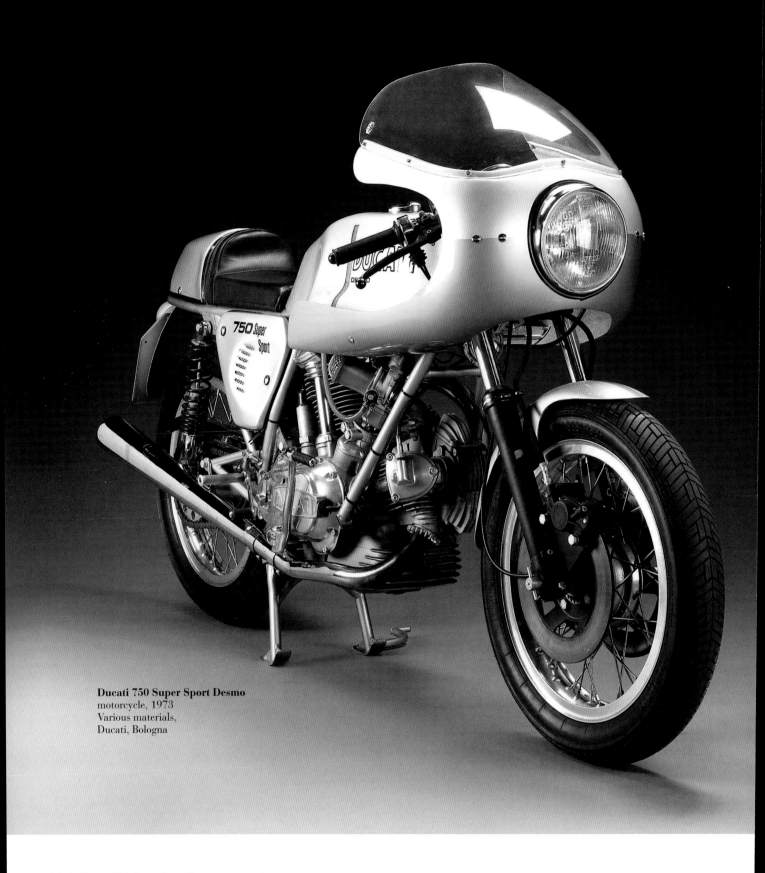

Ducati 750 Super Sport Desmo
motorcycle, 1973
Various materials,
Ducati, Bologna

Ducati 750 Super Sport Desmo motorcycle, 1973

Fabio Taglioni (1920–2001)

Renowned the world over, Ducati motorbikes have a road presence like no other. Even when they are stationary they seem to pulsate with the potential for speed. Their distinctive and purposeful sweeping lines promise exhilarating power, and Ducati's current crop of models do not fail in this regard especially on the racing circuit. However, among biking cognoscenti, it is the 750 Super Sport launched in 1974 that is generally considered the ultimate Ducati production bike of them all.

The Italian engineer Fabio Taglioni, who was the chief designer and technical director of Ducati from 1954 to 1989, conceived the 750 Super Sport road bike soon after the British racing legend Paul Smart and the Italian champion Bruno Spaggiari won the 200 Mile race at Imola on their Ducati 750 Desmo racing bikes in 1972 in a one-two finish – with Smart narrowly coming first. The elegantly

Above: Detail showing crankcase emblazoned with the "Ducati" name

styled 750 Super Sport introduced two years later was essentially a production model of the earlier innovative and super-stylish 750GT racing bike, which had brought the surprising and legendary victory at Imola. Intended for high performance recreational use, the Super Sport was the world's first two-cylinder road bike with a desmodromic system.

Also known as the "Greenframe" because of its colour scheme, many consider this elegant design to be the most beautiful motorcycle ever constructed with the sweeping aerodynamic form of its front bikini-style faring and its gleaming cast crankcase emblazoned with the Ducati name in stylish Art Deco lettering. Taglioni's V-twin desmodronic engine can also be considered an object of beauty in its own right and demonstrates the extraordinary engineering know-how and precision production methods to be found within Italian manufacturing firms.

The ultimate production bike of the 1970s, the Super Sport motorcycle not only set new levels of performance, but also marked a paradigm shift within the aesthetics of sporting motorcycle design. Originally, Ducati intended to build only twenty-five of these speed machines, however, demand was so high they actually manufactured many more, although the exact number is hotly contested and has been set at anything between 200 to 411 units. Highly sought-after by collectors today, the 750 Super Sport has been hailed by *Cycle* magazine as "the definitive factory-built café racer", while *Motociclismo* magazine states that "it may be considered the most significant motorcycle of all time".

Atollo table light, 1977
Enamelled metal (or opaline Murano glass)
Oluce, San Giuliano Milanese

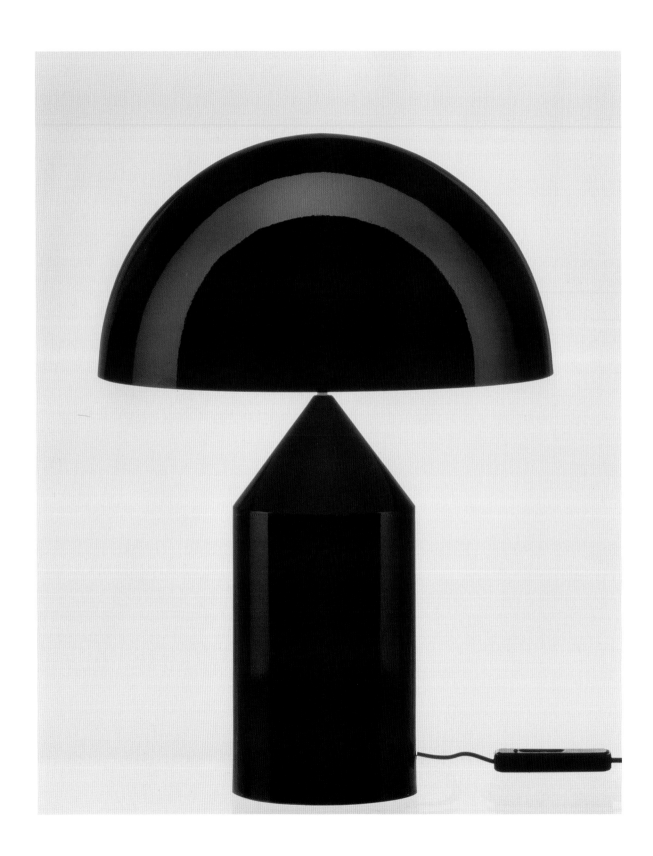

Atollo table light, 1977
Vico Magistretti (1920–2006)

Throughout his long and illustrious design career, Vico Magistretti created objects that had an innate "rightness" – designs that allowed form to follow function but that were not slavishly utilitarian, in other words, products that found the design sweet spot between usefulness and beauty. For Magistretti this was a conscious and intended goal, which led to what he described as "design without adjectives" – by which he meant designs that were not influenced by stylistic considerations but were instead driven by an understanding of functional requirements, as well as by constructional and material possibilities. For inspiration, he looked to earlier designs produced by the Shaker communities in America during the nineteenth century and appreciated the clean lines of such work that was stripped of decoration to reveal an underlying functional purity of form.

Magistretti would often take an archetypal form as his starting point and then distil it to its most elemental expression. An excellent example of this approach was his design of the Atollo table light created in 1977 for Oluce, which is not only one of Magistretti's best-known products and a realization of his desire to explore "the very essence of the object, looking at usual things with an unusual eye".

The Atollo's strong elemental quality was derived from Magistretti's use of three Euclidean forms – the hemisphere, the cylinder and the cone – that he arranged in such a way that they abstractly outlined a traditional table light. It was the Atollo table light's underlying symbolism as much as its bold sculptural form that made the design so visually captivating. This was a lighting design that was the purest geometric abstraction of the classic table lamp, and in its design DNA it reflected this almost totemically. Available in black or white and in three different sizes, the Atollo was awarded a Compasso d'Oro in 1979 and the fact that it has remained in continuous production for over three-and-half decades is testament to its enduring and timeless appeal. Its undeniable sculptural presence is also highly representative of the architectonic quality of Milanese design, while at the same time it is also confirmation of the effectiveness of Magistretti's mindful approach that was guided by a belief in the primacy of simplicity and usefulness.

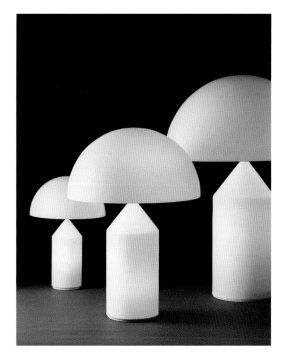

Left: Oluce publicity photograph of a group of Atollo table lamps made from opaque white glass.

Proust armchair, 1978

Alessandro Mendini (1931–)

It could be argued that Alessandro Mendini's main role in Italian design has been that of an editor – both in the literary sense and in the design sense of the word. Following his graduation from architecture at the Politecnico di Milano in 1959, Mendini edited *Casabella*, *Domus* and *Modo* magazines, using them as tools to both promote and provide a forum for debate for the international architectural and design avant-garde. This editorial role has also defined his architectural and design practice. Appointed creative director of Alessi in 1978, Mendini oversaw the Tea & Coffee Piazzas project, in which 11 leading architects developed designs for services that were released four years later. In the interim, Mendini joined Studio Alchimia, for which he designed the Proust chair, editing it together using elements from the existing creative landscape.

The Proust chair was born in the climate of uncertainty that permeated Italian design in the late 1970s. Global Tools, the collective formed in 1973 at the peak of the Radical Design movement at Mendini's *Casabella* offices, folded in 1976. Its dissolution was seen to signal the end of the utopianism of the Radical Design avant-garde, abandoned amidst little sign of their longed-for change in both society and the design profession. Yet the closure of Global Tools did not mean that the provocative energies of the architects involved ended. 1976 also saw the foundation of Studio Alchimia, the group heralded as the precursor to the Memphis design collective and the beginning of Post-Modernist approaches in Italian design.

Behind Studio Alchimia were Adriana and Alessandro Guerriero, siblings who set up the studio-gallery in their native city of Milan. Mendini was one of the visitors to the space, and they subsequently invited him to join the group two years later, alongside other former Radical architects including Sottsass and De Lucchi. Mendini soon became a leading figure in the group, and the Proust chair is an expression of both his increasingly prominent role in Studio Alchimia and the direction he was leading it in.

The chair was conceived as part of the Redesign series that started in 1978. This was a multi-faceted design collection in which a variety of objects, from anonymously designed supermarket goods to historicist reproduction furniture and modern design "classics", were subjected to a plethora of banal ornamentation. This was a deliberate attack on Modernist orthodoxy of the early twentieth century, with its disavowal of historical references and its negation of ornament in favour of a function-driven aesthetic. Instead, redesigns such as Proust were in the identifiably pluralist Post-Modernist vein. Its name comes from the French novelist writing a hundred years previously, its form is an interpretation of the eighteenth century Baroque style and its decoration inspired by the Pointillist style associated with the Parisian painter Paul Signac.

The redesign strategy can be understood in a number of different ways. On the one hand, its strategy of using the existing rather than creating something from scratch spoke of the nihilism of Mendini's approach. The architect believed that Italian design was creatively stagnant and socially ineffective in the late 1970s: architects could no longer design, but could only "redesign". On the other hand, this was also a pragmatic production strategy at a time when few manufacturers were willing, or able, to put these designs into production. There is a third dimension to be picked up on here: with its cutting and pasting of the existing, this was a decisively edited object.

The redesign strategy continued into the early 1980s, most notably with the Il Mobile Infinito furniture collection, in which every element, from the handles to surface designs, were authored by a different designer. While Il Mobile Infinito was Studio Alchimia's biggest project, its unveiling at the 1981 furniture fair in Milan was overshadowed by the launch of the Memphis design collective, the largest and loudest manifestation of Italian Post-Modernism. Despite the eclipse of Studio Alchimia, the Proust chair has gone on to have a life of its own, and in 1993 Cappellini put the Proust Geometrica into production, a bold, brightly coloured version of the original design.

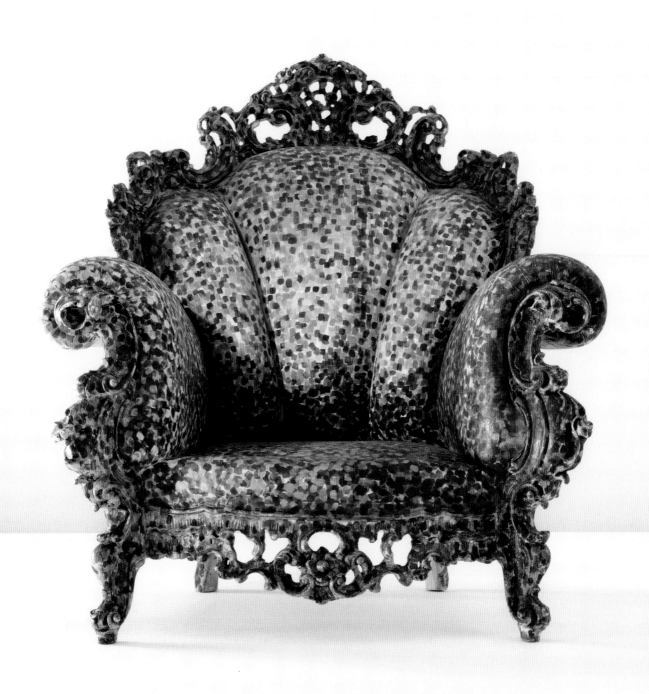

Proust armchair, 1978
Hand-painted wood, hand-painted upholstery
Studio Alchimia, Milan

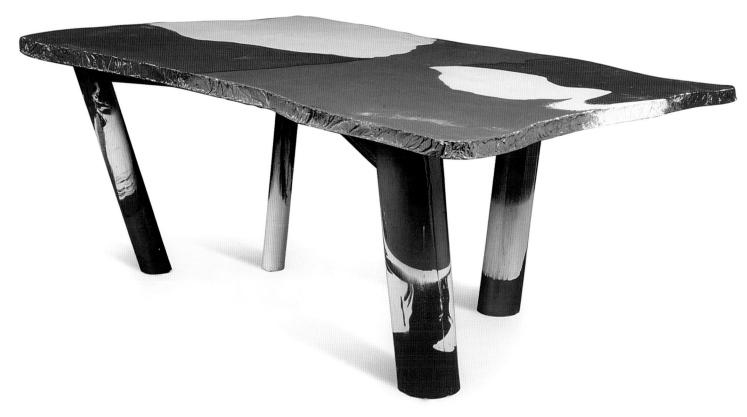

Sansone 1 table, 1980
Moulded polyester resin
Bracciodiferro/Cassina, Meda

Sansone 1 table, 1980

Gaetano Pesce (1939–)

For the design of the Sansone 1 table, Gaetano Pesce collaborated with the inventor Jean-Luc Muller, who helped to co-develop its innovative method of serialized production that utilized liquid polyester resin and flexible moulds that were neither round, square nor rectangular. This allowed the design's fabricators the opportunity to creatively determine the final outcome of each piece made, with to a certain degree every Sansone 1 being slightly different in its colour patterning of white, red and green as well as the shape of its irregularly formed top.

Part of Pesce's "diversified series" of designs, this unusual approach to manufacturing meant that rather than being a standardized design like those

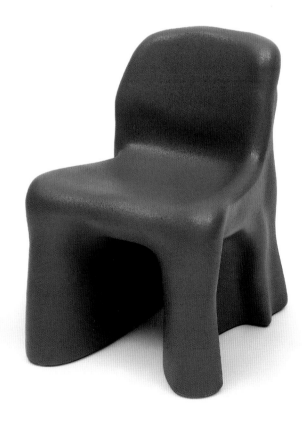

that are produced using traditional plastic moulding techniques, each example was a slightly different variant and therefore completely unique. As its manufacturer Cassina explained, the design resulted from the novel idea of "the individual unit in mass-production".

The curious form of this table, as its title suggests, was directly inspired by the Old Testament story of Samson's love of the beautiful yet treacherous Delilah and his subsequent reprisal. The table's legs set at odd angles recall the toppling columns of the Philistine's temple that Samson destroyed in a his last fatal fit of vengeance. Pesce saw this ancient tale as a relevant parable for our own times, reflecting the need for people to be set free from social, political and economic doctrines and dogmas. He viewed this well-known story as a rallying call to escape the stultifying confines of any kind of imperialism, but most especially those established conventions that had for decades defined what was "good" design. As such, the Sansone 1 table can be seen as an early example of Italian Post-Modern design, as well as a highly influential example of what would later become known as "design-art". Pesce also designed a series of three chairs known as Dalila (Delilah) to compliment this remarkable table, which similarly employed an innovative, though different, plastic moulding technology.

Left: Dalila II chair designed by Gaetano Pesce for Cassina, 1980

AC01 oil & vinegar set, 1980

Achille Castiglioni (1918–2002)

Questioning product typologies and improving the existing are just two of the reasons why Achille Castiglioni is such a celebrated designer. First presented in 1980 and put into production by Alessi in 1984, the Milanese architect's design for the AC01 is the result of one such rethinking. Although identifiable as an oil and vinegar set, it breaks with convention in a number of ways to create a highly functional and yet still elegant tabletop object.

Looking around at the contemporary landscape of similar products, Castiglioni questioned some of the basic tenets of their design: why were the oil and vinegar containers identical when they were intended to contain different, but visually similar, liquids? In response, Castiglioni made the glass containers different shapes to avoiding confusing the two condiments, and designed the oil container to be larger to reflect its higher usage rate.

This reconsideration of the conventional design did not stop with the shape of the vessels, whose distinctive form ensures that the set is endowed with the playful personality that is another hallmark of Castiglioni's design approach. In another departure from custom, Castiglioni decided to do away with separate lids for the containers, which so often seemed purposeless when not in use. Instead, each container is topped with a hinged polished steel lid that is attached to the vessel with a counterweight that ensures the lid automatically opens when the container is tilted into the pouring position and closes when the cruet is stood upright. This attention to detail permeates the design, as seen in the long, slender T-section handle that is designed to fit comfortably in the user's hand, and a rimless, flat metal base with grooves that demarcate the placing of the containers. The cruet set is completed by a small glass-and-steel salt cellar that has the same distinctive angular profile, albeit this time in a symmetrical hourglass shape.

The AC01 was not the only cruet set that Castiglioni designed for Alessi; in 1982 the firm put Phil into production, its name based on the Italian for the wire that wrapped around each container. Available in a variety of condiment combinations, the set was mass-produced in stainless steel. In contrast to this more accessibly priced design, the AC01 was initially conceived for a more restricted market. It was initially unveiled in 1980 as part of a series overseen by design impresario and collector Cleto Munari and first produced in silver by Rossi & Arcandi, a manufacturer located in Vicenza, a historic centre of silverware production in northeast Italy. While the Phil is no longer in production, the AC01 continues to be produced, now at the same large scale intended for the former. In 1984 the cruet set was put into production by Alessi in polished stainless steel as part of the firm's Tavola di Babele series of tableware produced by industrial means, which also includes Aldo Rossi's La Conica coffee maker.

Above: Alessi cartoon showing a waiter using the AC01 oil and vinegar set.

AC01 oil & vinegar set, 1980
Glass, polished stainless steel
Alessi, Crusinallo

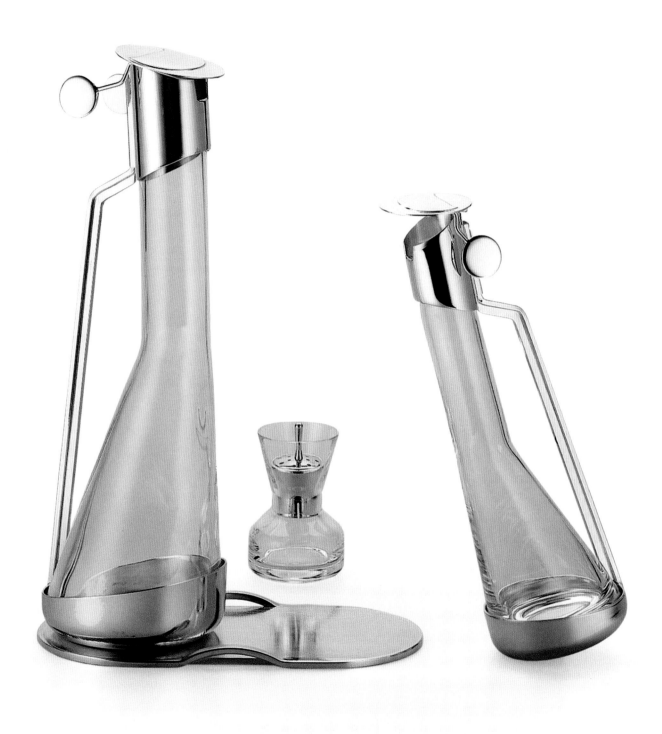

Carlton bookcase/room divider, 1981
High-pressure laminate (HPL), wood
Memphis, Milan

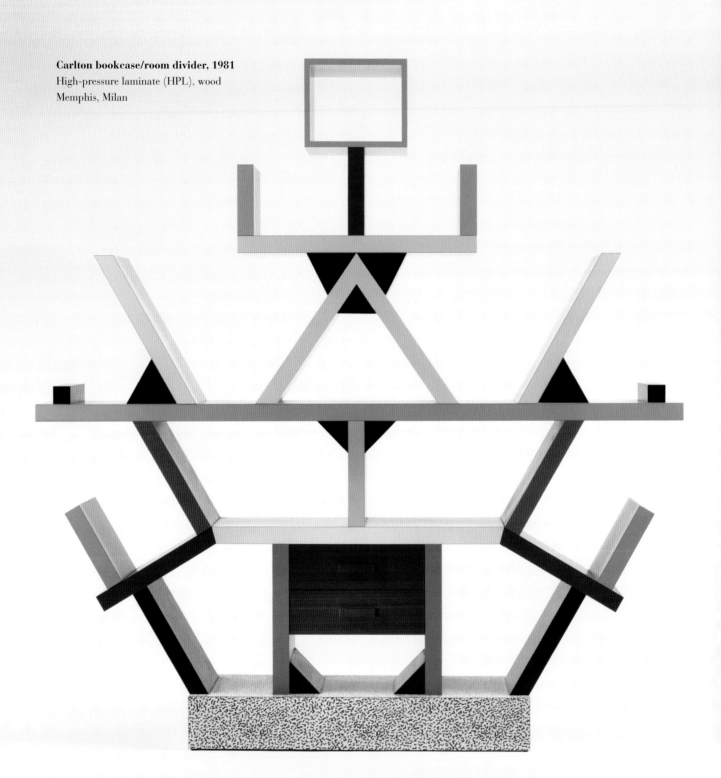

Carlton bookcase/room divider, 1981

Ettore Sottsass (1917–2007)

The Carlton bookcase/room divider is not only the most iconic furniture design by that great protagonist of Italian Anti-Design, Ettore Sottsass, but also the most notable piece produced by the controversial Italian design group Memphis. A radical departure from the traditional bookcase form, this design was a blatant Post-Modern statement that was intended to be a challenging provocation to the design establishment.

Prior to its realization, Ettore Sottsass had experimented with the creative potential of plastic laminates made by the Italian manufacturer Abet Laminati during the mid-1960s, creating a number of striking totemic case pieces for the progressive furniture manufacturer Poltronova. These early designs had helped to somewhat elevate the status of plastic laminates into materials of symbolic value. However, by the late 1970s and early 1980s, Sottsass had

returned to using laminates in the development of his avant-garde furniture designs, undoubtedly attracted by their perennial association with kitsch. Indeed, the majority of furniture produced by Memphis incorporated brightly coloured and boldly patterned laminates manufactured by Abet. However, it was the Carlton that more than any other design made full use of this man-made material's structural and expressive potential.

Designed in 1981, Sottsass's Carlton bookcase/room divider dramatically exploited the decorative surface qualities of laminates with its unusual and graphically striking form. This remarkable design had a forceful presence that intentionally countered perceived notions of good design, and thereby good taste, and instead projected the concept of design as metaphor. As Sottsass was later to write: "It is important to realize that whatever we do or design has iconographic references, it comes from somewhere; any form is always metaphorical, never totally metaphysical; it is never a 'destiny' but always a fact with some kind of historical reference. To put an object on a base means to monumentalize it, to make everyone aware it exists." The Carlton became one of the most celebrated expressions of Post-Modernism, and to this extent can be considered one of the most important masterpieces of Italian Radical Design.

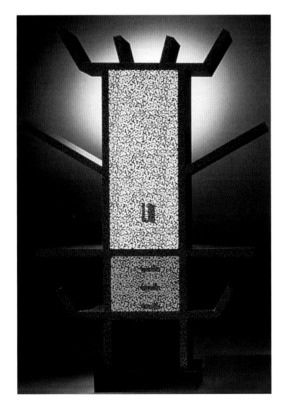

Left: Casablanca cabinet designed by Ettore Sottsass for Memphis, 1981

Olivetti Praxis 20 electronic typewriter, 1981

Mario Bellini (1935–)

The Italian industrial designer Mario Bellini has created literally hundreds of innovative designs for a wide range of manufacturers during his long and highly productive career – electronic products for Brionvega, furniture for B&B Italia, Poltrona Frau and Cassina, hi-fi systems for Yamaha, lighting for Artemide, Erco and Flos, pens for Lamy and ceramics for Rosenthal, to name but a few. He has also worked extensively as a design consultant to the car industry, including Renault, Fiat and Lancia. However, probably his best-known designs are those he created for Olivetti, with ten of these having the accolade of being included in New York's Museum of Modern Art's permanent collection. But there is one design that he created for Olivetti, which might be less well known but is in some ways more interesting than some of his better known products – the Praxis electronic typewriter designed in 1981 and patented the following year.

Although the first portable electric typewriter had been introduced in 1957 by the American manufacturer Smith Corona, most electronic typewriters were not particularly stylish – with the notable exception of some of Olivetti's earlier models. The Olivetti Praxis range, however, was aesthetically right on the fashion button when it was first introduced in the early 1980s. After the rainbow-coloured design fun-run of the late 1960s and early 1970s, and the woody, worthy but boring earth-toned style of the late 1970s, by the early 1980s there was a desire for a new more sophisticated look that was more in tune with the go-getting macho business ethos of this "designer decade".

In the early 1980s, matte black was most certainly "the new black" and this new, though short-lived, design trend was actually christened the Matte Black Style – thanks to the non-colour's all-pervasive dominance. Matte Black was hard-edged and angular, a Neo-Rationalist style that was urban and urbane, and Mario Bellini perfectly captured its essence in his design of the Praxis electronic typewriter (which came with different model numbers according to its variously integrated functions). Then a state-of-the-art and top-of-the-range machine, the Praxis incorporated a correctable film typewriter ribbon cassette made by Pelikan and even boasted a basic memory function so that multiple copies of a document could be typed electronically at the touch of a button. Instead of traditional touch-and-strike keys, the Praxis used interchangeable daisywheels, which meant the physical bulk of the typewriter could be reduced into an elegant sloping wedge-like form. The translucent clip-on black cover, designed to protect the typewriter when it was not in use, completed the stylish look and gave the overall design a fashionable minimalistic aesthetic.

During his career, Mario Bellini created other minimalist "all black" designs, including his ST 201 cube television set (1969) for Brionvega and his classic Cab chair for Cassina (1977). But the Praxis typewriter was without question the most technically sophisticated and the most aesthetically accomplished product that he created within this minimalistic formal language of design.

Above: Olivetti advertisement for the Praxis typewriter, 1982

Olivetti Praxis 20 electronic typewriter, 1981
Acrylonitrile-butadiene-styrene (ABS),
Polymethyl methacrylate (PMMA)
Olivetti, Ivrea

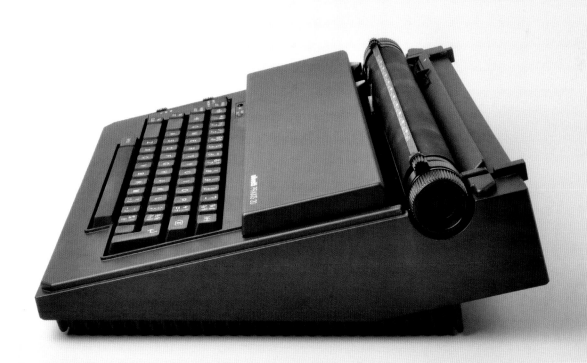

Murmansk fruit dish, 1982

Ettore Sottsass (1917–2007)

The launch of Memphis in 1981 confirmed the advent of Post-Modernism in Italian design. Led by the inimitable Ettore Sottsass, Memphis was unmissable, an attention-grabbing combination of bold forms, strong hues, brash patterns and eclectic references that mixed up styles past and present and cultures near and far and high and low. This cultural pluralism was summed up in the group's name: Memphis is the name of both an American town and ancient Egyptian capital, and was inspired by the 1966 Bob Dylan song *Stuck Inside of Mobile with the Memphis Blues Again*, which was stuck on repeat during one of the group's first meetings in the winter of 1980.

Sottsass's electroplated nickel silver Murmansk is typical of the contradictions and complexities of the Memphis group. Its gleaming silver surface and the six zigzagged legs that hold up the generously-sized fruit dish evoke the icy environment and faraway location of the north Russian city it is named after, but they also recall the ziggurats and Eastern iconography found in Sottsass's designs from the late 1960s onwards.

Murmansk was produced for the second Memphis collection of 1982, which stood out in its embrace of Italy's craft traditions. The hands of Italy's artisans had been important for the realization of the prototypes and short runs that made up the first collection the previous year. For the second, this widespread engagement with the handmade was marked by a distinctly luxurious air, with handblown glassware from Murano, marble tables from Carrara, and silverware items from Vicenza, renowned for the production of silver tableware, cutlery and household items. The fruit dish was made by Rossi & Arcandi, a small firm set up in Monticello Conte Otto on the outskirts of the city in 1959 by Romano Rossi and Arcandi Severino. Under the guidance of local design impresario Cleto Munari, in 1973 the firm started its relationship with Italy's design culture, producing a set of cutlery designed by Venetian architect Carlo Scarpa. This collaboration led to a series of objects including jewellery and small-scale domestic pieces designed by architects such as Alessandro Mendini, Sottsass, and Andrea Branzi, whose Labrador silver and glass sauceboat was also manufactured by Rossi & Arcandi for Memphis's 1982 collection.

The Murmansk dish contains another contradiction characteristic of the Memphis collective. Despite its large-scale engagement with Italy's craft traditions, Memphis was not intended to be a craft revival. Rather, Sottsass and his fellow designers turned to craft as a way to reinvent and revive Italy's design culture, to create what they termed the "New International Style". It is clear from objects such as Murmansk that Italy's artisans were willing and able participants in the creation of this new language for Italian design, a role that is often overlooked in Italy's design history.

Above: Design drawing of the Murmansk fruit dish, 1982

Murmansk fruit dish, 1982
Electroplated nickel silver
Rossi & Arcandi, Monticello Conte
Otto, for Memphis, Milan

Colorado teapot, 1983

Marco Zanini (1954–)

With its tall red lid, pink and green body, circular yellow handle and blue square base, Colorado is no ordinary looking teapot. This is not surprising given its background; Colorado was designed by Marco Zanini for Memphis and, like all of the objects produced by the Milanese design collective, this was a wilfully provocative object that rebelled against the functionalist conventions of Modernist design and Italy's reputation for good taste and elegant luxury. The Colorado was a playful design, an assemblage of clashing colourful forms whose toy-like appearance is found in a number of Memphis objects, from Michele De Lucchi's First chair to Sottsass's Carlton bookcase/room divider.

Zanini was one of the younger members

Above: Detail of the Colorado teapot

of the Memphis design collective: he was still in his twenties at its launch in 1981. Born in the northern city of Trento, he had studied architecture at the University of Florence before graduating in 1978. During his studies Zanini had spent time in the United States and, like Sottsass before him, his travels left an indelible impression on his design practice, most notably in the Pop-like colours and forms of the Colorado teapot. His involvement with Memphis also originated in this period – in 1975 Zanini met Sottsass for the first time, and in 1978 he started working in Sottsass's studio. Zanini was involved with Memphis from its very beginning; his designs include the Dublin sofa for the first collection in 1981 and the Alpha Centauri glass vase for the second, and both of these objects are imbued with the same playfulness as the Colorado teapot. Yet despite its seemingly frivolous appearance, this is a functional design: the square shape of the blue base is intentional, as it ensures that the rounded body of the teapot will not roll over. As with the majority of products that came out of the Memphis design collective, the Colorado was only possible thanks to the ongoing survival of Italy's craft tradition and the openness of its artisans to the experiments that these designs represented. Colorado was made by Ceramiche Flavia in Nove, a town with a history of porcelain production, near Vicenza in north Italy. As with several of the manufacturers involved in Memphis, Ceramiche Flavia was a relatively young firm, established in 1962 by a group of local artisans and directed by Aldo Londi, who also owned Bitossi Ceramiche in Montelupo Fiorentino in Tuscany. Although the firm did not collaborate with Zanini until the third collection, it had been involved from the very start, responsible for manufacturing designs such as Matteo Thun's Kariba fruitbowl from 1982 and Sottsass's Euphrates vase for the 1983 collection.

Colorado teapot, 1983
Glazed earthenware
Ceramiche Flavia, Nove, for Memphis, Milan

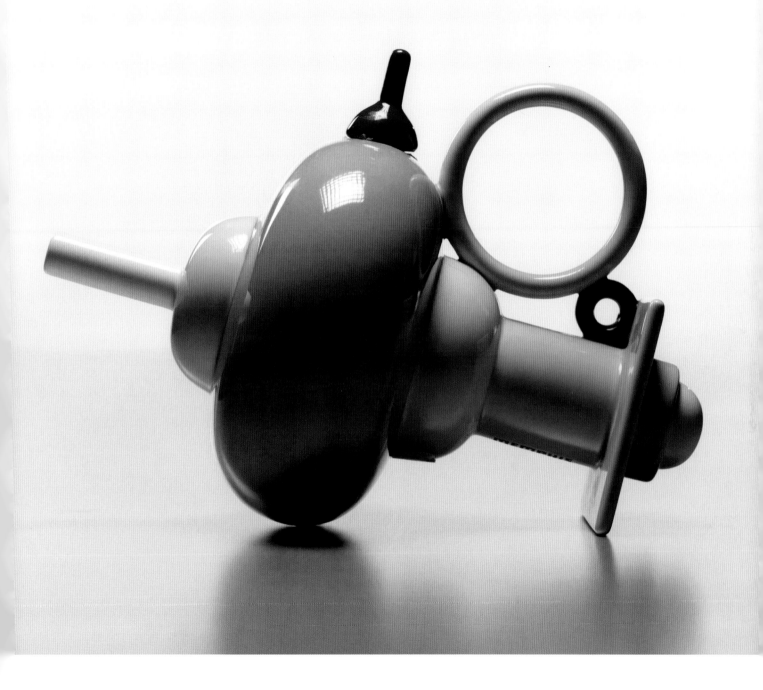

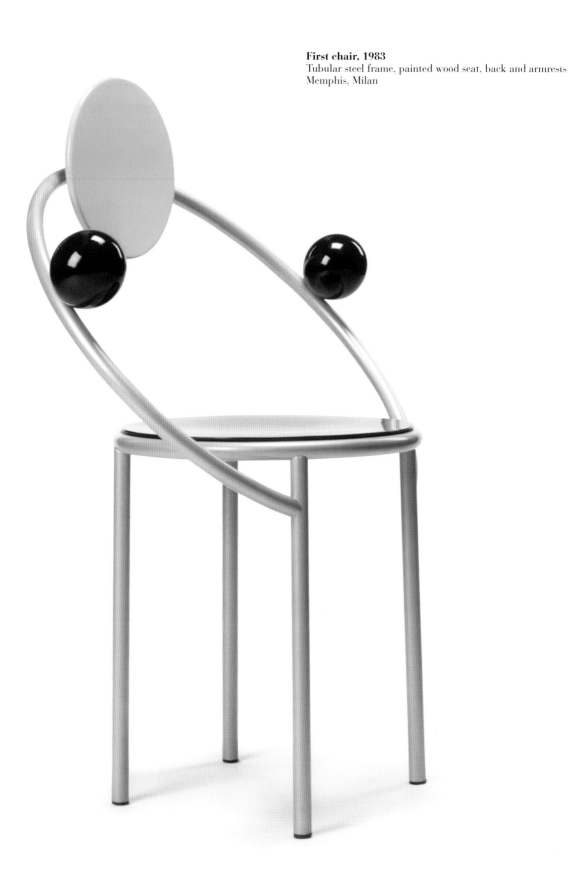

First chair, 1983
Tubular steel frame, painted wood seat, back and armrests
Memphis, Milan

First chair, 1983
Michele De Lucchi (1951–)

Michele De Lucchi entered the design profession in the early 1970s at the peak of Italy's Radical Design movement, and his approach to design would be strongly shaped by his emergence in this period. In 1973, while still an architecture student at University of Florence, De Lucchi co-founded the group Cavart that played a significant role in the architectural avant-garde. In the same year De Lucchi became a founding member of the Global Tools design collective, whose members represented the vanguard of Radical Design and many of whom would go onto be leading figures in Italian Post-Modernism. These included Ettore Sottsass, with whom De Lucchi became close friends in this period, both joining Studio Alchimia in 1978 before leaving to set up the Memphis design collective in the winter of 1980.

It is De Lucchi's designs for Memphis that best express the evolution of its style and ambitions following its launch in autumn 1981. The bright colours and loud patterns of designs such as the

Above: Promotional photograph of the First chair, c.1983

Kristall side table and the Oceanic table lamp embody the spirit of teenage rebellion of the first Memphis collection, while his more sober designs for subsequent collections, such as the luxurious marble Sebastopole dining table, made by Up & Up for the group's third collection in 1983, were intended to express the group's more mature phase. Compared to De Lucchi's earlier designs, the First chair from the 1983 collection is an essay in restraint, yet it is still imbued with a playfulness that is a hallmark of Memphis and De Lucchi's designs more generally from this period. This is most evident in the bright blue circular disc that acts as the chair's backrest and the two black wood spheres that constitute its armrests, positioned on the circular steel frame that envelops the sitter.

The First chair is De Lucchi's best-known design for Memphis and is also the group's biggest selling item. The chair's popularity was not just down to the growing appetite for Memphis in the early 1980s, but because this was the group's first attempt at mass production: a scale of manufacture that up to that point had not been possible. Despite the group's desire to be a democratic, accessible phenomenon, most of the Memphis output fell into the realm of luxury, due in part to the complexity of the designs presented that demanded the skills of the craft workshop, but also the desire to manufacture outside of the constraints imposed by large-scale industry. The simple design of the First chair made it more suited to mass production, and it was manufactured for Memphis in Pregnana Milanese, located in the furniture-making district to the north of Milan.

In 1986 De Lucchi left the group following Sottsass's own departure the previous year. De Lucchi had already set up his own studio two years earlier in 1984, and today he is considered by many to be one of Italy's most important architects. The First chair remains in production, following the acquisition of Memphis, first in 1988 by Ernesto Gismondi, head of Artemide, and then in 1996 by Alberto Albrici, who continues to manufacture Memphis products today.

La Conica espresso coffee maker, 1984

Aldo Rossi (1931–1997)

Aldo Rossi is respected as one of Italy's most theoretically informed architects, a creative individual who combined skills in drawing, theory, writing and architecture and design practice. A graduate of the Politecnico di Milano, in the 1950s Rossi worked with architects including Ignazio Gardella and Marco Zanuso and wrote for *Casabella* magazine, at the time edited by the Neo-Rationalist architect Ernesto N. Rogers. Throughout his career Rossi was responsible for a number of celebrated and occasionally controversial buildings. As with his design for the La Conica coffee maker, many of these demonstrated his own interest in Neo-Rationalism, including the floating Teatro del Mondo in Venice, a wooden theatre designed for the 1979–80 Venice Biennale.

Designed in 1984 for Alessi, La Conica is a slender stovetop espresso coffee maker made from pressed stainless steel. As with the Venice theatre, its form is composed of simple geometric forms and elementary architectural typologies: the two-part cylindrical vessel, hinged conical lid topped with a spherical knob, the v-shaped pourer and flat, bent

Above: Il Conico kettle designed by Aldo Rossi for Alessi, 1986

handle. The product reflects both his architectural approach to design and his love of drawing, at least in the early stages of an object's development; as with other Alessi designs, Rossi produced the initial sketch of La Conica and largely left the small print of manufacturing details to Alessi's skilled technicians.

La Conica is not the only product that Rossi designed for Alessi. It is the outcome of the first of these, the Tea and Coffee Piazza project that had been launched the year previous to its production. Overseen by Alessandro Mendini, then a consultant to Alessi, in 1979 Rossi was one of eleven high-profile international architects, alongside Michael Graves and Charles Jencks, who were invited to contribute designs for tea and coffee services for the firm. The Tea and Coffee Piazzas epitomize the plurality of the Post-Modern style, evoking an eclectic assortment of historical and contemporary inspirations.

Rossi's segmented, conical design for Tea and Coffee Piazza was inspired by his design for the Teatro del Mondo and there are clear echoes with his idea for La Conica, albeit this time the conical profile is limited to the coffee maker's lid. Furthermore, while the Tea and Coffee Piazzas were elite objects, produced in a limited edition out of sterling silver, La Conica was conceived for a wider market. It was manufactured in stainless steel for Alessi's La Tavola di Babele series of tableware, the series of industrially-produced designs that also included Achille Castiglioni's AC01 oil and vinegar cruet set, which was put into production the same year as Rossi's design.

La Conica is one of a number of coffee makers that Rossi created for Alessi in the 1980s and early 1990s. These include his design for a cafetiere and the Il Conico kettle in 1986, which share the same vocabulary of abstract, geometrical forms and architectural references. In 1984 Alessi published the extensive research that Rossi had conducted into Italian coffee culture for his designs in *La Conica, La Cupola e altre Cafetiere* (The Conical, the Cupola and other Cafetières), a publication that demonstrates both the architect's rigorous research-based approach to design, and the firm's understanding of the value of this for the promotion of its products.

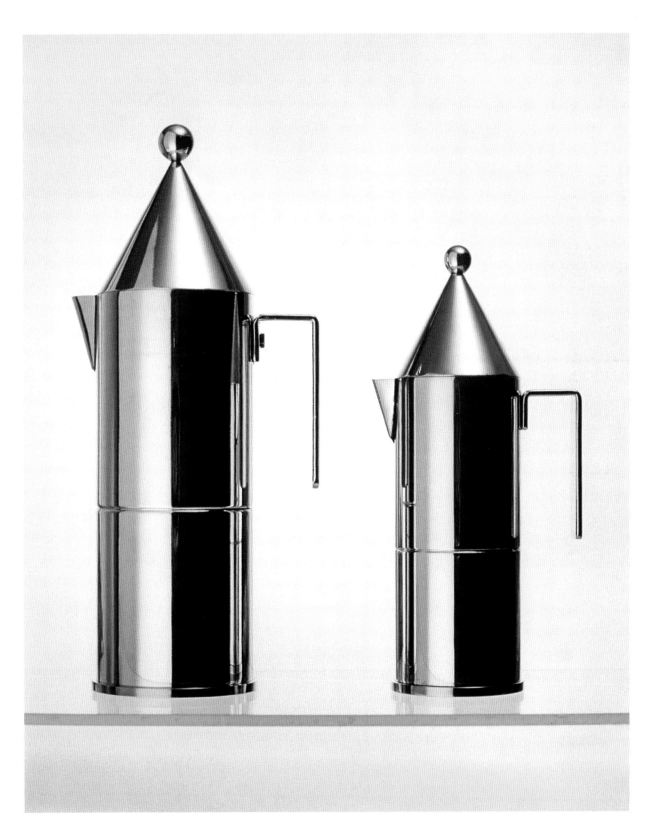

La Conica espresso coffee maker, 1984
Stainless steel
Alessi, Crusinallo

Tolomeo task light, 1986

Michele De Lucchi (1951–) & Giancarlo Fassina (1935–)

The Tolomeo is simply one of the greatest task lights ever designed, with its extraordinary engineered precision imbuing it with not only a high level of function but also a refined essentialist aesthetic. These qualities mean that it is able to straddle the domestic and contract markets as it offers the user exceptional performance while at the same time visually enhancing almost any room in which it is placed. It is this ability to work as well in a domestic setting as an office environment that has ultimately ensured the Tolomeo's incredible sales success throughout the world for over a quarter of a century – a beautiful and timeless Italian design that looks as fresh today as when it was first launched.

The architect-designer Michele De Lucchi co-designed the Tolomeo task light with Giancarlo Fassina in 1986 – the 1980s being a decade that saw Italian design experience a significant revival of fortunes with the blossoming of Italian Post-Modernism in its early years. De Lucchi originally studied architecture in

Florence and during the Radical years was a member of the art group Cavart whilst also working as an assistant to Adolfo Natalini at the School of Architecture in Florence. He started his professional career at Centrokappa, a research and study centre closely affiliated with Kartell, and also contributed designs to Studio Alchimia. It was, however, his role as a founding member of the Memphis design group in 1980 that first brought his work international recognition.

De Lucchi's designs for Memphis, such as his well-known First chair, had a distinctive elemental quality and this characteristic would be later translated into his work for other manufacturers, in particular the lighting company, Artemide. Among the most commercially successful lighting designs of the last fifty years, the Tolomeo task light reflected De Lucchi's almost obsessive attention to detail as well as his innate understanding of materials and proportion. Launched by Artemide in 1987, it subsequently won a coveted Compasso d'Oro award in 1989 and can be seen to have predicted the widespread obsession in the 1990s and 2000s with all things aluminum. A highly practical design, the light's polished aluminum cantilevered arm enables easy positioning, while its anodized aluminum diffuser rotates in all directions, allowing a remarkable level of adjustment. During the 1990s two smaller versions were introduced, the Tolomeo Mini (1991) and the Tolomeo Micro (1999), as well as a model designed to be used with VDU terminals, the Tolemeo Video (1991).

A masterpiece of Italian design and engineering, the Tolomeo continues to enjoy enormous commercial success, thanks to its imperviousness to the whims of fashion and the rationality of its underlying functional logic. On a personal level, the Tolomeo was also a career-defining design for Michele De Lucchi, one of Italy's most gifted designers, and marked a new stylistic maturity and purposefulness within his work.

Above: Artemide publicity photograph showing group of Tolemeo lights

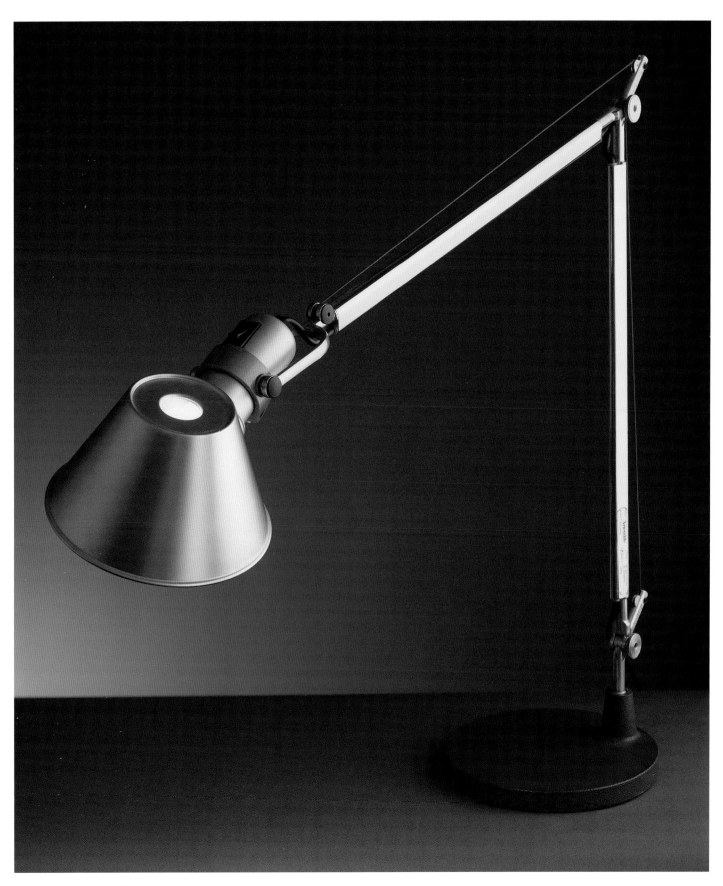

Tolomeo task light, 1986
Polished aluminium, matt anodized aluminium
Artemide, Milan

Tolomeo task light, 1986
Polished aluminium, matt anodized aluminium
Artemide, Milan

Titania suspension light, 1989

Alberto Meda (1945–) & Paolo Rizzatto (1941–)

Alberto Meda is one of the most talented Italian designers of his generation whose work is always distinguished by exquisite engineering precision and discreetly refined detailing that evince his earlier training as a mechanical engineer at the Politecnico di Milano – one of the world's great design teaching institutions. During his highly productive career, Meda has frequently collaborated with the architect, Paolo Rizzatto, who also studied at the Politecnico and who founded in 1978, with two other architects, the famous Milanese lighting company Luceplan. The three founders of the company had previously worked with the owner of Artemide, Gino Sarfatti, and similarly based their new venture on a desire for experimentation, research and quality. Their founding aim to create "beautiful items for the public at large" has since led to the development of numerous landmark lighting designs that have been derived from the Milanese firm's dedicated commitment to ongoing research into technological improvements within the realm of lighting design and manufacture.

This culture of constant experimentation is, of course, directly responsible for the development of one of the most radical lighting designs of the late 1980s – the Titania suspension light. Named after Shakespeare's Queen of the Fairies, the Titania light was co-designed by Alberto Meda and Paolo Rizzatto and when it was first introduced it must have seemed breathtakingly innovative with no lighting design ever having looked quite like it before. This otherworldly glowing luminaire is suspended on two almost invisible nylon strands that are height-adjustable so that it appears as if in magical flight. The curious elliptical rib-like elements come with a number of different polycarbonate filters that are available in interchangeable colors – yellow, green, blue, violet and red – so that the light can be used to create different yet stunning visual effects, from a single band of radiating color to a glorious rainbow-like spectrum.

The overall effect is truly spectacular, with the Titania seeming to hover in space like some strange unidentified flying object yet it also has an undeniable ethereal beauty – it is a poetic Post-Modern design that pulls the future into the present. Above all else, this remarkable light demonstrates the extent to which technical innovation can lead to new aesthetic possibilities. It also reflects how the on-going commitment of Italian manufacturers to pioneering research and development enables them to create products that are simply light years ahead of anything their competitors can muster. Significantly, the Titania is an early example of a product designed using then state-of-the-art CAD software, but it is also a perfect expression of Alberto Meda's skillful ability to infuse technical requirements with an engaging emotional dimension – or as he has defined it, "poetic engineering".

Above: Titania suspension light with red-coloured polycarbonate filters

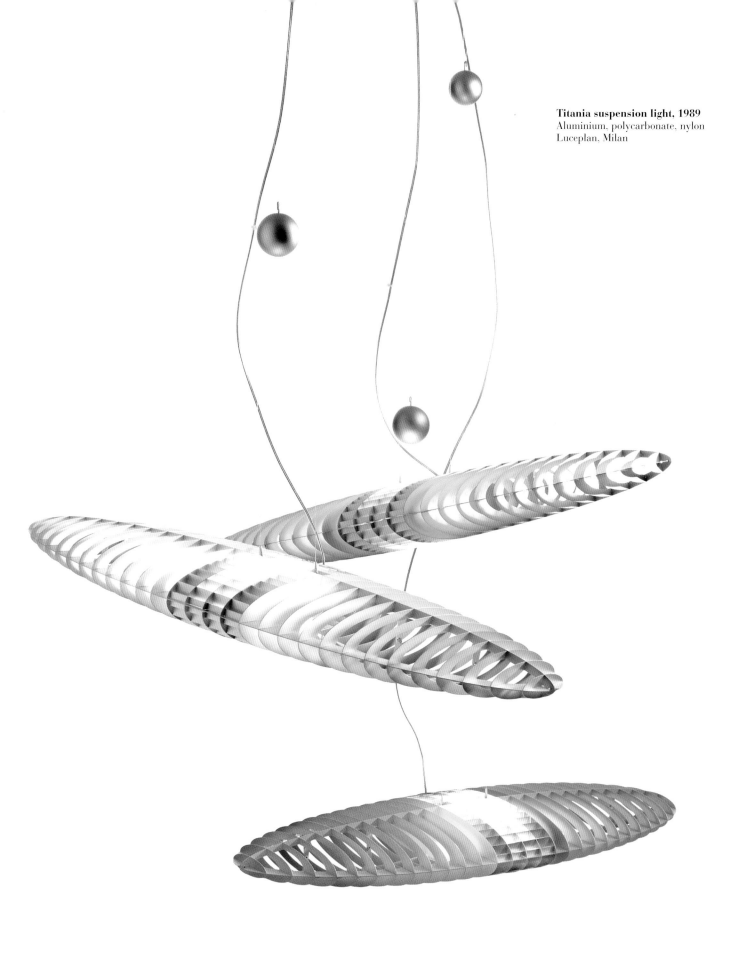

Titania suspension light, 1989
Aluminium, polycarbonate, nylon
Luceplan, Milan

Frame seating programme, 1992–94
Extruded aluminium, die-cast aluminium, PVC-coated polyester mesh
Alias, Grumello del Monte

Frame seating programme, 1992–94

Alberto Meda (1945–)

Having studied mechanical engineering at the Politecnico di Milano, Alberto Meda started his career designing parts for racing cars that competed in Formula Three races. Although Meda notes, "the first couple of races were a disaster", a notable win at Monza led to an offer to join Ferrari. However, having had this first taste of transforming a design concept into a reality, he felt ready to try his hand at something else in the design world.

A chance meeting with the founder of Kartell, Giulio Castelli, gave Meda the opportunity he had been looking for and he subsequently became the technical director of Kartell in 1973, where he was in charge of producing state-of-the-art furniture and laboratory equipment made from newly available injection-moulded thermoplastics. After six years of helping put other designers' work into production, Meda was now ready to strike out by himself and in 1979 he began to work as a freelance designer. In 1984 he began to design products bearing his own name – most notably the Titania suspension light (1984) co-designed with Paolo Rizzatto for Luceplan and a highly influential carbon-fibre chair, the Light Light (1984) for Alias.

Meda was to follow up these two design successes with the Frame seating programme created for Alias in 1992. This entire family of seating was based on a single constructional concept; which was, according to Meda intended "to establish an 'organic' relation among different elements, creating different typologies by making minimal variations in the proportions and form." Rationally conceived, this group of furniture paid homage to Charles and Ray Eames' earlier Aluminum Group seating range of 1958, however, this was no pastiche but rather a system of seating designed in the same exploratory spirit as that employed by the Eameses. The resulting chairs – the Highframe, Armframe, Longframe, Floatingframe and Rollingframe – all employed frame structures made of extruded aluminium and die-cast aluminium parts, while their seats were innovatively made of a hard-wearing yet flexible PVC-coated polyester mesh textile. This winning combination of materials gave the family of seats not only a wonderful visual lightness but also a compelling engineered aesthetic.

Meda's concealment of the connection between the textile and the frame was also highly innovative, with the die-cast aluminium parts not only functioning as separating struts for the extruded frame elements but also being used to hold the seating mesh in place and under tension. This ingenious construction not only helped to enhance the sense of manufacturing precision but also gave the seating designs a satisfying constructional unity and visual fluidity. Of the many seating designs that incorporated aluminium in their manufacture during the 1990s and 2000s, Meda's Frame programme was by far the most accomplished. As a body of work it can be seen as proof of Meda's extraordinarily inventive capability, which enables him to combine innovative design with superlative engineering to create truly timeless solutions.

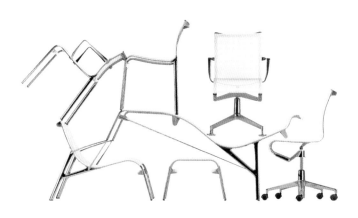

Mobil container system, 1993–94
Antonio Citterio (1950–) & Glen Oliver Löw (1959–)

During the 1990s many top Italian manufacturers underwent a significant transformation: instead of nurturing homegrown design talent as they had traditionally done for decades, they began to commission work from a handful of recognized "design superstars" from all over the world, which in turn gave these companies a greater international profile. However, there was one Italian designer who proved himself more than a match for the likes of Philippe Starck, Ross Lovegrove, Tom Dixon, Ron Arad, Jasper Morrison and Marc Newson: Antonio Citterio.

Citterio not only worked extensively for several Italian companies but was also commissioned to create products for design-led firms abroad, most notably the Swiss/German furniture manufacturer Vitra. One of the main reasons for his professional success was his ability to create understated furniture and objects that had a quiet purposeful usability – designs that were comfortable and practical, and that had a "tasteful" quality that was essentially style-free. This essentialist pared-down trait enabled the majority of his designs to be effortlessly fitted into virtually any domestic or public environment. Because of this, during the 1990s he became one of the most sought after designers to work with if you were a manufacturer. As Vitra's legendary CEO, Rolf Fehlbaum, noted: "Citterio isn't an icon maker but a great technical

Above: Mobil container units of differing configurations – their castors reflect the increasing functional flexibility of the office environment

problem-solver. People who don't work with him tend to underestimate him. His work is very elegant and fresh, but it doesn't shout so much what it's about."

One of Citterio's most interesting and innovative designs from this period was his Mobil container system created for Kartell around 1993. Receiving a Compasso d'Oro award in 1995, the Mobil storage system epitomized the minimalist look of the 1990s with its emphatic, pared-down Neoindustrial aesthetic. This landmark product series also introduced semi-transparent PMMA to furniture design for the first time, giving the drawer units an attractive, frosted appearance that marked a completely new direction in the world of home furnishings.

Conceived as a multi-functional container system, the Mobil was made up of different sized drawer units that functioned as basic modular elements, held in place by an exoskeleton-like frame made of chromed steel. The individual elements could be stacked to make a simple chest of drawers (with or without handles), or they could be placed side by side to create low cabinets, which functioned as stands for televisions or music systems. The drawers were supported on a fixed frame or on castors, which provided a handy degree of enhanced mobility – a useful attribute in office environments that were becoming increasingly adaptable in terms of how they were being used.

The inherent flexibility of the Mobil's modularity also allowed the system to be used in numerous configurations and in different settings, such as bedrooms, bathrooms, living rooms, kitchens and offices. Its commercial success can also be attributed to the wide range of colour options including icy translucent white, cobalt blue, citron yellow and orange. The Mobil was a highly creative yet thoughtful response to the growing desire for flexible living and working environments, yet its success was also inseparable from its stunning exploitation of the jewel-like qualities of semitransparent acrylic. This landmark design eloquently demonstrated that plastics are precious, noble materials and that they can be skillfully utilized to make beautiful yet practical designs that are ultimately life-enhancing.

Mobil container system, 1993–94
Polymethyl methacrylate (PMMA), Acrylonitrile-
butadiene-styrene (ABS), chromed steel
Kartell, Noviglio

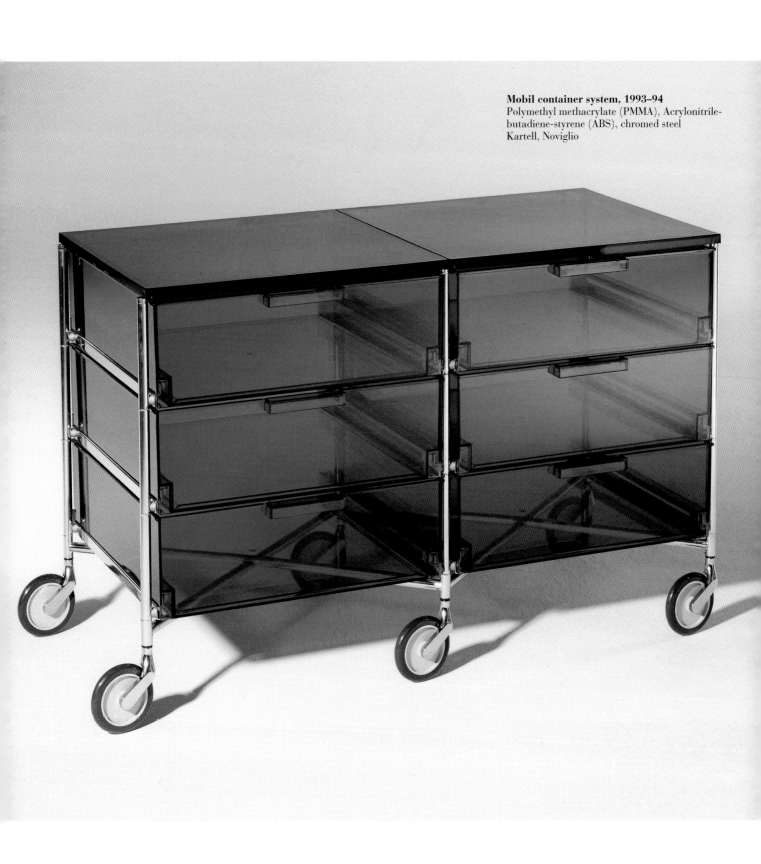

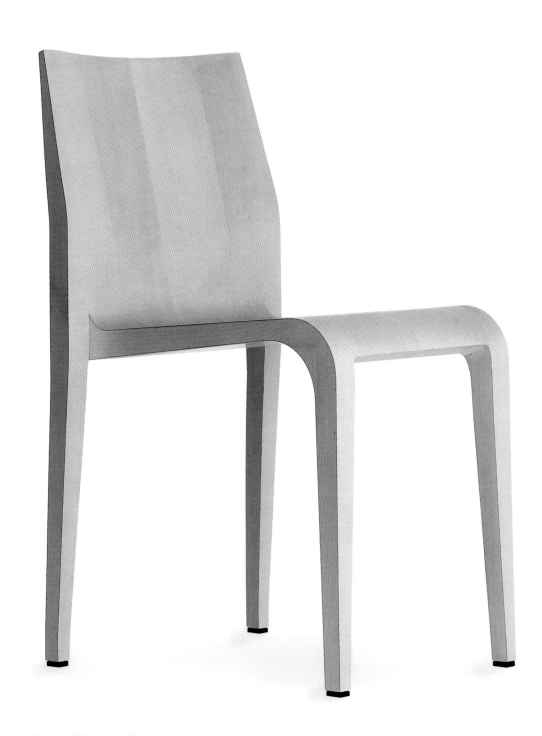

Laleggera 301 chair, 1996
Veneered maple or ash, expanded polyurethane foam
Alias, Grumello del Monte

Laleggera 301 chair, 1996
Riccardo Blumer (1959–)

Like so many Italian-born designers who have reached the pinnacle of their chosen field, Riccardo Blumer studied architecture at the Politecnico di Milano. Having graduated in 1982 he subsequently worked in the architecture practice of the renowned Swiss minimalist Mario Botta from 1983 to 1988. Following this formative experience, he established his own architecture and design office in Varese, and has since worked not only within the industrial and residential building sectors but also as a product designer, mainly specializing in furniture and lighting; his clients include Alias, Artemide, Desalto, Poliform, Ycami, B&B Italia and Flou.

There is one design by Blumer that cemented his reputation within the competitive furniture design arena – the strong yet very lightweight Laleggera of 1996. Its name means "The Light", due to its weight of only 2.3 kg (5.07 lb). Blumer managed to get this impressive reduction of weight by employing a radically innovative sandwich-like construction: sheets of maple or ash enclose an injected filling of expanded polyurethane foam. As its manufacturer, Alias, explains, "The Laleggera collection is the expression of research and technology at its maximum."

Cut and bent into the required form from a single sheet of this composite material, the chair has an engaging structural and visual unity. It is also surprisingly comfortable with its ergonomic contours echoing the human body. With its lightweight core, this stackable design is also easy to transport and comes in a variety of wood veneer finishes – maple, cherry, ebony and wengé – as well as in an impressively extensive range of matt-painted colours – sage green, dark green, blue, light grey, yellow, red, white, mink and brown.

Produced by Alias, the Laleggera exemplified the fashionable pared-down aesthetic of the 1990s, yet it was neither hard-edged nor minimalistic, but rather a refined and thoughtful essentialist design. A functionally versatile chair suitable for both contract and domestic use, the Laleggera was awarded a Compasso d'Oro award in 1998 for its pioneering construction, which bears a striking similarity to that used to make glider wings. In 2009, this award-winning seating design was also selected for the permanent design collection of the Museum of Modern Art, New York - an accolade only given to those products deemed by MoMA's curators to have progressively met exceptionally high design standards.

In addition to the Laleggera chair, Blumer also designed an armchair variant as well as matching stools and tables that incorporated the same innovative composite construction, used the same choice of finishes and expressed the same linear purity. The ingenious Laleggera is a realization of Blumer's belief that design must address not only our functional needs but also our spiritual ones too, and ultimately that this can be achieved through beauty. As he explains, "design is what joins our senses to the soul, thereby providing the only union that produces happiness".

Above: La Leggera Collection designed by Riccardo Blumer for Alias

Citterio cutlery, 1998

Antonio Citterio (1950–) & Glen Oliver Löw (1959–)

Functionality permeates every aspect of the Citterio cutlery set, designed by Antonio Citterio and Glen Oliver Löw in 1998 for the Finnish manufacturer Hackman. Made of brushed stainless steel, its matt surface, weighty feel and generous proportions endow each piece with a reassuring sturdiness and ease of use. Conceived for both everyday use and for more formal occasions, the unadorned elegance of Citterio reveals an ongoing currency of the values of Modernism in contemporary Italian design practice.

The cutlery set is one of the outcomes of Citterio's collaboration with Löw, a German industrial designer who moved to Milan in 1986 to study at the city's Domus Academy and started working with the Italian architect a year later. Other designs from their partnership include the Collective Tools flatware series, also designed in 1987 for Hackman, and the Mobil storage unit for Kartell from 1993. In 1990 Löw became

a partner in Citterio's studio, which was established in 1972 with the architect Paola Nava.

Citterio was part of a new generation of Italian architects that gained prominence in the 1980s, and like his predecessors he has become an internationally celebrated figure. He has won the Compasso D'Oro design award on two occasions and his designs are included in collections of various museums, notably MoMA and the Pompidou Centre. Given the quality of both the design and production of the Citterio cutlery, it is not surprising to find that the architect's background demonstrates the combination of craft and design for which Italy is so celebrated. Citterio was born in Cantù, a town in the heart of Italy's furniture-making district north of Milan, to a father who was one of the town's many cabinetmaker residents. In his youth, Citterio attended the local furniture school before graduating in architecture from the Politecnico di Milano in 1972, the same year as the establishment of his first studio. In 1999 Citterio co-founded an architecture and design practice with Italian architect Patricia Viel, which has been known as Antonio Citterio Patricia Viel and Partners since 2009.

Citterio cutlery is one of a select group of products included in this book that have not been made in Italy, but this is not to say that it is not the result of high-quality manufacture. Established in 1970, Hackman is Finland's most renowned manufacturer of cutlery and stainless steel wares. It became part of the Iittala group in 2004, and subsequently the Citterio cutlery was retailed under the Iittala name. Like Italy, Finland is endowed with a tradition of skilled craftsmanship, making this is a marriage of two different, but complementary cultures: of Italian flair and organic Scandinavian simplicity.

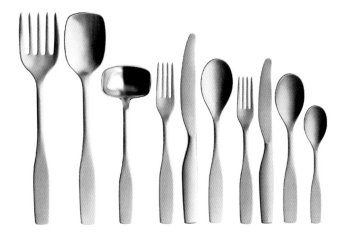

Above: Full range of Citterio cutlery including serving fork and spoon

Citterio cutlery, 1998
Stainless steel
Hackman, Kerava, Finland
Later by Iittala, Iittala, Finland

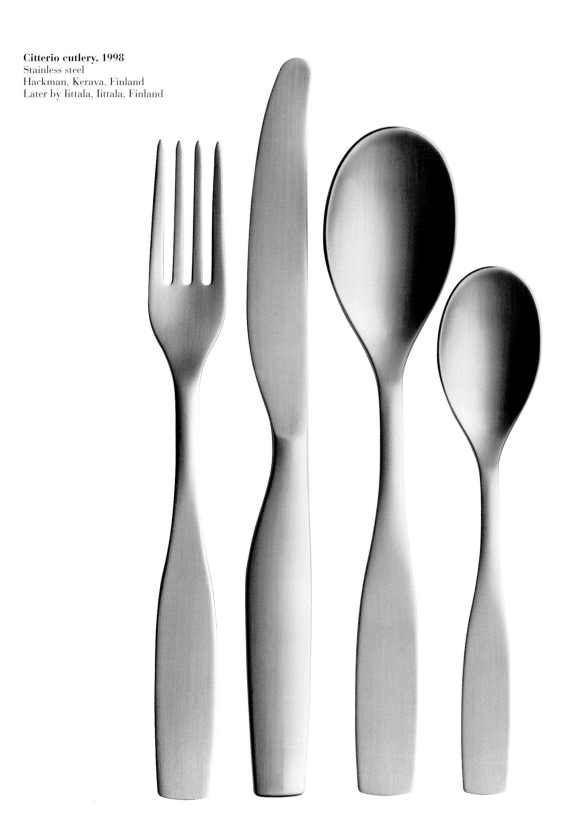

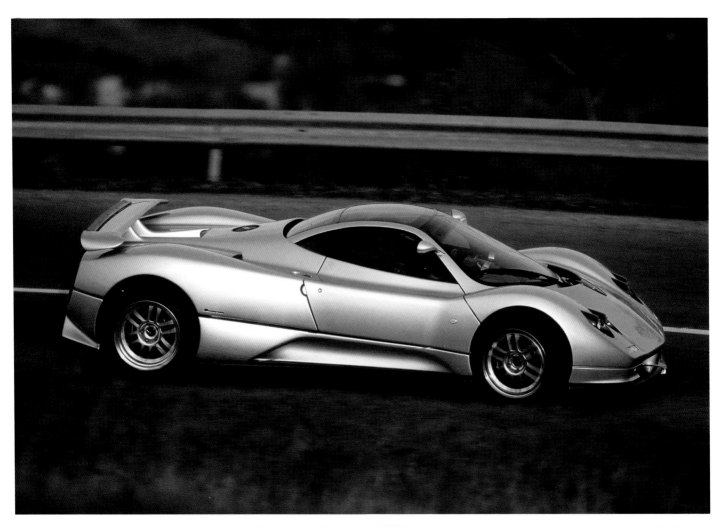

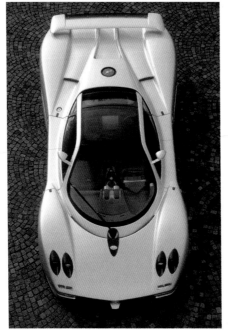

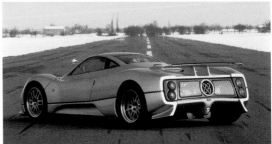

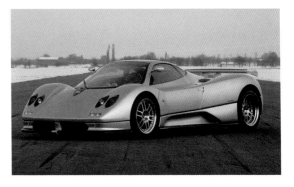

Zonda C12, first unveiled 1999
Various materials
Pagani Automobili, Modena

Zonda C12, first unveiled 1999

Horacio Pagani (1955–)

Italy has long had a reputation for companies that build the ultimate sports cars – Ferrari and Lamborghini being, of course, the most prominent. However, Pagani, a newcomer to this rarified field of high-performance excellence, has been making serious waves over the last decade with its Zonda supercar, which was launched in 1999 and since then undergone various refinements and upgrades.

The distinctively styled Zonda was the brainchild of the Argentine-born car designer Horacio Pagani who had previously trained as an industrial designer at Argentina's University of La Plata, and had then been awarded two scholarships by the Rotary Club to study at the Royal College of Art, London, and the Art Center, Pasadena. As the son of Italian immigrants, Pagani eventually moved to Italy in 1983 and in 1984 worked with the team at Lamborghini on the building of the Countach Evoluzione, the first car to be designed with a carbon-fibre frame. In 1987, Pagani was responsible for the design of the "celebration" edition of the Lamborghini Countach to honour the twenty-fifth anniversary of the company's founding – which many supercar enthusiasts believe to be the ultimate Countach and certainly it went on to become the bestselling Countach model of all time. Pagani then worked on the development of the Lamborghini Diablo using advanced composite materials. During the late 1980s he also began designing his own supercar, which was initially referred to as the "C8 Project" and which he eventually planned to rename the Fangio F1 after his friend, the Argentine five-time Formula 1 champion, Juan Manuel Fangio.

Later in 1991, Pagani established his own office, Modena Design, to meet the increasing demand for his design, engineering and prototyping skills, and the following year he began the construction of the Fangio F1 prototype. With its bodywork inspired by Mercedes-Benz's racing "Silver Arrows" of the 1930s, the resulting renamed Zonda C12 unveiled in 1999 combined art and science to produce a car of rare beauty as well as sheer raw power and ultra high-performance levels of torque. Using state-of-the-art composite materials – a specialization of Horacio Pagani's – for both the chassis and the bodywork, the Zonda C12 was strong yet lightweight, while its form was aerodynamically attuned for maximum speed.

Powered by a six-litre Mercedes-Benz V12 engine, the Zonda had an extremely low centre of gravity and an optimized suspension system that innovatively employed elastokinematic mounts, which helped to ensure both stability and driver comfort. In 2002, an even more refined version of this epic game-changing supercar was released, the Zonda S, which was notable for its more aggressive styling, its impressive acceleration of 0–100 mph in 7.2 seconds (0–100 kph in 3.7 seconds) and its top speed of 208 mph (335kph). From then, Pagani honed his ultimate dream machine and to date some 207 Zondas of various models have been built in his Modena-based factory.

While Ferrari and Lamborghini have perhaps lost some of their creative autonomy over the years, thanks to their ownership by bigger entities, Pagani has kept the Italian love of fast cars well and truly alive and the Zonda – not just a supercar, but a hypercar – embodies this national passion for cars that are not sensible runabouts but awesome power-throbbing design visions, albeit with pretty eye-watering price tags.

Production of the Zonda ended in 2011 and in March the same year at the Geneva Auto Salone its replacement was officially debuted – the Pagani Huayra (pronounced why-rah), an even more epic hypercar with staggering good looks and mind-blowing performance.

Kitchen units, 2008

Nico Moretto (1926–)

Like the French, the Italians have a profound love of food and an almost sacred respect for its careful and exacting preparation. Quite simply, the kitchen is at the very heart of the Italian home, a place to share memorable times with good food and good friends and family. It is not surprising, therefore, given the importance of the kitchen in every Italian's heart (and especially Mama's) that one of the world's leading manufacturers of stainless steel kitchen elements is an Italian firm – Alpes-Inox.

The entrepreneur-manufacturer Nico Moretto founded Alpes-Inox in 1954, and since then he has not only headed the company but over the years has also been responsible for the design of virtually all its products. Moretto was inspired to establish the firm when working as a young draftsman in the technical division of Smalterie Metallurgiche Venete, he saw stainless steel for the very first time, which had been imported into Italy from Scandinavia. As Moretto remembers, "It came from Sweden, packaged like a precious metal, and there it was pressed, shaped, welded, polished and finished on the surface. It was a magnificent material: complete, clean, essential…as soon as I could, I began working with it too."

In the early days of Alpes-Inox, Moretto made sink-cabinets – with the cabinets made of stove enamelled metal and the sinks made of porcelain-coated metal – which were "rather successful" and which led him to expand his product range to include kitchen furniture, boilers, clothes driers, etc. During the early 1960s Moretto looked towards using the material that had so captivated him as a young draftsman: his beloved stainless steel. Moretto was doggedly determined: it took him many attempts to perfect the pressing of the stainless steel into a successful sink form using an old hydraulic press and the existing moulds he used to make his porcelain sinks. As he recalls: "the sinks kept breaking, and I kept trying over and over again. Finally, using soap shavings that I ground very finely with a bar-quality coffee grinder, I achieved my first unbroken sink. It was like being on cloud nine. This was the beginning of a long friendship".

By 1964, the company was using high-grade stainless steel to produce a range of built-in kitchen elements – sinks, hobs, oven extractor hoods and the like – and the quality of these designs with their precise steel machining soon established the company's reputation for both design and manufacturing excellence. Happily, the company's high standing within the design world continues to this day. Its extraordinary range of freestanding kitchen units and equipment – as shown here – possess excellent hygienic and resistant properties, while also reflecting the very best of Italian design and manufacturing capability.

Apart from his many designs, Moretto is also credited with pioneering the introduction of "silver satin finish" for stainless steel and in 2011 his son Domenico – now president of the family company – was awarded a Compasso d'Oro for his own ingenious design of a flip-up cooking countertop that was intended for kitchens where space is at a premium. Like so many Italian design-led manufacturers, Alpes-Inox is a family-run firm that specializes in doing something extremely well, and that has a real heartfelt commitment to design excellence from initial concept to final product.

Above: Combination kitchen sink and cooking unit, 2008

Kitchen units, 2008
Stainless steel
Alpes-Inox, Bassano Del Grappa

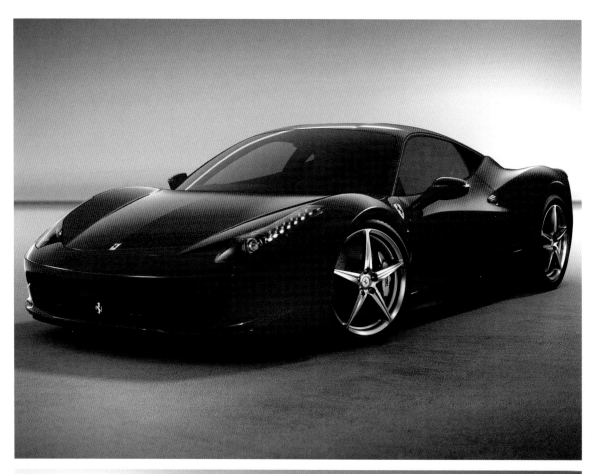

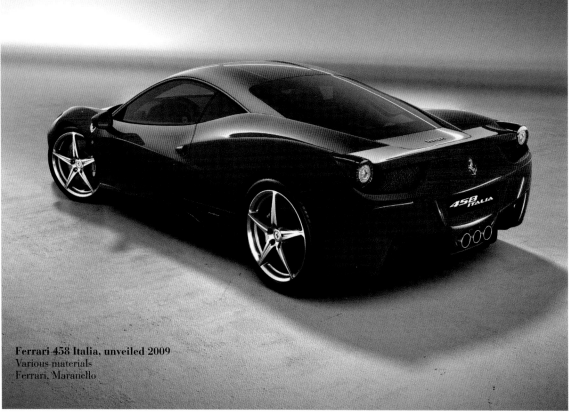

Ferrari 458 Italia, unveiled 2009
Various materials
Ferrari, Maranello

Ferrari 458 Italia, unveiled 2009

Pininfarina (founded 1930)

The Turin-based Carrozzeria Pininfarina is without question the most revered car design firm in the world having been founded in 1930 by the extraordinarily talented Battista "Pinin" Farina – one of the greatest car designers of all time. It was Farina's desire to develop coachbuilding into an autonomous industry and to this end he pioneered methods of serially producing custom-made car bodies using assembly line techniques. He also created numerous innovatively designed and sleekly styled cars for various automotive manufacturers including the landmark Cisitalia 202 (1947) – the first car to be selected for the New York Museum of Modern Art's permanent design collection and which went on to redefine the blueprint for post-war cars, both aesthetically and technically.

Battista's son, Sergio, inherited his father's genius for design and was later responsible for convincing Enzo Ferrari to let him create body prototypes for a new race-quality vehicle he was developing in the early 1960s. The success of the resulting Series 1 250 GTO racing car (1962) developed in conjunction with Ferrari's engineers and the coachbuilder Sergio Scaglietti, and the slightly earlier sublimely beautiful Ferrari 250 GTE roadster (1961), forged a long-standing partnership between the two firms. As the columnist and Ferrari enthusiast Michael Sheehan has noted: "Ferrari would not be Ferrari without Pininfarina. Ferrari built the machines, and basically Pininfarina clothed them."

Although Pininfarina has since worked extensively with other car manufacturers, and its distinctive logo – an F topped with a crown – has adorned literally millions of cars from Alfa Romeos and MGs to Volvos and Bentleys, it has also effectively taken on the role of Ferrari's design department over the last 50 years, with only a handful of Ferrari models having been created by other automotive design firms.

The key to Pininfarina's consistent ability to create aesthetically awe-inspiring cars for Ferrari – from the 365 GTB/4, better known by the unofficial name Ferrari Daytona (introduced 1968) to the exquisitely beautiful Ferrari 458 Italia (unveiled 2009) – was Sergio Pininfarina's understanding of what elements were needed to make a good design. Indeed, when asked to define this he stated the key constituents were "good harmony, classic style, proportion, grace – and honesty", but he also added with a smile, "Then, if you have good taste, the battle is won."

It is this tasteful sense of graceful proportion – power clothed in a sensual body – that has led many car experts to regard the Ferrari 458 Italia as one of the most beautiful Ferraris ever produced. Pininfarina designed its body and external features with aerodynamic efficiency in mind: its small aeroelastic winglets generate downforce and when the car reaches sufficient speed, they actually deform to reduce drag. The interior of this mid-engined supercar was equally well thought out, with Ferrari's former Formula 1 driver Michael Schumacher providing input into its design, including its steering wheel boasting many of the controls and features usually found only on racing cars. One of the main reasons for the widespread acclaim of the Ferrari 458 Italia is that its seductively slippery form was inspired by the immortal Enzo (2002) – a supercar that was befittingly named after the company's legendary founder and that innovatively incorporated F1 technology, thereby heralding a new generation of Ferraris for a new millennium. The Ferrari 458 Italia can also be seen as a refined production version of the Ferrari Millechili concept car, which was unveiled in 2007, yet its styling is less aggressive and as such it embodies the "good taste" that has always been the hallmark of all classic Ferraris and, of course, a trademark of Pininfarina design.

Honeycomb lighting system, 2010
Polycarbonate, satin-finished aluminium
Luceplan, Milan

Honeycomb lighting system, 2010
Habits Studio (founded 2005)

One of the greatest lighting manufacturing companies in Italy or indeed anywhere, Luceplan is renowned for producing innovative lighting solutions that are the direct result of its long-term commitment to pioneering research and development. Riccardo Sarfatti, Paolo Rizzatto and Sandra Severi, all of whom had previously trained as architects at the Politecnico di Milano, founded Luceplan in 1978. It could be said that Riccardo Sarfatti had lighting design built into his DNA, being the son of the famous lighting design pioneer Gino Sarfatti who had founded the Milanese lighting company Arteluce during the immediate postwar period. While still undertaking his studies, Riccardo had worked for his father's company from 1964 to 1978 and inspired by the democratic design principle of "beauty for all" he formulated a guiding vision to create better environments to live in through the application of better-designed lighting. Luceplan was the conduit for this design-led goal and it was his enthusiasm for experimentation that firmly established the firm's culture of perpetual innovation.

Above: View of interior showing Honeycomb lighting system in use

For over 35 years, Luceplan has been at the cutting edge of lighting technology, working with some of the most talented designers in the world, including Ross Lovegrove, Alfredo Häberli, Sebastian Bergne and Alberto Meda. Discrete refinement and exceptional quality born out of consistent experimentation and skilled technological research have been key characteristics of Luceplan's lighting products, which, as the company states, have "not been designed for short-lived wonder, but to be the natural outlet of a continuous, ongoing drive dedicated to the essence of every project, a fastidious care of detail and steady improvement".

Although Luceplan, like many other design-led Italian companies, works extensively with non-Italian designers, it has also continued to work with indigenous design talent. In recent years, for example, it has produced a large number of lights designed by the Milan-based Habits Studio. This interesting experimental-based design studio was founded in 2005 by Fabio Sergio and Innocenzo Rifino – both of whom have had hands-on interaction design experience: Sergio having been the creative director of Frogdesign's Milan studio and Rifino having worked as a product designer for Panasonic in Osaka. Among their designs for Luceplan, the Honeycomb lighting system stands out as being not only ingeniously simple but also captivatingly beautiful.

Like the cells of a honeycomb, the hexagonal three-cell modules of the lighting system are clipped together freely off a suspension fixture, giving a high degree of compositional freedom as well as a wonderful sense of organic symmetry. This lighting structure can accommodate various different lighting sources, from low-voltage halogen bulbs to energy efficient LEDs, which means that different types of emitted light can be achieved, such as direct accent lighting or softer general lighting. As Habits Studio says of the Honeycomb lighting system, launched in 2011, "Light and structure are designed as independent elements: you can choose, in fact, to equip some modules with light sources, alternating freely their compositions and lighting elements, and can expand the system infinitely."

Ducati 1199 Panigale sport bike, introduced 2011

Ducati (founded 1926)

As one of the world's most powerful production motorbikes, the Ducati 1199 Panigale unveiled at the Milan Motor Show in 2011 proudly lives up to Ducati's long-held reputation for producing thoroughbred racing machines that not only strain to have their formidable power unleashed on the open road or track, but have the stylishly aggressive looks to match. The journalist Dom Carter writing in The Sunday Times fell in love "at first fumble" with this amazing bike even though it gave him what he described as "an eyeball-loosening ride" when he tested it. Boasting a top speed of 186 mph (300 kph) this is a superbike that is not for the faint-hearted but for those who have been initiated in the joys of high-speed two-wheel motoring.

The 1199 Panigale superbike gets its name from Borgo Panigale, the thriving manufacturing town on the outskirts of Bologna, where the Ducati factory has been located since the 1930s. The origins of the company go back to the 1920s and to the Società Scientifica Radio Brevetti, which was initially established to manufacture radio components based on patents filed by its founder, Adriano Ducati. It was only after the Second World War, once the factory had been restored having been destroyed by Allied bombing in 1944, that the firm began producing under license its first motor intended for bicycles.

This early foray into the biking world was known as the Cucciolo (1946), which means "little puppy". Invented by the Turin lawyer Aldo Farinell, this four-stroke clip-on engine – thanks to its excellent fuel efficiency of 180 miles per gallon (77 km/l) – was a significant commercial success, selling over 25,000 units over the coming years. Months after its launch, a Ducati-designed frame was also introduced onto which the Cucciolo was mounted. Following the success of this early and economical post-war motorized bicycle design, Ducati began producing "proper" scooters and motorbikes in the early 1950s, including the futuristically styled 175cc Cruiser scooter of 1952. It was, however, when the supremely gifted engineer-designer Fabio Taglioni joined the company in 1954 that Ducati's destiny to become one of the great motorcycle manufacturers of all time was sealed. Under Taglioni's design genius, Ducati produced bikes that were avant-garde and non-conformist, and proved their superior performance consistently and unequivocally on the racetrack. In 1956, for instance, Ducati broke an astonishing 46 speed records in various categories, predominately using the streamlined and aluminium-bodied Ducati 100cc Siluro. Over the succeeding decades, Ducati continued to pioneer bewitchingly fast and beautiful bikes and in so doing carved out a rarefied reputation for itself within the sports bike market.

Essentially the motorcycling world's equivalent of Ferrari or Lamborghini, Ducati is *the* Italian manufacturer of superbikes, and the Ducati 1199 Panigale is testimony to this continuing heritage of design excellence and manufacturing brilliance. This awesome bike has the highest power-to-weight and torque-to-weight ratios of any bike currently in production. With its aerodynamically sculpted aluminium monocoque, its innovative electronically adjustable suspension system and its throaty quick-revving "Superquadro" 1,198cc V-twin desmodromic engine, it without question bears that rare genetic code of all classic Ducatis – or should we say the "Reds of Borgo Panigale", as they are affectionately known in Italy – which marries a love of cutting-edge design with a passion for high-speed performance. And let's face it, these two factors are far from exclusive where the latter is a direct result of the former.

Ducati 1199 Panigale sport bike, introduced 2011
Aluminium, other materials
Ducati, Borgo Panigale, Bologna

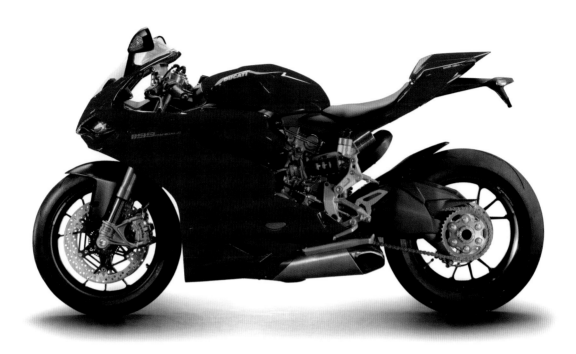

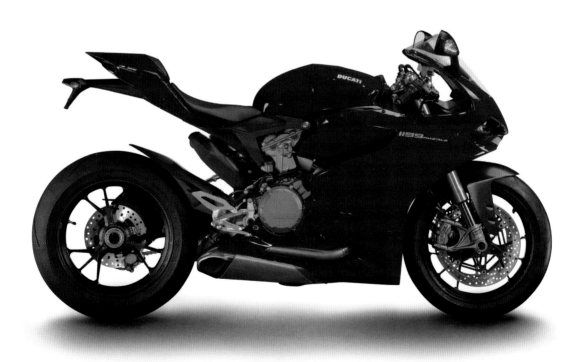

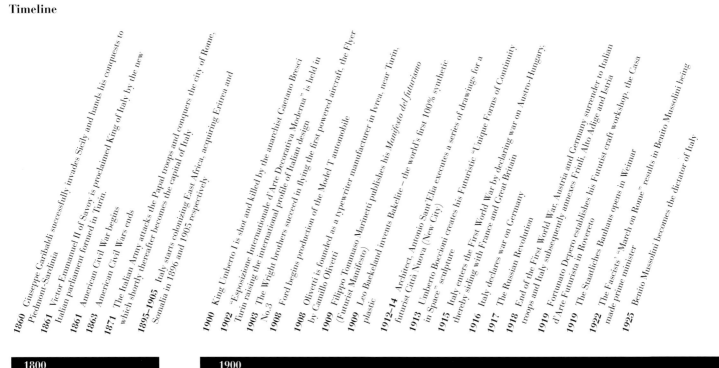

1860 Giuseppe Garibaldi successfully invades Sicily and hands his conquests to Piedmont-Sardinia

1861 Victor Emmanuel II of Savoy is proclaimed King of Italy by the new Italian parliament formed in Turin.

1861 American Civil War begins

1863 American Civil Wars ends

1871 The Italian Army attacks the Papal troops and conquers the city of Rome, which shortly thereafter becomes the capital of Italy

1895–1905 Italy starts colonizing East Africa, acquiring Eritrea and Somalia in 1896 and 1905 respectively

1900 King Umberto I is shot and killed by the anarchist Gaetano Bresci

1902 "Esposizione Internationale d'Arte Decorativa Moderna" is held in Turin raising the international profile of Italian design

1903 The Wright brothers succeed in flying the first powered aircraft, the Flyer No.3

1908 Ford begins production of the Model T automobile

1908 Olivetti is founded as a typewriter manufacturer in Ivrea, near Turin, by Camillo Olivetti

1909 Filippo Tommaso Marinetti publishes his Manifesto del futurismo (Futurist Manifesto)

1909 Leo Backeland invents Bakelite – the world's first 100% synthetic plastic

1912–14 Architect, Antonio Sant'Elia executes a series of drawings for a futurist Città Nuova (New City)

1913 Umberto Boccioni creates his Futuristic "Unique Forms of Continuity in Space" sculpture

1915 Italy enters the First World War by declaring war on Austro-Hungary, thereby siding with France and Great Britain

1916 Italy declares war on Germany

1917 The Russian Revolution

1918 End of the First World War; Austria and Germany surrender to Italian troops and Italy subsequently annexes Friuli, Alto Adige and Istria

1919 Fortunato Depero establishes his Futurist craft workshop, the Casa d'Arte Futurista in Rovereto

1919 The Staatliches Bauhaus opens in Weimar

1922 The Fascists' "March on Rome" results in Benito Mussolini being made prime minister

1925 Benito Mussolini becomes the dictator of Italy

1800

1900

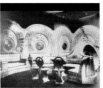

1902
Carlo Bugatti exhibits his "camera a chiocciola" (Snail Room) at the "Esposizione Internationale d'Arte Decorativa Moderna" in Turin

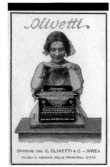

1910
Camillo Olivetti's M1 typewriter is designed and launched a year later at the Esposizione Internazionale di Torino (Turin International Exhibition)

1914
Guiseppe Merosi designs the streamlined Aerodinamica racing car

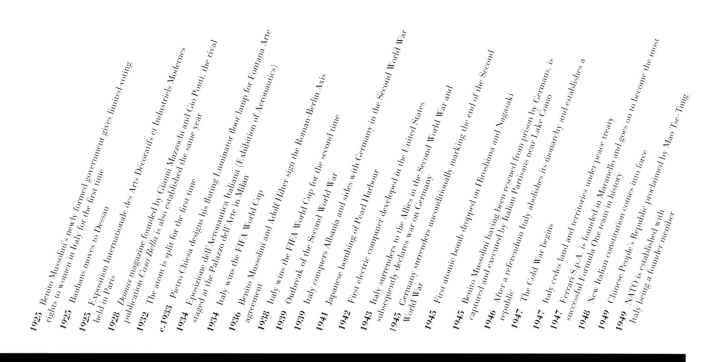

1925 Benito Mussolini's newly formed government gives limited voting rights to women in Italy for the first time

1925 Bauhaus moves to Dessau

1925 Exposition Internationale des Arts Décoratifs et Industriels Modernes held in Paris

1928 Domus magazine founded by Gianni Mazzochi and Gio Ponti, the rival publication Casa Bella is also established the same year

1932 The atom is split for the first time

c.1933 Pietro Chiesa designs his fluting Luminator floor lamp for Fontana Arte

1934 Eposizione dell'Aeronautica Italiana (Exhibition of Aeronautics) staged at the Palazzo dell'Arte in Milan

1934 Italy wins the FIFA World Cup

1936 Benito Mussolini and Adolf Hitler sign the Roman-Berlin Axis agreement

1938 Italy wins the FIFA World Cup for the second time

1939 Outbreak of the Second World War

1939 Italy conquers Albania and sides with Germany in the Second World War

1941 Japanese bombing of Pearl Harbour

1942 First electric computer developed in the United States

1943 Italy surrenders to the Allies in the Second World War and subsequently declares war on Germany

1945 Germany surrenders unconditionally marking the end of the Second World War

1945 First atomic bomb dropped on Hiroshima and Nagasaki

1945 Benito Mussolini having been rescued from prison by Germans, is captured and executed by Italian Partisans near Lake Como

1946 After a referendum Italy abolishes its monarchy and establishes a republic

1947 The Cold War begins

1947 Italy cedes land and territories under peace treaty

1947 Ferrari S.p.A. is founded in Maranello and goes on to become the most successful Formula One team in history

1948 New Italian constitution comes into force

1949 Chinese People's Republic proclaimed by Mao Tse-Tung

1949 NATO is established with Italy being a founder member

1932
Gio Ponti designs a small Modernistic glass table for Fontana Arte, later known as the "Tavolino 1932"

1933
Alfonso Bialetti designs the Moka Express espresso-maker

1934
Giuseppe Terragni designs the Follia chair for the Casa del Fascio (Fascist Headquarters Building) in Como

1938
Luigi Caccia Dominioni designs his classic Caccia cutlery

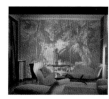

1946
Carlo Mollino designs the interiors and furniture for Casa M-1 in Turin

1949
Carlo Mollino designs the bent plywood Arabesque table

1936
Dante Giacosa's Fiat 500 Topolino car is launched – the first Italian car designed for the masses

1947
Gio Ponti designs the streamlined La Cornuta espresso machine for La Pavoni

1949
Piero Formasetti and Gio Ponti design the Architettura cabinet inspired by antique prints

1949 Lucio Fontana exhibits his light sculpture installation, "Ambiente Spaziale a luce nera" in Milan

1949 Kartell is founded in Milan by the chemical engineer Giulio Castelli

1951 Italy joins the European Coal and Steel Community

1952 Ernesto Rogers coins the phrase "From the spoon to the city." in an article to explain the scope of design.

1953 James Watson and Francis Crick publish their discovery of DNA's structure

1954 Italian chemist Giulio Natta invents polypropylene

1954 The Compasso d'Oro awards are established to promote the cause of Good Design in Italy

1955 Italy joins the United Nations

1956 Cortina d'Ampezzo hosts the V Winter Olympic Games

1957 Italy becomes a founding member of the European Economic Union

1957 Montecatini produce polypropylene on an industrial scale for the first time

1957 Launch of Sputnik satellite

1958 Texas Instruments demonstrates first integrated circuit

1960 Federico Fellini's seminal film La Dolce Vita is released

1960 XVII Summer Olympic Games held in Rome

1960 The Pirelli Tower in Milan designed by Gio Ponti and Pier Luigi Nervi is completed

1961 Yuri Gagarin becomes first man in space

1961 Piero Manzoni creates his controversial art multiple titled "Merda d'Artista" (Artist's Shit)

1900

1950
Piero Fornasetti designs his first Tema & Variazioni (Themes and Variations) plates

1951
Marco Zanuso designs his shapely Lady chair for Arflex

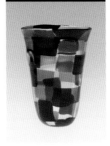

c.1951–52
Fulvio Bianconi creates the patchwork-like Pezzato vase for Venini

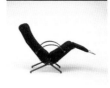

1954
Osvaldo Borsani designs the highly adaptable P40 lounge chair for Tecno

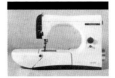

1957
The Marcello Nizzoli designed Mirella sewing machine is introduced by Necchi

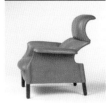

1959
San Luca armchair designed by Achille and Pier Giacomo Castiglioni for Gavina

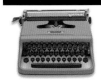

1950
Marcello Nizzoli designs the Lettera 22 typewriter for Olivetti

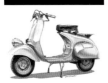

1951
Corradino d'Ascanio designs the iconic Vespa 125 motor scooter

1953
Ezio Pirali designs the award winning Model No. VE505 table fan

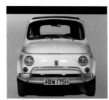

1957
The Fiat 500 Nuova automobile, better known as the Cinquecento, is launched

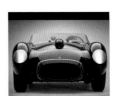

1957
The awesome Ferrari 250 TR racing car is unveiled

1960–62
Secticon clock designed by Angelo Mangiarotti and Bruno Morassutti

1962
Giorgio Barilani and Carlo Riva design the supremely beautiful Riva Aquarama motorboat

1964
Marco Zanuso and Richard Sapper design the Algol television for Brionvega

1965
Marco Zanuso and Richard Sapper's folding Grillo telephone is introduced

1965–66
Lamborghini introduces the world's first supercar – the Miura

1967
Anna Castelli-Ferreri stacks a winner with her Componibili storage system

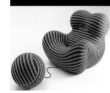

1969
Up Series chairs designed by Gaetano Pesce

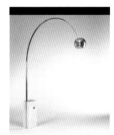

1962 – Achille and Pier Giacomo Castiglioni design the landmark Arco floor light for Flos

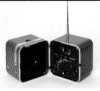

1965
Marco Zanuso and Richard Sapper design their TS522 radio-clock for Brionvega

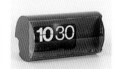

1965
Gino Valle designs the Cifra 3 table clock for Solari di Udine

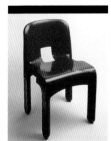

1965–67
Joe Colombo designs the first all-plastic adult-sized chair, the Universale

1968–69
Sacco beanbag chair is designed by Gatti, Paolini and Teodoro

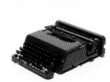

1969
Valentine typewriter designed by Ettore Sottsass and Perry King

1971 Microprocessor invented by Intel

1972 Italy: The New Domestic Landscape – Achievements and Problems of Italian Design exhibition held at the Museum of Modern Art in New York

1972 Giulio Andreotti becomes prime minister – a post he will hold seven times in 20 years

1973 Global Oil Crisis

1973 Global Tools design collective formed

1976 Studio Alchimia established by Alessandro Guerriero

1978 Former Italian Prime Minister Aldo Moro kidnapped and murdered by the Red Brigades, a fanatical left-wing group

1982 Italy wins the FIFA World Cup for the third time

1983 Apple launches Lisa – the first personal computer to use a graphical user interface

1983 Domus Academy founded by Maria Grazia Mazzocchi, Pierre Restany, Alessandro Mendini, Valerio Castelli, Alessandro Guerriero and Andrea Branzi

1983 Bettino Craxi becomes Italy's first Socialist prime minister since war

1984 Roman Catholicism loses its status as Italy's state religion

1989 Fall of the Berlin Wall

1989 Tim Berners-Lee invents the World Wide Web

1990 Reunification of Germany

1991 World Wide Web hypertext system used on the Internet for the first time / Cold War ends

1994 Silvio Berlusconi elected as Italian Prime Minister for the first time

1997 Earthquakes strike Umbria region, causing extensive damage to Basilica of St Francis of Assisi

2000 Wireless Application Protocol (WAP) mobile telephone technology becomes widely available

2001 September 11 attacks on New York City and Washington DC by al-Qaeda

1900

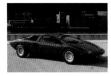

1971
the Lamborghini Countach LP 400 is unveiled and astonishes the car world

1977
Atollo table light designed by Vico Magistretti for Oluce

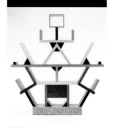

1981
Memphis exhibits for the first time at the Milan Furniture Fair and the totemic Carlton bookcase/room divider is launched

1983
Michele De Lucchi designs the First chair for Memphis

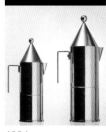

1984
Aldo Rossi designs his architectonic La Conica espresso maker for Alessi

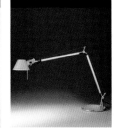

1986
Michele De Lucchi and Giancarlo Fassina's seminal Tolomeo task light is introduced by Artemide

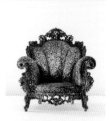

1978
Alessandro Mendini's Proust armchair designed for Studio Alchimia

1992–94
Alberto Meda designs the Frame Seating programme

2001 A centre-right coalition, led by Silvio Berlusconi of the Forza Italia party, wins the general election / First constitutional referendum since 1946 sees vote in favour of major constitutional change giving greater autonomy to the country's 20 regions

2002 Italian lira is replaced by the euro

2003 Iraq war begins

2006 Centre-left leader Romano Prodi wins closely fought general election

2006 Italy wins the FIFA World Cup for the forth time

2006 Turin hosts the XX Winter Olympic Games

2007 Prime Minister Prodi resigns

2007 First complete genome of an individual human published

2008 Collapse of Lehman Brothers investment bank

2008 Berlusconi wins general election, securing a third term as premier after two years in opposition

2009 Earthquake strikes towns in the mountainous Abruzzo region, leaving hundreds of people dead and thousands homeless

2010 Arab Spring begins in the Middle East and North Africa

2011 Prime Minister Berlusconi resigns / former European Union commissioner Mario Monti forms a government of technocrats

1993–94
Antonio Citterio and Glen Oliver Löw design the Mobil storage unit system for Kartell

1998
Antonio Citterio and Glen Oliver Löw design the Citterio cutlery range for Hackman (Iittala)

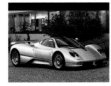

1999
The epic Pagani Zonda is unveiled

2008
Nico Moretto designs his award winning system of kitchen units

2010
Honeycomb lighting system designed by Habits Studio for Luceplan

2011
The Ducati 1199 Panigale sport bike is introduced and causes a sensation

2009
The Ferrari 458 Italia is unveiled and is widely regarded as one of the most beautiful Ferraris of all time

Index

Bibliography

Aloi, R., *Esempi di Arredamento Moderno di Tutto il Mondo: Tavoli, Tavolini, Carrelli*, Ulrico Hoepli Editore, Milan 1955
Mobili Tipo, Ulrico Hoepli Editore, Milan 1957
Esempi di Arredamento Moderno di Tutto il Mondo:Sedie, Poltrone, Divani, Ulrico Hoepli Editore, Milan 1957
L'Arredamento Moderno, Ulrico Hoepli Editore, Milan 1964

Bangert, A., *Italian Furniture Design: Ideas, Styles, Movements*, Bangert Verlag/ Bangert Publications, Munich 1988

Barzini, L., *The Italians*, Penguin Books, London 1964

Bayley, S., *La Dolce Vita: The Golden Age of Italian Style and Celebrity*, Fiell Publishing, London 2011

Börnsen-Holtmann, N., *Italian Design*, Benedikt Taschen Verlag, Cologne 1994

Bosoni, G., *Italian Design*, The Museum of Modern Art, New York 2008

Bosoni, G., Picchi, F., Strina, M., Zanardi, N. (eds), *Original Patents of Italian Design, 1946–1965*, Electa, Milan 2000

Branzi, A., *The Hot House: Italian New Wave Design*, Thames and Hudson, London 1984

Branzi, A., and **De Lucchi, M.**, *Il Design Italiano Degli Anni'50*, Ricerche Design Editrice, Milan 1985

Brino, G., *Carlo Mollino: Architecture as Autobiography*, Thames and Hudson, London 1987

Compasso d'oro, 1954-1984: Trent'anni di design italiano, Electa, Milan 1985

Duggan, C., *A Concise History of Italy*, Cambridge University Press, Cambridge 1994

Favata, I., *Joe Colombo and Italian Design of the Sixties*, Thames and Hudson, London 1988

Ferrari, F., and Ferrari, N., *Light; Lamps 1968–1973: New Italian Design*, Umberto Allemandi & C/ Klaus Engelhorn, Vienna 2002
The Furniture of Carlo Mollino, Phaidon Press, London 2010

Fiell, C. and Fiell, P., *Modern Furniture Classics Since 1945*, Thames and Hudson, London 1991
1000 Chairs, Benedikt Taschen Verlag, Cologne 1997
Design of the 20th Century, Benedikt Taschen Verlag, Cologne 1999
Industrial Design A–Z, Taschen, Cologne 2000
Designing the 21st Century, Taschen, Cologne 2001
1000 Lights, Vol. 1: 1878 to 1959, Taschen, Cologne 2005
1000 Lights, Vol. 2: 1960 to Present, Taschen, Cologne 2005
Domus (Volumes I–XII), Taschen, Cologne 2006
Design Now!, Taschen, Cologne 2007
Plastic Dreams: Synthetic Visions in Design, Fiell Publishing, London 2009
Chairs: 1,000 Masterpieces of Modern Design, 1800 to the Present Day, Goodman Fiell, London 2012

Fontana Arte: una Storia Trasparente, a Transparent History, Fontana Arte/Skira Editore, Milan 1998

Gilmour, D., *The Pursuit of Italy: A History of a Land, Its Regions and Their Peoples*, Penguin Books, London 2012

Ginsborg, P., *A History of Contemporary Italy: 1943–1980*, Penguin Books, London 1990

Gramigna, G., *1950/1980 Repertory: Pictures and Ideas Regarding the History of Italian Furniture*, Arnoldo Mondadori Editore, Milan 1985

Gramigna, G. and Biondi, P., *Il Design in Italia dell'Arredamento Domestico*, Umberto Allemandi & C., Turin 1999

Kries, M. and **Von Vegesack, A.**, *Joe Colombo: Inventing the Future*, Vitra Design Museum, Weil am Rhein 2005

Mauriès, P., *Fornasetti, Designer of Dreams*, Thames and Hudson, London 1991

Neumann, C., *Design Directory: Italy*, Pavilion Books, London 1999

Pasca, V., *Vico Magistretti: Elegance and Innovation in Postwar Italian Design*, Thames and Hudson, London 1991

Polano, S., *Castiglioni: Complete Works 1938–2000*, Electa, Milan 2002

Ponti, L.L., *Gio Ponti: The Complete Work 1923–1978*, Thames and Hudson, London 1990

Radice, B., *Memphis – Research, Experiences, Results, Failures and Successes of New Design*, Thames and Hudson, London 1985

Radice, B., and **Sottsass, E.**, *Ettore Sottsass: A Critical Biography*, Rizzoli, New York 1993

Rizzi, R., Steiner, A., Origoni, F. (eds.), *Design Italiano, Compasso d'Oro*, Centro Legno Arredo Cantù, Cantù 1998

Sato, K., *Alchimia: Contemporary Italian Design*, Taco Verlagsgesellschaft und Agentur, Berlin 1988

Severgnini, B., *La Bella Figura: An Insiders Guide to the Italian Mind*, Hodder Paperbacks, London 2008

Sparke, P., *Italian Design: 1870 to the Present*, Thames and Hudson, London 1988

Vanlaethem, F., *Gaetano Pesce: Architecture, Design, Art*, Thames and Hudson, London 1989

Vercelloni, V., *The Adventure of Design: Gavina*, Editoriale Jaca Book, Milan 1987

Exhibition catalogues

Alla Castiglioni, Salone Internazionale del Mobile, Cosmit, Milan 1996

Brani di storia dell'arredo (1880–1980), Museo dell'arredo contemporaneo/Edizioni Essegi, Ravenna 1988

Carlo Mollino Cronaca, Galleria Fulvio Ferrari/Stamperia Artistica Nationale Editrice, Turin 1985

Ettore Sottsass, Centre Georges Pompidou, Paris 1994

Gio Ponti, Salone Internazionale del Mobile, Cosmit, Milan 1997

Il Modo Italiano: Italian Design and Avant-garde in the 20th Century, The Montreal Museum of Fine Arts, Montreal 2006

Italy: The New Domestic Landscape; Achievements and Problems of Italian Design, Museum of Modern Art, New York 1972

Joe Colombo, Salone Internazionale del Mobile, Cosmit, Milan 1996

Sottsass Associates, Rizzoli International Publications, New York 1988

Stile Floreale: The Cult of Nature in Italian Design, The Wolfsonian Foundation, Miami 1988

Vico Magistretti, Salone Internazionale del Mobile, Cosmit, Milan 1997